MY FIRST MOVIE
TAKE TWO

MY FIRST MOVIE

TAKE TWO

RICHARD LINKLATER • RICHARD KELLY • ALEJANDRO GONZÁLEZ IÑÁRRITU

TEN CELEBRATED DIRECTORS

TAKESHI KITANO • SHEKHAR KAPUR • EMIR KUSTURICA

TALK ABOUT THEIR FIRST FILM

AGNÈS JAOUI • LUKAS MOODYSSON • TERRY GILLIAM • SAM MENDES

EDITED BY

Stephen Lowenstein

PANTHEON NEW YORK

Pantheon Books and colophon are registered trademarks of Random House, Inc.

Library of Congress Cataloging-in-Publication Data

My first movie: take two / edited by Stephen Lowenstein.
p. cm.
ISBN 978-0-375-42347-5
1. Motion picture producers and directors—Interviews.
2. Motion pictures—Production and direction. I. Lowenstein, Stephen. II. Title: My first movie, take two.
PN1998.2M97 2008
791.4302'330922—dc22 2007021606

www.pantheonbooks.com

Printed in the United States of America
First Edition
2 4 6 8 9 7 5 3 1

ILLUSTRATION CREDITS: *Slacker* © Detour Film, courtesy Kirsten McMurray. *Donnie Darko* Pandora Films, courtesy BFI Stills. *Amores Perros* © Zeta Films, Altavista Films, courtesy BFI Stills and Alejandro González Iñárritu. *Violent Cop* 1993 Shochiku Co., Ltd. *Masoom* courtesy Shekhar Kapur and Jugal Hansraj. *Do You Remember Dolly Bell?* © Jadran Film, Sutjeska Film, courtesy Matthieu Dhennin. *Le Gout des Autres* © Les Films A4, courtesy Jean Paul Dumas-Grillet. *Show Me Love* © Per-Anders Jörgensen/Memfis Film, still image © Ake Ottosson/Memfis Film, both courtesy Memfis Film. *Jabberwocky* © Python Films, Gilliam and cast members courtesy BFI Stills, other images courtesy John Goldstone. *American Beauty* © Paramount Pictures, courtesy BFI Stills.

For Jessica

CONTENTS

INTRODUCTION

This book is a sequel to a volume of interviews published by Pantheon in 2001, *My First Movie,* in which I talked to twenty leading filmmakers about their debut films. So positive was the response to the first book on the part of readers and critics alike that when I was offered the chance to edit a second collection of interviews, it wasn't hard to make a decision. Once I'd agreed to do the book, the next step was to decide on a wish list of potential interviewees. Based as it was in New York, Pantheon naturally wanted a handful of the interviews to be with directors familiar to American audiences. Apart from this, I had free rein. Looking back at the first volume, I realized that, as much by accident as design, the majority of the directors I had interviewed came from the United States and Western Europe. I therefore decided that for the second collection I would try to shine a light on various filmmaking worlds—such as those of India, Asia, Latin America, and Eastern Europe—a little farther from the epicenter of the global industry in Los Angeles.

At the same time it struck me that a second volume of interviews would provide the perfect opportunity to pursue various hares that had been set running by the first book. For example, several directors had talked about the American indie film *Slacker* as a source of inspiration for their early efforts. I could now approach the film's writer and director, Richard Linklater, and try to discover what it had been like to bequeath a buzzword to an entire generation. Similarly, although I'd interviewed the Indian filmmaker Mira Nair about her

experience of making *Salaam Bombay!* in India, her training had been as a documentarist in the United States. Wouldn't it be interesting, I thought, to hear about the experiences of someone—such as Shekhar Kapur—whose early career had been forged in the tangled web of Bollywood?

Of course, there were directors I wished to meet for no greater reason than that I was a fan of their work. For example, I'd long marveled at the work of the Balkan filmmaker Emir Kusturica, whose extraordinary, anarchic films seemed almost to explode with vitality and zest. What, I wondered, had it been like to begin making feature films under Communism? There were also directors who not only represented particular filmmaking worlds but whose individual stories I thought would be interesting for the book's readership. The Japanese director Takeshi Kitano, for example, had started out as an elevator operator in a comedy club in Tokyo before embarking on a career as an internationally acclaimed film director. The director of *Amores Perros,* Alejandro González Iñárritu, had been a successful radio DJ in his early twenties before segueing sideways into commercials and then film. In Britain, Sam Mendes had traveled a road few first-time directors could even dream of—being asked to make his debut film by a Hollywood studio and then, as if that weren't accomplishment enough, winning no fewer than five Oscars for it.

Once I had drawn up a short list of potential interviewees, I began to send out requests for interviews. My agent had told me with great confidence that she thought it would be far easier to persuade the directors to participate in the second book than the first. After all, on this occasion they would be able to look at the first book and so have an idea of what they were getting into. Nothing could have been further from the truth. Although several of the directors I'd set my heart on quickly came back with a positive response, I also had a number of responses to the effect that a particular director was too shy, too busy, or, and this was implied rather than stated, too downright *important* to have the time to devote to a book interview. Most of these kind of replies came from PRs, people who for some reason seem to have proliferated in the world of American indie directors. Although discour-

aging, at least these responses were polite. This cannot be said of all my communications with the directors' intermediaries. On one occasion, for example, I called a Hollywood agent to request an interview with his client. Before I had finished my first sentence, the phone had been slammed down and I found myself listening to the dial tone. Nothing personal, I concluded. I simply wasn't important enough to waste more than thirteen seconds on. Luckily I had already found a different route to the director in question. Once he was aware of the request, I received a phone call from his assistant saying he would be more than happy to meet with me. The interview proved to be one of the most interesting in terms of the insights it yielded into the filmmaking process, and the director himself proved to be one of the most charming people I met on my travels.

As in the first volume, the interviews took place in a wide variety of locations: bars, bistros, restaurants, dubbing theaters, and the directors' homes, with children running around at our feet. Perhaps the most memorable in this regard was the interview with Emir Kusturica, which took place as we drove at breakneck speed between his office in Belgrade and his village in the Serbian countryside. Emir's driver seemed to see it as a matter of honor that he overtook every vehicle on the road, frequently dipping back into our lane the instant before we smashed into some oncoming truck. As Emir quietly discussed various weighty matters such as the similarities between John Ford and Diego Maradona—in terms of their extraordinary spatial awareness—I found myself fantasizing repeatedly about the newspaper headlines the following day, should we both be killed in midinterview. When, after some particularly close call, I expressed my alarm, Emir dismissed my anxiety with a regal wave of the hand. "Don't worry," he said of his driver. "He may be fast, but he's very safe."

Fear, of course, is a basic element in every director's experience of making his or her first film. In a memorable phrase, Lukas Moodysson described his debut as a director as "bungee-jumping without ropes." Yet this fear is as nothing compared with the fear of *not* making your first film or, worse, not making the film you set out to make.

In this regard, development people came in for particular criticism for their dogged refusal to understand a filmmaker's vision. Lukas Moodysson—whose enormously successful first film, *Show Me Love,* had initially been turned down by the Swedish Film Institute—said he had been advised by his teacher at film school never to trust the judgment of someone who hadn't made a film. Accordingly, when he was advised to make changes to the script by an employee of the Institute, he smiled and nodded, then completely ignored her comments.

Development people weren't the only villains in the drama, however. Sometimes a whole industry came in for criticism. Alejandro González Iñárritu, for example, railed against all the people who had failed to support his early efforts to realize *Amores Perros,* blaming what he regarded as the venality of the Mexican industry. He remembered going to a successful producer in Mexico City and asking how he might find a foothold in the domestic industry. The producer's reply was to ask Alejandro if he had family already in the industry. When he explained that he didn't, the producer's response was a chilling one. "If you don't have a family in the film business, you should look for one."

On a broader level, many of the directors complained that the global industry has become even more corporate and business-oriented than ever before. "I sometimes feel disappointed and ashamed to be part of this industry when I see how much shit is being produced every year all over the world by these huge corporations," said Alejandro González Iñárritu. On the other hand, the emergence of digital technology has paradoxically meant it is now easier to make a film than ever before. After all, as Richard Linklater explained, the technology of filmmaking isn't rocket science. Stanley Kubrick, he said, didn't learn how to load a camera until the first day of shooting on his first film. "I belong to the Stanley Kubrick school of filmmaking," he added.

Another theme that emerged with enormous clarity in the interviews was the essential *madness* of filmmaking. Nowhere was this more evident than in Bollywood, where producers put up their homes and valuables as security when financing pictures. Shekhar Kapur

remembered a producer who'd just made a film visiting his uncle, Dev Anand. "Have you made any sales yet?" asked his uncle. "Oh yeah, yeah," replied the producer with pride. "Sold my house. Sold my wife's jewelry." Even those working on microbudgets had to take relatively large risks to make things happen. As Richard Linklater put it in relation to *Slacker*'s $23,000 budget, "It sounds like nothing, doesn't it? But when you don't have anything, it's a lot!" Accordingly, he maxed out his credit cards and borrowed money on a film he didn't consider remotely commercial. Not your normal risk-reward structure, certainly. Yet it was a gamble that paid off in Linklater's case. Looking back, he concludes that whatever freedom he now possesses as a filmmaker is directly attributable to the risks he took on his first full-length film.

Linklater cites Werner Herzog's dictum about doing whatever you have to do to make your first film, including stealing film stock and working in the sex industry. Yet it would be wrong to suggest that all filmmakers had to go through such extremes to make their mark. When the French director Agnès Jaoui was approached by Gaumont, who wanted to turn her hit play, *Cuisine et Dépendances,* into a film, so strong was the figure of the *auteur* in French cinema, it was assumed she would want to direct the film herself. Only when both she and her writing partner, Jean-Pierre Bacri, both turned down the opportunity was another director hired. In some cases a director had been so successful in another field that a film's backers were prepared to support their fledgling efforts despite having no evidence of their filmic talents. According to Takeshi Kitano's longtime producer, Masayuki Mori, the backers of *Violent Cop* were confident that Kitano's reputation as a TV comedian would ensure that the film made money at the box office. "They had no expectations in regard to the birth of Takeshi Kitano, the director," he added.

Whatever its backers' expectations, *Violent Cop* went on to be a massive critical and commercial success in Japan. In Kitano's case, such success simply built on the foundations he'd already laid in his career as a popular entertainer. But for many of the directors I met, success was a new experience, and one that was sometimes double-

edged. Lukas Moodysson, whose first film, *Show Me Love,* not only grossed more than *Titanic* in Sweden but was also hailed as a masterpiece by no less a figure than Ingmar Bergman, recalls that for three months after the release of his film, everyone in the world seemed to be smiling at him. It didn't last, he says somewhat wistfully. Similarly, Sam Mendes remembers that after winning an Oscar for *American Beauty,* he went through eighteen months of paranoia when he distrusted people's motives for wanting to know him. "It's gone now," he says. "My Oscar's in a safe deposit box, where it's been for four years."

Success with your first film may bring with it unforeseen pressures and burdens, not the least of these being the question of how to follow it with your second film. But in the context of this volume, it is worth noting just how exceptional an experience such success actually is. Many films are made every year that will never be seen or released, let alone showered with praise and awards by critics and audiences alike. Even so, first-time filmmakers never seem to be in short supply. Indeed, judging by the explosion in festival entries around the world, more people are making films now than ever before. Bearing this in mind, I hope the stories in this volume, though for the most part narrated by filmmakers whose first films launched successful careers, will be a source of inspiration and encouragement for all filmmakers currently making their first films, and for all those to come.

ACKNOWLEDGMENTS

An enormous number of people have helped in the preparation of this collection of interviews. These include agents and colleagues of various directors, who forwarded my initial requests for an interview, then found themselves fielding phone calls when a director went AWOL either before an interview had taken place or after part but not all of one had been completed; assistants with whom I liaised (sometimes for many months) in order to secure an interview with a particular director; friends of friends (and complete strangers) who showed me enormous hospitality in the countries where I conducted the interviews; family and friends in London who gave me moral and practical support throughout the different stages of the book; various stills photographers who allowed me to use their work in the book for little or no financial reward; and producers who helped me track down such photographers and sometimes the directors themselves.

For their help on my various trips to the United States, those to whom I owe a debt of gratitude include (in no particular order) Beth Swofford, John Campisi, Marcella Prieto, Corinne Weber, Yari Hernandez, Sara Greene, Laurent Lambert, Jeff Culotta, Frank and Barbara Lin, Robin and Eliza Campbell, Natalie Carroll, Jerry Simon, and Courtney Puffer. For their assistance during my trip to the Balkans, thanks are due to Vlaho and Suzi Kojakovic, Fedja Hadrovich, Biljana Jovanovic, Svetolik Zajc, Srdjan Vlaskalic, Dejan Vlaskalic, Alexandra Coliban, Calina Coliban, Rica and Dana Aurelian, Tudor Giurgiu, Mihai Chirilov, Ozana Oancea, and (for his help in setting

up my interview with Lukas Moodysson in Cluj, Romania) Rasmus Thord at Memfis Film in Stockholm.

For their help in arranging, interpreting, and translating the interview with Takeshi Kitano, I am grateful to Fumi Ide, Masayuki Mori, Naoyuki Usui, Makoto Kakurai in Tokyo, and Richard Lormand in Paris. Also in Paris I need to thank Sophie Kontzler for her help in arranging the interview with Agnès Jaoui, as well as Jackie, Philippe, and Isobel Freiman for their perennial warmth and hospitality. In London, thanks are due to Susie Farrell and Clare Williams for their help in gaining access to Shekhar Kapur, and to Hercules Bellville, Gareth Evans, Zena Howard, and Hannah Patterson for their help in trying to locate a number of difficult-to-find directors; to Maggie Gilliam for her speedy checking of the interview with her husband, Terry; to Milly Leigh for not losing her cool when I lost mine (after the interview with Sam Mendes fell through for the third or fourth time, I forget which).

I am also indebted in a multitude of ways to the following friends and colleagues: for general support, help, and advice, Jane Turnbull, Lesley Thorne, Neil Heathcote, David Harsent, Paul Nieman, Chris Dickens, Chris Mitchell, Mark Frith, Mark Carlisle, Jake Arnott, and Marjorie Ann and Oliver Lowenstein; for practical help and support, Toby Poynder and Robert Balyuzi; for their help in capturing some of these interviews on film, Steve Milne, Nick O'Hagan, and Steven Hall; for finding and making available many of the photographs contained in this volume, Lea Sadoul, Matthieu Dhennin, and Jean-Paul Dumas-Grillet in Paris, Ridhwana Khan in Mumbai, Roman Traycey in Austin, Larry McCallister, Henrick Knudsen, and Brian Palagallo at Paramount in Los Angeles, Junko Kawaguchi at Shochiku in Tokyo, and John Goldstone in London.

Finally, I need to thank Shelley Wanger, who commissioned the book, Wesley Gott, who designed it, and Ken Schneider and Robert Grover at Pantheon Books, who liaised with many of the photographers named above. Their efforts on my behalf are richly appreciated.

MY FIRST MOVIE
TAKE TWO

Richard Linklater

SLACKER

Can you say a little about your upbringing?
I was born in Houston and lived there my first ten years. My parents divorced when I was seven, and eventually my mother got a teaching job in Huntsville, Texas, which is about seventy miles northeast of Houston. So I moved there when I'd just turned ten. And that was quite different from Houston. When you live in a big city there's a lot going on, art museums, the zoo, pro sports teams, and so on. And then we moved to this pretty small town, eighteen thousand people, and there was a university and the state prison there. We were always moving around. Even in that town we moved every year. My mom was struggling, I guess. So I think I had a semirural Texas upbringing—because this was a small town with a lot of ranchers and a church on every corner, a really small, conservative town. But on the weekends I'd go and visit my father in Houston and go to movies and art museums. So I had this small town/big town upbringing. I'm thankful for this because I would see a movie in Houston and I would go back and tell my friends about it in Huntsville. And then it would show up in Huntsville six weeks later. So I was always ahead of the curve, culturally speaking. On the other hand, I only left Texas once before I was twenty!

Were movies already something you were interested in as a kid?
No, no. Movies were very far away. They were just magical things you went and saw. I liked every movie I saw up to a certain age. I just liked

movies. I still do. But the thought that you could make a movie—I can't explain how far that was from my thinking. The idea that I could ever make a movie never entered my mind until college. Now kids are very aware of the process. But then, movies just showed up. Oh, here's the cowboy movie! Every week it was a new movie. They were just social things we'd go to. But I was a writer from an early age. I was the fifth-grader writing the story that the teacher would read aloud to the class. In sixth grade we did a production of *Julius Caesar* and I ended up a kind of co-director to the teacher. I naturally took a lead role. So I think I had a feel for it. I wrote a play in junior high that got performed for the faculty. Looking back, some of it makes sense, but I didn't really think about it much at the time. I was probably most interested in sports. It wasn't until college that I started to take a couple of theater classes and started to think about film. That's a huge jump, though. I just went from junior high to college.

Can you say a little about your high school years?
I had a pretty mediocre education, although I had an influential English teacher in my third year of high school. I was in this advanced class—which I wasn't really qualified to be in, as I didn't have particularly good grades—but the teacher before had recommended me because I'd written something she liked. We wrote a lot, and our teacher actually showed us *Battleship Potemkin* and we had to analyze it. So I started thinking about film a little bit. In my senior year I remember four of us wandered into a midnight screening of *Eraserhead*. The three people I was with were ready to go about twenty minutes in. They were like, "What the fuck is this?" I was like, "I'm not going anywhere." Maybe I couldn't explain what I was watching, but I couldn't take my eyes off it. But in general I didn't have many serious thoughts in my head at that time. I was just being a kid. I'm amazed at how shallow I was at that age. I read now what other people were doing at certain ages and I'm really envious at how advanced they were and what great educations they received. I was just the opposite. I was a jock, chasing girls and just doing the dumbest shit! [Big laugh.] I mean, I had these sparks and inklings. I had this vague notion I wanted to be a writer someday. But I was not taking anything

seriously. I was just trying to have a good time. I had been through some existential teenage crisis, depressing myself. By the end of high school I was just consciously putting that away and saying, "I'm just going to have a good time." I was afraid I was going to drive myself crazy by thinking too much so I consciously wasn't thinking for a couple of years there. That all changed in college again. It swarms back over you.

What happened after high school?
Luckily I received a baseball scholarship, because I'm not sure I would have been able to afford college otherwise.

What were you going to study there?
I didn't really know. I was just drifting. I found myself taking a lot of English classes. I had a creative writing teacher who'd written novels and books of poetry and I enjoyed being around a bunch of people with writing ambitions. I also took a playwriting class that had a big impact on me. I never got around to taking all the requirements, all the biology and the things you have to take to get a degree. I was just taking classes that interested me. At some point I realized I was probably never going to graduate. I would have to take all these classes I wasn't interested in. I was always a bad student in that way. I couldn't stomach things I wasn't interested in. I couldn't be a good soldier and just get through it. Hence I was a pretty mediocre student, but what I liked, I liked a lot. This was the early eighties, and the VCR had just shown up, so once a week we'd watch a movie in the English department. You know, *A Clockwork Orange, Chinatown,* or something, and a teacher would lecture on it. Every English professor is also a film critic, a film thinker, right? So that was really interesting, thinking about movies. But what I was really into more than anything was theater. You know, studying playwrights, reading a lot of plays, writing a couple of plays. I had dialogue in my head. I remember hearing that Sam Shepard had gone to New York, worked as a busboy, and written for off-Broadway. And that just sounded cool. I was like, "I want to go to New York and write plays." I was starting to have these romantic, artistic notions.

So what did you actually do?

Reality has a way of crashing down on you. I had this heart problem that prevented me from being able to run, which meant I couldn't play baseball any longer. I legally could have kept my scholarship, but I thought I didn't want to be in school and not be playing baseball. In the U.S. we're all deluded into thinking like, "Oh, the world is open, you can be anything." It was around this time I was starting to realize I was kind of a nobody from nowhere. The George Bushes of the world go to Andover and Yale. The class division in our culture was becoming really apparent to me. When you don't have anything given to you and you don't have money or anything, you're like, "Okay, I'm going to have to find my own way through this, nobody is going to help me." The path wasn't laid out for me at all, especially with what I wanted to do, which was to write, be creative. The thought of having a real job was super-depressing. I would have been content to just live in a little closet and read all day and live on welfare. That would have been fine with me. I guess I knew what I didn't want in life—that was very clear—but I was still reaching for what I did want. So I lucked into this summer job working on an offshore oil rig. I was making a lot of money for someone who'd only had a lot of crappy jobs that paid minimum wage. For the first time I was making enough money to save, you know, a hundred and thirty dollars a day, which is a lot when you're used to making twenty dollars a day. I was living with my parents in Houston, my dad and my stepmother. I just had a room there and I was working all the time. So I thought, "Okay, I'm young, I have no idea what I want to do but at least I can save some money and buy some freedom once I know what I want to do." Looking back, I'm amazed I had the discipline to say, "Okay, I'm not going to get anything accomplished in the next few years anyway, so I might as well set myself up for the future." All I really wanted to do was read and watch movies.

What did your parents think about this?

I don't know. I guess they liked the thought of me being responsible. And at least I wasn't hitting them up for money.

You were improving yourself?

Yeah. I was still reading a lot. But I think no one had any idea where it was leading. I think there was a hope in my family that I would get back into school. Although we had no money, everyone got their college degree and did okay. So I was the least educated, and for a while there—for my entire twenties, actually!—I didn't have much to show for myself. I just saved up a lot of money and read when I was offshore. And when I wasn't working, that's when the movie thing kicked in. This was the early eighties and there were still repertory and art cinemas in Houston. There was the River Oaks, the Rice Media Center, and the Greenway Plaza showing all the classics and the latest arthouse releases. So I just found myself at movies. I'd see most of the mainstream movies that were out, but then also everything else I could find. I'd go home and read up on a particular director or actor I'd seen, or a book on the French New Wave or some other segment of film history. At some point I realized I wasn't thinking about theater any more—it was all cinema all the time.

This was the beginning of your celebrated five years of three movies a day?

Yeah! All I really wanted to do was watch movies and read. Actually, I think that's pretty much all I still want to do. [Laughs.] Anyway, somewhere in the two and a half years I was working offshore, I bought a book called something like *The Technical Elements of Filmmaking,* but it just sat there looming on the shelf for a long time. I knew I'd eventually pick it up, but I had read this Alfred Hitchcock quote in relation to film schools. He thought young people should see a lot of movies and learn as much as they could before they started making them. That kind of made sense to me, on a systematic level. I was certainly aware of the many film schools out there, and I knew there were kids my age, twenty-one or twenty-two, who were in school making films. I'd seen some shorts that had been made in and around the University of Texas in Austin. There had been a special program of them in Houston, and it made me think maybe Austin was the place to be. I was thinking I could move there and maybe eventually get into the film school. I also flirted with the idea of

UCLA. My uncle lived in Southern California so I went out there and looked around a little. But then I realized I couldn't get in because my grades weren't good enough. Then I found out my grades weren't good enough to get into the University of Texas, either. So I was thinking, "Oh wow, no one wants me." But it was kind of good because at my core I'm pretty anti-institutional. Once in Austin I got to know some people who were in film school and I'd sit in on various classes. Often I'd hear the teacher and think, "You know what? There's a reason I never liked the academic world." I just thought my path would be on my own. I'll learn from everybody, but I don't think it's in my cards to be accredited. So by the time I finally moved to Austin I'd already bought a camera, some editing equipment, and a bunch of film stock and started shooting film. I remember thinking, "This is it, this is what I'm going to do—no turning back." I was never worried about the technical aspects of filmmaking because I was always good with that kind of stuff—it's not that tough if you have a knack for it in the first place. The guy Stanley Kubrick rented his camera from taught him how to load it on the day he was shooting his first film. And I'm a believer in the Stanley Kubrick school of filmmaking! I've never understood people who are like, "I'm going to spend all this money and go through all this academic rigmarole so I can my lay my hands on a camera." Just rent a camera or borrow a camera so you can use it all weekend. The technical apparatus of filmmaking is not that big a deal; it's not that intimidating. Nowadays everybody owns their own digital cameras, so it's almost not even an issue.

I read that you took some classes at the Austin Community College?
Yeah, at that time I hadn't totally dumped the idea of going to film school, I guess, and to give myself a few options, I had to get my grades up by taking a few classes. It turned out to be the best thing I ever did. I took a film history and a film appreciation class in the same semester, thinking it would be easy and fun. It turned out I had to write about twenty-five papers, which was a bit grueling but exhilarating. Until then all my film studies had been on my own. I had seen all

these movies alone. I was reading alone. I was living alone. Now I had to articulate my ideas on various films and different aspects of filmmaking and film history. If the assignment were to write a four-page paper on *Citizen Kane* or something, I'd write a twelve-page paper. If you had to write two pages on Brando in *Last Tango in Paris,* I'd write six. I was like, "Wow, too many ideas, too much to express!" The teacher, Charles Nafus, who still works with me in the Austin Film Society, semi-jokingly says I could have been teaching the class. But it was fun to rock 'n' roll with it! At some point I gave up the idea of ever trying to get into film school—I realized I'd already seen so many movies, read so much about them, and eventually had made so many shorts and technical experiments that I was now too far ahead to go backwards. I didn't know where that might lead, and I wasn't a hundred percent sure I was a director, but I had a passion that would always guide me. I had movies in my head that I wanted to make, but if that didn't work out, I figured I'd be writing about film or running a theater or be in distribution.

You said you bought yourself a camera. What sort of thing did you do with it?
Pure formal exercises. I'd read somewhere that your first film is always really tough because your ideas are always so far ahead of your formal abilities that it can be really frustrating. So I took the pressure off by admitting that it wasn't going to be meaningful in any way other than as a technical exercise. I'd do an entire short film as simply a lighting or editing exercise. I'd do a film to practice camera movement. So I was very patient with myself, I guess. I've seen a lot of people starting out and they want to do everything at once and it's just overwhelming and frustrating. You might start thinking you just can't do this. Looking back, I'm amazed how patient I was with myself. I think filmmaking requires a certain kind of personality that can have extremely deferred gratification. Extremely! If you need an immediate response to your work, be a performance artist, be an actor, be something else, because it's not going to happen in film. Ever. By the time you get that response, you're on to your next film. By the time people see a movie

that I'm just finishing, I've left that film behind. So you never get immediate feedback.

What about the people you're working with?
Yeah, in the process, you get feedback from the people you're working with—which is all that really matters.

You have to sustain yourself?
Yeah, and I was always good at that. I think it was growing up the way I did. I think I figured out early on you had to be your own best friend, give yourself a break because no one else is going to. I've studied people's careers, you know, always asking, "So where did they go wrong?" It's helped me to this day. Not too consciously, but like, "Oh, okay, great talent but too much drugs." Or, "Got a little too big for his britches and fell." Or, "Reached for too much independence and got crushed."

You sound wise beyond your years!
It's not a conscious thing. It's a preservation thing. I'm an outsider with no connections in the industry. It's certainly not my birthright to be doing this. So I was always kind of cautious about it. I never had a sense of entitlement.

Have you met many people with a sense of entitlement?
Are you kidding? All the time—and the more privileged the upbringing and the more expensive the film school, the more the sense of entitlement. It's sort of a curse in the arts, which requires humility. So you have to have a long-term approach. I remember Godard being quoted as saying something about not getting to make your first film until thirty. I was sitting there, age twenty-two or twenty-three, thinking that's a long way away. So I figured if that was the case, I'd work toward that, but in the meantime I had a low overhead, I wasn't obliged to anyone, I didn't feel compromised, I felt completely free. I have to say it was wonderful to not be in school and not be working because I had money to live on.

You were no longer working on the oil rigs?
No. I had gotten laid off and moved to Austin.

So what were you living on?
I had saved up all my money and moved to Austin with about eighteen thousand dollars, which was a lot of money in the early eighties. I'd saved up a bunch of money and bought all that film equipment. I was living on a few hundred a month so I was putting all my money into film stock—that was the area where I'd indulge myself. Anything related to film I would spend it on. In the rest of my life I would eat rice and beans and live in a little room. I had my priorities, that's for sure. I had created a life for myself, how I could work. And I was thinking pretty long-term. I was going to watch a lot of movies, read and keep working on my own things. I had an idea for a feature I wanted to do. And after a couple years of shooting these little things, I was going to segue into a bigger piece that would be something I'd put more of myself and my thinking into.

When did you set up the Austin Film Society?
That was in the fall of 1985. It all started out of an upstairs flat that Lee Daniel and I were living in. He was working as an assistant cameraman in the local industry, shooting commercials and the occasional feature. We were both shooting a lot of Super 8 and some 16 mm shorts and wanted to see some more experimental films than what was showing. I was in the mood for making something happen. Like I said, so much of my filmmaking had been very solitary, and I was having to rediscover a part of myself that could be outgoing and get up the courage to go talk to a theater manager and say, "Hey, we want to show some films here and work out a business arrangement." I was having to tap into the leader part of myself, which I knew I was going to need. If you're ever going to get a film made, you have to be almost a hustler/criminal type of person. I was pretty far from that, so everything I did with the Film Society was like training. And it was fun to be taking my passion for film into the public arena. But it was always about a continuing film education—still is. If there was a director I

liked and wanted to see more films by, we'd do a retrospective. That was a great education, but on top of that, it was nurturing a film culture in Austin that has made it easier to stay here and do what we do. And the Film Society is still around, bigger and better than ever.

When did you make your short film Woodshock?
Nineteen eighty-five. That was a film Lee and I made together.

What was it about?
There was this annual music event that took place right outside Austin, where all these punk bands played. Lee was shooting something else and had this 16 mm Aaton camera for an extra day. I'd bought all this ten-year-old 16 mm film stock, so we went out and spent a day shooting stuff, then about six months editing. [Laughs.] It was about seven minutes long and an homage to the "experimental films" of the sixties, a lot of which we were showing at the Film Society. Again, merely a technical exercise ultimately. But it was shot on 16 mm, edited, conformed, finished, sound-mixed, like an A-to-Z thing. I'm amazed at people who've never even made a short film who want to make a feature. That just seems so odd to me. That's like saying, "I'm going to write a novel but I've never written a short story." It just seems unfathomable to me.

Does that happen?
Yes. It happens all the time. If you have a little bit of juice, say if you're an actor or a writer, you may get a chance. But even if you're an Academy Award–winning writer, you should make a little seven-minute short before you make a feature. Just an A-to-Z thing. I keep telling people this. This is my mantra to first-time filmmakers. You don't know what you don't know until it's too late. You can read every book, but you just don't know what you don't know. And I would really suggest learning it on your own at a low cost. Not blowing it on a million-dollar feature. You shouldn't have those as learning experiences. My first two features were so low-budget I considered them outgrowths of the same kind of learning thing. I was still aware that bigger films were possibly ahead of me and I still didn't know much.

Did you know from early on what kind of filmmaker you wanted to be?
Not really. I was a couple of films in before I realized, "Oh gosh, this must be who I am. I guess I'll never be that other thing." It's kind of a sad day. Before you've done anything, the world is completely open, just like any actor starting out saying, "Oh, I want to be Meryl Streep or Robert De Niro." At some point you look in the mirror and go, "Shit, okay, here's who I am. I'm not that, but I am this." You sense your limitations and learn to live with it.

A number of your later films are regarded as having a European feel to them, in the sense that they're more talky than the average American movie. Do you think the Film Society affected your filmmaking because it opened you up to European influences?
Definitely, but all my initial shorts and my first feature weren't dialogue-driven at all; I guess I wasn't trying to express that much with them. Parallel to everything else I was doing early on, I was always enrolled in acting classes. I knew that was one more step I had to take. Having flirted a little bit with it in college, I was intimidated by it. But I knew I enjoyed it and had a feel for it. I just had to overcome a fear of it, knowing that such a big part of what I wanted to do in the future depended on it. I read an interview with Spielberg who said he got into acting classes when he was younger, never wanting to be an actor but just wanting to know what actors are about. I recommend that to everyone. Get up there. Study your monologue. Do it in front of people. Just know what that's about. Just know the agony and ecstasy of that. That'll help you tremendously. But I enjoyed acting. I studied it for years. I think it made me feel a closer kinship with actors, although I never pursued it myself and knew I didn't have the personality to pursue it. I'm more of a behind-the-camera guy, but beyond that I really enjoy it. I appreciate the bravery of actors and I think actors sense that I like them. Even if I don't articulate it, I think actors who work with me sense that I'm totally enthralled with what they're doing because I admire it. Just the same way you'd admire a world-class athlete. Wow, you're doing something that a lot of humans just can't fucking do, whether you hit a baseball, shoot a basketball, throw a football, you just admire it on a physical, aesthetic

level. When I'm working with great actors, I just admire it on all levels. I'm a big fan.

*Can you tell me about your pre-*Slacker *Super 8 feature,* It's Impossible to Learn to Plow by Reading Books? *It sounds like a Bolshevik tract!*
Yeah! [Big laugh.] It's a Russian motto on a T-shirt in the movie. It belonged to a friend of mine who was studying Russian in Montana. It's printed in Russian on the shirt, but I mistranslated it later in the movie. That film is very much the precursor to *Slacker* in terms of where I was in life. That idler dropout mentality. Those two films were really my twenties.

What actually happens in it?
Nothing, you know? It's a very minimal movie. Very Oblomovian. There's a lot of travel. But you could argue that nothing happens. I had this idea about this lead character who's not really a lead character. Kind of a no-name person traveling through time. Structurally it was designed around my limitations. But it was a big film in my development. It's a three-thousand-dollar Super 8 movie, but it's the first one I really thought about and put a lot of time into. And I wasn't at that time certain that this would be my calling. I felt it in my heart, but I didn't know for sure. So I put everything I had into it. I put all my passion into shooting and finishing it. The main thing is finishing it. That's what I taught myself. I can conceive, shoot, edit—and finish. That's the most important thing. I will see it all through to the end and learn a lot in the process. That's been my kind of mantra ever since. So I spent about a year off and on shooting it, taking little trips. I took two trips on Amtrak and then I'd be back in Austin, editing and thinking about it. It was just scenes in and around my own life that I could fit into the movie. You know, getting my car repaired, house-sitting for my mom. The film is very nonverbal. It's about a lack of communication. It's like a lonely-guy-on-the-road movie, which is a subgenre unto itself. *Two-Lane Blacktop* would top the genre probably, with a healthy dose of Wim Wenders's seventies movies. I haven't seen Vincent Gallo's *Brown*

Bunny, but it sounds a lot like my first film, minus the blow job at the end, I guess.

Did it get shown?

Not really. I made it and proved to myself I could make a movie. I didn't think the film really should be shown anywhere—I never submitted it to a festival or anything. It's about as noncommercial as it gets, but it now has a home as bonus material on the Criterion *Slacker* DVD. When I finished it, I sent it to Monte Hellman because I'd seen *Two-Lane Blacktop* while I was editing *Plow* and was really inspired by it. And a few months later he sent me back a real sweet letter saying he'd really enjoyed it and thought I'd make more. It was a real shot in the arm. Someone I admired saying he predicted I'd go on to make more films. And that actually helped me with my local cronies—it really helped to have this letter from Monte Hellman saying he was looking forward to my next film. It was a small thing, but it was kind of a big thing, too.

Let's talk about Slacker. *How would you describe its evolution? Did it start with a single idea?*

Yeah. It was like one of those "eureka, voilà" moments. It was about two in the morning and I was driving from Austin to Houston, where my family still lived. I was driving along and I was thinking, "Well, why couldn't you just do a film where you meet a character and go with them for a bit and then go off with someone else? Why couldn't you tell a story like that? It wouldn't make any sense on paper, but you could just go with it. It would be purely cinematic, you know?" And that thought never left me. It was just planted. And then, sure enough, as I was getting closer to making it, I dug a little more and found out that, of course, there are precedents. I told my dad about it and he goes, "Oh yeah, Arthur Schnitzler. *La Ronde!*"

Was it always going to be called Slacker?

No, there were several working titles along the way. In my mind it would be a little more audience-friendly than *Plow,* which was the

opposite of pleasing. You know, a purposefully alienating movie. This was much more of a fun idea—I thought it would be playful. It'll go between these different characters and that'll allow me to go into these different worlds, but seemingly in the same space and time continuum. I thought I could get all these actors to work for one day because then I wouldn't need them again. So it was sort of designed around its limitations. And I would shoot it like a documentary. But what I had in mind was these long, elegant camera moves, which meant I needed a dolly. In this way, too, it's different from *Plow,* where the camera never moves. This I saw as flowing. And in *Plow* no one talks much. And this, I thought, would be all talk. But just monologues. I guess I was interested in obsessed people. I was interested in the unconscious dialogue that's going on in all our heads. But I was trying to make that work as film dialogue. I thought that would be funny and interesting. So much of the movie is these one-sided monologues. But I was surprised as anyone at it. Before that I would have thought, "I'm not that talkative really." I wouldn't be considered a bigmouth. But I was like, "Okay, this must be where I express that side of myself. I make talky movies!"

Did it have a long gestation period?
I was trying to get another film made, a more conventional script I'd written. But I never could raise the money for it. Looking back, I don't know why I thought anyone would give me anything. So when I failed at that, I thought, "Okay, I'm going to make that crazy film I've been thinking about all these years. I can shoot it on 16 mm in my own backyard. I can get people to work a day here and there and maybe swing it on a kind of no-budget level." I think there's a kind of movie, which is often a director's first movie or early movie, which I'd call the "backyard movie." It's the movie a director does in their own neighborhood for very little money. Scorsese's was *Who's That Knocking at My Door?* And then there's *Chan Is Missing, Return of the Secaucus 7, She's Gotta Have It, Stranger Than Paradise.* They're all these first films that, if nothing else, are interesting anthropologically because they take you into a world where you get to know some people who

are off the grid a little bit. Out of the mainstream. And as I was kind of living in the counterculture, I thought it would be fun to depict my own life and my friends' lives.

How did it evolve? Was there a script?
Not a conventional script. I didn't want a conventional script. That didn't interest me. It was all about the process. I liked the idea of a Godard movie, where he'd just have notes to himself and notes about a scene, but he wouldn't have a conventional script. So I was like, "Yeah, fuck the script!" But each day I had a script. By the time we were shooting, I had a script for that scene. But it's how we arrived at that script which, to me, was the interesting process. In terms of what I wrote, the most important moment came in a twenty-four-hour span. I sat down in a little warehouse apartment in Galveston, Texas, and in a twenty-four-hour period wrote out the whole movie. What scene goes to the next and to the next. I wrote out what would be called the road map, the characters and connections. And that first pass was kind of close to what goes on in the movie. It wasn't all off the top of my head, by any means. It was notes, it was poring through my own notebooks. I always liked that Godard quote about where your movies come from: twenty percent things you've heard, twenty percent things you've witnessed, twenty percent things you've read, twenty percent pure invention, and twenty percent something else I can't recall! I'd call it a real kitchen-sink movie. I created a structure that could encompass a lot of unrelated material that wouldn't fit together in a usual narrative—a weird little story or part of a story that you wouldn't want to build an entire film around because it's not substantial enough, but maybe here it's a fun little three minutes.

I wasn't certain if the characters were essentially playing themselves or if they were playing characters you had invented for them.
I didn't want the actors to act in the traditional sense. I used to say, "We're filming a documentary of you acting out fiction. So here's a fictional situation, but I've cast you to do this because I think you can bring yourself to this." So the casting process was really crucial. I had

this outline with the characters I was looking for, but I was just trying to meet interesting people. Anne Walker headed up the casting, but we were all out there looking for people that stood out in some way, and recommending characters we knew from around Austin who could maybe do a certain part. There were very few professional actors. But my attitude was that it wasn't about that. It was about whether I could make them comfortable so they could be themselves. Looking back, it was pretty bold. I didn't know that it would be tough to have these four-minute monologues by nonprofessional actors and actually make them believable! That's tough to pull off in any world. But our own naïveté was helpful. You just set up the rules of the film: "Hey, here's what we're going to do!"

Did you see many people when you were casting?
Yeah. But it was pretty specific. People would come in and we'd do these interviews and talk about what's going on in their lives. And pretty early on I'd go, "Oh, maybe he could be the UFO guy, maybe he could be the one in the van." You get talking to someone and you think, "Oh, you'd be good for this part." And at that point I hadn't really written the dialogue. It was very rehearsal-based. Before the first rehearsal I would write out what I would call sample dialogue. I'd just write the scene and give it to the actors and we'd often rewrite it to their specs and ideas. So it was pretty loose that way. Some scenes were as written and others were just transformed incredibly, based on what I felt was working. So it was all over the map. No two scenes were alike. It was just whatever worked for the movie. I think that's what a director does. You're sort of the conductor. Whatever works for the movie, you have the final say.

Could you tell me about the genesis of some of the characters? For example, the Pap-smear lady, the UFO obsessive, the woman in the bar who says she's a doctor? They're all so specific.
A couple of years earlier I was sitting in a little diner near Columbus Circle with a friend of mine. I look up and there's a woman who kind of focuses on me and says, among other things, "You should never

traumatize a woman with sexual intercourse." So that actually happened to me. And then I cast this woman, Lori Capp, who'd worked with schizophrenics. She had actually worked in mental health and she remembered some of the behaviors and some of the speech patterns. So we got to talking about that and she said there's a moment in a Bugs Bunny cartoon when Elmer Fudd says, "I own a mansion and a yacht, you know." So we put that onto the end of it just because it was funny. I'll never forget when *Slacker* premiered in New York at the New Directors/New Films series in the spring of 1991. It went over big with the New York audience; it was a real New York kind of film. In the Q-and-A afterwards, someone in the audience asked if everyone in Austin was crazy and wondered where we met all these people. And I said, "Who do you mean?" And they said, "Like that crazy lady sitting at the counter in that one scene." And I got to tell them that happened to me about ten blocks from where we were! The UFO-guy dialogue, believe it or not, was mostly all written. I'm a minor-league conspiracy guy myself just because I think it's amusing. But a friend of mine, Sid, was really hard-core. He came around and I told him up front, "Hey, I want to do this scene so let's just talk." And he didn't know I was recording. I was taking notes but I was also recording. We talked for thirty minutes and he gave me some of his most far-out stuff. I'll never know to what degree Sid believed all this stuff! He was a Film Society guy, came to all the movies, and was a friend. So as a director and an editor, I went through all this material and kind of fashioned this scene. And then casting the right guy was the big moment. Jerry Delony came in, and what was he talking about? That he'd had some sightings! It was like, ding-ding! Here we go! I spent more time on that scene with him than on most of the other scenes put together. It was a long scene. It was tricky. But he seemed perfect for it. And it was a lot of fun. And he threw in a lot of stuff, too. But that was actually more written than a lot of the others. Pre-written or at least preconceived. The Pap-smear scene was in two parts. When Teresa Taylor approaches the young man and woman who are already on the sidewalk, the story she tells in the first half of the scene is exactly the same story she told me a few years before. We were making

Film Society T-shirts together, and she said, "Did you hear? Some guy pulled into town and was shooting at people." It just seemed like an odd story, but I liked that. In most movies you would follow the guy in the car shooting at people. Isn't that what movies are about? Let's see the action. But this movie was more concerned with secondary sources and more about how someone might relate to an incident. So little actually happens in *Slacker*, but it's people talking about interesting things and imagining worlds, re-creating worlds in their minds through dialogue. So I just had a hunch: "Oh, that's kind of what this movie's about. Someone telling a fantastic story while we're hanging out on the street corner." And the second part of the scene—when she's peddling the Pap smear—was conceived on one of my trips to Montana when I was doing *Plow*. I met this guy, Matt Crowley, a pharmacy student/rock star kind of guy who eventually toured with the Jim Rose Circus Sideshow. We were sitting around in a bar in Montana and he was theorizing that the future of pornography might be something like Madonna Pap smears. And over the next few years that became something in my mind—a celebrity Pap smear that was worth something. I actually remember thinking that I didn't want to date the movie. I mean, the movie's very specific to a time and a place, but on another level I wanted it to be bigger than that. Not too pop-culture-y, ultimately. I remember thinking, "Will that date it? Will Madonna endure?" Then it's like, "She's been big for five years or so—seems like she's in it for the long haul." So in 1989 I made the commitment to Madonna and she hasn't let me down. [Big laugh.]

One further character—the guy with the TV on his back. Where did that come from?

Again, it was an amalgam, like almost every scene. The guy, Kalman Spelletich, is a hard-core artist. He builds these wonderful machines, he's a pretty fascinating dude. Around that time, he and a friend had a performance piece where they actually had the TV backpacks. So that was one reason for casting him. The idea of someone who lived for the televised image was something I'd come up with because it manifests one of the primary ideas of the movie about reality once-removed.

He's so into his video world that he talks about seeing a real knifing, but the blood was the wrong color. I'd had that experience in New York the summer before. I was getting on the subway, there had been a knifing, there was real blood, someone down. And I got a glimpse of it and it just looked weird. And I was like, "Okay, I've been subjected to tens of thousands of murders with all the TV and films I've watched, and here I am seeing the real thing, a pool of blood, and it looks a little weird, darker than I'd thought." Then the train comes and you get on. It's just a moment. So that's just one idea that channeled itself into the scene. But then there's an absurdist element to it, too. The idea that he has TVs on all the time. That one had been on for ten years straight. And making all those loops for the TVs, that was its own little production. I'd been saving up a lot of images. So that scene was one of the most time-consuming, hellish ones.

Slacker *starts a pattern in your work, which is to make a film where the action takes place over one day. Was this deliberate?*
It was twenty-four hours in the life of this town, seen through these people. Isn't that an ancient Greek dramatic device? All of their dramas were very limited in time—a day or so, no more than two. And for me, having no story, it was a structuring device. Cinema is really all about structure, and that seemed to ground it. I wanted it to be completely out there on one level, unexplainable, but on another level I wanted an audience to be able to follow it. It was just a hunch. I didn't have any huge ambitions for the film. I thought maybe it would play at some film festivals. I had some notion that maybe European television would be a possible outlet and I could get back the money I'd spent on it.

How much did it cost?
Twenty-three thousand dollars.

Where did that come from?
It sounds like nothing, doesn't it? But when you don't have anything, it's a lot! I did all the typical things. You know, maxed out all my credit

cards, sold things I could get money for. Did all kinds of illegal stuff. Looking back, I could have been arrested several times. I was right there on the criminal border, or actually far beyond the border. I was going to the Exxon station every night because I had an Exxon credit card and it was one of the few credit cards that hadn't been canceled. I'd go there to get craft service for the crew. I would buy three dollars of gas and then I'd load up on gas-station groceries, water, Gatorade, chips, whatever I could buy there. And one night I had all these groceries and I gave the guy my card, and he was like, "Sorry, they're rejecting your card and it says to keep it." And I was like, "Well, okay, that gig's up." So I moved on to something else. I just kind of went for it. Looking back, I think whatever freedom I have now in the world is probably directly related to the risks I took unknowingly on that film. I mean, I really bet the farm. I bet everything I had on something I didn't think would be commercial. I never thought it would get its money back. But I was just kind of compelled. It was kind of crazy. It really felt like it was an artistic, criminal undertaking. I can appreciate it when I hear Werner Herzog say [heavy German accent], "Steal the raw stock, steal the camera, work in the sex industry, do whatever you have to do." It's crazy, but I think you don't question what you're doing in the bigger world. You don't question the morality. Because you know you're right. Your needs are bigger and the film gods understand you, even if society doesn't necessarily agree with your methods. We stole a dolly because we needed it for all the dolly shots we'd be doing. There was one that wasn't being used at a local TV station. So we went up there and took it and used it. You just have to be this arch-manipulator, opportunist. We eventually returned it. I was quoted at the time as saying I can't wait to do a movie where I can pay people because then they have to deliver or they're fired. At the no-budget level, you're balancing everything and everyone's other priorities. You're trying to make it fun because no one's actually getting paid and they may or may not show up.

Was that ever a problem?
People didn't show up on time. We're shooting at dawn, and various crew members would wander in late and I would say, "If this were a

real movie, you'd be fired." Everyone should be there on time. But since they're not being paid, they can show up any time they want and you have to be grateful they're even there at all, which you are in the big sense. So it's like you have to instill a sense of purpose in everyone. It was the same with the Film Society. It was an all-volunteer organization, but there's a mission, and if somebody said they were going to get something done but didn't, we couldn't use them.

Did you sack anyone?
Yeah, suddenly you're the head coach. You can't be afraid of offending a few people. That's the price you have to pay for winning the big war. You discover a lot about yourself. Such as if you have the stomach to not necessarily be liked by everyone. You're not going out of your way to offend people, but you're creating something and people will spring up in opposition to you, challenging you, other guys who think they should be making the film. "Why are we doing your film when we should be doing mine?" You have to be able to drift away from some people and incorporate some others, go with your instincts. I think the most important thing is learning to trust your own instincts.

Do you think you were good at it?
Yeah, I think so. I was pleasantly surprised by myself. In my own mind I felt like kind of a phony. But I really think this is a necessary quality to be a director. You really have to be able not to show your hand all the time. Whether you're dealing with an actor who's not doing it right or someone who's going to give you some money. I mean, you need good qualities, talent and so forth, but you need bad qualities, too. Tolstoy said that about his older brother, Nicholas. He said he was every bit the artist Tolstoy was, but he didn't possess all the necessary bad qualities. Think of all the things that would make you want to do this in the first place and all the compromises you have to make.

So were there things you didn't like about the role of director?
Not really! [Big laugh.] I was like a pig in shit. That's when I realized that this is what I do. And I saw how I would do it differently if I had a little bit more of a budget. I mean, it's two in the morning and I'm

driving to the bus station to get the film. I'm getting the food for everyone. I'm going to get the shirt for the actor who left it twenty miles away. And I was thinking, "Anyone can do this. I can't wait to have people on the payroll to do this. Let me just concentrate on what the camera's doing, what the actors are doing, and the script." Because at that point I was like the all-encompassing producer. You're spinning all the plates.

There was no one else on the film who had a producing role?
There was Anne [Anne Walker, casting director, production manager] growing into it, but it was mostly me manipulating the money, hustling up money. I had enough to get going, but then I had to start hitting up family members. My sister came and visited briefly and I got a thousand from her. I'd been warning them for years. Everybody gave me a little bit. I actually got it shot and edited for about twelve thousand. But when I got to the point of finishing it onto film, I needed more money. And at that point I'd gotten interest from a German TV station. Some people spend years and years on their first film. This actually went really quick. We shot it mostly in July and August of 1989. I showed it as a work in progress at the Independent Feature Market in New York in October. I got a letter from a German TV station in November saying they wanted to buy it for their station. That would prove almost enough to finish it, with a loan from my parents floating it until we delivered. I couldn't go to a bank or anything, but I was able to say to my parents, "Hey, they're gonna buy it." And I got the lab to defer some costs until the money came in. I was really blessed, you know? It didn't drag on for years and years. For a no-budget film to start shooting in July and have an answer print in January, that's pretty damn quick in this world. So it was a most intense time in my life. I just remember every waking second and sleeping moment, it was all about the film. I loved that. I didn't think I was missing anything. I realized there was nothing else I'd rather be doing.

How did you prepare with your DP [director of photography], Lee Daniel? For example, the opening scene where the guy runs over his own

mother. You used a really long tracking shot for this. Was this all worked out beforehand?

Yeah. In that case we used a crane. Lee had a connection with the company that had the equipment, Texas Pacific. He'd worked with them on a lot of commercials. Austin is a pretty close community, and people help each other out any way they can. We were doing this film and everybody was working for nothing. We've got all this energy and it'd be like, "Can we borrow the crane in the morning just for a few hours?" And people would let us. I'd never done a crane shot before, but I knew what I wanted. I'd never done a dolly shot before, but I knew what I needed. It was just like, "This is the way this film is going to look and this is the way we're going to do it." There's a long Steadicam shot of the UFO guy coming out of the coffee shop. So the production values are pretty amazing for a no-budget feature. So much of that access was Lee's professional connections. And Ralph [Watson], the Steadicam operator, is a guy I work with to this day. He still gets a little check from *Slacker* every now and then because everybody's pay was deferred and everybody had a percentage of the profits. And everybody got paid. That was the proudest moment of my life. To pay people for what they had invested out of faith, who weren't really doing it for the money in the first place.

Going back to your preparations, can you describe how you worked with Lee?

It wasn't just Lee, it was a whole group of us. It was Anne and Clark [Walker]. Clark was the assistant cameraman and dolly operator, kind of everything. Then there was Denise [Montgomery], who did sound. Denise had done a lot of sound work so she was mixing, but she also sort of headed up the art department. We'd have these story meetings where we'd sit in a room and I'd walk them through everything and they'd ask hard questions. This was the moment where I learned to articulate what was in my head. Since the first shorts I'd worked on, I'd never had to explain myself. I just did it. Now I realized I had to talk! I need to talk to people, crew, cast, and it was a big [makes the clicking sound of a lightbulb being switched on]. And they were ask-

ing questions, throwing in ideas, wondering how people were going to understand this movie. And I was like, "Well, it's like a baton pass." We'd come up with these visual metaphors. It's a baton pass in a relay, and this is the moment we do that and then we're going to pan away. And when we were planning locations, it was like, "Well, all the locations won't technically be close, so where're we gonna cut? After that person walks off, when are we gonna cut to another?" So it was like putting together this big puzzle, like all movies are. And it was this group of about seven of us who were intimately involved in this process. Although we all had specific jobs, it felt like we all were doing everything. Anne was head of casting but we all still gave out cards. Lee was the cameraman but he was also helping in other areas, locations and what have you. It was sort of a group art project. At the end of the day they were calling us the "Slacker Seven." On one level, it was me manipulating everybody, it was my idea and everything, but on another level it was so highly collaborative because I knew the film would be so much better because of everyone's contribution. So it was sort of a group project made in the kind of family atmosphere that you don't get on a more professional level. But you also build that feeling up because no one's getting paid and you want people to feel a part of it. I was the director and had the final say, but it didn't behoove me to be playing that card too strongly. At the end of the day, when the film came out, some were a bit surprised. Oh, so it's *your* film?

No sourness, though?
Not really. It was more like a little bump.

What did you spend most time on before the shoot?
Rehearsals, probably. Casting. It's not like we had a regular schedule. Anne came in and contributed as an organizing force. She was the one who could get on the phone and make things happen, so she'd be like, "Here's your schedule for tomorrow. You're going to be rehearsing from noon to two-thirty." No one asked her to do that. It just emerged that some people would be good at one thing and other people would be good at other things. If Lee was working on a commer-

cial for a couple of days, we couldn't shoot for two days but we could rehearse. And then it was, "Oh, we can shoot Thursday and Friday so we'll do that. We can't Saturday, but we can Sunday." So it was like that for about two months. We didn't shoot every day, but the down-time was spent in prep. Someone like Lee was working every day, either working on the film or doing his job. So everyone worked all the time in one way or another.

Including you?
Every waking second, pretty much. That's just what it took. Casting, writing, rehearsing, editing, scouting locations . . . it never ended.

What was your level of technical knowledge at this point? For example, did you set the lens?
Yeah, it was easy. The lens was set by deciding there was only going to be one lens for the whole movie. I felt this would contribute to the visual continuity. The biggest visual idea was probably that I wanted very little editing, long takes, and the same lens. With the people changing constantly, I wanted it to seem real, like an unending flow. I wanted as little manipulation as possible. It kind of flies in the face of MTV imagery and fast-cutting that was taking over the visual lan-guage of that time. It was to be an anti-film film, which is a style in itself. But that was just how I visualized it. I think it took the people I was working with a while to understand what I was going for. I'd be trying to choreograph the camera and people would be asking why I didn't just cut. "Cut over here, then cut back. What's so fucking tough about that?" I just said, "Naw, I can't really cut." I didn't want it to share the syntax of a TV movie. I had this kind of flowing, real thing going on in my head. Lee saw what I wanted and went with it. But there were other people who were moaning behind my back about making it more difficult than it had to be.

Anything to distinguish it from run-of-the-mill movies?
I guess. On the one hand, it's how the film had to look, but on the other hand, it played to our strengths as well. To do it traditionally

would have played to our weaknesses. We didn't have a continuity person so continuity was an issue we would have failed on. It would have been kind of amateurish to go into that arena. So on the one hand, the style of the film was helping us technically and on the other, it grew out of our limitations. You know, take a disadvantage and make it a stylistic choice!

Do you think your stylistic ideas survived into the shoot?
Yes, an incredibly high percentage. I can't think of anything that was compromised. There were a couple of times where I did have to cut. We were at a table and I just couldn't get everybody in the shot, so I had a few cuts that felt immoral. But other than that, I didn't feel compromised at all. I think I got everything I wanted. I was very stubborn then. I'm more collaborative visually with the people I'm working with these days. But at that point I felt the film could get away from me technically if I didn't keep it really close. But Lee and I always saw things the same way, and that's why we've worked a lot together since. I think a good cameraman gets on the wavelength of the director and doesn't impose their own will too much.

What did you shoot on the first day?
What we shot the very first day, which was on a July Fourth weekend, was me getting off the bus and walking to the cab. So we had to get a cab, we needed a bus schedule, permission from the bus company. We were all set, and then at the last minute we found out that the bus was leaving in thirty minutes, so we had a lot less time. We had to do it real quick, you know, set up the dolly shot. It was kind of crazy. Still, it was like, "Wow, we're making a movie!"

How did you find doing your opening monologue in the taxi?
That was very similar to the movie I'd done before, and very private. I wrote it and rehearsed in private. I acted it in private. Denise was in there with the sound. She was sitting on the floor of the passenger seat with a mike. There was a camera mounted on the hood, and I did the slate, but no one heard the scene. I pretty much did that alone in two takes.

Were you nervous?
It was like, "Okay, get used to it!" But I felt good when it was over.

Your monologue seemed to sum up one of the themes of the film, the nature of chance.
Yeah. But I wasn't even that conscious about it at the time. I had an earlier idea that the guy wouldn't say anything. The cabbie would do most of the talking. But as I got closer to the filming, I thought, "No, this guy's got to set the tone." And then I thought, "Well, it's me, you know: kind of the same guy who was in *Plow*." But I was like, "What if he was to start talking? You know, to say what was on his mind?" So that triggered it. That set the tone. And it's kind of like being the first one into the pool. If I'm having this party, I'm the first one in. It's like, "I did it. You can do it! I did a four-minute monologue, you can do it, too!" [Big laugh.] I did that with all the people who worked on the film, by the way. Everyone has a scene. For Lee, I custom-conceptualized this scene around him and another friend of mine. They're the car guys, the mechanics who go to the junkyard after the JFK guy. It was good for everybody to have to get in there.

You shot the film over two months. Did you have to work very fast?
Sometimes the days were very long. Sometimes we worked half-days. It was all over the place, just depending on the scene and conditions. We did nights, everything.

What was hardest?
A lot of the time we were on the run, doing things without permits, underground, unofficial. So we'd just set up on a street and start shooting. We didn't have a permit. We didn't stop the traffic. We didn't own it. On a real movie you own it. You block off streets. You control the background. But we were integrating ourselves into the real world and trying not to get anyone hurt.

Did this cause problems?
Yeah, the problem would be if you were laying dolly track in front of someone's business and they can't open their front door. Then you

had to think fast. I remember one location where we set up, it had been closed on a Sunday, but we had come back on a Monday afternoon and this guy was so mad he charged us twenty dollars for the location. I was really angry. I felt that we got burned for twenty bucks! I mean, I didn't have twenty bucks. It took a real bite out of our budget! And we'd been getting this free sound recording for the most part, but then the Nagra that we'd been using was out and I had to rent one. It was like thirty-five, forty dollars. I was like, "Aaaaghhh!" We just didn't have any money. It was that kind of thing.

Was using nonprofessionals to act ever a problem?
Not really. I was a pretty nonprofessional director. I mean I had been in enough acting classes and I'd done enough scene-study work that I was confident I could coax the necessary performances out of everybody. And it worked more or less, to varying degrees.

You sound like you had luck on your side.
Yeah, it all felt pretty much as if it was meant to be. Things fell into place. People came aboard at the right time and contributed. Things pretty much broke our way most of the time. I remember we were doing this dolly shot down a big street. I was following these bikes. It's not in the movie, but I think it's on the DVD as a deleted scene. And when we were planning the shot I wondered how we were going to do it. The streets are rough and I wanted a gliding shot. Anyway, we showed up that night and they had just blacktopped the whole street that afternoon so it was a brand-new smooth street. We were able to put the dolly on this completely smooth street, probably the one day you could do it, and we just flew down the street on this dolly. That's when I felt that the film gods were with me!

How would you describe your job as director when you're on set?
I always think the director is the head coach. Beyond having a vision of what you're doing, seeing the entire movie and having all the answers to all of it. I think in a day-to-day sense, your job is to create an atmosphere where everyone can do their best work—actor, crew

member, everybody. You want to get the best out of them, create a way they can work and do the best they can in the process. And it's different for different people. Different people need different things. So you have to give everybody what they need to do their best.

Do you think the experience of making Slacker *taught you a lot about directing?*
Yeah, it taught me to communicate. It taught me to get over whatever shyness I had in communicating my ideas. It's one thing to sit alone in a room and write down all these crazy ideas. But another to try to articulate them on film, to render them on film with all the production, the people, the crew, all the circus that goes on around you at the service of these private, goofy ideas. I remember thinking, "Oh gosh, on the one hand it's a very egotistical undertaking to do this, but then it's also completely ego-less." I had to put that in my back pocket and just kind of go. You know, listen to everybody, exist from moment to moment, get the work done, and not question too many things. It was like, "Okay, here's what we're trying to do. I mustn't be shy about the fact that I wrote this, that this is my own personal thing." You have to put your strength behind your idea so you can get it made. So I had to find whatever leadership, strength, confidence I could. And it's hard. That's why I think filmmakers naturally have this kind of appreciation of other filmmakers. Anyone who can do it gets your respect because you know what it takes. It takes a certain kind of tenacity, I guess.

Do you think you evolved as a director while you were making Slacker? *Did you become more confident?*
It's more specific than that. It goes back to what I was saying about articulating your ideas. One of the professional actors said to me early on, "Rick, I'm finding you kind of vague as a director." And I realized that could be a problem. I mean, it's not uncommon. A lot of directors have trouble articulating what they have in mind. But I learned early on to have a point of view and when you're talking to people to be very specific. I think you do the actors a favor, the more specific you can be to get to what you want and what you want them to

do. Not to be wishy-washy around the corners, but "Here's what I need from you in this scene." "Why don't you try it this way or try that?" Without being bossy, there's a way you can be specific and helpful. But that goes for everybody. It goes for location people. It's everybody. So learning to do that was a big and necessary evolutionary progression.

Did you learn a lot about the technical aspects of filmmaking?
Most definitely. I knew I would be a different filmmaker at the end of the film. There were so many things I was doing for the first time. I wasn't intimidated by them. But it was, you know, the first crane shot, the first Steadicam shot, the first dolly shot. I was taking a great leap in my filmmaking, probably the biggest leap I'll ever take. When people say that doing *Dazed* [*And Confused*] must have been a big leap after *Slacker,* I say, "Well, actually the biggest leap I ever took was from *Plow* to *Slacker.*" I went from nothing to something. From nothing to people, a crew. That's where I had the first experience of that dynamic. And although it was still difficult to go from *Slacker* to *Dazed,* it was the same dynamic: crew, cast, rehearsal, schedule. So *Slacker* was the big leap. It was like the ultimate test to see if I had the talent and personality to pull it off.

How many people actually worked on Slacker?
Crew? Well, it came and went. We always had a core crew of about seven of us. But then there were always about four or five others who were helping out at different times and in different capacities.

Let's talk about postproduction. Did Slacker *take long to edit?*
Not very long. The way it's shot, there's not a lot of editing within the scenes. It's just these long takes. It was still deceptively hard to shape.

Because?
Because of length. It didn't bother me when I was making it that it would be a two- or three-hour movie, and it almost was. I identified two or three places where I could cut out a whole section, reshoot a

little thing creating a new connection between characters, then join it together again and cut out maybe twenty minutes of the movie. I did that in a few places and that's how I found the length. But it was too bad—I lost some good material. That was the biggest eye-opener for me—just how ruthless you have to be with your own material, the stuff you love. We started calling it "drowning babies." It's painful! It's painful to tell the actors they've been cut. I've never gotten used to that. It's one of my least favorite parts of the process, having to lose material for the greater good. I'm sure generals feel the same way when they lose troops in a war. So I was like, "Oh dear, I lost some good scenes this afternoon." But then I just got on with it. Then there's the very last scene of the movie, the last song, where they film each other running up and around Mount Bonnell. That section probably has more cuts in it than everything that came before it. That was always conceptualized to that song, and we edited it shot by shot like a music video, but on an old 16 mm Steenbeck.

What was Slacker *actually shot on?*
Regular 16 mm. Which was the traditional documentary format of the time. We never thought it would end up on 35 mm. So it was pretty tough when we blew it up, because you lose image on the top and bottom. It was kind of a surreal experience to sit there in the lab and pick what part of the film I wanted to lose—the top, the bottom, a little bit off each?

Once you'd actually got a cut you were happy with, what was the next step? Can you remember the first public screening?
Technically, our premiere was at the USA [Film] Festival in Dallas, in the spring of 1990. I think they took it because it was a Texas film. I remember waking up the day the film was being screened. I opened the paper and read a short review. You know, "what's at the festival today?" And the review was like, "In this meandering piece from Austin, the camera drifts around a character until it gets bored—and who can blame it?—then moves onto the next character. Might have made a decent short." And I was just like, "Ughhh, fuck! I've made

this disaster." I almost thought about not going to the screening. I thought I might be booed or something. But I went and the audience that showed up really seemed to like it. They laughed a lot, so I felt slightly encouraged.

How did it fare on the festival circuit?
We'd shown it as a work in progress at the IFP [Independent Feature Project] in New York. The people running that thing had liked it a lot just as a work in progress and were excited by it. I was hoping to finish it as a feature, but there was just no way we could get finished in time. So I showed it as a work in progress. I'd just finished it in December and I had a longer cut of it and I started sending that out and there was this early enthusiasm by some people who'd seen it. I was sort of flabbergasted by that early enthusiasm. I'd gotten that German television sale so I was thinking that I was sitting on something good here. And then I just went through this complete phase of rejection. Sundance rejected it. Rotterdam rejected it. Berlin rejected it. Everyone was rejecting it! We showed it at Berlin in the market, and about four people saw it. It's a sad moment when you realize just how oblivious and uncaring the larger world is to your life and your obsession. It's like, "Wow, a tree falls in the forest and no one hears it!" [Big laugh.] I don't think of myself as a big grudge holder, but I guess I must be. To this day when I get an invitation from a festival—you know, "Mill Valley wants to show your latest film"—I'm like, "Mill Valley, huh? Didn't they reject *Slacker*? Telluride, huh? Fuck them!"

But you hadn't expected much to happen to it when you were making it?
No. But as I was finishing it and I saw some excitement about it, I got my hopes up and thought, "Maybe people will like this." And the main crew that had been away from the film for a while saw it and they were like, "Hey, I think you may have something here." And I was like, "Really? You think so?" I couldn't necessarily see it. So I was like, "Who knows?" So anyway, I remember collecting all these rejection slips from everywhere, no one really wanting it. And then I got a call from Daryl McDonald who runs the Seattle Film Festival. He said

that two of his programmers there had handed him my tape and said if he didn't show this film at the festival they were going to resign. So he'd taken a look at it and said, "It's great. So come up to the festival." So, having been rejected everywhere else, I went up to Seattle. Unlike Dallas, the film had received some good local reviews, and the buzz on the film was big coming in. I remember walking up to the theater for the first screening and there was a line around the block of people who looked just like everybody in the movie! It was early summer, 1990, technically before Seattle became such a cultural hot spot, but it was right on the cusp of everything. It was like the spiritual wedding of the film and the audience. By the next year, when the film came out, Nirvana and all that had happened. So it was the ground zero of the particular culture of that moment. I'll always have a special feeling about the experience. We got the reviews, the audience response, and I even did my first decent Q-and-A. Then there was an article in *Film Comment* about it. Here's a film that doesn't even have a distributor and I'm getting an article about the film in a prestigious magazine. I thought this might mean we'd get into the New York festival in the fall, and Toronto. And of course we got rejected by both of those. New York, Toronto, Telluride, they all rejected us. I'd waited a while to send it out because I wanted to get a good response and didn't want to flood the market with the film—I'd done that earlier so it was like distributors had started to reject it, too. I wanted to wait until something good happened, then make another approach. But after the success in Seattle, I sent it to John Pierson, a producer's rep. When I talked to him on the phone he said he had just read something about the film. Anyway, some time passed and then he called and left a message saying, "Call me—there's something going on with your film." So I called him back and he said he'd shown the film to Michael Barker and Tom Bernard at Orion Classics and they were chomping at the bit for it. In a way, my life changed in that moment. I mean, I was hoping at best for one of these really small distributors who puts it out on 16 mm, but fully expecting to self-distribute or sell videos in the back of *Film Threat*. But suddenly I'm in negotiations with a major indie distributor. I was like, "Wow, we're in a whole new

world." So they picked it up and by the next Sundance, we got in with our 35 mm blow-up and a new sound mix. We were kind of a bigger film then. I got to shoot new credits and do some things differently. But it's really the same film.

Had it been anywhere else?
What I haven't mentioned is that we opened the film ourselves at the Dobie Theater in Austin in the summer of 1990, after Seattle. It's the theater near campus where I'd shown most of the Film Society movies. We'd done well at the Munich festival, at Avignon in France, and in Seattle. I think it helped in Austin that the film had gotten some acclaim around the world. Texas can be pretty cruel that way—a lot of hollow boastfulness sitting on a bed of solid inferiority. It helped that people elsewhere liked it. People think if you're only big in Texas, it just proves you're not really any good. When we opened, I'd just made a deal with the theater that we would show it at night and then split the revenue. From the get-go, it was just this phenomenon. It sold out the first eighteen days or something. Every showing sold out. There were people lined up around the block. It was incredible.

Austin saw it as their movie?
Yeah, yeah. It was everywhere. You'd be in a restaurant and the people at the next table would be talking about it. It kind of freaked me out. I never would have thought that could happen. Somewhere in all that, Orion picked it up so we had to pull it theatrically. But we made some money there and I was able to pay back the lab. Between the German sale and our little theatrical run we had made enough to pay back all the hard costs. People who'd given money got it back, the labs and sound, everything was paid back.

You sound like a consummate businessman despite yourself!
Yeah, but everyone owned a part of it. If an actor did a day they got a hundred dollars and that represented a percentage of the overall budget. So if someone worked a couple of months they'd get several thousand dollars deferred. This wasn't a hard cost. This was our wish pile that we thought we'd never get, but then we did. So everyone got their

hundred dollars or their twenty-five hundred dollars, whatever they'd worked. Like I said, that was a great day of my life, when I was able to pay everybody. After the initial money, we proceeded to get nothing but boned financially. Orion went bankrupt. A typical story—just like a record label when your indie band hits. They declare bankruptcy right at the moment they're supposed to pay you. And they totally blew the video release. I mean, here was a film many thought to be the cult film of the year. It had made an impact, culturally even more than box office, but they were going bankrupt and they didn't put the videos in the stores. They sold less than five thousand videos. There were thirty thousand video stores in the country and they put about four thousand videos out there. They just didn't make them available to the stores. I'd go into the stores—I was doing my own field research—and I'd ask if they had *Slacker.* And they'd go, "We get asked that all the time. No, we don't have it." And I'm like, "Why not?" They'd say they didn't know. That was too bad because that's where the money is on a film like this. So no one ever really made much money on it, but everyone made more than they ever expected.

Why do you think no one at Orion saw the film's potential?
A combination of incompetence and total lack of interest. The supposed higher up you get in this world, whether it's in the entertainment business or the government, the more shocking it is when you realize many people there really have no idea what they're doing. They're probably well connected and can talk the talk, but it's really the emperor's new clothes.

Do you still work with Tom Bernard and Michael Barker?
Oh yeah. It wasn't them. They'd left by the time this was happening. So I don't blame them. I'll always have a fondness and indebtedness to them for taking a risk, in fact.

How did they release it once they had bought it?
We premiered our new 35 mm print at Sundance in January 1991. And it was interesting: Desert Storm had just started two weeks before, and with a real war going on, a lot of the humor in the movie, which

grows out of a void of nothing big going on in the world, was suddenly not as funny as it was before. All the more nihilistic parts weren't quite as funny. So while people were laughing, they were also going, "Hmmmm?" But nonetheless it made its mark at Sundance. It didn't win any awards but it had a buzz. It was seen as one of the weird films, more avant-garde than commercial. It then played at New Directors in the spring and a couple of other festivals before opening July Fourth weekend. The only two films that opened that weekend were *Terminator 2* and *Slacker*. We opened on two screens, one in New York and one in Austin. *Terminator 2* was the first film that cost over a hundred million dollars, supposedly, and everybody was in a tizzy about that. And here was this other film that cost twenty-three thousand dollars! So that was kind of a story in itself. And it opened huge in New York. It played at the Angelika all that summer and into the fall. It played at the Dobie for even longer. It slowly played in all the towns where a specialty film like this would ideally play, and was seen as one of the indie success stories of that year. It ended up doing better at the box office than almost all the other films at Sundance that everyone had been so excited about.

After the film came out, the word "slacker" began to be embraced by mainstream American culture. Did this take a long time to happen?
It was pretty instantaneous. That word got out there and quickly took on a life of its own. The funny thing is that during production we weren't sure if it was a good title. It was just a term we'd started calling each other. Because no one was getting paid, people would show up late and we'd call each other "slacker." Like, "Get to work, you slacker." It was just a word we were throwing around a lot. And then someone asked what's the name of the movie? And I remember saying *Slacker,* and Clark, my all-encompassing dolly/grip/assistant cameraman, had a big smile on his face. And I was like, "*Slacker,* huh?" And then at the wrap party we had a vote for the title and *Slacker* won, but not by much as we had other titles we were bantering about. I remember when we showed it as a work in progress, a producer/distributor guy who was interested in the film for a while suggested we come up with a better title because it sounded too much like "slasher" or some-

thing. A year or so later, I remember talking to the great Sam Arkoff at the festival in Dallas. And he said [assuming a Groucho Marx voice], "So, kid, what's the name of your film?" And I was like, "*Slacker.*" And he quickly said, "Bad title! *Mars Needs Women,* now there's a title! *How to Stuff a Wild Bikini.* Million-dollar title [big wink], hundred-thousand-dollar movie!" So *Slacker* wasn't a good title until it was. And then it was more than a title. Pretty soon President Clinton was using it in graduation speeches and commencement classes. I was like, "What?!" It quickly became something not about the film, and always in a rather negative, judgmental tone. All you could do was go, "Well, whatever."

There was quite a lot of media coverage about the "Slacker generation," wasn't there?
Yeah. There were all these articles about what was going on. Who are these twenty-something people? There'd be an article about Nirvana that would mention *Slacker.* The band is Nirvana, the book is *Generation X* by Douglas Coupland, and the film is *Slacker.* That was the holy trinity that qualified it to be a bigger cultural thing. But that's pretty good company to be in. I wasn't complaining when, for a brief moment, people were talking somewhat intelligently about it, and based on the work itself. I mean it was these people's jobs to put these things together and you'd just nod your head and go, "Yeah, good point." But pretty soon it was like [nasal interviewer voice], "Well, I haven't seen your movie and I haven't read the book, but don't you think people in their twenties think such-and-such?" I always thought this was a generation that technically couldn't be simplified, generalized about, or certainly parodied. Then, sure enough, it gets beaten to death in the media on a completely superficial level. It was just weird to see something you do hit the bigger culture and bounce back. Ultimately I guess it was a kind of a blessing and a curse.

Do you think it was just luck that it hit the zeitgeist?
Yeah, timing, luck, whatever. One year earlier, two years later, it might have been totally different. You just have to enjoy the ride. But then it kind of burdens you as well. "Oh, you're that *Slacker* guy."

"Oh, you're that Gen X filmmaker." It's like, "I've made one film. I've got a lot of other films to make." But it took a decade for that not to be who I was.

How were you feeling about this at the time?
At the time this was really going on, I was so over the movie and just thinking about the next movie. I mean I'd already written *Dazed and Confused,* and I was just focused on that. But I felt this obligation to do whatever *Slacker* needed just for the people who'd worked on it. So I went through the wringer a little bit.

Do you think it changed your life in the sense of giving you access to money much more easily?
Yeah, it totally qualified me. I did an interview about *Slacker* in Washington where when the guy asked the obligatory "what are you working on next" question, I actually talked about this high school, seventies comedy I was working on. The reporter was friends with this producer, Jim Jacks, who worked for Universal in L.A. So Jim called me up and said he'd seen *Slacker* at Sundance and he'd heard about this thing I was doing next and that it sounded interesting. He admitted *Slacker* didn't scream out, "Hire this guy to do studio films," but when he heard I wanted to do this teenage rock-'n'-roll film, he put it all together. So they flew me out there and I described it to him and Sean Daniel because I knew I needed a real budget this time. I was thinking Spike Lee was a good model. He'd done *She's Gotta Have It* independently and then he'd done *School Daze* and *Do the Right Thing* in the six-million-dollar range. And I was thinking that would be a good niche. So, sure enough, I got to make my six-million-dollar studio film and I also got the whole studio experience. I remember meeting the head of the studio. I was having lunch with Jim and he was like, "Let's go say hello to Tom Pollock [who ran Universal Studios at the time]." So he said, "This is the guy who made *Slacker.*" Tom looked up and said, "Oh yeah, that made some money, right?" I told him it did. I realized he hadn't seen the movie, but there it was on the *Variety* top fifty, hovering there at the bottom for months and months and months. I realized then that I'd now reached a new level.

I'd made a film that someone had paid some money to see. I'm a film-maker now. Of all the filmmakers out there who've made films, I suddenly qualify as a filmmaker because I've made a film that's been seen a little bit. So that's the leap that they have to make toward you. There are a lot of films out there. It's like, "Oh, people responded to your film." And that helped me a lot getting *Dazed* made because they could actually pitch my movie and me at the same time. It's like, "How do you know this guy isn't the next big thing? I mean, he made this one weirdo, arty film that didn't make that much money, but how do you know he's not talented and couldn't be the next George Lucas? How do you know this isn't going to be his *American Graffiti*?" It's not like there was a bidding war or anything. There was just enough interest for me to get in there and qualify to get another film made. And I was ready. I'd written this script and it leapfrogged over some thirty other scripts to a production slot because I was ready.

But you didn't do Slacker *for this purpose—to unlock money for other projects?*
It wasn't a showpiece for the industry, that's for sure. It was only when *Slacker* was out there being distributed, making its little mark, that I thought maybe I could get *Dazed* made—I had an opening to try to do that. I had other film projects in my head at that time, much less commercial sounding, some of which I've been able to get made over the years. But at that moment I was compelled to do *Dazed* next, and I was lucky I got the opportunity.

You've said Slacker's *success changed your life. Do you think its success changed Austin?*
I've been quoted as saying I'm one of the people who helped ruin Austin.

Do you think that's true?
Well, the little café we shot some of *Slacker* in, the historic Les Amis, is a Starbucks now. But no, technically, the computer industry is probably more on the hook for changing Austin. Anyone who saw *Slacker* and was actually attracted to Austin was probably a lot like

someone who could have been in the movie, who's not likely to be a real-estate speculator.

But Austin was changed by Slacker'*s success?*
I think *movie* Austin probably was. It was sort of a breakthrough in that it was probably the first indigenous art film from around here to be taken seriously nationwide, worldwide, to have a distributor at that level. There'd been exploitation films made here before. For example, the *Texas Chainsaw Massacre* had been a huge success. But this was a different thing altogether. No one cares where a horror film comes from. In fact, there is a tradition of regionalism in that genre. I never thought that these New York critics would like this little film from this nobody from the hinterlands. I thought it was pretty much a New York industry thing. So I was as surprised as anyone that *Slacker* was embraced in the culture. I was always pretty cynical about it, how some things get out there and others don't.

Has Austin changed dramatically since you made Slacker?
The film culture here has matured. When I did *Slacker,* it was the only indigenous film being done in Austin in a couple-year window. I don't know how many films were made in Austin last year. There were so many I've lost track. Low budget, big budget—there's a much more cohesive film industry in Austin now. I'm not taking credit for that— Robert Rodriguez tends to employ more people than I do, and he can usually even pay them better. As far as the culture goes, the Film Society used to have twenty, thirty people turning up at a screening at the low point. Now we often have hundreds showing up for all kinds of stuff, and we show so much more than we used to. And we're able to give out grants to filmmakers all over the state. There are four film festivals in Austin now. Professionally, several features can be going on at once—there are that many crew members. So the industry has sort of grown up. People said my staying here and doing *Dazed* was a big thing. Because previously if you were going to get anywhere you had to move to L.A. But my goal was to stay where I was and do the next film. It wasn't because I was like some local benefactor to the Austin

culture. It just felt right to me. I'm selfish. It's all I wanted. I get credited with all this stuff to do with Austin. But the fact is that I'm just selfish and have done what I wanted to do.

Could Slacker *be made in Austin now?*
Sure. Not quite in the same way, but it definitely could be made today, and in some way probably is. The difference is that at Sundance it probably wouldn't be in the main competition. It would be a midnight screening, if at all. It would probably be a lot more marginalized because there are just so many films now. When *Slacker* got into Sundance in 1991, there'd been about two hundred fifty submissions for sixteen slots in the dramatic competition. Now I think there's twenty-five hundred submissions. It's like a tenfold increase for the same sixteen slots. And of those sixteen films, probably thirteen of them have big-name actors in them and fairly decent budgets, whereas back in 1991, hardly any of them would have. This is in no way a knock on Sundance. They've got to evolve in a way that mirrors what's going on out there and with all the films they're getting. The industry has kind of splintered into two pretty distinct camps: you've got the big studio films and you've got smaller "independent-type" films. They're still considered independent even when they're being financed by a studio or the specialty division of a studio. I worry that there's just less and less space for the off-independent. Like there's the "official independent," which might be a film with name actors and costing seventeen million dollars. That might be seen as an independent film if what it's about seems far from big-studio commercial, but can you really compare that to someone spending a hundred thousand dollars making a film on their own in their town? Should they really be in the same category? The answer is no, they shouldn't be seen in the same way. And yet the category isn't big enough to encompass the range that exists when you say "independent film."

So, knowing what you know now, would you do things the same or differently?
Same, same. I mean, for better or worse, your first films say a lot about

you. I think the best thing is to do the most personal film possible first, because it will be unique to you. I think some filmmakers are encouraged to do some kind of "showcase of their talents" and work in a genre that shows everybody what they can do. That just shows the kind of filmmaker they aspire to be, so it's probably just good to get it over with. The truth is, you can't help but be yourself, so you probably don't even have to think that much about it—just go where you're compelled. Looking back, I think I was lucky because I made a film that was totally off the wall and yet made its little mark. To this day I'd say it's probably the most radical narrative ever to gross over a million dollars at the box office. People talk about films like, "Oh, that's a crazy movie, has all these different story lines, it works backwards or goes this way or that." But at the end of the day it's still a story, just told in a new or unique way. I didn't have a story—there's no story at all in *Slacker*. Beat that!

Richard Kelly

DONNIE DARKO

Can you say a little about your background? What sort of movies did you see, and so forth?

I grew up in Richmond, Virginia, in a very upper-middle-class, white-bread suburb—very conservative, lot of Republicans—and went through the public school system. My mother was a teacher at Virginia High where I went to school. She was the end school suspension teacher which means she tutored all the kids who were getting into trouble and getting suspended. My dad was an engineer who used to work for NASA. I had one older brother. So I grew up with a very normal, stable family. I guess my parents saw I had the ability to draw very early on, maybe when I was five years old, so they put me in an art class. So they were very aggressive about pushing me into the arts and using my artistic ability and stuff. Richmond is a very conservative, Republican town where if you're creative and you're an artist, your friends at school don't really pat you on the back for being that way. So it was like I was living in a cultural environment that was in no way nurturing, where you're encouraged to follow a more conformist line. But my parents were always like, "Keep drawing, keep doing your art, because you're good at that." So despite my friends making fun of me for wanting to be an artist of some sort, I just kept at it and eventually I had a pretty strong portfolio of art in high school and I applied to USC. I wanted to get out of Richmond, wanted to go to California. And in the back of my mind I wanted to be a film-maker, but was afraid to admit that to people because it was embar-

rassing. People would have made fun of me even more than they already did.

Did you make any films as a kid?
No. Nothing at all. I didn't even own a video camera.

Was there a moment when you thought, "I want to make films"?
Some of the first movies I remember seeing that inspired me were *Back to the Future* or *Platoon.* I remember getting a VCR and renting movies for the first time. Also seeing *Aliens, Terminator II* in theaters. I mean there's a lot of films, a lot of science-fiction stuff, that turned me on, kind of awakened my imagination. I was reading a lot of Stephen King in high school. Embarrassingly enough, I was probably at my most literate in high school in the sense that I don't have much time to read much anymore because I've been so busy creating stuff. Kafka, Dostoevsky, and Camus and lot of literature I was taught in high school in the advanced English class formed the background to what I was interested in. I read "The Destructors," the Graham Greene story that turns up in *Donnie Darko,* when I was seventeen years old. That as well as Stephen King, Philip K. Dick, and a lot of the science-fiction authors.

In terms of the movies you were talking about, you seem to be referring mostly to mainstream Hollywood fare. Were you ever interested in independent movies?
Not till I got to USC. When you grow up in Richmond, Virginia, you've only got Blockbuster video. Blockbuster started in 1987. I graduated high school and left home in 1993 and at the time all I had was Blockbuster. And, sure, they might have carried some of those independent films, but there wasn't an awareness or cultural environment that would even make me aware of them. I didn't really get educated about film beyond the mainstream stuff until I got to USC. The cinema library there was this vast reservoir of film: they had every film you could ever imagine on laser disc. I spent hours and hours and hours in that library.

What sort of things did you see?

Everything. Everything I could get my hands on. In the critical studies classes we got to see everything projected. You get to see *Bicycle Thieves.* You get to see *Grand Illusion, Persona.* It was an eye-opening experience. Before this I'd just had Blockbuster and then I realized there was this whole other world of cinema. To go to the library and discover this stuff was amazing. I remember seeing Terry Gilliam's film *Brazil* on laser disc for the first time and I was like, "Holy shit, how could I not have been aware of this?" So it was really extraordinary: I felt like I was walking among the enlightened all of a sudden. And being in Los Angeles, I was like, "Wow, there's more to life than Richmond, Virginia, and the multiplex in Chesterfield town center." And the Internet and DVD have made these kinds of film accessible to people who grow up in places like Richmond and even smaller towns than that. So it was a really amazing, enlightening, eye-opening experience for me, getting to Los Angeles and going to film school and discovering all these alternative ways of telling a story. And the university is very aggressive about diversity and educating people about alternative cultures and minority cultures. Clearly the melting pot of Los Angeles and the fact that USC is located in south central L.A. made a big difference. I mean there's a lot of very rich kids in the fraternities. You know, girls driving the BMWs their parents gave them as a graduation present, and two blocks away there's a crack house. So you're aware there's a real culture clash going on.

You got into USC on a fine-arts scholarship. How did you end up studying film?

After two or three days I realized I'd go crazy if I had to sit there and look at slide after slide of Mayan architecture or Mayan vases and remember what year they were. I decided I had to try to get into film school. The film-school curriculum doesn't start until your third year in college, so you can take a lot of classes as a non-major. So I figured a way to keep the scholarship money but move out of the art school and into an undecided zone where I could take film classes.

Which courses did you take?

There's three options on the film program at USC: critical studies, where you get to make some Super 8 films; filmic writing, where it's all about screenwriting and you get to make some Super 8 films; and production, where you take a couple of screenwriting classes, a couple of the critical studies classes, but you also get to make not only some Super 8 films but also one round of 16 mm film with a partner and another sync-dialogue 16 mm project. So production is the closest to being a director and that's what I did. While I was in college I applied and I got in on my first try.

You got in on your drawing?

On that. And I was getting really good grades in the film classes I was taking, so I strategized and I applied in my sophomore year. I got almost straight As in my freshman year, first semester. And once I got into the film school, my grades slowly went down and down each semester because I realized that when you're going into the film industry, no one gives a shit about your grades!

So you weren't really thinking too much about the course?

I worked really hard. But I had plenty of fun, too. I was in a fraternity. If you want to meet girls and you want to have fun, you're in a fraternity. And that's what it was like for me. But then when you get to the film classes, no one else was in a fraternity or sorority. And they would look at me like I was a weirdo because I was the guy in the T-shirt and baseball cap. The fraternity guy in the film school. I sat in the corner quietly and didn't know anyone and they'd glance over their shoulder at me like I didn't belong, didn't fit in.

Did you learn a lot?

Oh yeah. I took the classes very seriously. I mean, it's the best film school in the world as far as I'm concerned. There's no comparison to USC in terms of what they have. In terms of educating you about the technology and about the form, it's extraordinary. You can learn everything there. And I took that all very seriously. But at the same

time it's not traditional education in the sense that you're sitting in a history class having to memorize who won the war in 1812, who fought in this battle. So basically I went on and on in the film curriculum, making Super 8 films and then I made a 16 mm black-and-white film.

Can you say a little about the films you made at this time, The Vomiteer *and* Visceral Matter?
The Vomiteer was one of the five Super 8s that I did. It starred one of my fraternity brothers, Marty Michel, and it was about a guy who can't stop vomiting over everyone and everything.

That was your idea?
Yeah! A lot of the student films I saw people making were about the plight of the homeless or someone getting raped by their gynecologist. Kind of worthy stuff. And you weren't allowed to have people talk in your first films. They wanted to educate you about telling a story without dialogue. It was called non-sync dialogue. That was the rule: you needed to learn how to tell a story without having your characters speak because you weren't allowed to have a boom mike on the set. The university didn't allow you to do that until you got further along in the program. So you'd have these people constructing these films where they'd get around the dialogue thing by having characters make facial expressions to each other. It was really awkward. You had to figure out a way of telling a story using just sound effects and music and no dialogue. And what I thought was that a character who just can't stop vomiting would be great because the vomit would be a replacement for the dialogue! It was also my response to the very serious, important films that I saw people trying to make. I thought, "I'm just going to make something that's completely offensive and disgusting and hopefully funny." And when we screened our films, we lugged in our Super 8 projectors and we threw them up on the screen. Then everyone would watch them and there'd be silence after each one and we'd write comments and everyone would try and be polite, but then sometimes people would be very snarky and judgmental. And it

turned out that my professor loved my film and she had to get up and leave right afterward as she had this thing where she can't watch people puke on camera because it makes her want to do the same. So she had to get up for a minute then she came back and said she thought it was great! And I got an A-minus on it! I don't think enough student filmmakers embrace comedy because that's the key if you look at people who've succeeded in making short films and have then made the transformation to being a feature filmmaker. Think of Spike Jonze. He made quite a few shorts, and all of them were very funny. *Jackass* with Johnny Knoxville, for example. It's very important to know how to get a good laugh out of someone. So that was going to be my kind of focus.

You wanted to do comedies?

Actually my other Super 8 films were kind of experimental avant-garde stuff because I was trying to cover all the bases. And then for my 16 mm project, we were allowed to make something of eight and a half minutes on 16 mm. We could use five tracks of sound mag and then mix it and cut it on a Moviola. This was right when Avid was being introduced. The university purchased two Avids and only two people on the curriculum were allowed to use them. It was a contest, a very political thing. I was very excited to get to cut on a Moviola, and I was one of the last people to use them because no one uses them any more. Anyway, we partnered up and no one wanted to be my partner because I was like the fraternity guy and no one really took me seriously because I'd made the movie about the guy who vomits: "Oh, you're the vomit movie guy, right?" So everyone was partnered up and I was the last person with no partner. And I ended up being partnered with this Italian girl called Paola, a nice girl. So the first half of the semester we were going to do my film, she would shoot and edit and I would write and direct and then we'd switch and do her film in the second half of the semester. My film was going to be on 16 mm, hers was going to be on video. I was like, listen, I'm going to do the film. Sorry! She was like, I don't care, I'll direct the video. So I wrote this little script, *The Goodbye Place,* about a little kid who has an abusive

mother. He meets these elderly people who are like these supernatural gatekeepers and they whisk him into another dimension in order to escape his abusive mother. So it was like a science-fiction drama. It was actually much darker than I thought it would be.

How did it turn out?

It was very well received, and we shot it over three consecutive weekends, which is how long you had to shoot. You screened your dailies in front of the class and your professor. Sometimes they'd be out of focus or overexposed. I remember it was a very emotionally draining semester. I'd come out of my fraternity house and everyone would be wasted and I'd just go to bed. I didn't really drink or do anything for a whole semester and my friends were like making fun of me and throwing stuff at me when I was in my bunk because I wouldn't hang out. But I took it very seriously and I wanted to get the film just right. Anyway it turned out pretty well. I wanted a helicopter shot for the end over the ocean when the kid escapes. So I went and I paid eighty bucks to get on a helicopter to Catalina Island with my 16 mm Bolex and I went up to the pilot and said, "Hey, you mind if I sit up front with you with my camera?" And he was like, "I don't care." So I sat next to him with my Bolex and got some great footage of us taking off and all this great helicopter footage of the ocean, and then when I screened it in the dailies, my professor nearly had a heart attack. "How did you do that?" And I told him what I'd done. And he got pissy with me for about a minute. And then he was like, "Well, it's clever you did it." And he could have taken the footage away from me and not let me use it in the film because the school is very strict about enforcing the rules and regulations that you'll encounter when you're making films in Hollywood. You can't have a firearm on set, for example. And there were a couple of professors who would have done that, they were dicks. But this professor was cool. He was like, "All right, I'll let you use it in the film." And then I did some animation. I learned how to use the Oxberry camera that they shoot titles on. I learned how to do animated titles. I did this animated titles sequence. I did this animation sequence that I use at the end of the film, which

I overlaid with the helicopter shot. So there were quite a few tricky little visual effects shots in the film. I had characters disappearing and appearing, the elderly people, who are these shapeshifter characters. So it was a pretty elaborate eight-minute film. It was pretty well received by my professors and my fellow students and then I had people saying, "you're a director, you're a director, keep with this." So it was a very good positive reinforcement. The next step in my senior year was doing a twelve-and-a-half-minute color 16 mm sync-dialogue project. Meaning I could have actors speaking and have a boom mike on the set and it was in color. But only four people got to direct one of these so it was a contest to be one of the four. And you had to crew on one before you could get to direct one. So I was a DP on another girl's film and then I wrote this ridiculously ambitious comedy, *Visceral Matter,* about a teleportation chamber and a mad scientist.

Sci-fi seems to be a vein that runs through your work.
Yeah. As I said, my dad used to work for NASA. He was an engineer who helped design the camera that photographed Mars for the first time. He worked on the smokeless cigarette for Philip Morris. All these top-secret projects involving new technology. So I've always had an obsession with technology.

How did Visceral Matter *evolve?*
I didn't get picked as one of the official four projects. So right after graduation I borrowed, cloak-and-dagger, a lot of the school's equipment for the summer. I took some friends and we went and did it on our own.

How did you pay for it?
I borrowed some money from my dad. And I got a 35 mm camera from a camera house that was going bankrupt and they were desperate to loan out, rent out their equipment that summer, before they sold it all off. So I got a really good deal on a 35 mm package and we got a bunch of film, just short ends, and we built this teleportation cham-

ber set in my garage on Hermosa Beach, then moved it using some trucks. And it was a very frightening thing as I was spending my dad's money and here we are, guerrilla filmmaking. You know, no one's making any money and this is a student film but it's not officially sanctioned by the university. And we went out to the desert and shot all the footage of the scientists there.

This is because you wanted to have a calling card?
Yeah. I was pissed that they hadn't picked me. It was actually a blessing in disguise because it was was too ambitious to do in twelve minutes on 16 mm. I got to do it on 35 mm and it was forty minutes long—ridiculously too long. But visually it was very impressive. I'd learned all this computer animation, so we used green screen and digital matte painting. It was basically a great education for me, learning how to do something very elaborate with visual effects and in 35 mm, and to really make a film.

What was the story?
It was about a mad scientist who has designed a teleportation chamber beneath the Nevada desert. And his colleagues murder him and they go and start teleporting matter, like an apple, then a person. And when you teleport a person, something happens in the soul. It was just this ridiculous psychedelic stream-of-consciousness kind of story.

Did you have professional actors?
Yeah. Some of them were professional who, unfortunately for them, had to say the dialogue that I had written. And others were not so professional. They were just people we grabbed off Venice Beach. You know, some of those people you get who act in student films! [Big laugh.] Nice people. One of my friends, Sasha Alexander, she's now a successful actress on a TV show called *NCIS*. She's doing well. Another friend, Lisa Wyatt, was also in it. She ended up being in *Donnie Darko* as one of Patrick Swayze's infomercial subjects. So I met some actors I really enjoyed working with.

You said Visceral Matter *was meant to be a calling card. How did it actually turn out?*

If you watch it with the sound off and just look at the imagery, it's impressive. But the story is complete nonsense and it's too long and it doesn't really make much sense. But for me it was a great calling card because all of a sudden I know how to do green screen and I know how to do digital matte paintings and I know how to stage a shot and I can walk around a set and direct and I know about 35 mm. I know how to load a camera with film. So, by doing it, I was educated and I was more confident.

You sound like you knew a lot about the technical aspects of filmmaking. Did you know much about other aspects of directing such as staging the action?

Not until I made the movie. I had to put myself through the experience. And it was only when I'd finished it that I had the confidence to tell people that I was a director. Because you know what? I finished it. I finished this really elaborate forty-minute film. It may not be good. Or you may not understand it. But it looks really good. It's visually very impressive and it has a style about it. For what it was, I was proud of the look of it and the design of it and the fact that I was able to stage something, that it worked, or at least worked on a visual level. It gave me confidence that I could craft something that looked professional.

That's when you sat down and wrote Donnie Darko?

Exactly. That's when I sat down and wrote *Donnie Darko.* I thought, "Now, this is when I'm going to try and do something serious. My first feature-length screenplay." It was daunting but I did it. I cranked it out in about a month and a half, two months.

That sounds pretty quick!

I wrote it in a fit of anxiety. I was like, shit, I have a short that I'm almost finished with. I need a feature. Because if anyone is going to respond to this short, they're gonna be like, "Great, what else you

got?" I need to have a feature script to show with it. So I panicked, thinking, "I've got to get a script written."

When was this?
This was October, November 1997. I'd just graduated from USC and I was finishing my short. I was working in a postproduction house making cappuccinos for Madonna and all those people, and Sam Bauer was cutting it with me. I said, "Dude, I've written a feature, it's called *Donnie Darko.* And you've cut my movie here, and you get the feature 'cause you've done this for me." And sure enough, he did. And he's going to cut the next one.

Let's talk about Donnie Darko. *Did you begin with a character, an idea, a name?*
It started with the idea of a piece of ice falling from the wing of a jet plane and smashing into a house. It's an urban legend. It has happened that gigantic pieces of ice fall from jet planes, whether flushed from the toilet or sliding off the wing. And it turns out that sometimes engines fall from jet planes. So it became an engine. And that became the central mystery. And it became 1988 because somehow the mystery of this engine is going to be a metaphor for the death of the Reagan era. And this kid is gonna be like a superhero so I'll call him Donnie Darko. He'll have a kind of superhero absurdist alliteration to his name, like Clark Kent. Those names have that kind of ring to them. So I thought, "let's make him this kind of antihero, and let's figure out how to solve the mystery of this jet engine." And as I was writing it, it became, well, there's no plane, it just fell from thin air, and that's an interesting conceit around which to build a story. And the mystery he ultimately comes upon is that the jet engine came from the future through some kind of vortex.

My reading of it was that the jet engine that fell from the plane was from a possible future. And Donnie's role was to use his superhero powers to ensure that the possible future didn't become the actual future?
There's some of that. I think the idea when I wrote the time-travel

book, *The Philosophy of Time Travel,* was that there's an alternative universe that's a kind of digression from the actual universe. It's like a branch on a tree that isn't supposed to grow, but it grows anyway. In the end it cracks and falls off the tree. I guess the key is that ultimately the engine is like an artifact from that branch. It's like something that's hurled back from it, the only thing that remains from it. I think the idea of duplicate realities, duplicate versions of things, takes the movie into a real brain-teaser zone. Any time-travel movie is going to be very difficult to wrap your head around, because no one can really understand the nature of corrupting time. It's something our brains aren't equipped to comprehend. So that in any time-travel movie, your head just hits the wall because you just can't get through it. You see that in *Terminator.* You see that in *Twelve Monkeys.* You see that in any successfully executed movie about time travel. At some point it requires a leap of faith or speculation in one's own interpretation of how those events came to pass. So you can do your best to draw up blueprints, but ultimately, unless you're Stephen Hawking or someone of his level of intellect, you're not going to be able to explain it in every way. [Big laugh.]

Was time travel also interesting because it allowed you to play with the structure of the movie? For example, Frank's injuries—which you see at the beginning of the story—are actually sustained at the end of the film.
In the director's cut, it works a bit more on the level of science fiction in the sense that a water barrier and metal are a mode of communication. The Frank you see prior to the car accident is some sort of projection or ghost image. How I've explained it is that he's like some sort of "reverse ghost." I got kicked out of Sunday-school class at a very young age because I asked, "What happens if you try to touch a ghost?" I was talking about this with Kevin Smith and he said, "Well, that's ectoplasm, isn't it?" So I said to myself, "Maybe they're using a barrier of water? And maybe whoever they are—whether it's a distant intelligence or higher intelligence—is using the image of this kid in the Halloween costume to communicate with Donnie?" So it's a device to communicate with this teenager whose consciousness has been altered to the extent that he's like a radio antenna of some sort.

So for me it's just a very elaborate science fiction. That's the best way to try to understand it. When I was allowed to reassemble a longer version of the film, I felt that this is the most exciting version of the film because it still has all the ambiguity of the original. But it's more cohesive and it opens up new levels of interpretation which I hope all good science fiction writing does. I wasn't just trying to be esoteric. I wasn't trying to put something in there just to be weird or to confuse people. It all had a design to it in terms of these rules I had set up in the time-travel book itself.

In the story there's a kind of ambiguity. You allow the viewer to read it as a story about someone who has suffered mental instability or who is actually a superhero. Was that deliberate?
It was always in the script that Katherine Ross, the psychotherapist, is giving Donnie placebos. In other words, he's not crazy. That was cut out of the original film, but reinserted in the director's cut. It was always important for me to point out that this film wasn't really about mental illness at all. There is no mental illness as far as this film is concerned. There is only a theory that people have come up with called schizophrenia, and people don't know what that is. Even the most lorded, revered doctor or expert in schizophrenia still doesn't really know. And this film is trying to delve into this. The world might see Donnie as mentally ill or screwed up or schizophrenic, but I gave him that superhero or antihero alliterative name, because I wanted to say, "Well, let's look at someone who the world regards as mentally ill, but let's look at him as if he's someone who could actually save the world and is a superhero."

Was there anything from your own experience which you used in your portrait of Donnie?
In 1988, people were just starting to see that there's a huge market in making drugs for young people. I mean, how much money can the pharmaceutical companies make now from confused, terrified parents who think drugs can fix their kids? So it was the beginning of a huge market which has grown and grown and grown. I wanted to comment on that. And also it was the beginning of the self-help movement, the

infomercial culture which has just exploded. Seeing the origins of that and the motivational speakers like the ones who came to our school. The "love and fear lifeline" is plagiarized directly from the curriculum taught us in our health education class. So a lot of these things I was taking from things I was witnessing or experiencing or from things that my friends had witnessed or experienced. I was just trying to turn it into this elaborate puzzle. How and why someone might go about firing a weapon. And the motivations for Donnie to do that are much more complicated in the film, but there was a kid who pulled a gun during a standardized test at my high school. They were taking some kind of standardized tests in the ninth grade, and this guy pulled a gun. He'd asked his teacher for a break and she'd said no. So he pulled out a gun and aimed it at her and said, "I need a break now!" And he held the class hostage for about an hour and a half and somehow she talked him down. Then the cops came in and he was whisked away, incarcarated or put in a mental hospital. No one ever heard from him again. It was on the news the next day and then it was never really spoken of again. Now you look at something like that as a precursor to the Columbine massacre on many levels. And you're seeing how the events and the environment of 1988–89 was like the calm before the storm which happened a decade or so later. So it's almost like looking back to the origins of popular medication, infomercials, self-help culture, the proliferation of guns in our culture. You look at all these things and how innocent it was then and at our loss of innocence: how these things have proliferated into people's lives and into culture. So I was trying to look back and concoct a kind of science-fiction puzzle, but also a cultural case study of this small town where the teachers and parents ultimately save themselves from oblivion. Or, rather, they're the architects of their own oblivion, but ultimately this kid provides an outlet. And this jet engine is the symbol of that lost world. So it's a complicated science-fiction story, but it's also a cultural case study of the environment I was brought up in.

I read that you were interested in time travel as a teenager. In particular, you were interested in a "god machine." What did you mean by that?

Well, *deus ex machina* is a common literary device that is often mocked in some literary circles as being a cheap way to conclude your story through the intervention of some figure who saves everyone at the end. My first exposure to this term was in *Watership Down* which we read in eighth grade. It actually had a chapter called "Deus ex Machina," which was about a little girl called Lucy who comes in and saves the rabbits at the end. I felt that, given the film was all about adolescence, on one level it was all about getting the pretension of youth out of your system, and on the other, Donnie is reading *Watership Down* and Drew Barrymore is teaching it to the kids. I wanted to bring in that literary device because I felt it was also very appropriate in describing the way that I was using the time machine: "god in the machine" is the idea that if someone could build a time machine, what if it wasn't a De Lorean with a flux capacitor which goes eighty-eight miles per hour, but was instead some kind of wormhole made of cumulus clouds or water, and that all you need is some metal object to hurl through it, like a jet engine? So to align that literary allusion with the idea of a time machine was interesting to me and felt appropriate.

Something else I thought when I saw Donnie Darko *was that it wasn't like a teen movie. The depiction of the teenagers was very unsentimental almost to the point of being icy. For example, the treatment of the Chinese girl, Charita, by the other kids was horrible.*
Horrific, yeah. The emotional abuse and cruelty inflicted on children by other children is probably unmatched unless you're dealing with adults who are sociopaths. Maybe this isn't something that's so prevalent in British culture; maybe there's more propriety there. But there's an emotional and psychological abuse that occurs between young people. Junior high is probably worse because your hormones are pulsing through you. You're going crazy and you're at that stage where you haven't settled into your clique and you haven't become an outcast yet. So everyone's figuring out where they're going to end up in terms of their social hierarchy, and there are a lot of horrible things happening. I remember kids who were picked on ten times worse than Charita. I remember a lot of racist things. A lot of just awful,

awful things that were said to people. I didn't want to step back from that. I wanted to be up front about it. You're meant to cringe when you hear the kids say those things to Charita. I wanted people to say, "Ooh, that hurts!" And not shy away from it because I wanted to depict life as I remember it being and not censor anything.

Did you write many drafts of the film?
The movie is pretty close to the very first draft on many levels. It went through my producing partner, Sean McKittrick, who I'd met through a mutual friend when he was an intern at Sony. He was working for an executive at New Line while I was finishing my graduation film and was trying to get *Donnie* made. And he was really good about helping me go through the script, edit it and get the screenplay into better shape to go into production. It was always long and I had to get the length down and cut things and trim things here and there and clarify things here and there. He was always a great defender of the screenplay. He helped get the script submitted to a couple of agencies and, lo and behold, Creative Artists Agency, the most powerful agency in Hollywood called me and said they wanted to meet me and sign me. And it was as though Sean, as my producing partner, helped orchestrate that very strategically. And all of a sudden we had the most powerful agency behind us representing the script, and there were a lot of people who wanted us to water it down or dumb it down. They'd say, "Is the rabbit the devil or is the rabbit an angel?" Or, "It can't take place in 1988, it has to take place in the present day." "Donnie needs to be eighteen, not sixteen." "He needs to drive a car." "You need to up the sex with the girl."

Who are these people?
These are development executives in the studios.

Did the agencies try to stamp their identity on the script, too?
Not really. I went into CAA and I said the script is as it is. I said I was going to direct it and my friend Sean McKittrick was going to produce it, and that's that. If you want to sign me, you're going to have to

deal with that. I was very straight with them, and they paused for about five seconds, looked at each other in the room, and said, "Okay."

Had they seen Visceral Matter?

I think I sent them the tape of it and they were a little freaked out by it. I mean, no one understood it and it was a mess. But it was visually impressive, so I said, "Just look at it with the sound off." So they were like, "Oh, okay." They supported me and they support me to this day. So the script was then submitted to everyone in Hollywood and it got a huge immediate response. People were really excited to meet me. And then when I walked in the room they were like, "Forget it." I was twenty-four.

Can you say a little about meetings you had?

I got to meet Ben Stiller on the set of *Mystery Men* on the Universal lot. He wanted to help me and loved the script and wanted to be involved. I got to meet with Betty Thomas and her producing partner, Jenno Topping. I got to meet Sydney Pollack and Bill Horberg. And I met with Francis Ford Coppola. A lot of people were really turned on by the script, but they met me and they were like, "I don't know . . . I don't know if you can do this. You're a bit young." And a few people saw the short and they were like, "Forget it." And there were a couple of studios who said, "We'll buy the script, but you're not going to direct it." And Sean and I were like, "No." We just held out. We knew that all we had was our ownership of this material that everyone was interested in and that eventually they would have to relent. Every few months Sean would get a call, and they'd be like, "He doesn't want to direct this any more, does he?" And Sean was like, "Yep, he does!" And we were so persistent about it that eventually the script kept rising to the top of the stack of screenplays. And a good screenplay doesn't go away. People don't forget about a good screenplay because they're rare. And for whatever reason this one aged well. And eventually my agent said Drew Barrymore and Nancy Juvonen had come up to him at Show West in Vegas and said they loved the script and

wanted to meet me. And I said, "get me a meeting! Maybe I'll ask Drew if she wants to play the English teacher." Because at that point Jason Schwartzmann had gotten attached, he was originally going to be Donnie. So about a week later we went to meet Drew and Nancy on the set of *Charlie's Angels,* and I said, "Do you want to play the English teacher?" And she said, "I'd love to. Will you let my production company produce this with you?" And we said, "Absolutely!" So we all shook hands. And she had a window of one week that summer. So all of a sudden we had to rush to get ready. And we were able to get four and a half million dollars, that was the money we could raise with Drew as an essential element.

How had the script found its way to Drew?

She was at the same agency. She'd just re-signed. And the script was being sent around. So it was like, "Okay, you should read this even if it's not for you." It was being submitted as a writing sample. A lot of people were saying, "He wants to direct it, but it's never going to happen." But it's a good writing sample and I was getting offers to write scripts.

Is this what you were actually living on?

Well, my first writing job was for Phoenix Pictures, a children's book called *Holes* that was eventually made into a movie. I was the first writer they hired to adapt that book, and I proceeded to turn it into something very different. I turned it into a very dark, *Cool Hand Luke/Stand By Me* kind of thing. It took place in a desert wasteland in Texas after someone had let off a nuclear weapon there. Robert Duvall was the warden, and the kids were digging for some mysterious weapon or artifact or something. I changed the book completely and was so naïve, arrogant, and stupid that I thought they would just go along with whatever I wanted to do. I turned it in and they freaked out and fired me and I didn't get paid for delivery. And my agents were like, "You got to be careful, you can't continue to do this." So it was like a rude awakening to the reality of being a writer for hire. It ended in total disaster. This all happened while I was trying to get

Donnie off the ground. So I was able to get a little bit of money, although they went back and started from scratch and the movie ended up being a cute kid's movie, which I guess is what they wanted all along. I just don't know how to write that kind of movie. I started to think, did they read my script? Did they read *Darko*? Did they know what they were getting into when they hired me? So anyway finally I was making a little bit of money, I sold a pilot to the Fox network for a one-hour TV show that I wrote that never went anywhere. So I got paid for that. So I'm always able to make money writing. If I fail in my career as a director, I always have my writing to fall back on.

When did you discover you had a talent for screenwriting?
Until I'd written *Donnie Darko,* I'd never written anything other than my shorts. So I didn't have a lot of writing technique, all the screenwriting experts like Robert McKee who tell you the rules and parameters of screenwriting. I didn't have a lot of that rhetoric pushed on me. Actually, I'm missing a little chapter here. The summer after my junior year, I interned for Oliver Stone for a summer. It ended up that he was going to option one of my scripts at one point. It didn't work out. But he's a hero of mine and always has been. So I was a summer intern at his company and I got to do a lot of coverage and read a lot of scripts for him and Danny Halstead when they were partners at a company called Illusion Entertainment. This was just before he was going into production on *U-Turn.* So that was my exposure to the development process. So I'd read enough screenplays and read enough bad ones to know what not to do. And by then I'd seen enough movies that I thought, "if I'm going to take my first crack at writing a screenplay, I'm not going to try to please anyone but myself." And I think I understood enough about the way stories are told through Joseph Campbell mythology and the literature that I read in high school. And I wasn't writing for the marketplace. I wasn't writing *Donnie Darko* thinking, "Ooh, this is going to sell as a spec." The spec market is just garbage. It's just a complete fraud. If you're writing something for the marketplace, you're not a real writer. As far as I'm concerned, you're a door-to-door salesman pretending to be a writer:

"Here's a spec if you want to sell it. A man and woman are about to get married and they drink a magic potion and the next morning they wake up and all the men are obsessed with weddings and gowns and the décor and all the women love football and couldn't give a shit about weddings, and a wacky romantic comedy ensues."

It sounds like something written by a computer program!
Yeah. But it's something the development executives think they can sell to their boss. They have a certain amount of money they can spend each year and they can pitch an idea like that in thirty seconds or less. I think there was a spec just like that that sold. In fact, usually it's just a pitch which is even better because then they don't even need to write anything down! They can do a razzle-dazzle and tap-dance and sell something. It's just garbage.

Let's go on. You had Drew signed up. How did you come to choose Jake Gyllenhaal?
It turned out that Jason Schwartzmann had another commitment that was going to conflict with Drew's available window, so he had to drop out. And when I met Jake, I just knew he was right immediately. And I got to meet a lot of talented people. We met with Patrick Fugit, who was in *Almost Famous,* although it hadn't come out yet. We met with the kid from *Slingblade,* Ben Foster. A lot of great young actors. It was just that I had a gut feeling about Jake.

You didn't have anyone in mind when you were writing the script?
I had written it with no one in mind.

So it was love at first sight with Jake?
Yeah. Jake is an extraordinary actor, and I saw great potential in him right away. And he comes from a family of filmmakers and his sister is obviously an extraordinary actress who I was also able to cast before everyone caught on to how talented she was. I was able to get her at that moment, and I was very lucky to get her because she was very hesitant. She was like, "Are you just giving me this role because I'm Jake's sister?" And I was like, "Well, you're really talented. And I

would be a fool to try to hire someone to pretend to be his sister when he really has a very talented sister who can act. I'd be foolish not to beg you to take this part!" And Maggie finally relented and agreed to take the part. But she didn't want to get it just because of nepotism. She's very aware of that. And she didn't get the part because of nepotism. She got the part because she's great. But it was a lucky coincidence for me that she was also Jake's big sister because you can't manufacture that kind of chemistry. And it helped everyone in those dinner-table scenes to know that we've got a real brother and sister here. It helped them feel more like a family. I was very lucky to have them.

What about other parts? Was it difficult to get Patrick Swayze? And was it part of the point that he was a big eighties icon?
Nancy Juvonen had the idea of Patrick. They'd met him on some other project, and he really wanted to do something provocative.

The character he played was pretty sleazy.
He didn't care. He got it. And he was really fearless about it. He's a really sweet guy. He let us film the infomercials out on his ranch in Calabasas. His wife brought out his actual clothes from the 1980s. Those were all his real clothes that he used to wear. He was a real good sport, and we were real lucky to get him.

I just want to backtrack for a moment. Can you tell me where the money actually came from?
Sean and I attended the AFM in late 1999. Ernst Goldschmidt, who owns a company called Pandora and used to run Orion, was in town, and we had Jason Schwartzmann attached. And based on Jason— because Drew wasn't attached yet—Ernst made an offer of two and a half million dollars to make the picture with me attached as director. He's the one who rolled the dice on me. So we had two and a half million dollars on the table based on Jason being attached. Based on what we'd been told by the line producers we'd met when budgeting the film, we knew we couldn't make the film for less than four and a half million dollars without cutting a lot out of the script. It was a very ambitious picture. A jet engine and all the locations and whatnot, the

number of kids and days. So we knew we needed about twenty-eight days and about four and a half million dollars. When Drew came aboard, Ernst's offer went up to four and a half million because Elie Samaha and Franchise Pictures were also in the game. They also wanted to make the film. So we had two companies vying for it which is how we were able to get the four and a half million. And then, in the process of closing the deal with Pandora, they were purchased by a company called Gaylord Films who are actually no longer in business. Pandora was going to become their lower-budget division. Gaylord went on to make *A Walk to Remember* with Mandy Moore, *Divine Secrets of the Ya-Ya Sisterhood, White Oleander,* a lot of women's-issue pictures or teen movies. So *Donnie Darko* was the kind of weird bastard stepchild that they inherited when they purchased Pandora. But they had Drew attached, and me, and we got along.

You managed to get Drew and Patrick Swayze attached. Did you have any difficulty attaching other actors? After all, you must have appeared pretty young.
Yeah, they were a little nervous. But I can talk a good game. I know how to talk to actors so I can put them at their ease. And I was pretty open about the fact that I didn't really know what I was doing. I think a lot of young directors immediately try to impress upon actors this elaborate method-speak. To compensate for the fact that they don't really know what they're doing, they overcomplicate everything with a bunch of confusing talk about character and motivation blah-blah-blah. I just kept it simple. And I had written the screenplay which made it much easier, I guess.

Did you have much time for rehearsals?
Very little. Maybe a day or two with the family. But Jake and I sat and went through the entire screenplay together.

Did you learn much from Jake?
Yeah. I think he challenged me in a way that I deserved and needed, in the sense that his mother is an Oscar-nominated screenwriter and his father is an accomplished director. He was nineteen at the time and I

was twenty-four, twenty-five, yet he had a lot more wisdom than I did about how an actor reads a screenplay. And given that he grew up in Hollywood in a family of filmmakers, he was a great partner to have in the rewrite process on the script. And we worked very meticulously on his role and getting it just right and continued this throughout the filmmaking process. So having Jake there was a real asset for me.

What about your DP? How did you come to choose Steven Poster?
We were going through a bunch of résumés—you only have a few thousand a week to spend on a DP and you're getting a lot of résumés from younger DPs who've done independent films—so we were going through these résumés and we came across Steven Poster. Well, he shot a Ridley Scott film in 1987. And in my eyes if you've shot a Ridley Scott film you can retire because you've worked with the greatest visual stylist in cinema probably ever. And I thought, "Can we afford this guy? Can we get him?" And it turned out that Steven had taken a couple of years off. His wife had gotten sick and had passed away and he'd taken a sabbatical from shooting films and he'd done some commercials and some music videos and stuff, but he was looking to get back in the game. And with this movie and with me he saw an opportunity to really do something provocative and interesting. Steven shot second unit on *Blade Runner* for Ridley, and before that he did *Someone to Watch Over Me*. He shot second unit on *Close Encounters* for Vilmos Zsigmond. He'd been there in the mix of some of the greatest science-fiction films of the late seventies and early eighties. And I thought, "We've caught a diamond in the rough here, someone who's still hungry." You know? The first thing he said to me was (a) "I want you to forget about the age difference between us," and (b) "Don't worry, I'm never going to tell you how to direct your movie. I don't ever want to be a director." So he knew all the right things to say. And I was like, God, we'd be lucky to get him. And it turned out to be a great partnership.

How did the partnership work?
I'm very meticulously visual and I know exactly what I want. I know what my visual style is. I make very quick decisions. I don't go back

and forth. I'm not indecisive about visual stuff. When I get to a loca-
tion I know within ten seconds whether it's the right location. Or I
know, "Forget it, I've got to look for something else." Stuff like that I
just know. And so Steven and I, we had a great, very direct, to-the-
point relationship. And if we disagreed about something, we would
figure out a compromise that would make us both happy immedi-
ately. He got me anamorphic lenses at Panavision. I fought to get
anamorphic lenses. There's always some joker who says you're not
allowed to have anamorphic lenses on your first picture because
they're too difficult to use. That's a myth that has been spread by peo-
ple who know nothing about cinematography, people who don't really
know what they're doing. Yes, they are a little more tricky to light.
And they require more light. And yes, they're larger and bulkier. But if
you have a good DP, the difference is negligible. You just have to
know what you're doing. It comes from people who don't know what
they're doing—the producers, the investors, the line producers—
they're intimidated by anamorphic lenses, so they often say no to first-
time filmmakers just because they get a little freaked out by the stories
they hear. But if you have Steven Poster, you have nothing to worry
about because the man knows what he's doing. At some point I had to
get in on the line with the investors because they were saying, "No,
no, no," out of principle. And I was like, "Listen, I got to do a fucking
time portal. You got all these psychotic psychedelic visuals here. I
need a widescreen frame in order to be able to do this stuff or it's not
going to look as good. I know what I'm doing and Steven knows what
he's doing." We got a discount from Panavision. I just had lunch with
Bob Harvey and he's going to give us the damn lenses for practically
nothing. Let me have my fucking anamorphic lenses! And so I
wouldn't take no for an answer and finally they relented and said,
"Okay, you can have them." And when the dailies started coming in
they were like, "Thank God we listened, because this looks really
good!" So you mustn't let them win little fights like that. That's my
advice to filmmakers. You can't let them underestimate you. If you
know you can deliver something and they're underestimating your
potential because you're twenty-five and you never shot a film before,
don't let them do that to you because you're then stuck and the film is

then stuck not looking the way you want it to. You've got to pick your battles. You can't win them all. But the ones you know you can win, you've got to fight them. You have to. And in the end they'll respect you for fighting for what you want.

How did you work with Steven? Did you storyboard the film?
We storyboarded probably sixty to seventy percent of the film. Storyboards are very important in certain sequences, but it's also about having a shot list every morning. You have to get on set twenty minutes early, while everyone's having their breakfast or coffee at the craft services, and do your shot list. So every morning my line producer, Tom Hayslip, and my producing partner, Sean McKittrick, would put a pen and a piece of paper in front of me and say, "Do your shot list for the day." And we'd cross them off as we were going through the day, and sometimes I'd sacrifice one or other of them because I'd realize I could get it all in one shot.

How many setups were you doing a day?
Oh, it was intense. One day we did as many as thirty-four, thirty-five. That's at the highest end.

How long were your days?
Long. Our unit production manager, Betsy Mackey, would always come in and say, "We've got to shut it down. We've got to get everyone back." Even so, there'd sometimes be ten-, eleven-, twelve-hour days. I can't really remember too well. But we were always responsible. We never paid a lot of overtime because we couldn't afford to pay the crew overtime. But we often had more than one camera package going. And Steven brought in a lot of great second-unit guys who could set up for us so we could checkerboard back and forth between two cameras as we got down into Long Beach and it got more complicated. The only way we could do it was to pre-rig every location so that the lights would be rigged the day before we arrived at the location. This was incredibly important in saving time. We had every location scouted meticulously so we knew when we had Steadicam, when we had Technocrane, when we'd go handheld. It was all meticu-

lously planned and designed so that you could get through that many setups. There was never a moment when we walked on set and said, "What are we going to do?" We always knew what we were going to do. This is the only way I'll ever work because it'll always be hard having enough money to make these kinds of provocative stories. The kind of films that I'm going to continue to make are very risky, and the only way I'm going to do them is when I'm given barely enough money, when the actors are all working for scale, and so on. So you have to have everything planned in advance, otherwise you're never going to make your day. There's no worse feeling than knowing that you're not going to make your day and there's a shot that you can't live without that you're going to lose. And we always got the shot that I couldn't live without. Sometimes I lost stuff but it turned out I didn't really need it. We got only what we needed and the film looks better and plays better because of that economy and because Steven would urge me to risk it all in one shot. Start here and move in and get it all in one shot. I became someone who would turn back to Steven and say, "Steven, we don't need any more coverage. I'm not going to use it. It's a waste of time." And that economy is something that helped my editor. It helps the film because a lot of first-time filmmakers shoot too much coverage or they think they need to use all the coverage— you know, because we had four setups we've got to use them all. The truth is you should only cut when necessary. Only shoot what is necessary. It makes the process of watching the film much more economical. Economy is a great discipline.

How long did you spend prepping?
Not a long time. Eight or nine weeks. But a very intense eight or nine weeks. Sometimes it's not how long you have, it's how you spend the time. And I think we were able to cut straight to the heart of what we needed. Everything about it was very intense but we made it work.

Let's talk about other aspects of the look of the film. Were you involved in things like the design of Frank the rabbit and the Mummy in the schoolyard?

Oh yeah, everything. I had my hands on the design of every visual element of the film. I'm all over that stuff. What people don't realize is that you have to use the same amount of care that you use directing your actors to direct your cinematographer and your production designer and your costume designer. You can't neglect them. They need direction. You can tell when the crew isn't in sync with the director because there isn't a consistency in the look and everyone's working on the basis of "I think this may be what he wants." So you have to be very meticulous in what you ask for and what you tell them.

There are several moments that remain in my memory. The moment in the school when the camera does this kind of ballet between all the main characters. And the beginning, when we find Donnie asleep on the road. Was that all preplanned?
It was all designed very specifically. There's not a single shot in the film that we came up with in the moment. It was all meticulously planned. It's really the only way I know how to operate. It's all about being thorough, and I think that that's what direction is: it's playing and it's execution and it's many things, but preproduction is the most important time.

Donnie Darko *is an astonishingly assured debut. Were you confident about things like where to place the camera? The staging of the action?*
I think it's a feeling you get that this is right. I don't know how to describe it. It's just when I know, I know. When I see a location, when I saw that cliff I was like, this is it. This is where we're shooting. When I saw that house in Long Beach I'm like, this is it. When I was growing up and creating art, I knew how I wanted a drawing to look. It's the same with a film: I know exactly how I want it to look. It's an instinct you have.

Were you nervous?
Yeah, the first day. But it went away once I had the crew behind me. As a first-time director, you've got to get your crew on your side, and that takes a couple of days because at first they're thinking, "Who is

this kid? I don't know about taking orders from him." You have to have an air of authority, and it circles down from you because if all of a sudden you're a nervous wreck it's going to spread like a virus through the crew to every level, it's going to fall apart. It's going to slowly deconstruct. If you do the opposite and project security and confidence and you know what you're doing and you make your days and everyone's feeling good, it just gets better. Everything just gets better. The camaraderie, the solidarity, the loyalty.

At this point, Richard Kelly left the bar where we were talking, saying he would finish the interview the following day. The next day, however, he was unavailable, and continued to be unavailable for the next twelve months—despite numerous phone calls to his agent and an e-mail corre-spondence with his assistant, which would fill a separate book. Some sense of what happened to Donnie Darko *after production can be found in the biographical notes. It is now widely regarded as a cult classic.*

Alejandro González Iñárritu

AMORES PERROS

Can you say a little about your upbringing in Mexico City?
I come from a middle-class family, a conservative Catholic family. I'm
the last of five kids who grew up in a middle-class neighborhood on
the edge of a dangerous area where there were a lot of gangs. I was
really happy as a child. I had my own gang and went to a boys-only
school. My father used to be a banker, a rich guy, but when I was five
or six years old he went bankrupt and lost everything. He used to
work in financial services, loaning money for ranches, and then the
government took everything from him and he was left with nothing.
So we faced a lot of economic hardship as kids. But my parents cared
a lot about education. I stayed in the same school because my mother
begged them to let her pay only half of the fees and sometimes
nothing. Then my father went into business for himself. First he sold
wood and then for twenty years he woke up at 4:00 a.m. every day to
buy fruit and vegetables in a sordid market in order to sell it to restau-
rants during the day. He went from the top to the bottom with the
nobility and the virtue of a warrior, and he has been my inspiration. If
he had been a filmmaker, he would have been a good one because it's
that kind of strength you need in this kind of work which can be so
humiliating at times.

How do you think this experience affected you?
I grew up with kids who had more than I did. They were used to
travel, and told me about Disneyland and skiing and Europe and so
on. But it wasn't until I was sixteen years old that I paid for a ticket to

get on my first plane. I earned money washing cars. That was my first job, washing sixteen to twenty-eight cars a day. I think I was really hurt by that in some way. I was always embarrassed by my mother's car. It always broke down in front of everybody and especially in front of the girls that I liked, most of whom had great cars with fancy chauffeurs. I was angry that I didn't have the same opportunities as my friends. Now I think this was a good thing because that's how I started to be hungry. I wanted to travel. That was my first big thing! So I think it affected me positively. It hurt at the time. But I think that when something creates a need in you and you have something to dream for, it's a good thing.

Had films already made an impression on you at this time?
When I was a kid, the films that were coming out in Mexican cinemas were the big disaster films like *Earthquake* and *The Poseidon Adventure* and *The Towering Inferno*. Pathetically, Charlton Heston was the big star at that time. I also remember films like *Bambi, Chitty Chitty Bang Bang, Melody, Friends,* and *Willie Wonka and the Chocolate Factory.* Those films became part of my dreamland as a kid. But the first time I was struck emotionally was by an English film which no one has ever heard of called *Baxter!* [Lionel Jeffries, 1973]. My mom took me when I was eight or nine years old, and it was really depressing! It was about a kid who suffers from manic depression. His father is getting divorced and he stays with his father-in-law and they treat him very badly and he ends up in a mental hospital. I remember seeing the film and really connecting with that guy! My fears, my depression, all my frustrations I projected onto that character. I was afraid I'd end up like him. At least that's the way I remember that film which I haven't seen in thirty-five years. That was the first time I felt the power of cinema. And that stayed with me. I'd like to see it again now so I can see how screwed up I was!

Given what had happened to your father, to your material circumstances, do you think that films were an escape from everyday life?
I think that television was more of an escape for me. I saw a lot of TV and a lot of films on TV. To tell you the truth, we were so hard up that

we didn't go to the cinema much, maybe no more than once a month or so.

Was film already something you wanted to be part of when you were growing up?
I was more interested in music. I was a music freak. I was buying albums and playing them all the time. The first time I wanted to be involved in movies was when I saw a Turkish film called *Yol,* by Yilmaz Guney. I remember that film really hit me. I was more mature by now—I think I was seventeen—and I said, "This is unbelievable; I want to be involved." There were three films that really struck me around this time. The first was *Yol;* the second was *Midnight Cowboy* which was one of my father's favorite classics, and the other important one was *Once Upon a Time in America,* by Sergio Leone. And in terms of visuals it was *Blade Runner* by Ridley Scott. All these films were around at this time—the middle to late seventies—and in each of them music was very important. The music by Vangelis in *Blade Runner* is unbelievable. The music in *Once Upon a Time in America* is by Ennio Morricone. The song in *Midnight Cowboy* was fantastic. And the music in *Yol* was great, too. These first three films were very human, very real and dramatic, and connected me musically with some emotion so that I said to myself, "There's something going on here."

Did you do anything concretely about this discovery? Did you study film?
I studied communication at the Universidad Iberoamericana in Mexico City. After one or two semesters you could choose between journalism, radio or film and I chose the film option. But I was a very bad student. All my life I've been a very bad student. I could never study because I suffer from a really bad case of attention deficit disorder. I think that's why the role of director fits me so perfectly. I can't spend an hour on the same thing. I have to jump from one thing to another. As a director you have to multitask, you have to keep switching between all the departments, and that fits me down to the ground. I can spend ten minutes with you and at the same time I can be thinking about something else here and something else there! It's perfect

for me. It means I can control everything without focusing on one thing. Because I'd kill myself if I had to do that! So I went to film school but I didn't like it. The teachers were really bad. They were always analyzing the films too much and talking about how something worked. You know, "that little bird that flies in the right corner of the screen in this Fellini film meant to him the freedom that he was looking for"; "that blue dress on this Bergman character symbolizes metaphorically the sadness of his political and psychological context," and blah, blah, blah. I used to fight with them all the time, but now that I'm a director I know I was right! Sometimes people tell me stuff about my films and I go, "Really? I didn't know there was a blue plate in that scene. That's really interesting." Of course, it's all bullshit!! I hate all that overanalysis. I didn't finish the course. Too much analysis is paralysis. But I did music for two short films and I assisted other people. I'm still working with the people I started out with twenty years ago, and that has helped me to be really passionate about what I do.

You said you did the music to two short films. Do you consider yourself a musician?
Yeah, a frustrated one. A good composer but a bad player. I play the guitar and I sang in a rock band. But the music I did for those films was with a piano guy. And I was just playing very basic chords. I don't read music, but I can follow it lyrically.

So film school wasn't a great success. What did you do next?
I met a guy, Miguel Aleman, whose father was one of the owners of a big media corporation. He became the head of a radio station when he was eighteen years old. His girlfriend was a friend of mine, and she told me he was looking for people to hire. So I went down there and tested for them. He liked my voice and two months later I had a radio show, three hours a day. There wasn't any programmer so I could play whatever I wanted and say whatever I wanted! I was free to invent my stories, my sketches, my jokes, and play any kind of music that I wanted. I became a radio host, an entertainer.

What sort of music did you play?
Rock 'n' roll. You know, Led Zeppelin, Peter Gabriel, Genesis, Yes, The Who, the Rolling Stones, Pink Floyd, and David Bowie. Some good pop music, too, and some exquisite classic jazz, like Miles Davis, Duke Ellington, Charles Mingus, Pat Metheny, Wayne Shorter, Chet Baker. I sometimes played some avant-garde things, too, or classical music. I was playing a really broad range of music, depending on how I felt. And I was just talking and telling stories. I learned to entertain people for three hours each day with stories and with sounds. In a way it's like making a film, because what I was doing was creating an atmosphere.

Do you think it helped you later on in terms of telling stories through film?
It wasn't conscious at the time. But looking back, it was a great background. It gives you the skills to talk, to express, to communicate anything—an idea, a poem, a sensation—without words, with music. We were the number-one radio station for five years in Mexico, playing very sophisticated music for a Spanish-speaking audience. So I had an audience of millions. Why? Because they loved what was happening between the songs. People listened to us not because they were crazy about the music, but because of what was being said between the songs. I was always making things up! For example, I made up a story about a guy who had locked himself in a strongbox in the middle of a freeway. While the police and journalists were trying to figure it out, he was expressing his political ideas. It was so well produced—we were pretending it was happening live, in the streets—that the people began to avoid that road and it created real chaos in the city. Stupid things like that, but it was a lot of fun. This radio station was having these kinds of happenings all the time, and it challenged people creatively.

While you were enjoying success as a DJ, was film still something you were dreaming of doing?
Yeah. I was studying film in the university at the same time as I was working in the radio station. I was very young. I became a director of

the radio station at twenty-one. I was a director. I was a producer. I had my show. So little by little, I became frustrated with university because I was having such a great time with my show. I wanted to move on but I didn't know where. After five years of doing my radio show, I'd had enough. I'd interviewed all the big stars, Elton John, Pink Floyd, Robert Plant, all my heroes. But after five years I was completely exhausted and I felt I had to move on. My show was number one and I'd made some money. But I wanted desperately to move into film without knowing how because I felt that the traditional way—being a film student and finishing the university course—wasn't the right way for me.

Did the fact that you now had a profile help you in any way?
By now I was a celebrity among young people. Everybody knew my name. I already had a public image. But every time I was at a party and people recognized me, I was embarrassed! I didn't want to be known as a DJ, because I thought I was more than a DJ. I was giving people my feelings, my stories. I don't know what to call myself. But I had my space of talk and play and communication. When I left, no one understood why because I was at the top of my career. The corporation had started paying me more money and had given me a car. But I knew I had to do it. Otherwise I'd be forty years old and still be a DJ! And I said, "I can't do that!" It was a very visceral decision.

How did you move from radio to television?
Miguel Aleman, the friend who'd given me a break at the radio station, left the company and joined a TV station, Channel Five, which was the young channel in Mexico. In 1990 we both went to see Pink Floyd in concert in Berlin. We were traveling around the Adriatic in a boat. But, in spite of everything, I was sad. I was really unhappy. When Miguel asked me why, I said it was because I wanted to go into film, but I needed to learn the craft of making images. So he said to me, "You helped make a great radio station. Why don't you help me make a great TV station?" He was a great friend and he believed in me a lot. So I said okay. I started to write promotional material for the sta-

tion. You know, thirty-second or one-minute commercials. But then Miguel said, "Why do this just for Channel Five? Why not do it for Channel Two, Channel Four, and Channel Nine? All these channels had different audiences. So I invited my friend, Raúl Olvera Ferrer, who's now my partner and who was more experienced in advertising than I was at this point, to work with me, and both of us started to write hundreds of ideas together.

What exactly were the things you were writing? Little stings? Station idents?

Station idents, exactly. But they weren't little. They were big. And all the channels had their own identity. Channel Five was totally crazy. Kind of MTV with weird images and comedy. Channel Four was very populist. We'd go out and do vox-pops in the street for that one. We had to create a lot of ideas. Very smart, very sharp, very challenging, very creative. Completely new for the Mexican audience. So we wrote them and we made a presentation to the president of the network. And he loved it and gave us two million dollars to make it and six months to produce it. It was a dream. But we didn't have a production company, so we hired directors and producers. To begin with, I was happy because I was the creative guy and the writer. I went to the set and watched the guys as they worked and went, "Wow!" But then I started to get frustrated because what they were doing was shit! In the end I got so mad that I had to do it myself. And that's how it happened. The first thing I directed was a little commercial for Channel Five. It was two twins, fourteen or fifteen years old, who began to say exactly the same things at exactly the same time. It was difficult because the guys were not actors. You know, it was like "take seventy-one!" And then I did twenty more of these. I had the time of my life. And the pieces were so successful that I kept on doing them. So this was my university of life! I had total freedom; I wrote all the ideas. I directed, I produced, I edited, I presented. It was like three or four years of full-time work. I always said that at that time I had more hours on set than any other Mexican director. I was literally living on the set. At that time I shot a hundred or a hundred and twenty days

a year. I shot in Super 8, 35 mm, all formats: I shot comedy things, cultural things, visual things, drama things. For example, we made all these trailers for Mother's Day, Father's Day, Christmas Day. All these tacky, corny, sentimental, melodramatic things. We wrote two-minute stories. I was working on exposing emotions, not products, and that was the greatest schooling of all: one camera, two actors, and that was it. I worked with costume designers, set designers, all the professionals. It was the most fantastic training I could have had!

Did you direct commercials as well?

Later on. Our work was so successful that everyone wanted to know who was doing it. So we created an advertising agency with a production house attached to it which was called Zeta Films. We began to produce commercials for banks and so on. And all this time I had the opportunity to write my ideas, then shoot them. We did the campaign for a bank called Bital which was the seventh largest bank in Mexico. Within two years it had become the biggest bank in Mexico. They had the most famous commercials in Mexico; everyone knew about them. They were insane for a bank, very funny. It was hilarious! So the company began to grow, and the same thing happened as with my radio career. Suddenly I was a commercials director, and I began to hate that title.

It sounds like as soon as you're accepted in a particular role, you want to move on.

I think I have a five-year cycle. After five years in radio, I quit. After five years in commercials, I quit. I said to myself that either I'd do a feature or I'd kill myself because in features you never get bored. Every film is a different challenge. It's an infinite sea of possibilities so you can never be dissatisfied. But I went through a big crisis because by then I was having a great time with a big company and I had to say good-bye!

Around this time you trained with the Polish theater director Ludwig Margules. How did this come about?

I knew that visually and in terms of the craft of telling a story and managing a set, I was getting hundreds of hours of experience a year. More than anyone else. But I felt I needed to know more about communicating with the actors. I was a two-minutes guy, and I didn't know if I'd be able to sustain emotion for longer than two minutes! I was really afraid of that. And I had a lot of respect for theater directors, so I thought I should study under one. And it was the best thing I've done because I went to study theater with Ludwig and worked both as a director and as an actor. And I learned from him the dignity of a director and the responsibility. The trouble with commercials is that the guys who do them are cool and fancy, but normally they're very ignorant. They're informed about what's going on in their trendy new visual thing, but it's all useless and very superficial.

How did it go?
Ludwig was a terrible dictator. I saw him destroy people's lives. People who didn't have talent, he destroyed them, literally. He was like, "You're not going to want to hear this, but you shouldn't be here. You should be a lawyer or whatever." So it was really hard with him. And he taught me a lot. He humiliated me sometimes when I made mistakes, but that was how I learned. I put on a play and I thought the actors needed something to work with, so I called an art director friend of mine who created a library and some furniture in the background, but it was too much for a play that was being put on in the classroom. After the play had finished, Ludwig destroyed me in front of everybody by asking why I needed the library and the books and the furniture. He was a Brecht kind of guy. He liked simple things. He said to me, "If you need those things, then you're not a director. If you can't make your audience imagine things by the actions of the characters and your silence and your blocking, if you can't create that world just with the actors, then you're finished as a director." And he was right. I didn't need all those things. It was just fear that I wouldn't be able to communicate with people, that they wouldn't feel comfortable. Ludwig was from Poland. He was always very strong on the economy of your decisions—not just the acting, but everything. Be

very economic. I then directed a pilot, which I also wrote, that was called *Behind the Money.* The idea was to invite four or five directors to direct two episodes each, thirteen in all, about a banknote that goes from hand to hand. It was a flexible way of moving between stories and between genres. And it was a very smart idea for TV. My only wish was that I could have just one scene that worked. The night before I was like, "Please, God, just let me get one scene right. If I get one scene right, I will be completely satisfied!"

Were you satisfied?
To tell you the truth, I think I was satisfied with one scene. Looking at it now, I have a lot of love for it because I know how much I invested in it and how much it meant to me. I remember that I was proud of one scene that worked well.

What happened to the pilot?
People loved it, but it was very expensive for Mexican TV because it was shot on film. So it cost around a hundred thousand dollars, which was an incredible amount for an episode on Mexican TV at that time. They transmitted it, but it didn't mean anything on its own because it was supposed to be part of a series of thirteen episodes. It got okay reviews, but that was it. I was really frustrated by that. I was really sad.

You must have learned a lot from the experience nonetheless.
A lot. After the whole process I was exhausted. I spent a month editing it on a three-quarter-inch-tape machine. It was really painful editing it. It was a nightmare. I learned a lot. It was a great exercise.

Do you think it helped you later on, in terms of people putting money into you?
Yeah. Because it was a very high-quality product. Even if you see it now, it doesn't look old or cheesy. You could air it now and it would look okay. I think it was like a kind of half-step between the short films and the features.

The next film you directed was Amores Perros. *Can you describe the evolution of the script?*

After the pilot, I was writing a script myself. I had an idea of the story and the characters, but I needed someone to work with who had more experience on the technical side of screenwriting than I had. I asked the producer at my company, Pelayo Gutiérrez, and he told me about Guillermo Arriaga. I met Guillermo and we started to work together. A couple of days later he told me, "You know, it's hard for me to start working on something as political as this. I have a couple of ideas, too." At the time there was a government award for short films. So we said, "How about if we made a short film about ten different stories that happen at random?" And we started working on an eleven-minute film about the city, with ten stories in it. Some kids were playing football in the street and they see a house that's on fire, but you don't see the house, you just see the kids' faces, so you imagine what's going on. And suddenly you cut to a restaurant and there's a couple who are getting a divorce and are fighting, and so on. After several more stories you realize that the house that was on fire belonged to the divorcing couple in the restaurant. It was many crisscrossing stories all put together in one short film. A slice of life. And that was the embryo for *Amores Perros.*

Ten stories in an eleven-minute film sounds ambitious!

In Mexico this thing happens that happens everywhere. You know you will probably have an opportunity to shoot your first film, but probably it will be your last because there's no industry. Or maybe you'll get a second chance in ten years. There's a great fear of that. It's a kind of syndrome which means that people try to put all their ideas together in one film. I think that's why people fail. Because you want to put your whole vision of life into your first film: your political, religious, social, personal vision all together. So it becomes very pretentious and then you're fucked! That's why I think we wanted to put ten stories into the film. You know, it was a case of getting as many ideas in it as possible. But suddenly we arrived at a different idea: of doing three stories in which we could talk about young people, social class,

old people, the middle class. Suddenly we found that we had an opportunity to make a film with three different kinds of people and environments and ideas. So this is how *Amores Perros* began. We started working on these ideas and Guillermo told me about a dog that was bitten by another dog when he was young and I told him about a friend of mine whose dog got lost under the floorboards. The real story was that the family didn't have the money to take the floorboards up, so they left the dog there, and after four days it died and the whole house began to smell. In the end they had to take the floor up anyway to find the dead dog! So it was by sharing things we'd experienced that we began to create this thing.

Were you influenced by other films that had this cross-cutting structure? For example, Robert Altman's Short Cuts?
I think we were more influenced structurally by a film called *Before the Rain* [Milcho Manchevski, 1994]. It wasn't that I liked the film particularly, but I was impressed by it structurally. *Short Cuts,* definitely. It's completely different, but I remember when I watched it, being impressed by how you can tell many stories at the same time and still be interested in each one. I remember that at that time I also saw *Smoke* [Wayne Wang, 1995], the tone of which I liked a lot. But to tell you the truth, I think that when you make a film, especially your first film, you are influenced not by one or two films, but by everything that you have read, listened to, smelled, and felt during your whole life. So I think that the perfect mix can be a little cocktail of avant-garde, pop culture, some classical music and literature. Also, there were some influences on *Amores Perros* that were even stronger than cinema. My favorite albums are often rock operas. *The Wall* by Pink Floyd. *Quadrophenia* by The Who. *The Lamb Lies Down on Broadway* by Genesis. The Yes albums. *Ziggy Stardust* by Bowie. They're albums, but they have all these stories crisscrossing. I remember that I always loved that. They're songs but they're part of a whole story. They don't exist anymore. Rock bands now, they just do a three-minute song to make a lot of money. They don't care about a concept. So that was a big influence. And the other was Latin American literature. Ernesto Sabato, Jorge Luis Borges, Julio Cortázar, Juan José

Arreola. I would say that all these guys have been playing with structure for a long time. It was always incredibly tricky the way they constructed things. So that was something I was born with. Telling stories that are not chronological or linear. That affected the way I wanted to tell the story.

What about Guillermo?
I think Faulkner was a big part of his inspiration for this kind of narrative. And Hemingway was an inspiration for his personal way of life. But on my side it was a little more about Latin American writers and the way my father used to tell me his stories, always starting in the center, going back and forward to the beginning and a little bit of the end, just enough to keep you excited. That's the way you talk on a day-to-day basis.

Do you think part of the inspiration for Amores Perros *was to do something completely different from what was happening in state-financed Mexican cinema at the time?*
The thing with Mexico at that time was that all the directors who were making films were funded by the state. It was a completely corrupt system, a friends' club. Some of them were a clique of mediocre storytellers. Even as craftsmen, they were mediocre. The films didn't look right. The sound was terrible, the color was horrible. The framing didn't work. This wasn't because of the money, but because they were intellectually poor and spiritually miserable. Not to mention pretentious. They'd become so self-conscious that it was terrible. I remember that when I was trying to get a job as an assistant producer, before I'd even got into radio, the message I received back from one of the producers was, "If you don't have a family in the film business, you should look for one." That was the message I was given when I was eighteen years old! This guy was one of those big producers. It was a complete fuck-up! So I wanted to do something with dignity. Something with life in it.

And also to get out into Mexico City? Which was pretty unusual for Mexican films at this time.

Absolutely. Mexican cinema at that time was always doing stories about poor people who lived in poor rural towns with a priest who was tricky and a village idiot or a whorehouse. They were all ridiculous caricatures. So to speak about the urban middle class was impossible for them.

If Amores Perros *resembled a concept album in the sense that it was a collection of stories unified by a concept, what was the concept?*
I was trying to achieve a film that smells, that can speak of a bigger and more complex reality, a reality of the biggest and most contrasting city in the world. All the extraordinary, contradictory things that can happen in a city like Mexico City, where there's so much violence and greed, but which is so alive and so intense and so passionate. I was trying to create a film that you could smell so you could feel it was alive, it was sweating. So you could touch it. It was about a reality that I have experienced, and not just theorized about.

Dogs feature in different ways in each of the stories. Was that always the case? Was Amores Perros *always the title?*
I put the title on at the end. My wife and I found the title. But the dogs were always there. The car accident was the thing that united the three stories. And Cofi the dog appeared in the first story and the third story. And then there's the dog that disappears under the floor. It was a lot about the relationship between the loyalty of the animals and our brutality as people. I was always conscious of the metaphors the film used. I think the dogs said a lot about the owners. You can see it here in Santa Monica: these neurotic little women with these little tiny chihuahuas. They're just like their dogs! I think dogs say a lot about people. In the end they become part of you.

You and Guillermo famously went through something like thirty-six drafts of the script. Did it change a lot?
A lot. In the first version of Octavio's story, the dogfights were taking place among these rich families in these neighborhoods. That was a bit of a cliché. Those things changed a lot. And the tone changed. The

truth is that the dogfights took place in very tough neighborhoods. And also in the first version of Octavio's story, the girl wasn't Octavio's sister-in-law. She was just a friend from the neighborhood. And they had a relationship that was more naïve: his dog hurt her dog and they became friends. It was a little more slick. But it didn't feel right so I suggested we do something more carnal, more primitive. She's the sister-in-law; there's the possibility of an abortion. So little by little it became a bit more gritty. Sometimes I put things in there which were a bit stronger, to add to the intensity, to make people reach their limits. I think that's when you get to know people better: when they reach their limits, when they're in a stressful situation. But when you change one thing, everything else has to be moved around. And the story of the model went through several changes. I don't remember the changes exactly, but the dog being lost in the middle story was something we added to increase the tension. The girl was already in the crash and losing her leg. So her outer world was getting really dark. But we wanted something to represent her inner world, too. We were trying to get the same intensity in the different stories without shouting each time. I remember that we worked through several drafts. I became completely obsessed by every word that was said. I always try to get involved in the script in such a neurotic way because I know I will be the one who will be managing the ship. I want to be sure we have done our best with the script so that when everybody's there, even when it doesn't work perfectly, it's the best there is and I can play with it.

How long did the writing process take, from beginning to end?
Almost two years. It wasn't full-time, but it was intense. We'd get together once or twice a week. Or, in the worse-case scenario, once every fifteen days. And the telephone bills were very high!

Was Guillermo working on it full-time?
He was a teacher. So he was giving classes in the university. But I think he was spending most of his time on the script. I was making him crazy, to tell you the truth. He used to say, "It's already finished." And

I'd say, "No, my friend. It's not finished." I think he got very tired, as we'd already been working on it for a year. So I had to keep pressuring him. He was very strong and noble for having supported me all that time. But I think it was worth it.

Did you have any fights?
Yeah. There were different interpretations of what we were doing. We agreed on what had to happen, but the ways we looked at the characters were different. I always try to understand my characters through their inner life, through who they really are and what they really want, what moves them spiritually. I always believe that even people who are agnostic and don't believe in anything must be moved by something. I believe there's an interior dimension to people. The actors I choose have to have that. If I find someone who's great but doesn't have an interior life, I can't work with them. If they don't have that, I have nothing to work with. I always try to see an X-ray of who they are more than their actions. For me it's not about the plot, but about the silent moments. Cinema is what happens between one line and the other. I'm always thinking about what they must be thinking, what sustains them spiritually. I always try to find a kind of spirituality in their actions and see how that affects them. Sometimes that helps to create a lot of subtleties, which I really love. It's the difference between what makes you go "Wow!" and what doesn't. So that's what I'm really, really careful about.

Which character presented the greatest challenge when you were writing the script?
For me the biggest challenge was with El Chivo. How to make the audience love a character who was killing in cold blood? If I can make the audience have empathy with this character at the end of the film, then the film has succeeded. For me, the scene that is the key of the film—in the sense that if it fails the whole film fails—is the scene where El Chivo talks with his daughter on the phone. If that scene works, the film will float; it will redeem itself of the violence and brutality and horrible things these characters have done. Because this character will be redeemed at the end by his love for his daughter. We

shot that scene twice. The first time was the last day of the shoot and we were exhausted. We shot it and Emilio couldn't do it, he couldn't go there. He was so depressed about it and I said, "Don't worry. I'll find the money, I don't know where, and we'll do it again." And I got the money and we got another day one week later, and we closed ourselves in a room for two hours and I talked to Emilio about my personal things. I shot *Amores Perros* in 1999 and I lost a kid in 1996, so I was still very hurt by that. And he told me about some personal things, too. And we were both very moved, just talking. And then, when he was in the right emotional place, I said, "Okay, let's do it." I didn't plan to edit it. So I said, "Okay, I don't want to move the camera. I just want to see what happens." And—boom!—he got it the first time.

Which scene do you mean?
It was the scene at the end when he left the message for his daughter, explaining why he did what he did. That he'd lost faith in humanity, that he'd tried to change the world. And he'd been wrong. It's a very hard moment for a father because it's the first time he recognized himself and he opened himself up to feel something because he'd always played this very cynical character, very closed, very smart. A very intellectual, closed guy. And I always love the moment where he cuts his hair because all that great personality just falls away. He's like a turtle without its shell. He's almost unrecognizable. With a suit that he's stolen from the other guy. He's a totally different person—clean, fragile. And he's a poor but dignified man because he's just confessed that he's failed as a human being, as most of us have felt at times. And for the first time he's trying to give something back to his daughter. For me that moment was the redeeming moment of the whole film. There was a big argument with intellectuals who saw the film, friends of mine, writers and so on, who I showed the film to before it was locked. They said, "You don't need that scene, you don't need that scene! You've already said everything you need." And I said, "If I don't have this scene, the film doesn't fly, the film doesn't go." I remember that for me that scene was something I became totally obsessed about: what he would say on the phone.

Maybe it gave the film a kind of closure?

The character wouldn't have a meaning without it. Everything he has done would lose its meaning. Emotionally what triggers him to reach this point is that he's lost his family. When he loses his dogs, he realizes what it was like to be killed. He's a hired killer, and it's only when a dog kills his dogs, which are now his family, that he realizes what he's done and this triggers his catharsis. So without that phone call it wasn't clear enough. But that scene was the one I really obsessed over. The same is true of *21 Grams*. The guy who killed the family went to a motel after the accident and just shut himself away there. And I said, "I need this guy to have more than just human guilt. I need him to have a moral guilt, which is worse." When you are a believer, when you're guilty in the eyes of God, that's a really tough one. That's the kind of existential conflict that I go for. Beyond the physical thing. The question is always what's going on in his beliefs. Benicio's character is Job, whose enemy is not only the law but his own conscience and, worse, an omnipresent enemy which is God.

Was the character of El Chivo based on a real person?

Yes. Guillermo told me the story of a friend of his, a teacher at the Universidad Iberoamericana who was a radical Communist. He left his family and went off to take part in the Communist struggle that was happening in Mexico at the time. He left two kids when they were really young just to fight a political campaign. I always thought that was fascinating—how a man can leave everything for an intellectual position, a political idea. Also, El Chivo represents to me the possibility of losing your dreams. I always have a fear of losing everything. If I pass a homeless guy or a crazy person on the street, I'm always afraid I will end up like that.

Maybe it comes back to the fact that your father went bankrupt?

Completely. My work is an intensely neurotic and perfectionist process, but there's a deep fear of failure in my identity. I don't allow myself to fail because of this fear. That's also why I get involved in the script. I want a perfect script and no possibility of failure. The casting

process, too. All these processes are really painful. I really suffer making films. Of course I enjoy it, but it's a masochistic kind of thing. And, yeah, I think you're right. The possibility of failing when you're middle-aged really scares me. Also, my uncle's situation always made a big impression on me. He was a really smart guy who played the piano, but he lost his mind when he was in his thirties. Nowadays he lives in the same conditions as El Chivo or even worse. No one accepts him because he's a disaster. When I used to meet him I'd be scared. Sometimes he'd think he'd been talking to the President. He'd talk to you like a very wise and very clear guy, but he'd be saying things that were impossible. "This morning I was talking to the President." It was scary because he's not crazy enough for you to think he's crazy, but at the same time he's not sane. It's a very frightening state of mind. I always used to wonder if that was a genetic problem. Could that happen to me?

Was Octavio's character autobiographical?
I think that both Guillermo and I had a lot to do with that character. He told me that when he was a kid he had this dog that he discovered was a killer, and he had a lot of trouble in his neighborhood. On my side, I can tell you that when I was sixteen years old, I ran away with my girlfriend. I stole a gold chain from my mother, got some money by selling it on the black market, and escaped by hitchhiking! I was sixteen and my girlfriend was seventeen. I left a letter for my family and I escaped with her. But after three or four days we were captured, so we had to return. It was my older brother who found me by threatening the friends that knew where I was. At that time I had a very tough relationship with my only older brother. She went to a friend's house and threatened to commit suicide. It was really intense for a sixteen-year-old. Her father wanted her to marry me because she'd compromised the dignity of the family. But when they found out I was younger than she was, they changed their minds. And I remember that at that time of my life, I was a prick, a fucking asshole. I used to think that nothing mattered. I didn't care about anything. I was really affected by reading Herman Hesse and Thomas Mann. I

remember *The Magic Mountain* very well. All those books affected me so much. When I was fourteen I was reading a lot of existentialism—Sartre, Camus, and so on. I didn't care about life. I was somewhere between depressed and wild. I was listening to the radio and smoking pot and living in a neighborhood which is very close to the one where Octavio lives. The green mosaic on the walls of Octavio's house was an *hommage* to my house in the Narvarte neighborhood, Uxmal 31. When we came to make the film, I told the production designer I wanted it because it's such a symbol of middle-class neighborhoods in Mexico City. I felt close to Octavio—the way he approaches the girl and wants to escape. I was him. I was Octavio! I escaped with my girlfriend. I didn't care about my father. I stole the most valuable gold chain belonging to my mother. I was like Octavio. A fucking prick who never learns.

It sounds like a lot of the material in the script came from your life.
Yeah. They are far from being biographical because they will be very boring, but in the end, films like this are just an extension of yourself, a testimony of your life experiences, with your virtues, your fears, and your limitations. And so *Amores Perros* is dedicated to my son Luciano. And *21 Grams* is dedicated to my wife, Maria Eladia, and *Babel* will be dedicated to my daughter, Maria Eladia, and my son Eliseo. So both films are very personal for me.

One critic described the film as a mixture of three different genres. Do you agree?
I don't think that *Amores Perros* changes genre. There's only a couple of very talented directors that can play with genres in the same play or film, but that is very difficult and dangerous. I think Guillermo del Toro is one of them. The scariest story for me was the middle one. That was such an absurd one: a model who loses her leg and then her dog. It's almost farcical. If you did it farcically, everyone would be laughing. "Oh listen to the dog!" So it could be a really funny, absurd comedy or farce. And I was terrified about that because I thought people would be laughing about it. So I tried to maintain the tone

throughout each story. "This is surreal, but it *could* happen." In other words, I tried not to change the genre. On the other hand, I can understand that it could be seen like this. The third story is a thriller about a stalker. And the first one is more like an action film. But I don't really think it's a genre thing. I think the genre is drama. But I think the tone changes maybe a little in the middle story—it's a little bit lighter perhaps.

Did you think of it as a bleak film? Or as a hopeful film? Or as a truthful film? Or none of these?
Ever since I was a kid, my father used to say, "If you want to make God laugh, tell him your plans," and that's why I put that line in *Amores Perros,* and that's what this film is about. It's not about God's plans, but about destiny, the same as Greek tragedy. Both films are about the fact that even when some things happen along the way without any warning, that's not what life is about, but rather what you do after those kinds of things happen. I think that both films are about free will, about what we do and what we decide to do with our lives, no matter the circumstances we have to face, and what we have to learn from them. That's what I think makes the characters fascinating; they are not victims. They made the final decisions, and that's why this film is about hope. Even Octavio. In the scene at the train station when the girl *doesn't* turn up, you see this guy who's a stubborn, selfish, adolescent motherfucker break down for the first time. I remember this caused a lot of conflict with Guillermo. He wanted him to take the bus at the end. But I was like, "No, if he does that, he hasn't learned anything." He's still thinking he's on his way to the north. But no, the reality is that there's no way out, my friend. So you have to stay here. And then you become a man. El Chivo learned something at the end of his story. And the guy who was cheating on his wife has to learn that his decision has consequences and he will have to carry the good side and the bad side of it. He will have to stay with Valeria. And even though she's lost her leg, he'll still have to love her and support her even in the most painful situation. In the end they all learn in a painful way and they are better people for it.

While you were writing this script did you have any idea how you were going to get the money to make the film?

No. I don't know why—whether I was stupid or innocent. I think innocence is more powerful than experience by far—and I know that by experience! [Laughs.] But the truth is I didn't care about it. I never thought that it would be a problem. I don't know why. A lot of people in Mexico complain that there's no money. I think there's a lot of money out there, but no ideas, no good scripts. So I was obsessed with producing a good script because I knew that I would find the right partners if I had one.

Did you have to pay Guillermo to write the script, or did he do it on spec?

We were both working on spec. We had no financing, so I was just betting that we'd make it. When we were close to finishing, Martha Sosa and Alejandro Soberon from Alta Vista came to me and asked me what I was doing. I told them about the script and they said, "Can you give it to us?" I said, "No, only when I've finished." I didn't want them involved creatively. They knew my work from the radio and advertising from long before, and they trusted in me because of that. So when I'd finished, I gave it to them. It was a one-hundred-sixty-eight-page script made up of three stories which was almost impossible to finance for a first-time director. But they did it! People say that I was lucky. And although it's true that I've had a lot of lucky breaks in my life—being in the right place at the right time—it wasn't just that. I'm a hard worker, and everything I'd done up to that point—the pilot, the TV thing, the commercials—made a really big difference. So they thought it was a really weird and difficult project. But it was my project and they believed in me, so they gave me the freedom to do it.

Did you get a response very quickly?

I was very privileged because basically they said, "How much?" And I said, "Two million four hundred," and they said, "We have one million eight hundred." I said, "I think it will be possible, so let's do it." In the end it was two million four hundred thousand as I'd said, and I put three hundred thousand in myself. I didn't take a salary, or rather

I put my salary, which was twenty thousand dollars, back in the film. Then I put in another three hundred thousand dollars from my company as well. In the end, I never received a penny from that film, but I didn't do the film for that purpose. All the actors and all the people involved got very low fees. The only one who was very well paid from the beginning was Guillermo Arriaga, because I really fought for it and I wanted him to get a dignified salary.

Did you try to get financing from any other sources? I.e., from the state?
No, thank God I never thought of it. Those people were really mad at me because they thought I didn't have a license to do the film. First I was outside their system. Then I was ahead of them. So this community of artsy bureaucrats and film people were really fucked off. And then, when we began to be recognized around the world, it was like the worst thing that could happen. But I think the film shook up a lot of things in the Mexican industry. Young people said, "If this guy can make a film, so can we!" To be fair, I don't think that the government should be one hundred percent to blame for the situation of the film industry in Mexico. Yes, it's true that they could have made a big improvement, but it's about the private investors, too, and the bad or mediocre projects all around. As a filmmaker, it's easier to blame somebody other than yourself. Many people were so used to being subsidized by them that they couldn't do anything without them.

How did you come to cast Gael García Bernal as Octavio?
I'd worked with Gael two years earlier on a commercial for WFM, the radio station I started. And I'd thought, "Who is this kid?" He had a face that I couldn't believe. He then went to study theater in London. And when I started to work on the script, I said it's going to have to be Gael for Octavio. So I sent him the script and a friend of his made a video of him reading some scenes. But when I saw the video I said, "Fuck, maybe he isn't the right guy!" Because he didn't have any idea about what he was doing. He hadn't talked to me about it. Only on the telephone. But he was cute! So I was like, "Fuck! What should I do?" Even so, I was completely obsessed by the power of this guy. I have a big instinct in things like this. When I believe in something

like this, I know there's something there. It's about the eyes. I see the interior of a person through their eyes. So I believed in his eyes! When he came to Mexico he was still in school in London, so we had to pretend that he was sick. We sent a letter to them saying he had typhoid! Anyway, he arrived about a week before we started to shoot the film. Everyone else was hanging around doing rehearsals, already warm and into their characters. And Gael's first question was, "Don't you think this character should maybe play tennis in the afternoon?"

Sounds like a different movie!
Exactly. I was really worried. But I said, "Gael, you have to hang out with these guys." And what was amazing was that he started to hang out with them and listen to the accents, and in three days he was there.

Did you have a sense he was going to become a big star?
There's a scene between Vanessa and him when she confesses that she's pregnant. She says she's scared that she may have to have an abortion, and he says, "Why don't we escape? Why don't you come with me?" And the camera is close to him and he's getting closer to her. And I was sitting there and I was watching the monitor and I was looking at him and he was so powerful. I got goosebumps. And at that moment it was the first time that I thought, "This guy is something special." He has those eyes of Alain Delon. This guy is River Phoenix. You know what I mean? He had one of those faces that appear once every ten years. It's something you don't see often. He's handsome and masculine, but there's also something feminine there. But I didn't realize how successful he'd be until Cannes.

How about Emilio Echevarría, who plays El Chivo?
Emilio is an actor who's in a theatrical play once a year. But he earns his living as an accountant. He actually works at quite a high administrative level. And he wears a suit and shirt and a tie, but in my opinion he's not only the best Mexican actor, but one of the best on the international scene. But when I showed Guillermo and the people at

Alta Vista that I wanted him to play El Chivo, they laughed at me. They were like, "Come on, you can't be serious!" And I said, "He's the best guy I've seen." I saw him in a play where he spent most of the time with his back to the audience, and he still made people cry! I thought, "If this guy can make people cry with his back turned to them, just by the way that he talks, with the pace and the beat, think what he'll be able to do in the film." I loved his voice, his face. But no one could believe he'd work as El Chivo. They were all saying, "Why don't you let the classic guy who always plays the homeless do it? But then Emilio let his hair grow for six months, his nails, everything. So he'd be in a meeting with other accountants, and his hair was really long and his nails were full of shit. That convinced everyone!

It sounds like he was living the character!
Yeah, I guess it was a Daniel Day-Lewis kind of thing. In fact, he was so realistic that one day we were having some tacos in the street and the people who were serving us didn't want to serve him because they thought he really was a homeless guy and that he'd smell horrible.

Was it hard to find a Spanish actress to play Valeria?
Yeah, that was difficult. I was trying to find someone who was beautiful but no longer in her twenties, and I wanted her to be a foreigner. In the beginning she was going to be Mexican, but I said, "No, she needs to be from outside, because if she's Mexican she will have her mother, her brother, her family. But if she's from the outside, she'll be completely alone." So I created isolation by doing that. But it made it very difficult to cast. I was tempted by Penelope Cruz, but I thought she'd be a distraction. So fortunately I saw a tape of Goya Toledo. She had been a model and was starting a career as an actress. She already had a couple of very solid performances, and because she had been there, she did an amazing and very painful job.

What about the actors who played the supporting roles?
All those guys came from the theater. I went to the theater in Mexico and found them. I rely on theater actors.

Mexico City is notorious in terms of the difficulty of shooting due to the fact that certain areas are controlled by gangs. Did you have any problems?
We had a really hard time. A lot of trouble. When we were scouting Octavio's house, there were eight people in the van. I was on the phone to Carlos Cuaron, and suddenly I began to hear shouts. I turned and I saw Brigitte with a gun to her head. The gun was in the hand of a fourteen-year-old kid, and there were two other guys with guns there shouting at everyone. So I said to Carlos, "I'm calling you back. We're getting assaulted." I put the phone down and then someone got hold of me and I said, "Take what you want, please." It was this scary fourteen-year-old kid with this crazy face, not a professional guy with a gun, which was very scary. So they take my ring, they take my change, they take my wallet, they take the camera we were using to do the tests. They take everything. And we were like, "Please, take everything." It was horrible. It was really unpleasant. They hit Brigitte and they told everyone to get down on the floor. It was very humiliating and very scary. And then they left. And everyone was saying, "Let's get out of here. We can't shoot here." But I was saying, "We have to shoot here. This is a sign. This is a real location." So we sent a guy who had connections with the gangs to talk to them. And they said, "If you want to come here, you have to tell us." It wasn't about money, it was about territory. So we got permission and we included them in the shoot. A lot of the guys that you see in the dogfight scenes belong to these gangs. So it was very stressful in the beginning. But then, after a week of shooting there, we began to feel calm and these guys were really nice. They never returned my things, which really upset me, but we were really protected by them. At the end they were really friendly and really funny. They were doing a lot of drugs and stuff, but they were friendly to us. If we'd arrived with police it would have been a battle.

How long did you shoot for?
Fifty, fifty-five days. Shooting in Mexico City isn't easy. And again, my fear of failure means I take everything so seriously. Casting, locations, everything. Before we began filming, I got so sick and tired I had to go to hospital and get shots of B-twelve. I was completely devastated

before we even started filming because I wanted to control everything, the locations, the actors, the extras, the costumes, what they did to the trousers to make them look used, every fucking thing. I was a complete maniac! And then I had a car crash and dogs.

How did you prepare in terms of working with your DP, Rodrigo Prieto? For example, did you use storyboards?
I did storyboards mainly for the car crashes and the dogfights and the things where I couldn't play around. Most of the film I storyboarded in a very basic way.

Were scenes like the car crash difficult to do?
A nightmare. We didn't have the proper resources. We didn't have a camera car. It was very hot in the car because there was so much lighting. Everything failed all the time. The lighting failed. The sound failed. The power failed. And we didn't have much help from the police. It was really rough. And I shot the car crash in an hour and a half.

How did you work with Rodrigo in terms of the look of the film?
Rodrigo and I had already been working together for a long time before *Amores Perros*. We were friends so we knew each other very well. The first time we got together, I took along a book I was using as a reference, and when I took it out he began to laugh. I said, "What's up?" And he said, "I have the same one!" It was a book by Nan Goldin. I like it because of the rawness of the characters, its toughness. So Rodrigo took out his copy of the book—and although we'd never discussed the film he felt the same as I did about what we had to do. We both wanted the film to be as real as possible, but with a lot of beauty. Rodrigo is like my brother and my closest collaborator. Nowadays we communicate just with the eyes and we can understand each other.

What practical steps did you take to achieve the look you wanted?
Rodrigo will always come up with a lot of ideas based on what we previously discussed about the film and his own ideas about the film.

He's amazing because instead of just being worried about the "look" of the film, he is really concerned about how to enhance the emotional level of the scenes and how he can translate that technically. He is always bringing and trying new things. The way we worked was really interesting because there's something about the light in Mexico City which is really horrible. It's great, but it's horrible. It's always milky because there's so much pollution there. And the laboratories in Mexico aren't very good. They can fuck up your film. We were trying to get a unique character in the way the film looked. We wanted the film to look different. Real, not commercial. So we started to shoot tests in Mexico City using different stocks to find the right balance— something that didn't look slick like a video clip, but at the same time was interesting. So we did a lot of tests which was expensive. Alta Vista didn't want me to do that because of the cost, but I convinced them. So finally we got the right stock, the right bleach bypass, which was something that was quite new at the time. No film has been done like that throughout. Only parts of a film. For me the best thing that happened was that the skin tones were pale. Because normally what happens when you use Kodak stock is that the skin tones are pink. Very healthy looking. With this film the skin tones were very pale. The white is really white and the dark is very dark so the contrast is really big. It looks like it has a strong personality without being fake. I loved it. At the same time, we chose different stock for different sections of the film. For example, the second story was different from the other two. It was slicker, less grainy. It becomes grainy for a few moments at the end, but for the most part it's slicker because it's a different social class. The texture is a little more silky. So Brigitte, Rodrigo, and I got together and decided the color for each character. The color tone for Octavio's story was green. The color for Valeria was white. And the color for El Chivo was yellow. And then it was grainier when the film got more emotional, slicker when it was cooler. For example, the car accident was really grainy.

How much of it was shot handheld?
Everything. There was no dolly. There was no tripod. The whole film was shot over Rodrigo's shoulder. *21 Grams* was the same.

Was this an aesthetic or a practical decision?
I think that handheld is as close as you can be to how we see things. I am never stuck in a tripod or traveling on a dolly or high on a crane. I experience life with my eyes, which are constantly moving in a free way. I am not against it, but those other ways feel too rigid and artificial, and I did it a lot when I shot commercials. I like the freedom that it gives me. The immediacy. I think that the camera is a narrative tool, too. You can describe things that are happening at the same time without cutting. If there's a moment that I think is important—what a character is doing with his hands, say—I don't want to have to cut from the face to the hands to see it. If I want to see how a character grabs a glass, I prefer to move the camera like that [AGI moves his hands downward]. This is a subtle way of showing something about a character without being obvious. And the actors like it because it allows them to move around.

Did you have much time for rehearsals?
I rehearsed a lot with El Chivo and with the other guys. Gael less, because he arrived late. But generally, yes, I rehearse. I read the whole script with all the actors. I choose the most difficult scenes for me to block during the rehearsals. I'm very good at that. When I'm developing the script, I know exactly what the characters will do and how I want them to move, I imagine every detail. I find myself very comfortable arriving in a place and choosing where we'll film. I'm very secure with that. I can arrive in a place and I'll know exactly what will have to happen. So I normally block the scene with the actors. I say, "You have to go from there to there." And they normally feel really comfortable because of this.

Do you always know what you want the actors to do?
When I arrive at the location I usually know what they're going to do. It sounds stupid, but, as Ludwig Margules said, in the end there are really only a few things that you have to ask yourself: Are the actors going to be standing up, lying down, or sitting? Where are they going to be? Once you've chosen one of those alternatives, there aren't that many other choices. You know what's going on. If I do a rehearsal I

explain what I want, and ninety-nine percent of the time it works and the actors feel confident. The place I normally start with is the blocking so they know the space they're in and can understand it. Sometimes I'm very, very specific, but sometimes, depending on the scene, I'm more flexible. And if they feel okay about it, the next thing is to set up the lining so Rodrigo and everybody else can see what is going to happen. Obviously I'll suggest what I want, but then the actors will make some suggestions and at that point, once the actors and I have arrived at the same objectives and the different ways they have to accomplish them, I say, "You can do whatever you want." In order that they can feel free. That's another reason for the handheld camera. It's that there'll never be a limitation, you know, "This is your mark," and so on. I hate that. You're right there or there, I don't care. The camera will be where it should be and will be serving the dramatic purpose of the scene. The problem with a lot of directors—and coming from commercials, I knew that territory very well—is that they arrive at the location, put the camera down somewhere, and say, "Wow, it looks great from here." And then the actors have to submit to this frame. In my films, by contrast, the camera is subordinate to what is going on in the scene, even if it looks bad!

Do you have a strong sense how a particular location will work?
When I arrive at a location, there's often something about it I respond to immediately. And sometimes I give people a hard time because I have such a clear idea about what I'm looking for. In *Amores Perros,* for example, I knew I needed a corridor in the pool where the dogfights take place because I wanted to use a low angle of Octavio as he arrives to create some tension. So my location manager spent a month trying to find a pool with a corridor. I often know what I want even before we start looking for locations. Then, when I arrive in a location, I can say, "This has exactly what I need." Or there may be some other sign that I should use a location. Like when we were assaulted on *Amores Perros,* I knew that this was the location that we had to use. Or on *21 Grams,* when we arrived in the house in Memphis that we were going to use as Benicio del Toro's home, we found a dead body. The house was all shut up when we arrived, and when we opened the front door,

the smell was overpowering. When we got to the room at the end, we couldn't open the door. And when we finally opened it, there was a body on the bed. So I said, "We have to shoot here!"

One might call that masochism!
No, it's because I think these places have their own thoughts. It's like the walls speak. I hate building a set because you never get that feeling.

What scene did you shoot first?
The first scene we shot was when Vanessa arrives in Octavio's house and the mother is in the kitchen cooking and she asks her if she can take care of the baby.

What were your feelings as you were about to start?
I was nervous. But then I saw that the camera, the angle, everything was right because I'd worked hard on the preproduction. When you've worked for three years on a script and you're happy with the casting and the locations are right, it feels great. If things don't work, they often don't work on the first day.

As you continued shooting, did you have a sense that something very special was happening?
I knew I was doing something good. I knew I was accomplishing something that I wanted. I was loving the film as I was shooting it. I knew that all the textures, all the actors, everything was making sense. But I never knew where I was in world cinema. Because I wasn't a cinephile. I'd never been to a festival. Now that it's done, it looks great, but it was very messy and it was difficult at the time. You wouldn't believe how many people read the script and said, "This is going to be a disaster! Who cares about dogfighting? It's stupid to make a film about that."

Which people?
Three or four film companies. All these people, their scary readers, they were all like, "Come on, who cares about dogfighting? Dogfight-

ing is such a horrible, disgusting thing. Who can make a film about dogfighting? A homeless guy who kills people? Who would care about a guy like that?" And I don't blame them because it's only the director who knows what the film is in his head and in the script. Nobody can see that but him, so to make a film is an act of faith, not only for the director, but for the guys who put the money in. The same thing happened with *21 Grams*. No one understood it. What's happening? Why's it like this? They're not obvious films. But when I was directing them I never doubted them. Never.

How fast were you having to work?
I had to do a lot of setups every day. Three, four pages of the script every day. That's very hard, especially when you have a lot of emotional intensity in the scenes. People think that an actor just starts working during preproduction, but that's wrong. The actors need time to go there and to sustain themselves. And when an actor begins to arrive at the emotional terrain of a character, they often have doubts about things. So I prepared myself a lot for that in order to be ready to help them. If the actors realize that I have been living with the character for three years and that I know the character sometimes better than they do, then they can trust me better.

Were you getting much sleep?
Four hours a night, maybe five. No more than that. Because I'd arrive on set, but then watch rushes and have meetings with people. And we were in trouble on every front. There was always bad news. Locations that were failing. We couldn't pay for this. We couldn't get permission for that. An actor would get sick, so we had to shoot a scene on a different day, but then we couldn't get the same location again. When you don't have money it's worse because you don't have alternatives.

How were you feeling?
I was really exhausted physically. But that's the easiest part! I love that because I'm hyperactive. It's emotionally really tiring to make so many decisions every day. As Truffaut said, "A director is a person whom a

hundred people are asking a thousand questions every day and he has to pretend he knows the answer."

But there was nothing that actually threatened the film?
No. Nothing important was ever threatened. The actors were fine. I had a great relationship with the actors. The actors always trusted me, and all of us were doing the same film for the good reasons. I felt the same in *21 Grams.* I felt supported and loved, and I loved them, too. I remember Emilio came to the set for a fitting when we were shooting Octavio's story. When he saw the street and the way we were shooting the scene, he said there's something very special here. The same was true with Sean Penn. Every morning he found a way to make a compliment about this or that, and I felt very thankful and my self-esteem was reinvigorated. It's in those moments that you need it the most, because there are other things that can really threaten a film, starting with yourself. When something's going well you can feel it, I think.

How would you describe your method of working with actors and crew?
I go through each scene at what I call a "molecular" level. In other words, I go through every molecule of the script. If I'm discussing a scene, the first thing I try to do is identify the objective of a scene, whose point of view this scene is from. That's one of the biggest questions and one of the most difficult to answer. For example, in the middle story of *Amores Perros,* to some extent Valeria is the main character. But her husband is present all the time and he's suffering like she is. He made a decision to go and live with her. He's not an obvious secondary role. He lost his family, he said good-bye to his daughters. He's suffering a lot. So you don't want to leave him far behind Valeria. Whereas Octavio is obviously the main character in his story. So when he's playing with his brother, for example, his point of view is always the most important. But when you're playing with a scene between Valeria and her husband—for example, when she finds out that the dog is under the floorboards and he's saying don't worry and then his wife calls him and he says it was no one—at some point you have to ask yourself, "Is this scene about him or about her?"

What happens if there are more than two important characters in a scene?
In *21 Grams* it was really difficult because it was about three people. In
the last scene in the motel, for example, when Benicio gets together
with Naomi and Sean, all three of them are main characters. So whose
point of view is this scene about? That's when it gets really compli-
cated. You have to make that decision. There are some directors who
don't make that decision or who don't even understand that there is a
decision to be made. They just put the camera in a two-shot. It's so
cold! There's a distance and there's no guts in it. When you solve the
problem, the camera will have to play toward that object. So the over-
the-shoulder shot should be from the point of view of the character
you want your audience to identify with. If two characters are fighting
and you put your camera on the shoulder of one of them, you'll be
feeling what that character is feeling. That makes it powerful. Once I
knew whose point of view the scene was from, I solved the problem of
the camera. You also need to ask which of the two characters is going
to be closer to the camera. So there's a lot of grammar here.

*What other aspects of a scene do you consider when you analyze it at a
"molecular" level?*
Of course there's the question of what the scene is about! How can I
describe the scene in one word? It can be three pages, it can be five
pages, it can be one-eighth of a page. But you still need to know what
this moment is about. Once I've solved that—it's about threat, say,
and it's about the point of view of this character who is threatening
another character—once I find that, then I go, "Okay, the subject of
the scene is that you are threatening him." Once the actor agrees with
that, once he knows the action verb that is guiding the scene, you've
done ninety percent of the job. The alternative is bullshit and confu-
sion: "I like him and I need him but I hate him and I want to make
him feel bad because I'm mad at him and I want to make him feel bad
but at the same time I love him." How do you play that? And when I
tell the actors it's going to be like this, they normally kiss my feet and
say, "Thank you very much," because now, if we're doing the threat-
ening scene, they have to find one of the million ways of threatening

people. I can threaten you by shouting, by throwing an object, by silence, and by ignoring you. Or I can just look at you! There are millions of ways to arrive at the same objective. It's then the actor's job to find with you which one is best. So there's a main theme in every scene and as simple as it sounds, it's very difficult for me to find the right action verb in every beat to help the scene and the actor.

Isn't it sometimes hard to identify the theme of a scene?
Sometimes it's really difficult to reduce it to one word. After all, there are scenes that go on for three pages and start with rage and end up with laughter. There are scenes that make a lot of transitions. So I try to tell the actor, "Here it's going in this direction, then there's a transition." Which is why I call it molecular. You're going from what the film is about to what the scene is about and whose point of view it's from. And you're looking at every beat, where it's going, and which transitions you can do. So it's molecular, but I'm trying to be as simple as possible with the actors. And the great actors normally get it. They're not confused. Then if you find out that you've got it wrong, that it's not working, you say, "Actually it's not about threat, after all. It's about something else." So you can change it easily if you have to!

Does the blocking of a scene come from you? Or from the actors?
First I go and say what I want them to do physically because I feel very confident and good doing that, and I have to spend a long time working on that before that happens. I trace the moment for them. I know how the action's going to be when I'm developing the script. I even know how I'm going to shoot it sometimes. I know what kind of room it should be, what kind of color it should have, where the door is, how the actors are going to move, where I'm going to pan. Sometimes the script is really precise because I've already told Guillermo how I would like it or how I'm going to shoot the scene. But as I told you before, when an actor is not feeling comfortable for some reason, or when my idea is not working, I'm open to listening to the actors, and whenever somebody has a better idea than mine, I will take it without a problem. Now, if I'm sure on something, I can be very stub-

born, and if the actor is very stubborn, too, and we haven't agreed, then I shoot both versions and that's it. The work with Rodrigo is very interesting because we define the colors and the textures. I go with Rodrigo and make notes on each scene on index cards: objectives and facts, tools for every scene. If the scene is about seduction, I explain to Rodrigo what I want. I say, "At this moment this character is doing this." And then we discuss how to shoot it. You know, if we shoot it on a wide angle, they will seem very vulnerable and small because this scene is about that. So when we arrive we shoot it like that, but we may cover it in a different way as well. And I'm confident because I know what I've achieved, and that the camera lens and angle have helped create the emotion that the scene is about. So there's a big connection between what the actors are doing and the camera.

What was it like working with the fighting dogs?
It was dangerous, scary, uncomfortable, because those dogs were really savage. They were for real and the actors had to suffer a lot, you know! Gustavo Parra, the blond guy who plays Octavio's main enemy, Jarocho, was scared to death of the dogs before we started shooting. He's a great actor but when I first saw his face, I thought, this guy is not the obvious bad guy. So he couldn't believe it when I said, "Okay, you'll be the bad guy. You'll have to do some exercise. You'll have three months to get yourself into shape. And you will have to train with dogs!" So he worked every day with the dogs. And to train a dog like that is horrible because those dogs are really strong and often his dog was trying to bite his wrist or something. And if it tries to bite you, you have to show it the wall. And this guy showed it the wall and the dog was taller than him, and he needed two guys to help him!

What did you find hardest about directing a full-length movie for the first time?
To trust in myself. When you are making your first film, you question yourself, and I'm a very, very horrible judge of myself. A terrible perfectionist. So if one day something went a little bit wrong, the performance or something, I started to doubt myself. I started to question

myself. So I would say that the fight against myself was the most diffi-
cult thing for me. I was really free. I had a lot of support, you know. I
can't complain about the studio or the producer or the money. Obvi-
ously there were money problems. I was really limited, as you can
imagine. And I had a lot of troubles to solve. Confidence is tricky
because you can feel very confident, you can feel that you can do it.
But if you feel too cool, that you know everything, then you are
fucked. But at the same time, if you doubt every setup, then you're
fucked, too! So you just have to say to yourself, "I'm doing great!" But
not too often!

What was hardest about directing in technical terms?
To lose all my bad habits from directing commercials. That was really
hard. To wash my hands of the temptation to do more coverage or to
make it more attractive or beautiful. I had this theory of pure cinema.
Just to watch things. I wanted to be more sober, more economical,
and more cinematographic. But sometimes in commercials you have
all day to shoot thirty seconds so you shoot a lot of coverage, a lot of
beauty shots. So in the beginning it was really hard for me to get rid of
all that baggage. And to be sure that I was getting enough material.
Should I cover? Or should I leave it? And you have your AD, who is
saying you have to move. So you know you don't have time. And you
have three pages more to do. And it's maybe two o'clock. And you say,
"Fuck!" And you have to solve things on your feet. That was scary. I'd
also say that directing is a physically exhausting job. And to shoot a
film as complicated as *Amores Perros* without money, you have to be
really strong physically. You have to wake up at 4:00 a.m. and not get
to sleep until midnight, and in between make eighteen thousand deci-
sions every day of the week. It's enormously physically and emotion-
ally draining to direct a film, to finish a film, and to promote a film.
The demands are so enormous that if you haven't prepared yourself
physically, emotionally, and spiritually, it can kill you. Every time I've
made a film, I felt I was going to lose a kidney, or a piece of me, the
cost of it is so high. So you have to be ready to pay the cost. Some-
times I've met people who feel that being a director is cool, is great, is

fancy. But you have to make a lot of sacrifices. I don't know if students are aware of that. I really want to tell them that you have to be ready to make a lot of sacrifices. Economically. In your life. It doesn't leave a lot of time for your family. So the cost is really high. Film can demand so much from you that it can kill you little by little.

Do you think you learned a lot?
In the end I learned to be confident. That I can be trusted. That's indispensable with a director. The moment a director begins to lose his confidence, the film is fucked.

Was the editing of Amores Perros *another test of your stamina?*
It was a nightmare. I took the Avid to my house and I edited for seven months nonstop. I started every day at eight o' clock in the morning. I worked until two o' clock, had lunch with my wife and kids, then at four o' clock I'd start again and work until eleven or twelve at night. Every day of the week for seven months. It was crazy.

Did the finished film resemble the script structurally?
I think it did in some way, but there were a lot of decisions that I had to make in the editing room, which shaped and changed a lot of things, including the structure, but the spirit remains the same. Beyond the fact that I took out around forty minutes of different scenes from the original script, every change that I made had a big repercussion in the structure of the piece so when you realize this, it's a big challenge and responsibility, and that's why I was going crazy when I was editing *Amores Perros.* It was a great education for me to do this alone for such a long period of time, but I had a thousand possibilities that worked and it was scary! Every scene could work differently depending on how I put it together.

How did you cope with this?
I lost my mind! It was scary because there were so many decisions to make. I took forty minutes out of my first cut. It started out at three hours, ten minutes and went down to two hours, thirty-somethng minutes. One very nice thing that happened was that the Mexican

director Guillermo del Toro saw the film on tape and loved it. He called me up and said I should cut the film a bit more. He was a little bit radical. He said you should take out the second story. You don't need it. I was like, "Fuck you! Who are you to tell me to do this?" He ended up calling me every day and giving me comments. In the end I said, "If you really want to help me, why don't you come over here?" So he took a plane from Madrid, where he was scouting a film. He arrived and said, "Hi, I'm Guillermo." He stayed in my house for three days. He's a fat man and he ate everything in the fucking fridge! But he was the most helpful and funny colleague I could hope for. He helped me so much. He was like, "You should take this out." And I was like, "No, that's impossible!" In the end he helped me take out the last five minutes, which was really valuable.

Once you had a cut of the film, how did people react? Alta Vista, for example?

They were really moved by it. But they were also worried about the length. The owner of Alta Vista gave me a smart and helpful comment about the ending of the film. The ending was different. The ending was that El Chivo walks out of the house where he's left the two brothers. He walks out, then we return to the exterior of the house and hear a gunshot. And then two more. Pow, pow!! And then the screen faded to black. He loved it but he said, "You don't need those gunshots. You already have this guy leaving. It's already a tough film. You don't need the gunshots." I realized he was right.

Was the finished film close to the script?

I have to say that when you are writing a script, it's like you're planning a strategy to go and hunt an animal. Everything seems to be right on paper. But when you arrive in the real jungle, a lot of things can change, fail, or become different. A film is a wild animal that is alive and can kill you at any moment. Being in a jungle is a vulnerable place, so you have to adjust, adapt, reinvent, and change your plans every now and then, depending on the conditions in which you are living. So because a film is made in stages and the script is in the first stage, a film almost never ends up like the original script, because by

the time you arrive in the editing room, you are rewriting it, and that can always fuck the actors' performances, the writer's vison, and your own vision, or it can elevate it and make a sublime poem by the juxta-position of images, music, sounds, and silences.

What was the reaction at the first public screening?
The first public screening was at Cannes, in Critics' Week. I'd never been to festivals. I didn't know what to expect. I was really nervous. I remember when they showed the film the theater was packed. It started and I was so nervous I couldn't watch. I thought that people were going to leave. And then, seven minutes in, I saw the first people stand up. And then after ten minutes more people left. And I was like, "This is a disaster!" I didn't understand that they were buyers and sales agents and so on, and that's the normal way they behave. So I said, "I can't stand this." So I went out to the beach and I was walking around like crazy. And then when it was finished there was applause. But it wasn't big applause. It was quite quiet. Because it's a film which really affects people a lot. I was with Gael and the guy who plays El Chivo, Emilio Echeverria. Gael was crying at the end. Later that day I began to hear a lot of things from people about the film. I only understood the consequences a day or two later when I suddenly noticed that a lot of journalists were trying to get hold of me. But I still didn't know if this was normal. Because I didn't know what Critics' Weeks were like. But in this case everyone wanted to interview me. In one week I had twenty-five or thirty interviews every day. And then the parties and invitations started. So I started to feel something was going on. I thought, "This can't be normal. Not every film can be like this." That was how I felt the response of the people: not in the theater but out-side. The film left the people who watched it devastated. It was even worse with *21 Grams*. The response to that film was complete silence. People couldn't move.

Did you sell the film easily?
Lion's Gate paid around four hundred thousand dollars for it. They offered to put some money into the advertising, eight hundred thou-

sand minimum. I regret that decision now. We thought that no one would buy it so we sold it immediately to the U.S. and we sold it for the wrong price. I think we should have got more money for it than we did.

It sounds pretty low given the response it got around the world.
Completely. Lion's Gate was really smart. At the same time, it's easy to judge in retrospect. At the time, you never know. It's about dogfights. It's a two-and-a-half-hour film. It's by a Mexican guy no one has heard of before. It wasn't bad. But looking back, I think we should have waited a little.

What was the reaction in Mexico?
There is something very interesting here connected to the Cannes experience. I was so proud of the film that I thought, "Why shouldn't we be in the Official Selection?" So I said to Alta Vista's sales rep, Rosa Bosch, "Can we send the film to the committee to see if they'll accept it as part of the Official Selection?" At the time there was this Greek guy who spoke Spanish, whose job was to recommend films from Latin America. So Rosa showed him the film and he said, "No, this cannot be in the Official Selection. This should go to the Critics' Week. That's it." I asked if he could submit it to the committee. And he said, "No, the committee isn't interested in films over two hours, it's too violent, it isn't a film which qualifies for the Official Selection. It's Mexican!" So Alta Vista called me and said, "We have good news, you're going in the Critics' Week." But I wasn't happy. And they're like, "You're an asshole. What's wrong?" And I said, "Why not the Official Selection?" "Because this guy says it's better here." "But why not show it?" I got really mad. And this guy threatened us. He said if we sent it directly to the committee, he would make sure we didn't get into Cannes. So the film went into the Critics' Week and we won. There was a lot of word of mouth about *Amores Perros* that year in Cannes. And the Greek guy was nearly fired because the organizers were so mad that it hadn't been included in the Official Selection. I was really mad about this. I mean, it was good that we got into the

Critics' Week and won. But bad in other ways. And how many films has that happened to? That kind of prejudice can kill me.

Did its success at Cannes affect how the film was seen in Mexico?
In Mexico it was a big success. Because of Critics' Week, people were proud of it. In Mexico, it's funny. If you're recognized outside the country, you're worth something. If we hadn't won anything outside, we wouldn't have been noticed. But because we'd been recognized, everyone was interested.

Do you think its success had any effect on the industry in Mexico?
I think that the way the industry worked was shaken up. People said, "This guy is not in the system. This guy is an outsider. And he got what we never dreamed of." The film was seen all around the world and sold all around the world. So it was great for reviews. For the critics. For the money. And even then, other filmmakers complained that it was just about marketing. It was a marketing phenomenon. At the same time, though, I think a lot of people realized that if you make a good film, you can have success.

In the UK there was a big furor about the dogfighting. Was there anything like that in Mexico?
No. Only in England!

Were you surprised?
Yes. It's so stupid. You can kill people but not animals. And anyway, what happened to the dogs was a trick of the camera. The dogs had muzzles on, we used sound, the camera always moved. It wasn't like it really happened. The uproar about it was all a bit stupid. English puritanism.

What was the effect of Amores Perros *on your life?*
It changed my life completely. It gave me a chance to live the life that I wanted: as a film director. Now I hope I don't have a crisis every five years. I hope I can do this for the rest of my life. My big dream will

always be to make, just once, a good film, a really great film, even when I know I will never do it because sometimes I feel that my talent is millions of light-years away from the things I dream of doing.

Did you feel under a lot more pressure when you made 21 Grams?
I think the second film wasn't difficult. Now this third one is getting worse. It's a little bit tricky. It's like the first one is "Wow!!" The second one maintained the same spirit and is a film where I really express myself. Everyone in Mexico said, "How can you go to the United States? You're going to lose your identity." And I say, "I went there and I made an independent film with all the freedom I wanted." So if the film is shit, I don't have anybody to blame, it's my fault. If the film is good, it's my fault, too. I'm an independent filmmaker and I think that being independent will always mean having more pressure. Now, about the expectations of the people, there's nothing I can do. My theory is that if I like the film that I'm doing and I feel passionate about it and it's close to my heart and to what I think and feel, then I'm sure that there will be a couple of hundred people out there that will like it, too.

But you must get a lot of scripts sent to you?
A lot. But I've never found anything that I love as much as my own ideas. The way I do films is really exhausting. I have to create them. And then the way I put them together is very different from normal. I finance everything. I hire people, I pay them, I go to the locations, all that. And once I've got the locations, the actors, the budget, then I go to the studio. Now, on *Babel,* I'm paying for all the trips to Morocco and Japan. I put in all the money. It's a lot of risk, but I pay to be free.

I thought you'd be on a massive contract with a studio!
I've been offered a lot of money to direct films. But I haven't accepted. Economically it's a very stupid decision because I have to pay the rent. It's very expensive to live here [in L.A.]. But I can't work like that. I've directed one commercial since I've been here. That's the only thing I did. But I say no to their things. I concentrate. And if people say, "Are

you working?" I reply that I'm working every day. Every time I go to a bar. Every time I smoke a cigarette. Every time I read a book. Because I'm directing the film two years from now. All I've done for the past two years is think about *Babel.* I work in advance. I finance everything. But I'm still in other people's hands. I asked Guillermo to write *Babel.* But he said he couldn't straightaway because he had these studio projects. So I had to wait for him. It's tricky. But I love the way I work, too, because it gives me complete freedom.

I'm surprised you couldn't do a deal with a studio that allowed you a lot of freedom.

If I made a deal with a studio, I'd feel that I was working for someone. I have this kind of leftist spirit that feels that as soon as someone is paying for me, I'm a slave. I have good relations with Alta Vista and Focus. But I've never been good with someone paying for me. I don't know why. I feel threatened. I feel I have a boss. Even when they've been beautiful and supportive and I don't have to cut one scene or change one word of the script. I don't know why, but I feel that I have to be against them, that they're my enemies. If I had a studio on board, they'd be asking me when I will finish and so on. So I have to explain something to somebody. But doing it this way, I have complete autonomy. I guess it's because since I was twenty-one, I've been my own boss. I've never had to give accounts to anybody. And as soon as there's someone above me, even if it's a nice guy, I feel they're taking something away from me. I'm not saying it's good. It's stupid. I'm probably wrong. But that's the way I've done it. Believe me, it's very painful. Because economically I'm paying the consequences for it now. Because if you got delayed for some reason, you're losing money. But that's why I do it. It's like, "Let's see what happens with this one . . ."

Do you think it's getting harder to express a personal vision?

I think that the way the industry is now can discourage a lot of people from becoming filmmakers. Even I sometimes feel disappointed and ashamed to be part of this industry when I see how much shit is being

produced every year all over the world by these huge corporations. And people are only interested in the films that are commercially successful. Every time I see those awards ceremonies, I think maybe I'm mad because I feel so apart from that world and from the industry that I supposedly belong to. That can be very discouraging. I am also mad about the way the global corporations now control distribution and therefore the possibility of getting a chance not only to direct a film but also to be distributed—which is now the hardest part of making a film. On the other hand, these days there are high-quality video cameras which didn't exist when I was younger. And the quality is getting better and better all the time. So what I'd say to people without a lot of money but with a great idea, with a good script, is that now they can take their camera and they can produce their film for a few bucks. You shouldn't be discouraged by the industry because if you have a good script and a video camera, you can always shoot it. And despite the global thing, there are always a lot of people who are really hungry for good things, too!

Takeshi Kitano

VIOLENT COP

(The interview was conducted with the participation of Kitano's producer and longtime collaborator, Masayuki Mori, whose answers are denoted with his initials, MM.)

Can you say a little about your background, growing up in Tokyo in the 1950s?

I grew up in a typical working-class neighborhood in the east of Tokyo, Shita-machi, where most of the adults were either yakuza or craftsmen. My father was a housepainter who wore a craftsman's tattoo. He used to come home drunk and would then go berserk in the house. My mother, on the other hand, used to work as a maid for a prestigious family before she married my father, and took a lot of pride in her previous occupation. She was a very strict woman whose aim was to get all of her children into higher education because she thought that education was the only way to get us out of poverty. She kept on telling us to study hard so we could get into a distinguished university. As far as I was concerned, she wanted me to concentrate on science and mathematics in the hope that I would become an engineer for one of the big automobile companies like Toyota or Honda. She didn't even let me study literature or art subjects.

Did this mean you didn't see a lot of movies as a kid?

Very few. My strict and education-minded mother tried as much as she could to keep me from doing fun stuff. Not just movies, but comics and novels, too. Plus, for kids in my neighborhood, movies

were considered too sissy, and I was much more into boys' stuff like baseball and boxing.

When did you first start watching movies? Can you remember the first movie you saw?

The first film I saw at the cinema was *The Railway Man* [*Il Ferroviere*, Pietro Germi, 1956]. It was a really dark film. I didn't really understand it or know much about socialism and strikes, but I did understand that it was a sad film. On the way home after watching it, my older brother and I were beaten up by a gang of local kids who took all our money. So that made the experience even sadder than it probably was. Another film I saw was a Swedish one called *The Virgin Spring* [*Jungfrukällen*, Ingmar Bergman, 1960]. I probably saw it because I thought it was an erotic film. But it turned out to be a very obscure and abstract movie which I didn't understand at all.

So no one made a particular impression on you when you were growing up?

To tell you the truth, I only started watching films regularly after I started making films myself. More precisely, it was after I started going to film festivals in Europe where I had to answer journalists' questions on "films and filmmakers you have been inspired by/ admired the most"! Even now I find it very hard to name directors or actors I like. Sure, there are directors such as, say, Akira Kurosawa or Jean-Luc Godard or Federico Fellini, who made films that I admire, but they also made films that I'm not particularly impressed by. To be honest with you, I am not too fond of watching films in general, whether they're mine or other people's, because when I come across great scenes while watching other people's films, I get irritated and frustrated, thinking, "Why haven't I come up with that idea?" And when a film is bad, I think, "What a piece of shit! Give me back my time!"

Can you say a little about how you came to work as a comedian? How much was it a matter of chance and how much a matter of design?

I just couldn't think of any other options. I was kicked out of college

and ran away from home and inadvertently stumbled across Asakusa, which at the time was the mecca of comedy and stage entertainment in Tokyo. It wasn't that I had a romantic notion about the city or much knowledge about the *manzai* tradition of standup comedy. There just didn't seem to be many alternatives for a guy with no academic qualifications or professional experience. It happened that one of the theaters, the France, was looking for a lift operator. So I applied for the job and got it. I worked two shifts, mornings and evenings, but it soon became clear that the job was too boring for me. So much so that I suggested to the manager that I wanted to do some comedy on stage. And there I met Kiyoshi, my partner-to-be in the Two Beats, who was one of the senior comedians in the troupe I joined.

What was distinctive about the kind of manzai *practiced by the Two Beats, as compared to existing Japanese comedy acts?*
The comedians of the older generation, our seniors, usually started off their stage acts by greeting the audience politely. You know, "Thank you so much for coming here," and stuff like that. But I used to start off like, "Hey, what are you guys doing here? Damn it, if all you guys hadn't shown up, I wouldn't have to work and could have been taking a nice rest by now." Compared to the older acts, the subjects we picked and my talking style were unique in that older comedians usually dealt with general subjects about ordinary lives and talked more slowly. They basically aimed for people of all generations. We, on the other hand, focused on subjects strictly for young people, and I would rattle on very fast, moving from one totally irrelevant topic to another in a few seconds.

Were you surprised by the huge success of the Two Beats?
I didn't have the time to be surprised. Plus, the Two Beats were part of the phenomenon of the *manzai* boom. By the mid-seventies we'd started appearing on television, but it wasn't massive exposure or anything like that. By 1979 to 1980, numerous Osaka *manzai* acts were invading Tokyo and soon the TV networks, who were trying to cash in on the boom, started producing *manzai* shows. So we were at the

right place at the right time, because the TV networks were looking for *manzai* acts from Tokyo to balance out the numerous Osaka comedians pouring into Tokyo. This is how the so-called *manzai* boom started. It was a pretty competitive scene, and I felt like I was in a game of survival. But years later I realized I was the only one who considered it this way. One of my biggest rivals, Yoshichi Shimada of B&B [Boy and Boy], possibly the most popular act in the heyday of the *manzai* boom of 1979 to 1980, later became a good friend of mine. He told me, "It was a fabulous time, wasn't it?" and I said, "Was that how you felt, you dumb bastard? I was always thinking of ways to outdo all you guys!" Most of my fellow comedians were enjoying all the fame and fortune of their celebrity, but I, for one, was sure that it was a transient phenomenon and would soon be over.

Building on the success of the Two Beats, you and Beat Kiyoshi became well-known TV comedians. Around this time you began to be given acting roles in a number of comedies. Were you offered these parts simply because you were a celebrity?
The producers were jumping on the comedy bandwagon. As I got more and more popular on TV, my management at the time received numerous offers for us to play in TV dramas and comedy movies. My manager would say, "Takeshi, they want you to do some acting. You wanna do it?" And I'd go, "Sure, whatever." So it wasn't a big deal. I didn't really give much thought to the matter.

Did you enjoy acting in these comedies or did you feel typecast?
I certainly was typecast, but it was okay because I didn't really put too much into acting in those early pieces. I wasn't really expected to act or perform. I was just supposed to be there as a comedian, "Beat Takeshi." One of the people I worked with during this period was Mr. Mitsuhiko Kuze, a very prominent TV director, known in the industry for his professionalism. But even he didn't once yell at me on set. Because it was my presence rather than my performance that mattered. The characters I played were mostly very stereotypical. I was the "funny one of the comic duo," and what I did in those films

was pretty much the same as what I did onstage, only with different partners.

Do you think acting came naturally to you?
No. I really didn't understand the mindset of actors in those days. I find it very awkward to make people laugh in one scene and then cry in the next. Looking back, I used to make fun of pretentiousness in my *manzai* act, of tacky acting, of typical actors. So I had my theory on acting, that it should be natural and spontaneous.

Was acting something you actively pursued?
I didn't mean to pursue it. But it happened that Nagisa Oshima offered me a part in *Merry Christmas, Mr. Lawrence,* which turned out to be more or less the first "real" film I was in. Looking back, I might have felt that I could only go so far doing standup comedy. It felt like one cup was about to be filled and the water would just be spilled unless I could get another cup. So it was a good opportunity to try to do something different, which was films. But I didn't actively pursue the role. It was Mr. Oshima who approached me first. I knew who he was and what he did for a living, but hadn't met him in person. I hardly knew about his works, only about his notorious temper on set. But I was curious enough to see how it would turn out. So, after an initial conversation with Mr. Oshima, I called up Ryuichi Sakamoto, who I knew had also been offered a role, and we both conspired to say the same thing to Mr Oshima: "I'll do the film if you promise you'll never scream at me on set. If you shout at me just once, I'm out of the project right there and then, okay?" And he agreed. So then we flew to Rarotonga Island to shoot the movie. On set we were two nearly amateur actors, hardly able to memorize our lines and repeatedly getting messed up during the take, but Mr. Oshima couldn't scream at us because he'd sworn not to! What he did instead was to vent his frustration on the other actors by scolding them for mistakes the two of us were making! When I fluffed a line, he would turn to my costar and say, "It's your fault Takeshi can't deliver his lines!" After a while I felt sorry enough for them to straighten up my behavior. Throughout the

shoot, I enjoyed observing how weird and over-the-top a film director can behave on set, but I never imagined myself becoming one in the years to come!

Did the film allow you to forge a dramatic identity that was distinct from your comedy persona?

Not really. When the film was completed, I watched it and thought it was pretty good and my acting was not bad at all. And I expected that the audience would be very impressed with this image which was totally different from my character in comedy shows. One day, after the film was released, I sneaked into the cinema to see the reaction of the audience. But at the moment I appeared on the screen, every single person in the cinema burst into laughter. Obviously I was shocked and humiliated by the experience, because my character in the film was not someone to be laughed at! I swore then that I would stick to serious and dark characters in any films or TV dramas I was in, which I did. And it took me ten years, until maybe the time I directed and starred in *Violent Cop,* to be perceived as a "serious" actor.

Let's talk about Violent Cop. *Can you say something about how you came to direct it?*

At the time I was recording about eight TV programs a week, which meant that I was only able to act in a film every other week, not every day. When people started talking about *Violent Cop,* I assumed that the filming would be done every other week because this was how it had always worked for me. But then I was told that Mr. Kinji Fukasaku, who was going to direct the film, wanted to shoot consecutively for sixty days. So I said, "Let's forget the whole thing." But one of the producers, Mr. Kazuyoshi Okuyama, then working for Shochiku [one of the largest film production companies in Japan], came and asked me if I wanted to direct the film in keeping with my normal schedule, and I agreed.

I realize you were already a big TV star. But you hadn't directed any films yet. Were you ever nervous about directing a film for the first time?

I'd already had the experience of directing comedy sketches in my shows, giving instructions to the directors, in terms of the camera angles and number of shots and so on. Plus, whereas you use multiple cameras on TV shows, you basically use one camera on films. So I thought making a film would be easy.

What about the film's backers? Was there any anxiety on their part?
MM: To tell you the truth, we had no worries about Takeshi directing *Violent Cop*. The reason why Shochiku agreed to let Takeshi direct was because at the time it had become fashionable for people such as writers and novelists to direct films. So, rather than focusing on the quality of films, it was like an event, a marketing tool, for film production companies to let someone like Beat Takeshi, who was already famous on TV, direct a film. I think Shochiku thought that they could gain enough publicity and money by letting Beat Takeshi do the film and didn't have any expectations in regard to the birth of Takeshi Kitano, the director.

Violent Cop *started life as a comedy. But you turned it into something much darker. Did you have experience in writing scripts at this time? Did you write on your own or work together with the writer of the existing script, Hisashi Nozawa?*
They gave me the script. I read it and it was boring. Even so, I wouldn't say I rewrote the script. At that time I didn't write scripts. I just told the crew the main storyline and forced them to start filming. I wrote lines on pieces of paper! In the end, the only things that remained from the original script were the name of the scriptwriter and the fact that it was a story of a cop and a criminal. Everything else changed.

MM: The setting, casting, and the name of the scriptwriter remained the same as the original. So there was a negotiation over the script, but it was done in the Kitano way. I remember Mr. Nozawa asked for his name to be taken off the script. [Laughter.]

You've been quoted as saying you personally dislike violence. Yet the film contains many violent scenes. Did you add violence to the story, or was it already in the original script?

At the end of the day, films aren't real. They're made, created things. When I was a child, I saw bad kids fighting and stabbing each other in my neighborhood. So I felt uncomfortable watching violent scenes and acting in exaggerated and unrealistic films. For instance, boxing scenes in films always look fake to me. In reality, violence is simpler and therefore more realistic. I guess it's because there were many situations and circumstances like that in my childhood that I'd always thought action scenes on TV looked fake, even if they were cool.

Once you'd rewritten the script, how did you prepare for the actual shoot?

MM: Rather than using the script as a starting point, Takeshi would simply explain to the crew the images in his head and the scenes he wanted to shoot. To begin with, most of the crew needed to be told precisely what scene contained what lines, and so on. But now, as they've worked together for such a long time, there's no need for Takeshi to explain all the details to the crew. At the time, the crew would get together to discuss how to create the images Takeshi had asked for. If they didn't understand the image Takeshi wanted, the assistant director would go and ask Takeshi on behalf of the whole team. If an outsider saw how Takeshi and his crew worked, it may have looked rather clumsy or awkward. But the way they worked was actually very practical. In some ways, out of all the crew, I felt that the cameraman was the one who didn't fully understand what Takeshi wanted. Even now, when I watch *Violent Cop,* I sometimes wonder if Takeshi was dissatisfied with some of the framing. Takeshi and the rest of the crew communicated with each other thoroughly, throughout the filming. But in terms of the cameraman, it was too late by the time Takeshi checked the end product. I think Takeshi hadn't anticipated some of the ways in which the film was shot. So this was probably one of the very few things Takeshi didn't achieve in his first film. On all the other aspects of the film, Takeshi and his crew communicated with each other when anything was unclear. Takeshi had very clear

images of how he wanted the film to look, so he just had to explain them to the crew.

Going back to the question of storyboarding, certain scenes in the film were very precise. For example, the scene where Kiyohiro pulls a gun on Azuma, but Azuma kicks him and the bullet is deflected and hits a girl in the street. This must have taken a lot of planning.

The scene was that my character, Azuma, kicked the gun out of Kiyohiro's hand. We cut that right there at the time of the filming. If Kiyohiro had managed to shoot me, that would have been the end of the film, so after he pulls his knife on me, I head-butt him. He then falls and goes to shoot with his gun. When I kicked the gun, someone had to fall on the ground, otherwise they would have had to fight forever. So we made a girl walk by and get hit. But it was a night scene, so even if the bullet hit her stomach, the wound would have been really small. So I thought it would be more effective if we made the bullet hit the wall behind the girl and have her blood splatter on the wall.

Can you say a little about how you worked with your DP, Yasushi Sasakibara?

I don't like most Japanese gangster films because I find the camerawork in them highly artificial. Mr. Sasakibara was a successful and popular cameraman at the time who followed the traditional style of filming. But I said that I didn't like the traditional way of filming and wanted to film in a different way. So from the very beginning we clashed. In fact, we didn't agree with each other once. But because I was the director and he was the cameraman, he had to listen to me. And even if I told him to film in certain ways, I could see his resistance to me! So that really annoyed me! I couldn't show my anger with my face, but I was boiling inside. In the end, I asked him why he wasn't filming in the way I wanted, and he replied that he was. But in fact he couldn't accept the way I was making him film because if he did, he thought, he would be laughed at by other cameramen and be embarrassed. So we continued our confrontation like this!

Did you inherit the crew and cast of the previous director of the film?
The crew were selected, not inherited. It was full of young people who'd previously been assistants.

MM: Mr. Sasakibara was the most experienced member of the crew, and recruited the new members.

What was your technical knowledge at this time? Did you have any knowledge or interest in the effect of using different lenses? Or did you feel this area was the responsibility of the DP?
I didn't know the names of things, or any technical terms to do with filming. But I knew a few things about creating different images. When I explained how I wanted different scenes to look, the crew would respond with different technical terms and names. So that's how I learned. Every time I didn't know something, I'd ask. I'd be like, "Oh, so that's called a track-back?"

What about working with actors?
We hardly did any rehearsals, even on location. If I didn't like the way an actor was performing, I would tell them once or twice to change what they were doing. If they didn't change what they were doing, I'd change the camera angle so that their acting wasn't too noticeable. I didn't wait until their acting improved, but moved the camera instead. I'd move the camera so you could see their back or something. It's like filming a dog. You can't wait until their acting improves!

There were quite a lot of long takes in Violent Cop. *Was this an aesthetic or a practical choice?*
I don't really like the idea that a camera is something you have to move. And if you move the camera, you end up filming unnecessary things.

What did you find the hardest about the shoot?
The most difficult things were that the crew didn't work the way I wanted them to and also the film seemed to end up being too short.

[Laughter.] The script girl came to me one day and said that if the film continued the way it was going, it would end up being only an hour long. So we discussed whether we could increase its length by making the actors walk or run again [at different speeds]. I ended up doing some walking shots because cops walk a lot. [Laughter.] I realized then, when we were filming, that one has to think about the length of the end product. But in the end we didn't need to reshoot at all. The other problem was that none of the key crew members drank. So Susumu Terajima ended up drinking with me. We're still drinking buddies, in fact.

Was it difficult to play the lead role and direct the film?
MM: The problem was that Takeshi was already very famous in Japan, so even when he was directing, let alone acting, a crowd of people would come to watch. This was something we hadn't anticipated, and it made it difficult for everyone to concentrate.

TK: Some people came and waited for me to sign my autograph with a pen and a piece of board. I'm not sure if they were edited from the final film. I think they may have ended up in the film!

How would you describe your role as director when you're on the set?
I think a director is like a commander in a war. I'm the kind of guy who marches ahead instead of leading the troops. So I'll always be the one who gets shot dead on the front line. [Laughter.]

How would you describe yourself when you're directing—calm, quiet, loud?
I'm quiet, I think. People around me probably think I'm deep in thought when I'm sitting there. But in reality I'm asleep! There have been a few occasions when I've actually been woken up by a member of the crew.

MM: Takeshi may be quiet, but I think he's very active. He moves around a lot on set. When we film one scene, Takeshi is already think-

ing about the next scene. Sometimes he'll only spend half a day to cover what we've scheduled three days for.

How long did you have to shoot Violent Cop?
MM: It took about thirty-five days to shoot.

How fast were you having to work?
We were doing fifteen to twenty shots a day.

Were there any times you wished you hadn't volunteered your services as a director?
Not at all. It wasn't until my second, third, fourth film, until *Zatoichi*, that I wished I hadn't directed films. [Laughter.]

Can you say a little about the editing on Violent Cop?
I had an extremely experienced editor, Mr. [Nobutake] Kamiya, who was even more stubborn than Mr. Sasakibara, the cameraman. He was an old man and he really didn't like doing what I asked him to. [Laughter.] In the middle of it all, he almost quit. I asked him to do something and he said, "That's unheard of!"

Despite that experience, you've said that editing is your favorite part of making a film.
That's right. The editors I work with now follow and listen to my requests. Sometimes they add things.

Did the film change much during the editing?
Not much. The order of the scenes changed. That's probably it.

Once you'd finished the film, who saw it first and what was their reaction?
The producers, the key crew members, and I saw it first. The producer, Mr. Okuyama, was furious, but the person working just below him praised the film. A decent number of people went to watch the film in the cinema, so it was a success.

MM: Many film critics and novelists praised the film, saying that it exceeded their highest expectations. They praised Takeshi as a genius.

TK: There was jealousy and praise at the same time.

You said earlier that, in spite of your efforts, Japanese audiences laughed when they saw you in Merry Christmas, Mr. Lawrence. *Did the same thing happen in* Violent Cop?
Not really, because I had already played a few bad-guy roles on TV.

You've said that you can't watch Violent Cop *now. Why?*
It's because I can see my effort in trying to succeed in films. It reminds me of the time when I was a new face in the industry, and I don't like that.

Shekhar Kapur

MASOOM

Where did you grow up?

I was born in Lahore just before partition. At this time there were huge movements of people from Pakistan to India and vice versa. So my mother, my sister, and I moved back to India. My father stayed back because he was a doctor, but so many people were getting killed that he came back. My memories of this time are very vague as I was less than a year old. But I still remember the house that we lived in in Lahore. When I went to Lahore to do the score for *Bandit Queen* with Nusrat Fateh Ali Khan, I went back to the house. The moment I saw it I recognized it. It was a huge bungalow and outside it were these little shops, a *paan* shop, a bicycle repair shop, a tea shop. There was an old man there with a tea shop. When I told him I was from India and that I was Doctor K. V. Kapur's son, he hugged me and said, "I remember Doctor Kapur. Did you know no one's lived in the house since you guys left?" The guy had had a tea shop in the same place for more than forty years!

Can you remember the first movie that you saw?

It was a Hindi film called *Udan Khatola,* which means "flying saucer," and it was an adaptation of Ryder Haggard's *She.* And then as a kid I used to go and see all the Tarzan movies after school. Then came the so-called big Bollywood movies. And then American B-movies. So my knowledge of America at that time was totally based on B-movies. The U.S. looked like a B-movie. All the girls there behaved like B-movie girls. All the sexuality there was B-movie sexuality.

What impression did these movies make on you?

I was fascinated by the power of the movies, the power they could exercise over several thousand people sitting in a theater. Remember, theaters in India were much bigger in those days. They were huge, huge theaters. I was fascinated by the way somebody was controlling this medium, by the way they could make me laugh, cry, and be scared. I have often wondered about this attraction. I don't know if it was the creation of a myth through an image or the ability to be transported to another world. It doesn't matter whether you're hungry or thirsty or hot and sweaty. When you walk into an air-conditioned movie hall, you're transported into a world that doesn't exist. That's what excited me!

When you first thought about getting into movies, what role were you thinking of?

When I was growing up there was no television, there were no sports, so the film stars were the people that India loved. My uncle, Dev Anand, was the matinee idol of India, so I was always Dev Anand's nephew. We don't have matinee idols like this anymore, but in those days my uncle was like a combination of Tom Cruise and David Beckham. He was such a big star that when he lost a tooth in an accident, young men all over India took out a tooth to have the Dev Anand smile! I used to live in Delhi, and when he came to see me at my school, the school would shut down, the streets would shut down, the city would shut down. When he visited our house, within minutes there'd be two thousand people screaming and yelling outside in the street: "Dev is here!" He was like a pop star. When I went to Bombay, I'd always have a whirlwind tour of the studios and things like that. And I thought, "My God, this is so glamorous. I was so awed by the fact that this man was my uncle that—without being able to say it to my parents who were professionals—I dreamt of being a movie star.

How did your parents feel about your aspirations?

They were really afraid I'd go into the movies. I'm sure part of the reason my parents packed me off to London was to keep me away from

Bombay. They knew that given half a chance I'd end up there. They were scared I might want to go into movies because it wasn't considered a profession. It was something you did only if you couldn't do anything else. So only those who couldn't do anything else became actors and directors. If you were educated you didn't do that kind of thing. That's how the movies were looked on by the professional classes, even though for the mass of India they were the only form of cultural interaction. So I came to London to train as an accountant, and my interest in movies developed there.

What happened when you got to London?
When I got to England I forgot about being a movie star and got totally involved in swinging London. It was the sixties. I lived in a students' hostel in Leinster Square in Bayswater, then in a shared apartment. I earned nine pounds a week, which wasn't too bad at that time because you used to get luncheon vouchers as well. If you ever went out on a date, you'd use your luncheon vouchers! So I lived on luncheon vouchers till I graduated. Then, once I became an accountant, my salary jumped hugely. Suddenly I felt very rich. I worked in my own company for about six months. Then I got restless, so I went traveling. When I came back, I worked as a corporate planner for Denis Thatcher at Burmah Oil. It was about that time that Margaret Thatcher was saying that all student loans should be reduced. So there were always these protests outside the office. If they couldn't get to Margaret Thatcher, they'd get to Denis Thatcher's office. I worked for Burmah Oil for about a year, then I went and worked for a small management consulting company for three or four years.

Did you see many movies in this period?
Yeah. I went to a lot when I was in London. I don't remember what I saw. What I do remember is that I joined the ICA [Institute of Contemporary Art]. My office was in Victoria, and I used to walk across and see all these films there. I started to think about movies a lot, and I remember reading a book called *The Art of Film*. That's all I've ever read on filmmaking, one book! I don't even remember who it was by.

And when I read it, I realized it was saying exactly what I was thinking. I realized I was in sync with it so much that I wasn't just being silly about directing. So I started to develop a passion to be a director. I approached the London Film School and they said, "Write a script." I didn't know how to write a script, but I bought one of those golfball typewriters and started writing a script anyway. It was a really interesting script and I really enjoyed writing it.

What was it about?
It was about a kid in his bedroom, a young boy, six, seven. He hears his parents scream and shout at each other and goes a little crazy because, you realize, it isn't the first time it's happened. So he's having a sort of trauma listening to these screams. And then the screams stop and there's total silence. And now he's really worried. He was upstairs and I remember the shots of him coming down the stairs and going into the living room. And what he saw, from the back of the sofa, was his mother's head lolling to one side and her hand on the other side, and the father looking over the mother. That was really frightening to him. And I still remember that little tracking shot as he walked across to look at his mother, who, in his mind, was obviously dead. But when he looks at his mother, she opens her eyes and says, "Why aren't you asleep?" And then he looks at his father, and his father says, "Why don't you go to bed?" And then he looks at the television, which has these fuzzy lines on the screen. And that was it. What was really going on? Was the trauma all in his head? That was the script I wrote.

It was meant to be a short?
It was a five-minute short.

Did anything come of it?
No. Before I sent it in, the film school sent me examples of a lot of scripts. I was surprised how dark they were. And my viewpoint of life has never been dark. It's always been intriguing. That's why the first script I wrote was about what was really going on. It was about how life can mean many things at the same time. About what is reality. And I'm still facing that now.

So what happened to your script?

Two things happened at once. I'd been talking about wanting to be in movies for so long that the senior partner in the company, Peter Needham, finally told me piss or get off the pot. Then, before I sent it in, my uncle Dev, the movie star, came to London with his new girl-friend who was also a big star in India. She was so attractive I fell head over heels in love with her. He said to me, "Come back to India and work with me, and I'll make you a star." My uncles had a production company, and he said, "I'll put you in a movie and make you a star!" And this girl was saying, "Yeah, yeah, yeah! Come!" So I said okay. And I chucked everything in and went back to India. I remember I gave away everything I owned. I gave away my car. I gave away my clothes. I gave away my stereo system. I just said, "Okay, time to go." Because obviously the time had come. So I went to Delhi to see my parents and tell them about my decision.

How did they react?

Terribly. By this time I had a sports car. I was earning lots of money. I was one of the first Indians in London to embrace mainstream life. I was a management consultant, I drove a sexy car and had an apart-ment just behind Harrods in Knightsbridge. So I was seen as very suc-cessful. Nowadays, of course, the richest people in England are Indian. But at that time it wasn't something that happened often. But I'd done it and people had been telling my parents, "My God, your son is so successful!" So my mother was very proud of me, and here was I telling her I was going to chuck it all in and become an actor. I don't really know what my parents thought about it. I remember my father was shaving when I walked in. He looked in the mirror and saw me and said, "Hey, what are you doing here?" And I said, "I'm here to go into the movies and I'm going to Bombay." Just like that! And then we talked and my parents talked to each other. I used to have a girl-friend, and I think they may have thought that the problem was that I'd broken up with her. After that, there was a series of meetings with girls because, as a chartered accountant, I was considered a very good catch in the marriage market. So my parents were constantly intro-ducing me to beautiful girls who came with a lot of wealth. And every

time I was finishing the conversation at the dining table in the girl's house, I'd say, "Well, actually I'm going off to Bombay to become an actor." And there would be a deathly silence! I have no idea what my parents had said to them—probably that it was a little phase that would pass. But it didn't pass, and I remember the day when I took a train to Bombay and became, for a long time, an out-of-work actor.

Did you still want to be a movie star?

By now I was talking about wanting to direct movies. I started as an actor only because I couldn't direct immediately. The system of assistant directors in India is like an apprenticeship: it's how more or less every director in India has come up. Not through film school, although there are some, but by assisting other directors. But nobody would take me on even as an assistant director because the job of the most junior assistant was to get a chair for the star, get the tea, and get shouted at. But they didn't think they could shout at me because I was Dev Anand's nephew, I spoke English, and I was a chartered accountant! So I couldn't even get a job as a third assistant.

You were damned by your impeccable credentials!

I was damned, yeah. They were really unsettled by being confronted with this guy who walked in and spoke the Queen's English and said, "I want to be your third assistant." So in the end I learned by acting. By being in front of the camera.

Can you say a little bit about Bollywood? How does it compare to Hollywood?

I remember sitting with my uncle, Dev Anand, one day and a guy came to ask him to do a film. He said he'd just made a film, it's a wonderful film and everything. And my uncle asked him, "So have you made any sales yet?" He says, "Oh yeah, yeah. Sold my house. Sold my wife's jewelry, you know?" And he said it with great pride. That exemplified the business. There used to be a studio system in Bombay, which collapsed a long time ago. But by the time I got there, most people were borrowing money against their houses, against their

wives' jewelry, borrowing at three percent a month—that's thirty-six percent a year—from loan sharks. And it was even worse than that because the loan sharks would take the first six months' or year's interest up front. So if you're borrowing a hundred dollars, you're actually getting seventy dollars or sixty-four dollars in your pocket. In other words, you're paying almost fifty percent interest on your money. So the people who were making the films were going broke all the time or committing suicide. They either thought they were going to make a fast buck or they were obsessed by glamour or by filmmaking itself. So it was fascinating, these people were fascinating. And I had these three uncles who were doing exactly the same thing. Every time they made a film, they'd invest every last penny they'd made in their lives and hope for the best. That was the movie business in India. These days people talk about the industry becoming more and more corporate. But if you look at the Indian movie business now, ninety-five percent of the biggest hits are films where the producers and directors are the financiers themselves. They've borrowed the money and it hasn't come from any corporate world. It's a very interesting statistic because about seventy or eighty percent of all films made in India are financed by producers who hire directors, but ninety percent of the films that succeed are by directors who produce their own films. It's a hugely interesting statistic and something the West could really learn from.

Did Bollywood have movie moguls in the same way as Hollywood once did?

When I was there, Bombay was full of studios owned by filmmakers. If a filmmaker had had a big hit, they'd build their own studio. So RK Studio was built by Raj Kapoor, Mehboob Studio by Mehboob Khan. There were all these studios built by filmmakers, most of whom had come from nowhere. Some of these people had been fruit sellers, street vendors. Then they came and made great movies, became great filmmakers, and created their own studios. The interesting thing is that all those studios have been torn down because property prices have gone so high. There's a very interesting story about the Mehboob

Studios, where Mehboob Khan made three great movies, big hits such as *Mother India,* a black-and-white film he made forty years ago, which was recently rereleased in color and did really well. In his will, Mehboob said that the studio could never be broken up. But now, forty years after his death, his grandchildren have found a way to break the studio into pieces so it can be turned into shopping malls and complexes. But look at the passion of a filmmaker who says in his will that none of his heirs can ever do anything with his land except make movies! So Bombay at this time was full of these passionate people. And that's the industry I came into, that's the industry in which I struggled to survive. Admittedly I'm talking about ten, fifteen percent of the people. The rest of the people were fly-by-night operators. Not only fly-by-night operators but people obsessed by film. Raj Kapoor, one of our greatest directors, used to say that his problem when competing for an actor's time was not another great director, but a farmer from the Punjab.

What do you mean?
In a good monsoon, a big landowner farmer will make a lot of money. And all his money is tax-free because agricultural income is tax-free. Suddenly what he wants to do with this money is make a movie. So he'd come to Bombay and contact the big directors, the big actors, give them huge sums to commit to a movie. And they'd commit, knowing that this movie would never be made, but that they'd make some money anyway. The farmer would then have a party, he'd shoot for four or five days, and then it was time for him to go home again. He was willing to spend that kind of money because then he'd have all those pictures of himself with the stars. He'd then look for somebody to buy the project, and no one was interested. But he'd made a windfall from the monsoon, so he was willing to spend it on this adventure in Bombay. And why not? That's what I was doing in Bombay. I was having my Bombay adventure. So that was the business—something that nobody looked upon as a business.

Which explains your parents' reaction to your decision to go into the movies. It was like opting out of a career.

Totally. It was looked upon as an irresponsible thing to do. Even today it's the same. The sons and daughters of wealthy businesspeople come to me and say, "We've made a lot of money in our parents' business. We want to make a movie." It's still like that! I recently had a guy come to me who said his parents had made fifty, sixty million dollars and he wanted to spend ten million on a movie. I said, "You know what? Talk to my lawyers." Because these guys will waste my time and their own time and they'll spend tons of money flying here and there. And then at some point the guy's dad will say to him, "Okay, you've had your fun. Now can you get back to business?" Okay, so let him go and spend some money, meet some actresses, you know? As long as he doesn't waste my time!

Tell me a little bit about the roles you played when you were in your Bollywood phase?

I produced a film in which I played the leading role. It was called *Toote Khilone,* which means "broken toys." It starred a young girl I'd met on *Ishq Ishq Ishq* [*Love, Love, Love,* Dev Anand, 1974], Shabana Azmi, who became a huge star. I'm sure she was the only reason we got funding for *Toote Khilone.* It was about a man who wants to live without any structures around him. And it was a love story about a girl who says, "That's fine, but you can't live on the street." Which, ironically, is what I was doing at the time: I was living on the street and loving it.

How did you feel about acting at this point?

All I can say about my film career is that when I look back at some of the roles I played, I showed potential. But I could never have been a star because I wasn't comfortable with the acting styles that go with becoming a star. I wasn't narcissistic enough. I've known some actors in India who are amazing, world-class actors, but have always remained on the fringe of the industry because they've never been comfortable with that style of acting. I'd call it performing as opposed to acting. Most Bollywood films feature performers as opposed to actors: people who can dance, who can sing, who can create believable, larger-than-life characters all the time and indulge in larger-than-life situations. In

fact, most Bollywood stars become stars because they have the ability to indulge in mythmaking. They have the ability to create myths by the way they act. It's even truer in the south than in the north. And that's what I could never do; I could never become a larger-than-life myth. I was always very uncomfortable with what I call the "Three-penny Opera" form of acting.

What do you mean?

If you watch Indian film acting of that time, eighty percent of it is pantomime or what we call *notunki*. Nonrealistic. I was too shy to do that and I was constantly trying to play parts for real. It was like trying to be Brando in a Bollywood film; it didn't work. So I don't think I could ever have become a big star. I actually became much more successful later on television, and at that time television was new and soaps were new, and after I had directed my first film, I went back to be in a soap. Television soap doesn't need mythmaking. Television needs something completely different. So I adopted a realistic style of acting and for a while became one of the most popular television actors in India. I was actually the first person to bring a more realistic style to television. And it was hugely successful. For the first time I saw the difference between television and film. I was playing a district magistrate in one soap—a district magistrate is a big daddy in small-town India—and I remember when I walked into the smallest villages that television reached, people came up to me and bowed down and called me "DM sahib," although they knew I was an actor. So I saw the power of television in India because I'd played that part. That was my acting experience.

How long was it before you began to direct?

It was ten years before I made my first film as a director. I had a career of sorts as an actor. I was in a few things. But nothing really launched my career as an actor till much later. Nonetheless, I enjoyed my time in Bombay. I used to run on the beach and have lots of girlfriends. People used to ask me, "Don't you miss having a sports car and that great life you had in London?" I never missed it! And my parents got

the brunt of it because they were so upset and so worried about me. "We educated him, we gave him everything we had, and what's he going to do?" As far as they could see, I was going to be a struggling actor for the rest of my life. In the end my uncle came through by giving me a part in a film he shot at the foot of Everest, *Ishq Ishq Ishq*. It lasted for a total of four or five days at the box office. And I was on screen for a total of about five minutes.

What were you living on during this period?
Nothing. I made very little. I've always lived frugally. I've always been very adaptable. I've never been a great spender. If a friend has a Porsche I'll drive it, but I'll never buy one. I've never needed anything. What do you need? I have a friend here [in Los Angeles] who has a huge estate where I go and stay sometimes. We were talking once and I said, "Here's what I'm going to do. I'm going to put a zoom camera in the center of the universe, right? And I'm going to start zooming out very gradually and it'll zoom into the whole of Bel Air, right? And now you tell me how big you want your house and I'll tell you how big I want mine. Because I want to live in the center of the universe. I want to live in this infinity." So you see, wealth, for me, the need to define yourself through wealth or the need for wealth beyond the basic comfort levels, is to make your life finite. So going from having a sports car in London to going up and down on the Bombay trains because I couldn't afford to take a cab, it was fine! It's always fine as long as you're doing something creative. It's always fine as long as what you're doing is what you're passionate about, as long as you define yourself through passion. The moment I'm not passionate about anything, I start thinking about money, about the big house. But if I'm passionate about something, it doesn't matter! Ultimately nothing matters, of course.

So you had no doubts about what you were doing?
At that time? None whatsoever. People asked me, ask me still, "What was it like?" And I try to remember doubts. Yes, I was humiliated every now and then when I fought for a part and didn't get it. But it

was over in five minutes, right? Because you were passionate about life and you were passionate about living. Not passionate about achieving. Just passionate about being. And that's why I get surprised when people say to me now, "What are you doing? Why aren't you making a film?" And I say, "Film is an adventure. And it's play. Because life is play." In India the old Hindu mystics, the Vedantas, used to call it *leela*. Life is *leela*. Life is play. And the reason I made some good films is because I played. And if I made some bad films it's because I forgot to play. It's because it became a job I was paid to do. Would the world's great artists have painted so well if they constantly had to show their work at a certain time? No, because they used to play. It would be traumatic for them sometimes. But it still has to be play. So I can't ever remember it bothering me. It still doesn't.

Let's talk about Masoom. *Was it the first film you tried to direct?*
Masoom wasn't the film I wanted to do. I had written a script called *Badarjit* [*Tolerance*]. Basically its idea was that the most dangerous man is a man who has nothing to lose. So don't push a man to the point where you take everything away from him because if you do and he has nothing to lose, he'll become the fiercest enemy you'll ever have. It was a film about a man who was very gentle, but who was pushed to a point where everything was stripped away from him and you just didn't recognize him any more. That was what I wanted to do. I met the producer, Devi Dutt, who'd made a first-time film, *Aakrosh,* with Naseerudin Shah and Govind Nihilani. I'd seen the film and really loved it, but it wasn't having any luck being distributed. I had an old school friend who was a distributor in Delhi. I phoned him and set up a screening and he bought the film. And the film went on to be a big hit. So of course the distributor was very grateful to me. And Devi Dutt was very grateful to me. He said, "What do you want to do with your life?" And I said, "I want to direct." He said, "Would you direct a film for me?" And I said, "Sure!"

It wasn't a problem that you hadn't directed anything before?
Not for him. He'd just done a film with Govind Nihilani, who was a

Richard Linklater
SLACKER

TOP The Pap-smear lady,
Teresa Taylor, selling her wares

LEFT Jerry Delony (on the
left) as the UFO obsessive

Richard Linklater on the set

Richard Kelly
DONNIE DARKO

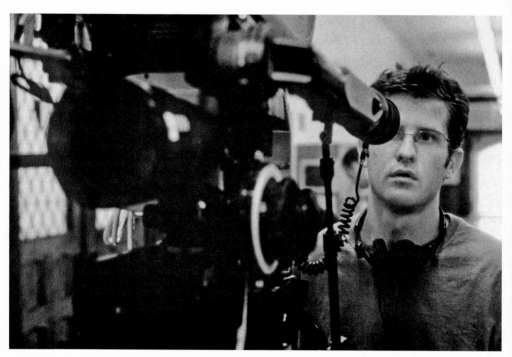

Richard Kelly lines up a shot

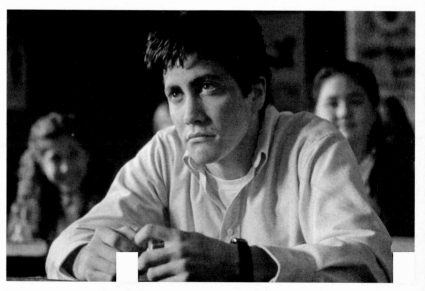

Jake Gyllenhaal as Donnie Darko

Real or imaginary? Donnie's friend, Frank the Rabbit

Alejandro González Iñárritu
AMORES PERROS

Emilio Echevarría as the hit man with a history, "El Chivo"

LEFT "One of those faces that appear every ten years": Gael García Bernal as Octavio

BOTTOM Alejandro González Iñárritu

Takeshi Kitano behind the camera

Takeshi Kitano
VIOLENT COP

Detective Azuma lives up to
his reputation

Shekhar Kapur
MASOOM

Shekhar Kapur surrounded by
the three child stars of the film

Artwork for *Masoom*

Emir Kusturica on the set of *Dolly Bell*

Emir Kusturica
DO YOU REMEMBER DOLLY BELL?

Kusturica's alter ego: Slavko
Stimac as Dino, in *Dolly Bell*

Dino and his father (Slobodan Aligrudic) take a walk

Agnès Jaoui
LE GOÛT DES AUTRES

TOP Agnès Jaoui directing

LEFT The newly shaven Castella (Jean-Pierre Bacri) has tea with the object of his affections, Clara (Anne Alvaro)

Manie (Agnès Jaoui) has a drink with Bruno, the chauffeur (Alain Chabat) and Franck, the bodyguard (Gérard Lanvin)

Lukas Moodysson
SHOW ME LOVE

Young love: Rebecka Liljeberg and Alexandra Dahlström as Agnes and Elin

Terry Gilliam with Terry Jones, Michael Palin, and Eric Idle

Terry Gilliam
JABBERWOCKY

Dennis (Michael Palin) leaves the city

Dennis reluctantly marries the princess (Deborah Fallender)

RIGHT Terry Gilliam takes time out from filming *Jabberwocky*

Sam Mendes
AMERICAN BEAUTY

Sam Mendes and Kevin Spacey confer on the set

Sam Mendes

Iconic image: Mena Suvari
covered in rose petals

first-time director, and the film was a big success. So I think he was very confident about taking on first-time directors. Also, we were very cheap! He just said that after *Aakrosh,* he wanted to do a commercial film. I said, "That's fine. I'll do a commercial film." He said, "I want songs in it," which Govind had refused to put in, and I said, "Fine." So we went out and padded it with big names. We padded it with Shabana Azmi who came in at a cheap price, probably because we'd been in a long relationship. We padded it with [Sampooran Singh] Gulzar, who was the writer, and we padded it with one of the greatest film composers in India, R. D. Burman.

Where did the money come from?
Before I signed on with all these people, Devi said, "Okay, I've got this financier who wants to meet you. You've got to tell him your story." So I went there to tell him the story, and this financier sat on the other side of the table, put his watch on the table, and said, "I've got fifteen minutes. Tell me the story." It was classic textbook stuff! So I told him the story of *Tolerance.* Within about five minutes he was yawning, and in that big yawn I saw a void in which I was going to fall. So I decided to change the story. On the walls behind him there were lots of photographs of little children. I'd recently read a book called *Man, Woman and Child* by Erich Segal. So I just told him a variation of that story and he bought it and said he'd do it. And that was the beginning of *Masoom.* Then we went out to cast it, and Shabana agreed to come in at a price.

Do you think Shabana's agreement to be in the film made it easier to finance?
The producer has never admitted that this was one of the reasons he asked me to do the movie. But I suspect that that was part of the reason I was offered the film. It was as if you were, once upon a time, Julia Roberts's boyfriend and Julia Roberts agreed to do the film for very little money. Shabana was always very encouraging of me doing a movie, all my friends were, because I'd bore them with stories. If I ever went to a party, they'd say, "Run, run, run! Shekhar's going to tell you

a story!" [Big laugh.] And everyone would run away! Of course, being totally stubborn about it, I would say, "Yeah, I've told another story." So Shabana was very used to it; I'd known her a long time. She said, "Why don't you just direct?" She was very encouraging.

R. D. Burman and Gulzar were both enormous figures in Indian cinema at this time. How did you go about persuading them to work with an actor who was directing a film for the first time?
I met them and they said, "Fine."

Were they paid?
None of them were paid a full fee, but they were being paid a reasonable sum for the time. I think they probably just liked me.

What was the budget for the film?
It was all of twenty thousand dollars.

That sounds very low!
Twenty-five thousand, perhaps. But you should remember that people don't do one film at a time in India. Someone like R. D. Burman will do five or six films at a time. On the other hand, Gulzar would always do one thing at a time. I had my differences with him on the script. Gulzar, being a director as well as a writer, had some different points of view from mine. I'd just met my first wife at the time, and I would dictate and she would write. And one day I took some things I'd written to Gulzar and said, "What do you think of this?" He looked at it and said, "This is more of a bible than a screenplay. How many hours of film do you want this to be?" So we sat down together and edited it. It was a fairly collaborative effort. In fact it was a hugely collaborative effort. But there was a lot of input from me. The basic input was that I liked drama. And that was one of the differences with Gulzar. He's a poet and likes to express things poetically, whereas I like to express things dramatically. So that's where the collaboration was interesting. I would bring in melodrama and melodramatic situations all the time. So when you see *Masoom,* there are so many ironies going on there.

How would you describe the story?

It's about a middle-class family. They look like the incredibly well-adjusted family. D.K., the father, has a good job, they have two daughters. No tension or anything. And into this family walks an innocent kid—*Masoom* means "innocent"—a kid who takes the family apart at the seams and totally destroys it because it turns out that he was born as a result of an affair D.K. had when he went to an old school reunion and met an old girlfriend. She had the child, but nobody knew this had happened until she died and the one person who knew the truth sent the kid to live with the family. That was what the story was about: how this boy disrupts the family and how the family learns to come back together again. Then there was also this part about the mother wondering if she's in some way feeling guilty about not having a son. In India it's a big thing in the middle class, in every class, that you have to have a son. And they've got two daughters. So it was not only the intrusion of an exterior member who needed acceptance, but also the fact that the situation is a consequence of a betrayal. It was about how you handle betrayal. But at the same time the person who is the product of the betrayal needs a family.

It doesn't sound very Bollywood!

It was more a hybrid between a Sham Benegal film, which was almost villagelike, and a Yash Chopra film, which was about family, love stories—things on a larger-than-life level. It pitched itself somewhere in the center and caught the imagination of people there. But I remember a filmmaker friend looking at the film and saying, "Shekhar, you are crazy to make this film! It's got no melodrama"—which to him means people screaming and shouting at each other. "There's no romance, it doesn't have a villain, there's no protagonist and antagonist, nobody's going to like this film." You see, those are the rules of mythic filmmaking: "stated conflict." *Masoom* had conflict, but it wasn't stated as heavily as in a Bollywood movie. You could just feel it. It didn't have a bad guy. Nobody was at fault. It just happened. The fact that the film didn't take moral sides was different. It didn't come up and say, "You bad boy, Naseerudin Shah. You went and had an

affair while your wife was pregnant." It made no moral commitment to the fact that it was wrong. It was just an event that happened and therefore these were the circumstances they now found themselves in. And this was never questioned by the audience. He never got called bad. That was what made it different from other Indian movies. That and the fact that the kids were not always mouthing adult lines. That was what made the movie memorable for Indian audiences.

The film had a tough side—the cruelty the little boy experiences initially at the hands of the two sisters and the fact that D.K.'s wife, Indu, won't forgive him for what he's done. But it also had a satirizing side—for example, the party given by D.K.'s friend Suri, where everyone wears bow ties and tries to out-English the English. Was this accurate?

Delhi at that time was becoming less the center of Indian bureaucracy and more the home of the new business class. It had become the hub of exports in India. Whenever I went back to Delhi and asked people what they did, they'd say import-export, export-import, and that covered a multitude of sins. So you're right, Suri was a takeoff of what we call the Punjabi yuppie. The kids' school uniforms were based on a school I went to. The language was similar to the language of two nieces I had. So I started to pick up a lot of things that were going on in Delhi to infuse a sense of reality into what was a very dramatic story. You know, create characters that you actually think could exist. That's what you always have to do in films: have the extreme conflict of drama together with characters that are touchable, reachable. That's what I was trying to do in *Masoom*.

Let's talk about your preparation for the film. Was it easy to find locations?

No. It took me a long time to find the right house for the family, for example. I must have seen a hundred houses. Because I had the images in my mind and I was trying very hard to find offices and houses that matched the images. So in fact the family's home in *Masoom* is composed of three houses. The back garden is one house, the interior is another house, the front garden is another house. So there are three houses I joined together to create the image I had in

my mind. When we came to shoot the climax at the railway station, I had to hide my cameras because we had no permission to shoot there. I'd get my actors to walk and say, "Okay, where can I put the camera?" When you see Naseerudin Shah stepping out of his car or the kid stepping off the train or the two meeting in the station, they were all hidden-camera situations because it would have taken too long to get the right permissions. It would have been too complex. I just hid the cameras in places where the authorities wouldn't be able to see them. We'd get the actors primed, then wait for a train to come in and start to shoot. Then I did the wide shots of the car park and went over to my own house outside Delhi and Gulzar's house and shot some of the close-ups. So there was very little preparation. I'm a very instinctive director. I still am. Of course, if you're shooting big action scenes, you have to do storyboards because the setup takes so much time to pre-pare. But I've always been a very instinctive director on how the choreography between the actors and the cameras should be.

The children in the film were brilliantly cast. Was it hard to find them?
The kid who plays Rahul was in a commercial. Of course it was a big cheat. He was such a beautiful little kid, your heart would go out to him. I went to meet him; his parents said, "It's up to the kid." He said, "No, I don't want to do it." I was already recording the music for the film, so I invited him to the recording theater and he got interested and said yes and then the parents said yes. It was a very strange thing, because he hated girls. So there was no way I could get him to touch any of the girls. There was no way I could get the girls to touch him. There was no way he would let Shabana touch him. And sometimes if I wanted that feeling of touching, I would tell the girls to do it in the shot and not do it in rehearsal. And I remember one time he almost hit one of the girls because she came and embraced him. But of course what I was doing was rewriting the kids' lines on the set. I'd see what they were saying naturally, and then rewrite their lines. So I was con-stantly adapting the film on the set for the kids. The older girl, Urmila [Matondkar] had done a movie before, so that's how I found her. She went on to become a huge star. Very sexy. And the girl who played

Minni was a little girl that Gulzar had seen when she came to sing in his house, and he had suggested her to me. She was not from a very well-to-do family. And I remember that when we began shooting she was very thin, and then she became quite chubby because there was food available.

Did you have much time for rehearsals?
I didn't do any rehearsals.

So the first day you arrived on set, that was it?
Absolutely.

This didn't create any problems with the kids?
Not at all. A lot of the scenes with the kids were created on the set by watching the way they behaved and then writing around that or creating shots around that. That's the reason the children are so good. Because rather than giving the kids a script—you know, "these are the lines you have to say"—it was "say something like this and see what happens." It was an attempt to create an atmosphere of play and then to capture that atmosphere. So the kids created their own mindsets and played very serious games with each other, because it was play and not work. And my job was to capture that play. So I had to be constantly adaptable in order to catch everything.

How did you work with your DP, Pravin Bhatt?
The good thing about Pravin Bhatt is that he's a really gentle person and doesn't have the ego of a DP. That was very important for me. So that if I was doing something wrong, he would say to me, "Well, how about this?" There was no imposition on me. I was allowed to evolve. It was a beautiful way to work with somebody. Since then I have worked with DPs who feel very strongly about their particular art. And it's a totally different way of working. So thank God that in my first movie I worked with a DP who was totally giving, who said, "Okay, if you want to do it, you do it. But watch out for this or watch out for that." I would just say, "Okay, I need a closer shot or a wider shot, then he would give me a lens. From what I can remember, there

wasn't that much camera movement in *Masoom,* but the choreography was something I was playing with to the point where I covered a whole scene in a single wide shot and used the choreography of the characters to represent the story and the tensions not only of that scene, but the essence of the script.

How would you describe your technical knowledge at this point?
Zero. *Masoom* was a very instinctive film. It was written instinctively and shot instinctively, with no parameters of what a film should or should not be. To be honest, I had no knowledge of filmmaking. I remember the day before I left for the shoot, my editor sat down and started to explain to me the concept of "crossing the line." I had no idea! I'd never seen a Steenbeck. I'd never been in an editing room. I didn't know that a negative comes out and then you make an internegative. I still get confused sometimes! So it was one of my most instinctive films. And I still do that. When I get into a film, I still forget technique and just shoot instinctively. So I didn't know anything. But I always remember asking myself, "How does what I'm doing help the storytelling?" For example, I remember shooting the scene where the boy first comes into the house. There are no close-ups. It was a very long scene, but the way it was choreographed meant you realized that everybody was now separated. So, for me, part of the story of what happens when the boy arrived was in the way I choreographed the scene: the way Indu called her children toward herself, then went upstairs and left D.K. on his own with the boy. I remember my assistant saying, "Aren't you going to shoot some close-ups?" And I said no, because I'd never thought of film that way. I never thought of film in terms of mid-shots or close-ups or wide shots. I'm now learning that there's something called coverage. And it's only since I've come into the studio system that the concept of coverage has come to me. Because on *Masoom* my shooting ratio was three to one. So I only shot three times more negative than actually went into the final cut. Which effectively meant that I gave no leeway to my editor at all, except in terms of minor things. It was a very precisely shot film. But within that precision it was totally organic. Sometimes I was writing and shooting at the same time.

I suppose this was also a consequence of directing a low-budget film.
Yeah. I often wonder whether, if I shot the same scene today in a Hollywood movie, I'd have ten executives and five producers saying, "Why are you taking long shots? Why aren't you taking any close-ups?" I'd have to say, "Because I don't need them." Then they'd say, "But the studio wants them." So your instincts start to waver. But I realize that in *Masoom,* even in *Elizabeth,* there was a point where I was asked why I didn't take many close-ups. And I would just say, "I don't need them." But I know that if I do a big Hollywood film, the studio would look at the coverage and they would say, "You're not covering enough." And the concept of directing, it's a contradictory concept, so you're asked to explore your vision as a director—that's what they say to you, anyway—and on the other hand they're telling you to do a lot of coverage. So the two are contradictory because the only way you can explore your vision is by being specific.

How did you feel when you were about to start filming?
I can never remember feeling stressed out about anything except stock. Stock is very expensive in India, so I got obsessed about running out before I'd shot the whole movie. I can't remember any other tensions. I can remember going off to this hill station in Mussoorie and wanting to go up and my producer saying no, because he was scared that somebody would get hurt. I remember getting the crew ready at night and not telling the producer that we were moving out and climbing the mountains and wouldn't be back until the next day. We just took off before the producer woke up! And my crew loved every moment of it. I can remember shooting songs by literally sitting on the roof of a car and driving through the mountains, looking for locations. When I spotted something, we'd get the camera and the actors out, start filming, then get back in the car.

How would you describe your own role on the set?
I think what a director doesn't do is as important as what a director does. I don't like to impose myself upon a film. Otherwise, why do we have great actors or great DPs or great set designers? I like to influence

people in order for them all to be thinking generally in the same direction. Not exactly in the same direction, because if everybody thought in exactly the same direction, the film would become one-dimensional. It's exciting that an actress can be performing with one thing in her mind and the lighting has been done by someone with something else in their mind and I am choreographing it with something else again in my mind. As long as the banks of the river are defined enough for the audience, they'll feel that the river is deep and raging.

Were you helped on Masoom *by the fact that you'd been involved in the writing process?*
Absolutely. These days, storytelling and directing are separated from each other. The studio says, "Here's a script and here's a director who interprets the script." I'm far better when I'm involved in the storytelling. I find it difficult to direct a script if I haven't been involved in the process of walking through every door and wondering if it's the right door to walk through. Writers say to me, "Why are you unraveling everything?" But I'm not actually unraveling it. I'm allowing it seep into my subconscious and making it mine. Once I make it mine, I have no problem at all making the movie. It's when I'm unable to make it mine that I have problems. I have enough experience to direct a film with skill. But I don't know if it's right or wrong. How do you know if this is right and this is wrong when the options are a million? How do you select? So the only way I know how to select is when something in your subconscious tells you, "This is the way to do it," and you go with that instinct. So for me it's very much the expression of instinct. Because directing for me is visual storytelling. It's using a lot of things available to you, like music and camera. I get uncomfortable with too much definition because ultimately it's the expression of life itself. So I let it go and wait for the answers to come. Because that's what I've always done. The experience I use to direct is my life experience. It's my understanding of the universe. And if I can get that understanding into a performance, into the way the camera moves, into the music, then it makes it very meaningful in many, many different ways to many, many different people.

Do you think one of the aspects of your job as director is to preserve spontaneity?

It's more aggression than spontaneity. It's almost attacking structure. Because part of our problem—all of us, including me—is that we get so afraid of chaos that we get addicted to structure. Because we are afraid of the infinite. When I was a kid I used to sleep on the terrace in Delhi, and there was no light or sound pollution, so you could see the whole universe. And I remember as a twelve-year-old looking out and trying to imagine an infinity and breaking down because I couldn't stretch my mind toward infinity. And that breaking down and crying and my father telling me, "It's okay, you'll understand it one day," was the fear of not knowing. But ever since then that's all I've been trying to do, trying to stretch my mind to embrace infinity. And there's only one thing that stands against you in your attempt to get to infinity, and that's structure. Because we're afraid of it, we tend to create labels and then to live in small rooms of structure. And so when I talk about chaos it's a two-headed thing. The aim of creativity is not only allowing spontaneity, but actively provoking myself to create a little bit of chaos. So that you're throwing everything into the air and then the right things start to fall in some sort of pattern. So it's about letting the pattern emerge rather than trying to create the pattern. It's not indiscipline. It's a large part of the work that you've done before you begin. You've gone through the trauma of breaking structures and being chaotic before you get onto the set in order that your mind can travel in every dimension. So when you come onto the set you've experienced all the dimensions and have the confidence to allow those dimensions to take place. And if someone suddenly rewrites the script at that moment, you don't worry because you've been through every dimension.

So a lot of the chaos you're talking about comes at the script stage?

Right. A large part of the chaos I'm talking about, of breaking down structure, comes at the script stage. There are huge examples of that in *Bandit Queen,* huge examples of that in *Elizabeth.* It's about peeling layers away to make a scene mean ten different things to ten different

people. For example, there's a scene in *Bandit Queen* where a twelve-year-old girl is married off to a thirty-five-year-old man who effectively raped her. Later she left, and that and many other things led her to be a killer bandit, Phulan Devi. And she comes back one day to take revenge on that man and ties him to a stake in front of the village and beats him up. And I talked about that with the actors. I said, "The script says she beats the man up. The event is that she beats him up. Let's look at that event. What is revenge? Ultimately, is revenge guilt? Are you avenging the other person because you're effectively revisiting the same event and imposing upon yourself the same humiliation that you suffered then, because all your life you have to go on doing it. So does a girl who has been raped have to keep revisiting that event? Because hate is one way of hanging on to trauma." So we talked about many many things, about what it means. And what we decided was that all of them were true. And when we shot it, I told the actress and the other actors, "It doesn't matter what you feel, as long as that moment is honesty. We've talked about it so much now, just let it go and leave it loose. Let's see what happens." I had a grip from New Zealand who saw what happened and he said, "My God, no one's going to allow you to do that in the West," but I said, "I'm going to do it." I waited till the sun was setting. I placed the camera and I told the DP, "This is what she's going to do. All I want is for you to operate the camera, which is going from side to side, and be in rhythm with her emotion. Watch her emotion. If she's getting into a frenzy, go faster. If she's giving herself a pause, give yourself a pause. And let's see what happens." And it was a great scene because I'd allowed everyone to indulge in all those talks. She did it. So the same scene which was about one thing became about ten things.

You think that's true of cinema in general?
Yeah. The greater the movie, the more information you compress in it and then allow the audience's subconscious to unravel it. And the difference between a really good movie and an okay movie is probably the fact that at one level the audience isn't aware of that stuffing. They've just said, "Hey, watch this. This is all it's about!" But on

another level, because the people who made it cared about it, it was stuffed full of bits of information which the audience cared about.

Let's go back to Masoom. *What did you find hardest about directing it?*
Directing Shabana. Not because she wasn't a great actress. Everyone else's performance was me, very much me, in fact Naseerudin Shah *was* me. But Shabana's performance was her own. And I realized it's very difficult to direct people that you know extremely well because all the other aspects of your prior relationship start to impinge on you. So it's not a clean play anymore. It's a complicated play, complicated by previous ways of relating to each other, previous ways of saying things, of playing games with each other. Which we all do, I think. When you're working with actors, you're playing games with them on set. And the actors are playing games with you. I realized on *Masoom* that the best people to work with are people that you're extremely excited about working with because they're great people, but with whom you have little contact off the set.

Better not to be too close?
Better not to be too close. And if there's a terrific relationship on the set, it's better to let that relationship have its incredible attraction. Because when you wake up in the morning, you've got to go to the set and you've got to enjoy that relationship. If you take that relationship outside the set, the sublimation of that relationship can happen out-side the set, and then you discover that you're two ordinary people. Whereas on the set you're playing the games of extraordinary people. You're the director and they're these extraordinary human beings, because it's all drama. Off the set, we're all the same: we're ordinary people. And that becomes a problem because your ordinariness can start to leak into the set.

Let's talk about postproduction. Who edited the film?
I edited it with some friends of mine who were very very good editors, one of the best known in India from the Film Institute. They'd been friends of mine for a long time, and all the time I was an actor they'd

been encouraging me to direct a movie. So they came and edited it, a husband-and-wife team. It was quite an interesting cutting job. Editors like lots of material to give them options. When you've shot a film three to one, there's not many options. But to be able to contribute to a film within those constraints was quite a lot. Quite a skill.

Did you learn a lot during the editing process?
I think that watching the editing I learned the value of holding back. Directors are often so happy with what they've shot that they don't want to lose any material. You have to hold back from that. I don't think there's a single scene that I shot that wasn't in the movie. So it was more about how much to leave in, how much to take out. Some of the beginnings and endings of scenes were not used. Some close-ups were not used. Some bits within scenes were not used. But that's it.

Was there anything about the finished film you didn't like?
I almost have to close my eyes now when I see that bit where D.K. and Rahul's mother are gazing at each other in the boat and the soundtrack is full of music. It was the one moment with me indulging in what I thought was commercial Indian cinema. It was very silly. And even after I'd made the film, I knew it was very silly. So when we started to show the film to distributors, I did a very strange thing. All Indian films have an interval [intermission], and that scene came straight after the interval. So during the interval I'd always tell them, "Oh my God, I forgot to order the tea and the Coke." And as soon as the second half of the film started I would say, "Sorry, guys, the tea and the Coke have arrived but I'm not going to stop the movie." So for the first five or ten minutes after the interval they wouldn't be watching it very carefully.

How did the release go?
The most traumatic part of *Masoom* was the release. When the distributors saw the film, everyone thought, "this is a good movie, this is going to do well." But then it was released on a Friday in about twelve

cinemas, and no one came. I remember going to the first day, and there were five people sitting in the theater. Then on Saturday no one came. Sunday the same thing happened.

Had the film been advertised?
The advertising had been designed by me. And it was wrong. I had an intimate knowledge of the film and had assumed that that intimate knowledge would come across in the advertising. But of course it didn't. Why would people go and see a film with the face of a child on it and barbed wire in front of it? To me it meant a lot, but to the audience it meant nothing. In India when a new film comes out that's been publicized a little and talked about a little, the black marketeers come out in hordes, young boys, and buy up all the tickets. So when you go and see the film, you buy your ticket from them. And when the black marketeers realized I was the director, they were very upset with me because they thought they were going to lose a lot of money. I remember one saying to me in Hindi, "The problem is you made an article film." He was trying to say an *artistic* film! Anyway, Friday, Saturday, Sunday, Monday . . . nothing. By Tuesday they withdrew the film except in two theaters. But on Thursday, for some reason, they started to fill up. Then gradually they had to buy back theaters. Then it just had a huge run. But that was one of the most traumatic moments of *Masoom,* because two of the people who'd bought it, distributors who were friends of mine, would look at me and say, "You've ruined us!" What could I say? "Sorry." And it wasn't just Bombay. Exactly the same thing happened in other territories. In Delhi, Friday, Saturday, Sunday, the theaters were empty. The following Thursday they started to fill up. And I was lucky they started to fill up by Thursday, because if they hadn't, the film would have been pulled by Friday.

What was the public reaction to the film?
It was huge. When I'm in India, people still talk about *Masoom* as my best film. It's my purest film, it's the most innocent film I've done, and people react to that. Also, after its release, it was for a long time the most viewed film on cable, satellite, and television. So by now *Masoom* is a pretty legendary film in India.

Who was its biggest audience?

It was a middle-class audience. They were a little tired of the big Bollywood film, but didn't want something as heavy as an art film. I mean they wanted something far more emotional and relevant to us, something more real for us. On *Masoom,* I had a middle-class person sitting on my shoulder saying, "Give me something much more real, but more relevant and more emotional."

You don't regard yourself as a member of this group?

I only experienced it after taking part in what at that time was an incredible moment in Western culture—London in the late sixties and early seventies, swinging London. I was really, really lucky. I was on the fringes and even then I had an incredible experience. Then to suddenly to come back to Delhi and see Delhi with new eyes was amazing. So *Masoom* was a reaction to that different Delhi and the different people that I found there. And my experience was now contextualized by my experience of the West.

So Masoom *would have been different had you not had this experience?*

I often ask myself what would have happened if I'd become an actor before I went off to be an accountant in London and spent seven years outside India. I think I would have been much more Bollywood, because that would have been my movie experience. In fact, it was more than that. At that time in London everyone was saying, "Have the courage to change the world." So we all thought we were going to change. Now this isn't true any longer. Now in London and elsewhere the addiction to one job and one career is again very strong. But the sixties and early seventies were a time when everyone was dropping careers. I may not have even gone into the movie business if it hadn't been the sixties and seventies. It was a time when everyone was looking upon life as an adventure. So I was very much a child of the late sixties and early seventies. And when I returned to India, I constantly wanted to do things differently. I constantly wanted to think out of the box. I wanted to discard any kind of accepted grammar in the same way I saw the musicians of my time doing with music. I realized what was thrilling about the music was that musicians were dropping

any addiction to the past, any addiction to grammar, and it's exactly what I did when I went back and did *Masoom*. I still remember meeting Gulzar after he'd seen the movie—because we'd had a few very gentle disagreements on how the script should be—and he said, "Now I get it." What he meant was that he was trying to understand my point of view in the context of the existing grammar of Indian cinema, and when he saw the film he realized I was experimenting with a totally different grammar. So he said, "That's what you've done: you've taken the grammar of cinema and chucked it out and developed your own grammar."

Do you think the experience of making Masoom *taught you a lot about filmmaking in general?*
I think what I learned from *Masoom* is that your own instinct encompasses almost everything that you need to make a film. Rely as far as possible on your instinct. Because that's all *Masoom* was: sheer instinct, pure instinct. And it was interesting because I'd never made a film. And I went in with great naïveté. I went to make *Masoom* with no heaviness. I went in to make *Masoom* saying, "I've never made a film before, but I think I have enough intelligence to compete with at least the top fifty percent." It wasn't to be the best director. It wasn't to create the greatest film. It was just to make a film where people would say, "Yeah, he's okay." So don't burden yourself with the need for success, number one. Be totally instinctive, number two. And love what you're doing. That may sound a very strange thing to say. But I loved my actors. I loved the script. I loved the film. I loved everything that I was doing, and I think that showed in the film.

Do you think instinct is more important than technical knowledge?
I'm suspicious of any technical knowledge or technique which has a value of its own. For me, cinema is much more like poetry than like prose or a novel. The film version of a novel is taking prose and storytelling and putting it into the context of poetry. And the great thing about poetry is that it constantly breaks all rules. A great poem is great because it takes fundamental leaps in the way that it does not accept

the grammar of speech. And it doesn't say, "I went there and one day I . . ." It finds a way to force upon you or sting you with the particular emotions I'm talking about by what it *doesn't* use. Because just as important as what you say is what you don't say, what is held back. It is what close-ups you *don't* take. It's the wide shots where you don't quite hear what's going on. So in film it's as important what you don't say as what you say, the space between the cuts, although there's nothing there, it's only imagined space. There's no technical way to do that. It only comes from instinct. The only place I failed on *Masoom* is when I tried to do a montage, because it was an old grammar I was using. I'd said to myself, "I don't know how to do this," and I'm still so embarrassed about it. I still remember trying to make those shots look pretty. And the moment you try to make shots look pretty, you realize that's technique rather than instinct.

Now that you're making bigger budget movies, do you work in the same way?

I now plan a lot. I plan like hell. Especially on the bigger films, on the more-complex sequences. But I then drop all the plans. The advantage of planning is that you've been through all the alternatives. But I can't remember planning with *Masoom.* I just went and I shot it. You see, here's the thing: all my planning is done instinctively when I'm writing the script. To me the world is very visual. So as I'm writing it, I'm seeing it. It's not just a script. It's visual. So I've already engrained in myself what the visuals will be, and it's not very difficult for me to go and do it. The places I select and the way I do it are based on the way I saw the film. It emerges in front of me. And partly I see it because I allow myself to see it. Sometimes I dislike telling people what I see, because then there's no play, because then the surprise, the adventure, has gone. I quite admire directors like Hitchcock, where every detail was discussed in advance. On the other hand, what did he leave for the set? Nothing. So why was he there? I believe in a much more organic process. I also believe that by focusing so precisely on what is going to happen on set, you become less able to be organic and change when change is required. Often you get onto the set and

things won't be the same. The actors won't be the same. The light won't be the same. And part of the adventure of filmmaking is the unknown. To adapt your vision constantly to the unknown. That in itself is a very adventurous thing to do. So I'm not a controller. I don't control. I adapt. I am a facilitator.

Do you think your experience as an actor in Bollywood has helped you with directing in general?

Yes, in terms of the director I am now, the learning process was Bollywood. For example, in *Elizabeth* there was no shying away from melodrama. There was an acceptance and embracing of melodrama in almost every aspect of *Elizabeth,* whether it was the production design, the colors, or whatever. I remember a point where everyone was undecided how to introduce Elizabeth at the beginning of the script. I kept saying, "She's dancing." It came very naturally to me that music and dance would express the romance of the moment. And if you look at the film, that's exactly what I did. *Elizabeth* is a very melodramatic film and it's a very mythic film. The narrative surge of *Elizabeth* is very Bollywood. Before I directed it, I had to sit down and decide what kind of director I really was. You can't decide what kind of director you really are until you know *who* you really are, because all the expertise in the world will leave you when you have to make a thousand decisions a day, and then you'll fall back on your instinct. And if you make decisions that don't express your instincts, you'll find that you start to move from who you are to what you're doing—from instinct to technique—and you'll start to see two different styles in the film, and the results will be discontinuous, disharmonious. Actually, I've seen one director who can unite instinct and technique. That's Ang Lee, who did *Sense and Sensibility.* If you'd shown me *Sense and Sensibility,* I'd have said that this man has lived in England with English literature all his life; that he was probably an Oxford don or something. But I'm not confident enough to do that without who I am constantly leaking in. I can't do anything, whether it's making a film or writing or talking or living or falling in love without who I am leaking in, constantly knocking at the door. When your world

becomes very seamless, as it has for me, you feel uncomfortable if you try to create walls of separation between who you are and what you do.

Any idea what you would have done if you hadn't directed movies?
I'm not so much a director as an adventurer, an explorer. Before films were born, you know what I'd be doing? I'd be exploring. I'd be going places, discovering new cultures. Now we do it through directing films. It's one of the main reasons I do films now. Take my Mandela project [*The Long Road to Freedom*]. I've already spent a year in South Africa talking to Nelson Mandela, talking to all the people, understanding the culture of South Africa, understanding what happened, apartheid. So although I haven't made the film, I've already come away with a great experience. On *Elizabeth,* I had to learn everything about that part of England and what she was all about. Even on *Four Feathers,* I was learning about the culture of the British army and so on. And the best way to learn about your own culture is through other cultures. Other people become a mirror to discover yourself. Each culture holds up a mirror to your own. And in constantly dealing with this, you discover yourself.

Emir Kusturica

DO YOU REMEMBER DOLLY BELL?

Can you tell me a little about your background?
My father worked for the government first as a journalist then as one of the deputy ministers. My mother was a clerk. So we belonged to the middle classes, neither very rich nor very poor. I think that this social environment was very important in terms of my development as an artist. I'd never shown any inclination to artistic activity when I was young so it was surprising when I finally started making movies. But if I think about my parents, who they are and what they were doing, this could come from the fact that for two generations there were no peasants in our family. At the same time, I grew up on the outskirts of Sarajevo where a lot of poor people also lived. So although I was better off than the others, I was exposed to things that other people living in Sarajevo missed: beautiful Gypsy girls, thieves, people dying early, people giving birth early. Everything was somehow much more intense there than in any other place. Given that I came from a family that was quite middle class, if there was such a thing during communism, I'd say I was lucky because—although I didn't know I was going to make movies at the time—all these contrasts, all this intense perception of life, came to me at a very early stage in my life.

What was your main interest when you were growing up?
Football. I wanted to become a big football player but never did. I played quite well but, as in any other activity, you need one more step to become the best. Football in my neighborhood was mostly a matter

of social identification with a group. If you didn't know how to play football, you were a nerd—someone who wasn't allowed to share life with the rest of the group. And, growing up with football idols, it was very important to me to be accepted by the group. I think it's the same reason why people today share their warrior feelings when they go to a football match. It's like going to a small war every Saturday, or a simulated war. So my football idols were much more important for me in the beginning than John Huston or John Ford. But somehow, when I think how film directors need to see things and put them into perspective, it's very John Ford–like. It's not like cinema today because these days it no longer has any perception of time and space. A footballer like Maradona is sensing what is out there a hundred and ten meters away from him on the corner, whereas cinema today has no sense of perspective, no layers. There's no game that's played properly like it used to be in John Ford's period.

Your films are full of brass bands and Gypsy music. What kind of music were you exposed to when you were growing up?
When I was growing up, music came into my life mostly in the form of Italian canzonas, *Venti Quattro Mille Baci* and so on. I and my friends listened to all this music in these small community clubs where we tried to imitate it. These were the first times we played in our bands. They were funny, clumsy attempts to imitate what we'd heard. But they still revealed a wish to identify ourselves with the rest of the world. So music was very important to us. The next step for me was the punk music that was coming from London in the seventies in which the outrage against the Conservatives was expressed by bands like The Clash and the Sex Pistols. This was another important step. The last step today is turning our traditional music into a worldwide form of communication.

Did your interest in film follow the same pattern as your interest in music, in the sense that you were interested in and inspired by what was happening in the West?
Yes. I'd say they've been very much parallel activities. In fact, the first

time I made money was by shoveling coal in the cellar of the Cine-
mathèque [in Sarajevo]. Then, instead of being paid, I went to see
some Hollywood movies, Frank Capra and people like him. So this
was basically my first step into the cinema.

What did you see by Frank Capra?
It's a Wonderful Life.

Did you like it?
I liked it very much because, unlike today, this was a period when
Hollywood was still good at propaganda. Hollywood has always been
the center of the idealistic world: art that idealizes life. And until a cer-
tain point it was very beautiful. I think Frank Capra is one of those
who represent it at its best. Also Ernst Lubitsch. And many others. So
the first steps from my family into the world of music and cinema and
football was somehow—and this is a good part of Communism—in
those places where people socialized: social clubs. And since Tito was
not an orthodox Communist, I had an opportunity to learn how to
play music and football and to get close to cinema.

Which was the most important to you when you were growing up? Film,
soccer, or music?
In the end it was film. Because when I was given the chance to study
film in Prague, I realized that, unlike any other activity, film has the
capacity to synthesize everything else.

Before we talk about film school, tell me a little more about the films you
were seeing in this period. Were you seeing films from the West or from
Yugoslavia?
I didn't see Yugoslavian films in this period. I was watching spaghetti
westerns by Sergio Leone. Also, there was a particular atmosphere you
could find in Fellini's movies that I liked. I was very young, and my
mother used to let me go to the cinema with my relatives or with all
my elders, all the neighbors. And going to the cinema in Sarajevo was
like a fiesta: it was more about celebrating life than just concentrating
on the plot. It was about the jokes you could hear during the screen-

ing and many other good things that could happen. There'd be people who were trying to outdo the cinema by bringing their birds into a Hitchcock movie and throwing them in the air in the middle of the most intense, most suspenseful scene. So it was very funny to be part of these screenings. Of course, no one was expecting me to become an artist. But because my life with cinema as well as football took place on the outskirts of the town, where there were a lot of outlaws, my friendship with the older brothers of my classmates was bringing me into contact with people who were already criminals, pickpockets and many other things. So I was very close to the sources of life which I found very cinematic. And as I said, because I was not expected to become an artist, this helped me a lot when I finished film school and was trying to place myself in the middle of my memories. Because you need something to say if you're going to be a director. And I had many things, all these experiences, from first love to a newsstand robbery or whatever. It was a kind of low-key participation on my part. I was not doing it myself, but I was observing from very close. Maybe that's why I became a film director.

Was there a moment when you can actually remember thinking, "This is what I want to do"? I think you went on the set of a film being directed by a friend of your father, Hajrudin Krvavac, which was called Walter Defends Sarajevo.

Yes, Hajrudin was the one who helped me. I was not a bad student, but I was always on the borderline. So my father said, "Why don't you help him? Why don't you go and do a little acting?" And for me it was a great experience to be part of this big circus. In the end, the circus got into my veins.

Did this experience inspire you to make your own movie?

Yes. It was the kind of movie where I made a lot of mistakes in order that I could make good movies later on. A small amateur movie makes no sense at all except as the first contact with the camera and the first time you concentrate on what you've seen in other movies. And you can get close to the major secret of cinema: "How close and how far from somebody and how long?" The best thing about the movie was

that the screening was stopped twice because the bulb had burned the film. The excitement around all of this was very cinematic. I'm not talking about the quality of the film, but the fact that it got burned. It was good that this happened because the movie itself was very bad.

What was the film about?

It was a very superficial social drama about a worker who visits his classmate and falls in love with his classmate's sister. And when the friend realizes the worker's in love with his sister, they get into a fight. Very stupid. But somehow, as I said, an exercise of "how close and how far." It was very important for me that this movie was not a great movie because if it had been I probably wouldn't have made any more movies. I would have started drinking or using drugs. So my development was very slow up to the decision to go to the film academy in Prague.

What did you do to get into the film school in Prague?

I made a kind of photo scenario about a city from the morning until the night, which was pretty good. And I made a film inspired by a story by Ivo Andrich. It was about a young man who wakes in the morning and hears the bells of three different churches, Roman Catholic, Serbian Christian, orthodox Muslim. He spends his life wasting time in bars and imagining a more beautiful, idealistic life. Then he sees a person behind the stage in the theater, a woman who's a dancer. He enters the theater and falls in love with her. This was the film I used to qualify to study in Prague. But I also got in because I was young and had passed the exams.

How did your desire to study film go down with your parents? Were they supportive of you?

Very much. They were afraid that if I stayed in Sarajevo I'd only be a few steps away from small-time criminals. At the same time I was on the verge of becoming a professional footballer. But I had a bad ankle injury. That's the reason why I never played professionally. So my ankle injury launched me into the world of cinema!

Tell me about the film school in Prague. Who taught you?

Otakar Vavra was my professor. He was an incredibly experienced director who'd made about thirty movies. He was very skillful and had survived many films and many periods. He was alive in the first republic, which was the Democratic Republic, then had lived under the Fascists and Communists. He was an incredibly good professor. And I must say that for me, as a man from Sarajevo, Prague opened a wide range of humanistic activities and humanism in theater and cinema. The heroes in our literature and our cinema are mainly very aggressive, very absurd, very macho. In Czech literature, by contrast, everything was much more ironic, distanced. Much more humanist. So this helped me to form my vision, my approach to many problems.

Do you think it formed you as a filmmaker?

Yes. But studying isn't the same thing as becoming a director. You don't become a director the moment you say you are one. You need time to train yourself. So, with me, it wasn't until the third year, when I had a good plot with *Guernica,* that I actually became a director.

Can you say something about your training in Prague?

There was a very good habit in the Prague school. It's a first director's exercise called "working process." You find any process—you can go to a bakery or whatever—and then with the theme "how close, how far?" you express the story. And I did an exercise where I filmed someone changing a car tire. It was the first exercise where I felt I was into the cinema, because of the possibility of changing angles. For example, because the tire was flat, the man was pumping it. I put my camera behind him so he was appearing, disappearing, appearing, disappearing. Next, the part he'd just dismantled from the tire rolled down the street and I followed it through the city. It was at this point I realized that you could follow many details in an action that someone is undertaking. So this was the first exercise I did, after which there were another two or three that were not the best, not very good, some of them very bad actually, because it was difficult. Then in the second year there's an exam where you work in the studio. You have to

tell a story in ten minutes with a huge camera and light and so on. And I was shocked how difficult it was to work in a studio, to work in a small space and make something unusual rather than classical and standardized. This is what I did up till *Guernica,* which was, I now know for sure, the discovery of two different aspects of cinema: time and space. It had a very good plot and was a movie that extended into beautiful spaces and combined fiction and photographs. It was reality being exported into a mythical story.

What was the story of Guernica?
It's a story about a Jewish family living in Paris in the period of the Nazis. They're taken to some kind of anthropological examination to see if they're Jewish or not. And the information that reaches this boy they hide in their apartment is that they're Jewish because they all have big noses. So the boy gets scared and takes out a razor and cuts off the noses from all the family photographs. He then remembers the time when his father took him to an exhibition in Paris where Picasso's *Guernica* was being shown. So the end of the movie is that he puts all these noses he's cut out of these photos into his own *Guernica.*

What was the reaction to the film?
Very good. My professor told me, "This is a serious movie." And I recognized why. Because every element of the movie somehow hit the mark. The casting was very good. The way I moved my camera was good. So the movie was a kind of breakthrough. It's very important to recognize that you've done something influential for your future. After this, I also made some TV films, *Buffet Titanic* and *The Brides Are Coming.* They weren't as good as this one, but they still had a great amount of energy invested in them.

Was there a moment when you realized you had a gift for filmmaking?
This was the moment I discovered that one day I might make a good movie. Because I'd discovered many aspects of cinema that are necessary to make an organic movie. Then what came later with *Dolly Bell* was that I found a story and an existential moment that were con-

nected to my soul and to my past. And when you combine something you've experienced with the knowledge that you have what is needed to be noticed in cinema, then you can say you have a battery that can light the darkest tunnel in the world.

Once you'd graduated, you returned to Sarajevo and taught at the academy there, as well as making the two TV films you've mentioned. Can you say a little about how they came about?
Buffet Titanic was a story based on the Ivo Andrich novel in which there was an interesting relationship between the perpetrator and the victim because they were both the worst people in their communities: the worst Croat and the worst Jew. I found a way to express myself and my need to have strong scenes by using material from *Titanic,* the movie that was made in the 1930s. The film was partly intercut with pieces from another fiction and partly it was very exciting. But looking at it as a whole, I wouldn't describe it as my best work. The other one, *The Brides Are Coming,* was much more organic in the sense that every piece corresponds to the whole thing. It's not like one particular fragment is good and then another piece doesn't work. And stylistically it was very provocative. It was about incest in a village in Bosnia, so it was not very welcome.

Did you have problems with censorship?
Yes and no. It was shown and then it was never shown again.

Did you think of it as a success as a film?
It was a very significant experience for me. I learned to combine long shots and details and discovered how nature could be the best background for the state of psychology of the actors—how it could express their state of mind. But it's like with my concerts: with all these movies, I was always creating a lot of excitement. But it was a slow way of getting to *Dolly Bell.*

But you were still very young when you made Dolly Bell?
I was twenty-six.

That seems very young to make a first feature film.
This is the advantage of this country that doesn't exist anymore.

How did you meet the writer Abdulah Sidran, who wrote the script of
Dolly Bell *with you?*
He came to me after watching these two TV dramas and told me,
"You don't have to work with anybody else, but you have to work with
me." And then he brought thirty pages of the script, which was the
story of something that had happened to him. It was about a woman
who'd been brought to his village in preparation for being a prostitute,
plus the very touching story of his father, the way he died. The best
thing about his script was the language, the dialogue. He has a very
musical ear, people talk very well. But although he later became a very
experienced screenwriter, he didn't have much experience at this time.
So I took what he'd written and wrote a technical script. I tried to
write the whole thing in a way that was needed for cinema, not for lit-
erature. So I did more the structure. He did more the dialogue.

Did you work on it together?
At the time I couldn't work with him. I was kind of angry with him
because he didn't understand that between the two media, writing
and filmmaking, there is a big difference. Whatever has been written,
if you don't find an equal language, a cinematic language, you just
become an illustrator of what somebody wrote. So I had to find some-
thing that came deeply from my own perception of life and cinema.

One might call Dolly Bell *a coming-of-age movie. But it was also quite
satirical in its depiction of the father and the way the whole family sat at
the dinner table discussing Communism. How did you think about it at
the time? Satirical? Autobiographical? Both? Neither?*
First of all, it corresponds historically to the time when Tito died. If
he hadn't died at that moment, I don't know if the film would have
been made. Maybe it would. After all, there was a great wave of Ser-
bian and Yugoslav cinema in which they really hated the Commu-
nists. I never hated anybody—including Communists. It was my

experience in the academy in Prague, where I learned how to create an ironic distance from whatever happens and to make life bearable at difficult moments by using comedy and humor, that was the dominant factor in defining the style of this movie. At the same time, I was juggling with the ways history and politics and many other elements affected the life of my hero and the others around him.

So you took the irony, the satire, from the Czech school but the content was more autobiographical?
Yes. And it was softened by the poetry that I've had in my soul since I was a kid. You know, you grow up, you fight, you are a street fighter, then you go to school and you discover that you are basically a very tender person. This is why I am very thankful to cinema. Cinema discovered my nature, which in this movie is particularly visible.

One critic said rather unkindly that your films are about a Yugoslavia that no longer exists. Do you think your depiction of Sarajevo in the sixties in Dolly Bell *is a realistic or satirical one?*
When my critics were accusing me of being a traitor, a Serbian supporter, I wrote that if they destroyed Sarajevo completely they could always reconstruct it based on my movies. So I think it was the spirit of these people I was preserving in these first two movies. The point is that they want to insult you by saying you've made one film and nothing more which is absolutely stupid and vicious. Especially as I've made eight or nine movies. But what is true is that you can't repeat your first movie. You've been compiling your experiences for twenty-five years to put into it, so its sincerity is unrepeatable. It's like a first love. How can you repeat a first love? You can never do it.

The film's central character, Dino, is a rather gentle, dreamy youth. Was he based on you?
Yes. I tried to put myself into all characters that were at the center of the film, including Dino. Many things I intended to do in my life, Dino was doing. Even if I wasn't hypnotizing rabbits, I have a lot of connections to animals.

Animals figure in all your films, whether they be turkeys, rabbits, geese, or monkeys. Were you surrounded by animals as a child?

Yes, many. Dogs, mainly. And cats. But the point is something else. It's that, like Fellini, I have a constant need to have a circus around me, whether it's animals, people, sensations. It's like creating a good environment for the movie I want to do.

You mean you use animals in your movies because you see the circus as a symbol for cinema itself?

Yes, absolutely. I am against the notion that cinema is storytelling and a film director is a storyteller. Storytelling is for a talkshow, not for the cinema. It's one of the aspects of cinema, but cinema is a much more complex picture of the world than storytelling. It's like saying James Joyce is a storyteller, which would be completely stupid. Of course, there are storytellers. But if you read Shakespeare or Chekhov, you cannot say they are just storytellers. They had a story that they turned into a drama. But drama is not the same as story. Drama contains many aspects of what needs to be built. It contains many things.

Going back to Dolly Bell, *was Dino's father, who treated suppertime as a Communist Party meeting, in any way modeled on your own father, Murat?*

My father, Murat, wasn't the same as Dino's father. But he did some things that were very similar. Each time something big happened in history—for example, when the Egyptian president Nasser, turned his back on the Russians and went to the West—my father would get drunk and come home and wake up the family. And we thought something very strange and very powerful had happened. Then he'd tell us in a pathetic voice that something very sad had happened in the history of humanity, that Nasser had moved from the Russians to the Americans. He was basically using the stage of the family to announce these tragic moments of history on the world stage. So the father in *Dolly Bell* was, like Dino, modeled on many people I knew and then somehow generalized through my own spirit.

Unlike many of your later films, Dolly Bell *doesn't feature any gypsies. But it does feature kids who are very marginal. Was it a conscious decision on your part to look at this world? Did you feel it hadn't been adequately explored in existing Yugoslav cinema?*

I was speaking with the American writer Toni Morrison the other day, and she said, "You Serbs are like African-Americans." I said, "Yes, we are the blacks of Europe." Somehow we feel like this, even if it's not exactly the truth. But if you look at how we play basketball, how we do physical things, play music, you could come to this conclusion. But the gypsies, who I was surrounded by when I grew up, are the most cinematic element of my cinema. Why? Because these people haven't changed for thousands of years. They haven't been affected by industrialized nations, medieval ages, fortresses, killing, empires. They always stick to the basic things. They're the most bizarre and most cinematic phenomenon at the same time. For example, when a Gypsy guy takes out a mobile phone, it's already bizarrely cinematic, unlike if the rest of us do it. And people sometimes call the Serbs the gypsies or the blacks of Europe because we're unpredictable, crazy, whatever, even though we've produced names like Nikola Tesla and many incredible scientists and Nobel Prize winners. So we're a people who may not have created the best system in the world but who achieve a lot individually. Dino somehow represents this kind of very strong individual. He could have been Nikola Tesla or a thief. He could have been the best football player in the world or a mass killer.

A footballer or a film director?
Exactly. What you become is always very open here.

Were you fascinated by gypsies as a child?
I admired them. But I never counted myself as one of them. My stories are often about criminals and gypsies, but I've always kept my distance even when I was very close to them.

One writer described you as being interested in marginal people with an ecstatic relation to life. This seems to describe very well the Gypsy mentality. Do you think there's a Gypsy element to what you do?

Yes. It's absolutely defined by those first steps I described when I recognized that the environment I grew up in would be the thematic source of my work. My inspiration always came from the margins, and this corresponds to my political vision of the world. I was never political in the sense of belonging to a political party. But since the strongest impact on my mind was when I was growing up, I never stopped being on the side of these people. Even in my last movie I was trying to do this. My major aesthetic goal was to see aristocracy in this environment, to observe a certain aristocratic feeling in it. Remember when the father is holding the Communist Party meeting at the dinner table? There is a certain procedure, a certain protocol that he observes. And this is what I've continued doing all my life. In every movie I do. It's not just that I've never spoken badly about marginalized people. I've always tried to make them even more idealistic than I believed they could really be.

A lot of the dialogue in Dolly Bell *was in Sarajevan slang. Was this significant?*
It was how I heard people speak. Plus, I was disgusted by the way television looked for aristocracy in the way people spoke rather than in human emotion. This was the first time that the people of Sarajevo identified themselves with the way people spoke on screen.

Once you had the script for the film, how did you go about raising the money? Was it easy or difficult?
It wasn't very difficult because it was a film that was financed by television and the only existing state film production company. Luckily, the director who had taken me on to his movie to act [Hajrudin Krvavac] was on the committee and was pushing it along. So he helped me a lot.

No anxieties on the part of your backers, then, that you hadn't made a feature film already?
No. I was lucky. It's incredible how I could go through life like I did. It was always one thing after the other. Sometimes I can't believe my

luck. But this is me basically. I'm like my mother. The energy that goes through the world, that goes through everything, it goes through me, too.

How did you go about casting? Had most people had professional experience or did you use quite a few natursciks *[untrained, amateur actors]?*
Natursciks were part of my style. I hadn't studied theater, so I didn't know a lot about the formal rules of acting. I was very afraid of getting into this type of acting because I hate it deeply and profoundly.

What type of acting do you mean?
The way they pronounce everything when they get onstage. The way they artificially relate to each other onstage. In the theater it's fine, of course. But as soon as you get close to the camera, the rules change. And I was very afraid of this and therefore very keen to find people who came from life. Slavko Stimac [Dino] had done five or ten movies before and had never finished school, so he was perfect for the cinema. I found him and many of the others—except perhaps the mother and father—among the people I'd seen in Fellini's movies. I mean types rather than actors. Of course, it took longer than normal to work with the *natursciks* but, in my opinion, the result was very good. I still believe that most actors, except the best of the best, bring a kind of routine to the screen rather than the excitement that people who are not actors can bring.

I imagine children are the same. They aren't trained, therefore they can reveal something completely authentic in front of the camera.
Exactly. It's the same thing.

Was it hard to cast the film? For example, did you know immediately that Slavko Stimac would be right for Dino?
Absolutely. But I knew this because I'd seen him in other movies. But, as I told you, he'd only appeared as a nonprofessional.

How did you prepare with your DP, Vilko Filac? Did you have a clear sense of how you wanted the film to look, where the camera should be?

Vilko and I learned in Prague that the director and cinematographer have to be very well prepared in terms of how to direct the people on the set. We even made drawings so we wouldn't lose control when we were shooting. Most of the time directors have great ideas, but when they have to cope with the actors' psychology and situations on the set, they just go for the most simplistic way of filming a scene. Directing is then reduced to how to get people close to the table, how they sit and how they say the dialogue. So we were doing it the other way round. We wanted the strongest weapon of our movie to be the moving image. And from that time up till now, I've almost always treated dialogue like a hum, like noise that has a meaning. So the dialogue was always—perhaps not always, but most of the time—cut, reduced, extended, depending on how beautifully we were able to move the camera forward and back. In other words, the dialogue was the thing that we victimized the most. But I always took care not to cut it to the point where you couldn't follow the story because you didn't have enough information. So we were very well prepared. But the problem with my cinema is that when I get inspired on the set, I change or correct everything I've prepared.

So you throw away your preparations on set?

Yes. But the base is always there.

What kind of preparation did you and Vilko undertake? Storyboards? Shot lists?

In the beginning when Vilko and I worked together, we'd draw a storyboard. Not a complete storyboard, more just indications of how the camera would move left and right. When you draw a storyboard it's not cinema because cinema is another language. So most of the time we'd just make sketches and take measurements of the place where we were shooting—something that would show the directions in which the camera moves. And then later, when we were on the set, we'd dis-

cover that the perspectives different lenses give you meant we had to change everything again.

When you go to a location, do you have a very strong sense of what you're looking for in terms of its spatial characteristics?
Absolutely. And you know what? There's not one location that I shot in my life that I did not change. My specialty turned into absurdity on *Underground* when I was building destroyed sets. It's like treating nature as a studio. This was my ideal. And I was doing it all the time.

Didn't all the filming on Dolly Bell *take place in real locations?*
Real locations, yes. But I always painted everything. I was always adjusting the locations to the color I wanted to be the dominant color in the movie.

Which was?
Brown, blue, beige. The colors I thought would convey the emotions I wanted to convey to the audience.

You think colors make a big difference?
Yes. I think most of the time a movie attacks the subconscious of the audience. It's what a filmmaker is working on. So when a member of the audience goes home after seeing your movie, most of the time he doesn't know why he likes the movie. One of the elements in this—a very important element, in my opinion—is what kind of color he carries out of the cinema. This has always been very important for me.

Any nerves before you began filming?
Yes. My heart was beating like crazy.

Can you remember the night before the first day of the shoot?
Yes. I couldn't sleep. Not at all.

Did this go on for the whole film?
No. I settled down. But I'm someone who works very much on adren-

aline. At night when I get an idea that I think is marvelous—which doesn't necessarily mean that it is—I just get so excited, so euphoric, I can't sleep at all.

Once you began directing, did you find you had a clear idea how to stage the action? Or does the staging come out of the rehearsals?

In my cinema, I think the most important thing is to be able to mesmerize the actors so you can get them to do whatever you think they should do. The acting and the synchronization of the acting with the camera movement is defined not by certain acting methods, Stanislavski, for example, but by how the camera sees what people do and how they do it. You can train with them, you can spend two months rehearsing with them, they can know every word of the text, but it is the optical world of the cinema that defines how people act. If you say, "Go to the drawer, take out your shirt." Then, "Go to the window, in the window you see something very important." Then, "Turn back and see somebody opening the door." These three actions, if they're in one shot, are defined by the one who sees them. And who sees them? The lens. In other words, movement and action in space are those parts of a performance that define it cinematically. In theater you are defined by the situation, by the noise that you produce, by a low voice, a funny voice, and so on. But the universe in the cinema is reduced to two elements: the lens and how the camera moves. And then why it moves and what do you do in front of it. Directing is about placing people in different active situations. Bergman does it statically. Kurosawa does it dynamically. My idea about directing is that, after reading or writing the script, you have to know what you want to do in terms of putting the action into space. First you have to define what the camera wants to see: Is it a long shot, is it a short shot? Then, if it's a longer shot and you have a series of actions you want someone to perform, you, the director, have to define these actions concretely. And by defining concretely what they have to do, you are basically working with the actor. You cannot make a movie with the best actor in the world if he stands there and you put a lens on him and he says the line, then the next one says the line and the next one says the line and so on. That's not directing. That's stage management.

So when people ask me, "How do you work with an actor?" the answer is that I know how to interpret what the actor needs to interpret. He needs to do it in the space. And how can you do it in the space if you don't know how your camera is going to move and how your camera determines his behavior? Is it from straight on, from profile, from here, from there? Does he move quickly? Does he move slowly?

This contrasts with some of the other directors I've spoken to who talk about the performance as being the primary factor when they're directing. But then you lose the nature of cinema. The nature of cinema is moving pictures. That's very much a stage way of working.

I'm just speculating that there's a difference in what directors prioritize when they're on set.
Of course, some directors just want to get everyone to sit down as soon as possible so they can do a master and some intercuts which to me means nothing. When I see a movie like this, I go home. Because then it's working against the nature of cinema. Bruce Lee is much better cinema than talking heads.

One of things you've said about your films in general is that directing exhausts you because you have to find an original shot. Was this the case with Dolly Bell?
It was because I'd never learned how to be a director who controls his power. I am exhausted after my movie because all I have in my life I have put into my cinema. I always look like the nonprofessional actor who is using too much power even though he could use a little less. So I'm absolutely sacrificing myself to my cinema. And what I said once for *Underground* was that making a movie is the slowest way to commit suicide.

Do you think there are any limits to what you'll do for a movie?
No. You know why? Because I never stopped being a child. I live for the moment. When the smallest units of cinema—the shots, scenes, and so on—are put next to each other, are juxtaposed with one

another, they produce a feeling of joy in me. And for most of my life, this joy is what I've lived for. When you get into the screening room and share your joy with the people around you, that's when cinema makes sense.

What was hardest about Dolly Bell *for you as a director?*
You know what? This was the only movie where I didn't have a hard time. I was always angry if production didn't bring me everything I wanted. I remember now the beginning of *Dolly Bell*. We all got drunk after the first day of shooting and we were very happy afterwards. The next day they were waiting for me a little longer because I'd overslept. I overslept and got there late. Which doesn't happen often.

Were there any scenes that were particularly hard to do? For example, the scene where Sintor offers Dolly Bell *to the kids?*
The point is that this was the movie where I was discovering beautiful things. Dino under the rain. The attic through which the light comes and which defines the face beautifully. A lot of discoveries which, although they were hard for me, were not as hard as you might expect. The biggest discovery for me was the visual language we were talking about. One thing is to imagine. The other thing is how to apply what you've imagined in the real world. You see many movies where the rain goes around the face. But then you discover there are a million ways to do it and to make a big emotional impact on people.

Do you think you learned a lot from the experience of Dolly Bell?
Absolutely. The most awful thing is to direct the movie. But the most beautiful thing is to enjoy it when the movie is good. This was a very particular film. Every film afterwards was very difficult for me. Very difficult. So if you ask me about this movie in particular, I would say that this movie was fine, more or less, but whatever came later was really difficult.

It was an exceptional not a typical experience?
Yes.

How long did it take to edit?
Editing for me is made more or less on the set because I always determine the editing in the way I shoot it. So in every movie, editing was the easiest part for me. Every scene that I shoot is very strictly defined. I know what it's going to look like, and since I was never part of any big industry program, I was never pushed to do anything different.

So, given you had a strong sense of how it would cut, did it resemble the script or did it evolve into something different?
Every movie I've done is only inspired by the script. Then on the set the explosion comes and improves the movie. This is why modern cinema suffers from a sickness. The film director is not the creator. He is the one who executes the production and the script. In my case it was the opposite.

What was the reaction to Dolly Bell *when it was first shown in public? Did its rather satirical take on life under Tito affect its reputation in Yugoslavia?*
I was lucky that Tito had disappeared before the film was shown in the National Film Festival. And since the film was welcomed by everyone who saw it, the distribution in our country was very good. I also think the fact it won the Golden Lion in Venice for a first movie helped with distribution here and in other countries. It wasn't a big release but it was okay. This is the case with every one of my movies: almost every film I've made has been distributed in forty or fifty countries. Like them, *Dolly Bell* wasn't a hit at the box office, but it made enough money.

Were you surprised by its success?
Yes, very much. But I'm still surprised by my success. It's like, next to me there's someone else. I still don't realize it's me. I suppose I lack self-confidence. Then again, sometimes I think, "I'm the one!"

Agnès Jaoui

LE GOÛT DES AUTRES

Can you tell me a little about your background?

My mother and father were born in Tunisia, and after independence they went to Israel to start a kibbutz. But it wasn't what they were expecting: it was very socialist/communist and my father was an individualist. So after a year they returned to the Paris suburbs where I was born. I should say that my parents weren't at all religious. My father was a nonconformist who was influenced mostly by the ideas of 1968: the idea of freedom, of everything being possible, of there being no difference between men and women. It was also the year my mother discovered her interest in psychotherapy. So this was my background: a lot of good sides, some not so good, but nothing that made me feel I belonged to a particular community, certainly not the Jewish community in France. In fact, my parents were opposed to it even if Jewish culture was important to us. Also, my parents were very young when I was born—my mother was only twenty and my father was twenty-three—so I think they really wanted to live their lives to the full. When we returned to Paris, we happened to end up in a very bourgeois neighborhood, the fifth *arrondissement,* and I went to a very smart school, the Lycée Henri IV, a bit like a Parisian version of Eton. But I always felt different from everybody around me.

You felt like an outsider?

Not consciously, although in fact I was one. My friends were very

French. They were very bourgeois with houses in the country and so on. It's just that my roots weren't in this bourgeois community.

You were in this community but not of it?
Exactly. As you can see, I am very Parisian. I don't deny it. But I never felt I belonged to any particular group.

Do you think this sense of not belonging to a group was important in terms of your desire to write?
There were two important things that led me to start writing. The first was that I read Anne Frank's diary when I was eleven—which was a big shock for me—and began writing a diary of my own. The second was that at around the same time I went on holiday to England and stayed in a city like in a Ken Loach movie, a worker's city. I don't remember its name. But it was one of the worst holidays of my life. I was bored a lot of the time so I wrote aphorisms and proverbs as well as my diary: you know, "after the rain, the beautiful time," and so on. When I got back to Paris, I read these out to my family and they told me they were wonderful! Of course, I was really proud of myself, so I went on writing.

How old were you when you realized you wanted to be an actress?
Thirteen. No, eleven. At eleven I was in my first play at the Lycée Henry IV. And then at the age of fifteen I went to a real theater school. I already knew I wanted to be an actress. In fact, I wanted to be a princess!

Were you already interested in movies at this age? Or did that happen much later in your life?
I loved film. I went to see a lot of movies with my parents. I saw all of Woody Allen's films. I also saw a lot of Russian films. Tarkovsky, Mikhalkov, Loteanu. I used to see all these Russian films in a beautiful cinema called the Cosmos in rue de Rennes. It was the cinema of communism, of the communist people, which is now called the Harlequin. They were such beautiful movies, such great actors. A film

called *The Gypsies Go to Heaven* [Emil Loteanu, 1975] made an enormous impression on me. Oh, I'm also a huge fan of Ken Loach. I like directors who have a point of view. He has values, and also the actors in his films are incredible! Each time I see a movie of his, even when it isn't his best, I know what he's searching for.

Did you ever think you might want to make films when you were growing up?
No. I wasn't thinking of making movies. I was dreaming of being an actress. Of being famous as soon as possible, being recognized, loved, so I knew I existed! Except that I was already writing. So I had this introspective side, but also another side, where I was dying to be noticed. From the age of fifteen I began going to different theater classes. I then went to Amandiers, Patrice Chéreau's acting academy in Nanterre. No, actually I stopped acting completely after school and studied soprano singing for two years in the conservatory of music in Enghien. And then there was a competition to get into Patrice's school and I was offered a place. So I quit the music conservatory and went to Nanterre, where I found a very good singing teacher!

What was it like, studying with Patrice Chéreau?
It was a war experience. He doesn't like women. Not only women. He doesn't actually like people. It taught me that people easily lose their judgment and courage in difficult times.

How long were you there?
Two and a half years. Twenty-four hours a day. It was very intense.

Did you continue to write in this period?
I was still writing my diary. But I wasn't writing fiction.

What about music? Had you continued singing?
Absolutely. I never stopped doing music. Never, never, never! I was doing Schubert's *liede* and baroque music because my teacher was a specialist in baroque.

What happened when you left Amandiers?
We went to the States to do a workshop in musical comedy for two months. It was great. And when we came back, a director saw me and hired me for a Pinter play, *The Anniversary.*

Which is where you met your future partner and collaborator, the actor and writer Jean-Pierre Bacri?
Exactly. I was still in Amandiers. I was only twenty-one, twenty-two. I'd been in Patrice's academy and had this experience with him, but the thing you have to understand and it's very hard, as I tried to show in *Le Goût des Autres,* is that the culture here is very *cloisonnée,* very segregated. Some people go here, some people go there, and so on. And in France there is a very important difference between subsidized theater and commercial theater. The crime of the director who hired me was that he was doing Pinter in a commercial theater.

What did you do after this?
Then it was the years of—nothing.

You mean you weren't a working actress?
No. Not at all. Not a working actress at all!

Were you a writing actress?
Not yet.

So what happened?
I got depressed.

Was writing a means of taking control?
Yes, of course. But to be honest, I didn't have many alternatives at this point. I was in a TV movie. I was in another play. But I had the feeling I was wasting my time. As you know, time goes fast for a woman, and it's worse when you're an actress. So I got to twenty-four and I thought, "My God, I cannot wait like this!" It was impossible. But Jean-Pierre had already been writing before we met, and I'd also been writing. So we began to write together.

Who would you count among your influences as a writer?
I adore Colette, I adore Flaubert, Boris Vian. I also love Edith Wharton. And I'm a huge, huge, huge fan of Jane Austen. In fact, I'm very fond of English writers. David Lodge, for example. And to be honest, he inspired us for *Le Goût des Autres*. In one of his books [*Nice Work*, 1988] the main character was called Wilcox, and for six months when we were writing the script, we called Jean-Pierre's character Wilcox or Will. In the book, Wilcox runs a factory and a woman who's an intellectual comes to work in his office and they have an affair. Of course, she isn't at all from his milieu and so, blah, blah, blah, they split up again. It inspired me a lot!

How about Jean-Pierre? Hadn't he already written plays?
Yeah. Before he met me. But he stopped ten years before we met because although he had a facility for writing dialogue, he wasn't happy with what he'd done. And as an actor he was already much more famous than me. So for me, but also for him, to write together was our freedom and our big luck.

You and Jean-Pierre now make up one of the most respected screenwriting partnerships in France. But you started out writing plays. Do you think there's a big difference between the two forms?
They have the same method. The theme, the character and so on. *Cuisine et Dépendances* and *Un Air de Famille* both started life as plays and were then adapted for the cinema. And both had a lot of dialogue.

So a lot of dialogue doesn't necessarily contradict cinematic enjoyment?
That's my experience. Because, I think people are looking for meaning. We're all a little lost, you know? So we look for meaning. It's about meaning and about identifying yourself with somebody else. Okay, there are a lot of ways of enjoying movies. Some can be just entertainment, but still there is this question of identification, of shared experience. In fact, I don't see so many differences between theater and cinema. We first worked for theater because in a way the fact of having fewer possibilities in a play was much easier for me as a

writer. Because in cinema you can write for thousands of actors, thousands of locations, thousands of countries. There are no limits.

You mean you're freer when you're writing for the theater?
Yes. And I believe that the constraints you work under can inspire creativity. This is a paradox, but I've had this experience. And, also in the theater, Jean-Pierre and I would keep to the rules of the "three unities," location, time, and action. And this made writing *Cuisine et Dépendances* much easier. The beginning of the party, the dinner, the main course, and the end. And the same is true with *Un Air de Famille.* Also, we never wrote too many characters. And also, as we were actors, all the characters in our work have an equal value. So we were developing a kind of genre, but we didn't know it. No, I don't see much difference between writing for theater and writing for cinema.

How do you and Jean-Pierre work together? Who does what?
In the beginning, our working method was the same. We'd sit on a couch with two pencils and a notebook, talking a lot about character and theme. And in a way not only the theme, but the expression of the theme, what we want to say about it. And after a few months of talking like this, we'd begin to see a structure and then we'd write the structure down, more and more precisely. And then, after six months, nine months, we'd begin to write the dialogue together. In fact, I still think Jean-Pierre is better at dialogue than me. Because he's much more "synthetic."

Do you ever argue when you're working on a script?
Yes, of course! But it doesn't last. And the interesting thing for me is that I have to convince him and he has to convince me. And that's a good feeling. Sometimes people ask me, "Don't you want to do it yourself?" And the answer is no. First of all, I enjoy it more this way. I think we make a better job together. I believe that if I was doing it for myself it wouldn't be as good.

Is it true that you only work in the afternoons?
That's right. From three till seven or eight.

You make writing sound almost like a hobby. Nothing to do with produc-
ers or money. Was this the case when you began?
That's absolutely true. We were writing for the theater, and in the the-
ater you don't ask for money up front from anybody. You write a play
and then you offer it to a theater and they say yes or no. So that's how
we did it. And to be honest, when we began I didn't have much faith
that anything would happen with our work.

You were doing it for its own sake?
Yes. And because I didn't want to do nothing. As you may have
noticed, I'm not content with inactivity, with contemplation. So we
wrote. And then there came a time when we couldn't go on so we went
on holiday. And when we came home I read what we'd written and I
thought, "But this isn't so bad! I want to see the end of this play." And
so we went on. And then we offered it to theaters.

Which play was this?
Cuisine et Dépendances. So we went to the theaters and most of them
said no. One said yes, but only if we used famous actors. And we said
no, because the only people we were working for were myself, Jean-
Pierre, and a friend of ours, Sam Karmann, an actor and director who
is now in our film company, Les Films A4. In the end, a director who
was working for one of the big theaters said, "Okay, even if they don't
want you, I will take you in my little theater, the Theatre La Bruyère,"
which is a very important theater in Paris because it is a little theater,
a commercial theater, but its plays are always very good, very high
quality. So he took us. And then a miracle began. After a week, four
days, it was full. At this point the big theater came back to us and
asked, "Do you want to put it on in our theater next?" Anyway, the
beautiful story began.

Soon after this, you and Jean-Pierre began to write for the veteran French director Alain Resnais. How did this come about?

It was because of *Cuisine et Dépendances.* As I told you, it was boom, boom, boom! It was like winning the lotto. It happens like that sometimes. It wasn't just that it was a big hit. I had the feeling somebody was going to say, "Do you want to go to the moon?" Anyway, a couple of months after the play began, we had a phone call. "Hello, it's Alain Resnais. I want to meet you. Is tomorrow possible?" Yes!! And he came to our house with this play by Alan Ayckbourn [*Intimate Exchanges,* 1985] and said, "If you like it, I would love to work with you."

This must have been pretty amazing!

It was one of my big joys. It was worth more than any prizes. It was great because this project was so crazy! And I thought, "My God! If it hadn't been Resnais, I would have thought this guy is crazy." And also it was a huge experience because Resnais is a good human being as well as a good director, creator. So it was very, very good for me to know that it's possible to be both.

How did the script for Le Goût des Autres *take root?*

Le Goût des Autres was a little bit special because at first we had wanted to write a thriller and also we wanted to write for friends. And this changes the theme a little bit because when you think of a character they also have to fit your friend. Anyway, we tried to change our method in order to write a thriller, but after a while we realized we hadn't discovered the theme. Somehow we weren't expressing what we wanted to say. We were just producing clichés. You know, a guy with a gun . . . blah, blah, blah. Cocaine . . . blah, blah, blah. And so on.

Why did you want to write a thriller? It seems out of character.

I don't know. I think Jean-Pierre wanted to. And also because even now it's difficult sometimes to reinvent ourselves, to change, to have fun. We didn't want to just say nothing. We didn't want to just do a "thriller" [AJ holds up her hand and fires three bullets from an imaginary gun], pow, pow, pow! Not at all. We wanted to do it because we

liked the genre. Then we discovered, especially me, that it wasn't pos-
sible for us. That it wasn't what we were good at. So we went back to
first principles, what do we want to say, to express? What do we want
to show to the audience, what do we want to share with others?

How long did you take to write Le Goût des Autres?
A little bit less than a year. It's always about a year.

Was it difficult to write?
Only because we'd wasted two months writing a thriller before we
realized we'd made a mistake. After that, we went back to our theme
with the same characters, the bodyguard, the dealer, the chauffeur.

You changed the genre but kept the characters?
Exactly. And then we wrote about the theme of segregation.

You've said you're inspired by real life. Does that mean that Le Goût des
Autres *was inspired by people you know?*
Yeah.

Do they know who they are?
No. People never recognize themselves. Never.

Had you begun to imagine yourself as a director by this point?
I was not directing, but I was still observing things. You know, when
you read a book, you imagine things, and when you see the movie,
you go, "Ah-hah!" I had the same feeling, especially because I wrote it,
so I was imagining things. And, of course, with Resnais or [Cédric]
Klapisch [*Un Air de Famille*], what they did was great, but sometimes
it wasn't what I'd had in mind. So little by little I came to the idea of
directing. Then again, this is another French specialty. Out of about
two hundred movies made in France every year, only about ten or fif-
teen aren't directed by the writer. So when Gaumont came to see us a
week after *Cuisine et Dépendances* opened and asked us to make a
movie of it, they asked, "Who's going to be the director?" And we said

we didn't know. At this point there wasn't anybody because in France the *auteur* is the one who creates things. All we knew was that we wanted to adapt the same script we'd used in the theater and use the same actors. So they said, "Do it yourselves." In fact, they said this mostly to Jean-Pierre because he was the senior one, and a man. I was a young girl at this point. But he wasn't interested because he hates having endless meetings and I was twenty-six and afraid and blah, blah, blah. So finally we found a director [Philippe Muyl]. But each time I was watching on the set, I'd think, "What would I have done?" So I think it was the first jump for me.

Had you actually directed anything prior to Le Goût des Autres?
The producer of *On Connait la Chanson* knew that I was interested in directing and suggested that I do the trailer for the movie. So I did it and really enjoyed it. Instead of taking images from the movie, I took the actors and put them in a new situation. So it was like a short movie. In fact, I did the opposite of *On Connait la Chanson*. The actors spoke the lines of the songs. It was as if I were interviewing them about the movie, but they were saying the words from the songs. So it was funny. And I gained confidence.

Once you'd written the script, was it easy to raise the money? Who was your producer?
Charles Gassot had produced *Un Air de Famille,* so to be nice, we went back to him. But we already had our own production company, so it was half Charles Gassot and half Les Films A4. The fact that we'd already had some success meant it was easy to raise the money. And it wasn't just that we'd been successful. Our budgets were always quite reasonable. We weren't trying to make expensive movies. Also, France is a lucky country to make movies in.

Did you have various actors in mind when you wrote the screenplay?
Yes. Many of them were friends of ours. Christiane Millet is a friend. Wladimir Yordanoff is a friend. Gérard Lanvin, Alain Chabat, Anne Le Ny are all friends.

There was never any pressure from your backers to use bigger names?
At one moment they said, "Are you sure, blah, blah, blah?" And I said, "Yeah, I'm sure." End of story.

You were already a successful screenwriter and actress. Did this mean you were confident of your potential as a director?
No, no, no, no! I was terrified! Especially because, before this, I'd been directed by Klapisch and Resnais. But I had confidence in the script and the actors. I knew the actors. And I knew the meaning of the script, of course. So the only thing I wanted to do was to serve the script and the actors and to be as discreet as possible in serving it.

Can you say a little about how you prepared with the actors?
The preparation was helped a lot by my experiences as an actress, especially with Alain Resnais. Resnais doesn't direct his actors a lot. What he does—and what I've done on both of my films—is to see each actor quietly on their own, just to read, to avoid misunderstandings. Resnais's rehearsals are all like this. But their purpose is actually to give the actors confidence. Because this is the most important thing you can do as a director. In my opinion, the best actors have doubts about what they're doing. A bad actor is an actor who thinks he's great. A good actor, even the best, the most popular, often needs reassurance. And because the important thing is to have a good actor for a good part, this is one of the most important things a director has to address. And once you've gone through the script with the actor, you have to bring it to life. And to help the actor bring it to life, you have to create confidence. Well, this is my experience.

So the role of the director is to inspire confidence while letting the actors be as free as possible?
Exactly, exactly. So they feel loved. So they feel reassured by me. The crazy thing about cinema is that there's so much money at stake, but you arrive on set on the first day and you've only seen the costume designer and then you're told, "This is your husband, this is your best friend." Okay, of course, it's your job, but it's also totally crazy! I want

to benefit from the time with the crew before the shoot. You know, it's quiet and everybody can meet each other. So you don't arrive on the first day of the shoot and find there are sixty people who you have to meet for the first time. On the contrary, it's just another day like the others. The day before, you were at rehearsals. Now there is a camera. But you feel the same. And it's like life, which is the most important thing of all. This is my job as a director.

Did you have much time for rehearsals?
I had a month. First there were the rehearsals, then there was the test shoot with the camera. Then the costume designer came in and we tried out the costumes. And everyone was together the whole time. So there was a lot to do. But it was very comfortable.

How did you work with your DP, Laurent Dailland?
My experience on other movies was of famous DPs with big egos who wanted to have power. I didn't want that so I chose someone whose work I admired, but who was also a nice guy with no ego problems. And then we watched a lot of movies together. Woody Allen. Mikhalkov. Lubitsch. Then we discussed everything. Then we storyboarded all the scenes.

In terms of its quiet humor and innocence, the film reminded me of the work of Eastern European filmmakers like Milos Forman. Do you think these filmmakers were an important influence?
I accept the compliment! The Eastern European school, if we can call it that, is very important for me. But the film wasn't part of an overall theory. It's just my taste. For example, the choice of Super 35 mm. It's a Cinemascope frame but it isn't Cinemascope. As you say, it's reality but not reality. I knew that I didn't want to be just real. I wanted something that showed it is cinema but a little bit unconsciously. So it was a play between reality and fiction.

What was your technical knowledge at this point?
Nothing. And now, too. I'm a big failure when it comes to the techni-

cal side of filmmaking. I have a block with technical things. I heard there's a therapy for it, and I should probably have it! I'm like a ten-year-old in a math class. Suddenly my mind goes blank.

You didn't make any effort to learn about technical matters such as lenses and so on?
No, because as I said, I'm a stupid human being with all that stuff! I can't even change a lightbulb! So, no. The only thing is that when I look through the frame, I say yes or no. Also, I look at movies some-times and say to my DP, "I like this, how is it done?"

How did you work with Laurent? Did you have a clear sense of how you wanted to film a scene? Or did Laurent make suggestions?
Laurent made suggestions, but not many, as I'd planned most of the sequences before we began shooting. I'd done a lot of *plans séquences* [i.e., moving the camera during the scene rather than cutting from one shot to the next]. Like Woody Allen, for example. Or Ken Loach or Mike Leigh. With no *chook, chook, chook* [AJ cuts the air with a pair of imaginary scissors], cut, cut, cut, cut! I don't like that very much. So I'd already asked myself, "Where is the camera?" for every scene. It was the same for *Comme un Image*. I didn't arrive on the set and say, "okay, let's do it like this or like that." I rehearsed everything either with the actors or alone with Laurent.

Did you rehearse on the set?
On the set when I was lucky enough to have it, or elsewhere when I wasn't. But I usually knew how I wanted to shoot a scene before we shot it. Sometimes it changed, of course. But usually I knew how I wanted to do it beforehand.

Does it start with drawing? Or are you inspired by the set itself?
I would like to do it on the set. But no, I do it beforehand. On paper. In my head.

Did you find this came to you easily?
I wouldn't say it's easy. It's work. Another kind of work.

Let's talk about the shoot. How did you feel when you were about to start shooting? Did you sleep?

No. Not at all. I was terrified. For a long time I'd been a student, an actress. I was the girl who was waiting for the others to take care of me. Now, for the first time, I was the one who had to take care of the others and to make all the decisions. I was afraid of making a bad movie and wasting good material. And also, finding the rhythm was tough. Even after we'd been editing for a month, I couldn't sleep. I only managed to sleep after a couple of months of editing. Each day I saw the scenes and I thought they were good. And I was confident with the actors. I knew they would be good. And they were terrific. I had the greatest actors in the world. So I was seeing each scene on its own and it was good, it was great. But what I didn't know was whether the whole movie would be good. And this was a terrible feeling. And it wasn't until the second month of editing that I could see that the whole thing worked together. And then I began to sleep again.

Which was the first scene you shot?

The first scene was where Christiane Millet and Alain Chabat find the bird in the road. It was okay. It was nice. But I wasn't relaxed. Really, I only began to sleep after about eight months.

Did you ever feel a bit abandoned by Jean-Pierre?

No. He was very helpful. He was very involved. But he was much more relaxed than me. Much more confident. For example, in the evenings he went out to eat with friends, whereas I never did. Well, maybe once I ate out till ten, then went home to bed because I had things to do.

What was it like, directing and acting in a film at the same time?

That was a big surprise. I was very frightened of doing it. And also very guilty. I thought, "I'm not a real director, because I want to act in my own movie. If I were a pure director, I would sacrifice myself as an actress." But I didn't want to do that. So at first I felt guilty. But then I really enjoyed it. First, I was in makeup for an hour. They took care

of me, so it felt good. I could sleep a little bit. I could rest. And of course acting is what I know best. So for a moment I was *phewww!* I could relax at last.

It was like a little holiday from directing?
Exactly. It was a vacation.

Was there anything you didn't like about the experience of directing?
I didn't like having to choose the crew and the actors. I don't like that moment because I don't like having to say no, having to choose. I know that some people are very good at the first meeting, but actually not very good. And others are bad at the first meeting but actually very good. And I respond to people's efforts to impress me. After all, I've been an actress dying for a part. So I'd meet actresses like that and I'd feel like, "Oh my God! I don't want to hurt you," and so on. It's a moment I don't like. It's very tiring.

What did you like most about directing?
Some moments with the crew. During the preparation for the movie, we laughed a lot. And I adored the moment I put music on the movie.

Was the music you used on the soundtrack very important?
Absolutely. I think you can change everything with sound and music. Resnais told me that his famous documentary, *Nuit et Bruillard* [*Night and Fog,* 1955], was successful because of the music. He said that it featured the same things as other documentaries about the camps, but the big difference was the music. I agree. I'm absolutely sure that if you take a movie and change the music, you change the movie as a whole. Of course, all of this is very personal, very subjective.

Had you always thought you'd use the music of Schubert in the film?
In fact, at the beginning of the movie I wanted to hire a composer to do the music. But then, when you edit on Avid, you can experiment with all the different elements. So I tried out some music I had in my head. I said to Laurent, the DP, that we'd use Schubert for all the

English lessons with Anne Alvaro and Castella. I'd had Schubert's music in my head since we wrote the script. And I played some Schubert to Laurent and Anne Alvaro. I also tried some other pieces, but Schubert is Schubert! Who is going to make better music than Schubert? Unless I meet my Bernard Hermann or Nino Rota. Unless I meet someone like that. One day I'd like to meet a composer and have a connection with him. But so far I haven't needed that. I don't know, music helps me so much. I listen to music every day.

Do you think there's a link between music and filmmaking?
I think the most important link between acting, directing, and writing is the rhythm. [AJ starts singing.] "The rhythm is all, yeah, yeah!" For example, the Russian movies I was talking about. There is a film by Mikhalkov, *Sans Témoin* [*Without Witness,* 1983]. The story is about a woman's lover who returns to her after a gap of ten years. It's just in an apartment with people who aren't especially beautiful. Normal people, poor clothes, you know. But you never get bored. Everyone knows that a two-minute movie can bore you to death, and a four-hour movie can be amazing! You don't want it to stop. So rhythm is incredibly important. In fact, the big strength of Hollywood movies is this sense of rhythm. Except it's always the same. It's very boof, boof, boof! Like the beat from a stereo. Still, you begin watching the movie and you don't want to stop. And with good actors, it's the same. There is something about their rhythm: they give you a sense of where they're going, of the meaning of what they're saying. So with a good actor you can understand Shakespeare, you can understand the most difficult writing. Everything is clear. With a bad actor, you understand nothing, even when they're doing the simplest thing. It's a question of rhythm. And a lot of comic actors, who for me are the greatest, are also musicians. Like Woody Allen, like Chaplin. Like Louis de Funès, Darry Cowl in France. It's just that thing! [AJ snaps her fingers several times in quick succession.] Humor is rhythm. You can say the best joke with no rhythm, you can say a bad joke with rhythm. It changes everything. Music is life. And all the great directors use not only rhythm, but also great music.

Once you began directing, did you find it came quite naturally? Or was it quite a struggle?

After the last day of the shoot I went on holiday. In fact, though, I couldn't stay on holiday. I had to get back to the editing. But I had four days. I went to this house with Jean-Pierre. And they asked me, "Do you want this room or that room?" And I began to cry. I said [high-pitched whine], "I don't want to make any more decisions! Just give me any room!" Because I'd been making all these choices on the film. I want this one, not that one. I want this one, not that one! And then I couldn't go on any longer! And it was almost worse on *Comme un Image*! Because I'd been successful with the first film, it was "Do you want this blue, this blue, or this blue?" And I'd say, "I don't care! Take whatever blue you want! Take the yellow! Leave me alone! Make your own decision!"

Was it harder directing Jean-Pierre because you knew him the best?

In a way, yes. In a way, no, because he's the best actor I know. It's great to have an actor who is so live, so here, so present. The only problem was that sometimes as a director you have to reassure your actors, but with Jean-Pierre sometimes I'd forget. I mean, I know him, I love him, and I'm sure he knows that I love him. So it was difficult to say, "That's wonderful, but maybe you could try it like this?" Also, Jean-Pierre wasn't just my other half. He also wrote the script with me.

In contrast to the lightness of the other performances, Anne Alvaro had to maintain a kind of blankness through the film in order to make her smile in the final scene all the more extraordinary. Was this hard to achieve?

Not that hard. Sometimes I had to really urge her, "Don't flirt, don't flirt! You are somebody who's given up on seduction." There was something bitter about her character. "Don't flirt! Seduction is finished for you." I was inspired by somebody I knew very well, and I knew that was the point with her. Anne is a great actress, of course. So this was the only thing. Because when her character, Clara, is in work, she's like this! [AJ's face lights up in a big smile.] She works on things for ages in the theater. Money, no money. It doesn't matter. But I said, "No, no, no. With men, nothing please."

How would you describe what you learned when you directed?
I learned that, as in life, you mustn't focus on a problem in isolation. The more distance you can have, the better. On *Le Goût des Autres,* I had a problem with an actor who had a nervous tic, and I kept thinking about it. I was so close to this problem that I didn't see other problems. And also to think that one particular actor is especially good. No, no. You have to keep as much distance as you can. Even if you adore this guy, keep your distance. And the good thing about having an editor who is starting to work on your film while you're shooting is that he has to keep his distance. And because he's not on the set, he doesn't know who's a nice person and who isn't. So he'll say, "No, there's no problem with that actor." So this is what you must do. Maintain a distance. As in life.

Who saw the film first?
First, Jean-Pierre, alone.

What was that like?
It was good!

A bit like a father coming to see the birth of his child?
[Big laugh.] Yeah, of course! Something like that.

How did he react?
It was okay. But the big experience was when I showed the film to our two best friends from our company, Les Films A4, and my two best friends from my first school in Paris when I was seven. They cried so much after the screening. Especially one of them, who is the less expressive of the two, she was crying and crying and crying. It was very moving.

Were you surprised by the film's success when it was released in France?
Yes. But before the Wednesday it came out—because in France films come out on a Wednesday—we did a month of tests in the countryside. The first one was in Aix-en-Provence. Everyone was there, all the actors, Alain Chabat, Gerard Lanvin, Anne Alvaro. And we came out

at the end of the movie and the whole theater gave us a standing ovation, and I think the oldest person there was twenty years old! I will always remember these incredibly young people smiling at us like we were the Beatles or something. We were shocked. Also, almost all their questions were about the text. There were very few questions about the actors. Just the text. The meaning, the meaning. And each time I go back, the director of the theater tells me this was the busiest evening of his life. Then there were the numbers of people in France who saw the film when it came out. One, two, three, four million. As I told you, I'm not very good with numbers. It all feels a little bit virtual. Of course, it's great. I'm not stupid. But it's not the same as seeing the reaction of a real audience because it's abstract, whereas the faces of the young audience are concrete.

Why do you think it was so successful in France? Do you think its theme touched a nerve?

Not only in France. Everywhere. It's hard for me to say if it is so French, because I think the experience of being despised because you're not chic, because you're not regarded as having good taste, is an experience that everybody has. That's what we tried to show in the movie. Even the very fancy painter has it. Everyone has it in his or her life. Everybody has it at school, even before school. You know, "you're not in the cool group." And this is such a personal experience that everyone can recognize it in themselves.

Do you think the success of the film changed your life?

In a way, because it gave me confidence. But what was important in my life was meeting Jean-Pierre and the first play we did together. That was the beginning of my success. The beginning of my freedom. That definitely changed my life. The film was another step, but less important in a way than the first one.

You've said you couldn't write without taking characters from real life, without observing real people. Has your success in France made this harder?

I don't really have a public profile because in films you can change your appearance. For women, especially, it's very easy. And then I don't go on TV shows and I'm not in the tabloids. All in all, my freedom is more important to me than anything. To be honest, this changed quite recently for me. I don't need to rely on other people to prove my worth any longer.

Lukas Moodysson

SHOW ME LOVE

Were movies already an interest when you were growing up?
No. When I was ten I wanted to be a surgeon because I was interested in cutting things up. Then when I was sixteen or so I became interested in writing. My interest in movies came much later and came more out of being very bored with my life. It wasn't in opposition to my writing. It was more in opposition to the town where I lived, Malmö, and to my job as a bartender. So I was bored with where I was living and with everything around me and I wanted to do something else. And for some reason, I don't really know why, I just started to make films.

You wrote poetry when you were a teenager. Can you tell me something about it?
It's very difficult to talk about poetry. Poetry is for me and was for me a way of saying things that I cannot say in any other way. And films are a bit like that. Which is why I don't want to talk about films. [Big laugh.] I try to use all my energy to focus just on one small point, but then it's very difficult to talk about it. And it's even more difficult to talk about things I've written.

Was there a moment when film took over from writing as the main focus of your interests?
I don't think I ever saw myself as someone who would make films or would work with moving images. But there was something about film,

some kind of flow of images, that connected to the things I was writing. And I think I saw that in many different things. At one time I was a TV junkie. That was just when MTV and those channels were starting up and we had cable TV for the first time, so we could watch CNN all night and day and hours and hours of MTV. And for me there was the same kind of flow of things in Tarkovsky's movies. So it was like MTV and Tarkovsky at the same time. But I don't think I felt this was something I wanted to do. That didn't come until much later. I don't think I was inspired by films until I started to make them myself.

In the minds of many filmgoers outside Sweden, Swedish cinema has for a long time been almost synonymous with the work of Ingmar Bergman. Were you influenced by his films?
I remember I saw *Fanny and Alexander* when I was twelve, and was very moved by it. But apart from that, not at that time, no. Bergman has never played a big part in my life. I've never been in opposition to him and I've never been a fan. I like some of the things he's made, but I don't feel he's someone I relate to. It feels like he's made some movies and some of them I like and some of them I don't like. There are some artists I really have to wrestle with, and I don't think he's one of them. But I think that the film of his that connected the most with me was *Fanny and Alexander.* I think it had something to do with being approximately the same age as Alexander. I think it had something to do with some kind of identification. If I had to pick not a film by him, but a character I had to write about or make a film about, it would be Alexander, because there are some things in his life which in some ways feel similar to things I've done.

Can you tell me a little about the [Swedish] Film Institute, where you studied?
It's the only real big film school in Sweden. It combines theater, radio, and film. So part of the time we were in a class with people who were doing theater and some of the time with people who were doing radio things. The course is three or four years long and sometimes very practical and sometimes very theoretical. At the time I was much

more interested in the practical things, so I wanted to learn about cameras. When I was at the school, I wanted to be a camera assistant or operator rather than the DP, because I thought they were the coolest guys. I think I just wanted to be the person with all the equipment. [Laughs.]

What did you have to do to get in?
I did a bit of lying, I think. You were supposed to write two reviews. I wrote two reviews about films that I just made up. I don't think I'd seen the films. Actually, I don't think the films existed! Then I had to show a film I'd made. I really hadn't made a film, but there was someone else who'd made a film based on a poem I'd written, so I was a little bit involved in that. I put some snails on a railway track which I think had something to do with extreme vulnerability because they'd be smashed when the train came. We had some images of a rescue team with ambulances and fire department and divers and things. And we had some documentary shots of that and then the snails. And then the ruin of a factory where my father used to work. I was there to help make some of the images, so those are the images I'm talking about. They're like the foundation of everything I've made after that. So snails on tracks, diving accidents, especially ambulances and the factory where my father used to work, which I think was empty at the time. So those are the cornerstones. I don't think they accepted me because I was good at making films but because they saw that I had a very strong will, that I wanted to do things. So I think that's what I started with, just wanting to do something. And I remember we had some sort of test where we had to work with actors, and I'd never worked with an actor before. And I think the actors were also told to be difficult. I think it was a test of how I would react as a director to someone who says, "But why should I do this?" I think I just forced them to do things rather than describing things. I remember when I was accepted by the school, my teacher said it was one of the worst tests he'd ever seen, but he felt I had a very strong will, and for some reason that will was enough. A director is supposed to be able to communicate what he wants, but with me I was more like, "Just do it because I tell you. Now!"

Like a parent to a child!
[Laughing.] Yes!

Were you already writing scripts at this time?
Yes. But the things I wrote in those three or four years were complete nonsense, complete rubbish! I guess I was reinventing myself or something. I wasn't a very good poet. Well, sometimes I was. Two or three years ago I put together a collection of my poems, and maybe about one in ten is okay and one in twenty is great. But in the period when I was at film school, I was completely without talent in any way. The things I made in there were, with a few exceptions, completely untalented. But I still had a feeling that things would work out in the end. I've no idea why!

Because of your iron will, perhaps?
I don't know what it was.

What sorts of projects did you work on while you were at film school?
When I did my very first film at film school it was seven or nine seconds long. I think it had something to do with numbers, so I wanted it to be exactly five, seven, or nine seconds long. I was into numerology, and for some reason I thought there was some magic in those numbers. The film had a girl who was dead on the floor, a stuffed chicken, and some playing cards, and it was cut like this [LM snaps his fingers rapidly]. I think I was trying in a very minimalist way to do this kind of flow I was just talking about. I don't think anyone liked it at all. But when I look back, I think there was something there that I'm still doing. I think I was trying to make a movie that was like some kind of ritual, some kind of voodoo or something, a movie that could put you in a trance. And I think that now I'm getting back to that feeling after telling stories. I'm getting back to some kind of ritual. And then I made some films where I was directing other people's scripts. There was a group of screenwriting students who were writing the scripts. But I didn't really understand anything about how to direct actors. It was easy when there was a girl who was dead on the

floor, because she wasn't supposed to move! But I didn't really under-stand anything about where to put the camera and so on.

You make it sound as if it was all a big mistake.
In one way, yes. In another, no, it wasn't a mistake, because I think someone has put us in this place for a reason. Anyway, I think the school was very good at allowing me to take it very slowly, step by step by step.

Also, I suppose you learn from your failures?
Yes, I guess you can say that. Also, this was the first period of my life when I was really trying to see a lot of movies. Everything from the latest Hollywood movies to screenings of silent movies and experi-mental things and the New Wave, and just trying to get everything into my head in a few months or a year. I think it was in the second year that I started doing this. And I think I saw small portions of everything. I haven't seen everything by Godard, for example. But I think I've seen one movie by every director in the world. Only joking! [Laughs.] But sometimes I really just had to fast-forward through them because I felt I had to get them into my head as fast as possible. And as we're talking about things flowing, I've always been a fan of fast-forwarding things like movies. It means I can get the images into my head, even though it's really fast.

Do you think you learned from this process?
I think it was like being drunk or something. I think I was interested in intoxicating myself with it. I think this has something to do with what I said before about getting into a trance, about using the images to intoxicate myself.

Did you write anything in this period?
In school, yes. A few things. But I think they were really talentless. The films that I made were bad, but the scripts that I wrote were even worse!

What do you think was the most positive thing to come out of film school?
After the period when I was just trying to put everything into my

head, I think I found some kind of direction in what I wanted to do. So in my last year, when I made two films, I think I'd learned something.

Can you describe either of those films?
Yes. One was a movie about an old couple who are watching television and on the TV there's a report about a brutal killing, like a real splatter movie or something. And the man says, "It really looks like our basement." And it *is* their basement! And there's this girl who looks like she's out of a horror movie—she was actually in a James Bond movie afterwards, because she was blond and cute—and there's this crazy man who's trying to kill her. So she climbs the stairs and knocks on the door to their apartment and they let her in. But when they realize there's this crazy killer in the basement, they push her down again. And then he kills her and they watch it on television.

It sounds nasty!
Yeah, but I think that's the way we behave, isn't it?

Not everyone!
As a society, I mean. It's as if all those starving children on television are in the basement. And they're also becoming some kind of entertainment. So I think I was trying to make some kind of horror movie. But at the same time I wanted the atmosphere to be quite realistic. I mean, people are entertained by real violence so in a way it's quite a realistic movie.

How did the school react to your horror movie?
Things started to get better for me in my last year at the school. And also I had some really good teachers there. Michal Leszczylowski, for example, was a teacher of mine and he's still my film editor.

What did you do after you graduated?
I met my wife, and that was probably the biggest change in my life ever. Both meeting her and having my first child, who was born six months after I graduated from film school. If I analyze what hap-

pened, I think I had three years in film school which were all about me destroying myself and destroying what I had done before and then I had maybe two years where I built something new through being a father and starting to write things again which were of any relevance at all. And I think that's what you have to do sometimes. You have to destroy everything you stand on and build something new.

What were you doing in this period?
We actually lived for some years in a small cottage in the countryside. It was really nice. And I think it was the foundation for something new in my life. I had a short period when I was trying to make some commercials. I was trying to get some money together because I didn't have any money at all. But I was really bad at that. And I tried to write some ideas for commercials. And I went to three or four meetings with people who worked at ad agencies, and they were the most horrible people I have ever met in my life! I really hate that business completely. Those people are very high on my list of people I don't want to sit next to if I'm in a plane and it crashes, because I don't think there's any help you can get from people who work in ad agencies. They're terrible people.

Did you make any commercials?
I made one or two commercials that were really bad. Worse than average, I mean.

It sounds like a difficult time.
Financially, yes. But it was also a great time. The commercials thing was just a parenthesis, actually. I then started to write scripts. And I got in contact with a Swedish producer, Lars Jönsson. I think one of the advantages I've had as a filmmaker is that very early on I could collaborate with a producer who was able to read my scripts and see that there was something he was interested in, but have the courage to say that it wasn't working yet.

How did Show Me Love *take root? Had you already written other things?*

That's what I wanted to say. The advantage for me was that I'd found a producer before I'd written anything good enough to make into a movie. So I think that for a period of a year, no, two or maybe nearly three, I really hated Lars because he'd say no to all my scripts. But it was still a really good collaboration all the way from the beginning, because he always replied and told me what he thought. So we were working together even before we made anything.

How did this happen? After all, Lars Jönsson was a fairly major producer, and you were a relatively recent film school graduate.
Yes. But Lars is also a very hands-on producer in the sense that he works on quite a few projects, but when he works on them he works with them completely. He's not like a producer who sits in an office and has fifteen movies at the same time. At that time he was a success-ful producer, but he'd only produced two films or so. So he was more like an up-and-coming producer.

It sounds like you met him at just the right moment.
Absolutely. This is one of the difficulties I hear from other directors. They don't have anyone who takes care of them. And Lars continues to work like this. Sometimes all he sees is a short film by someone—in this case he'd seen my graduation film from film school and liked it a little bit. I'd asked a friend for help as I didn't know any producers at all. So I just asked who should I send my script to and she arranged a meeting with Lars. So it was a coincidence that I was looking for him and he was looking for me because he'd seen my short film. But I think I was the one who took the initiative. If I was a producer, I'd work the same way. Find someone I like and work with them. I read an old interview with Jean-Luc Godard about how it used to be that there was this family and that family and how the family thing in films has been lost. And Memfis Film, the company I work with, is like my family. I'm not sure I could make any films without them, because it's a small group of people. And it's not that Lars and I have signed a contract to work together. So I can say, "I don't think this is a movie for you," and he can say the same thing.

Let's go back to Show Me Love. *How did the script evolve?*

At that time I wanted to make something like a Ken Loach film, a realistic portrayal of young people, but at the same time had elements of real horror movies, like splatter movies. Not like *Scream,* because they're just fantasies. Something that was completely realistic, but at the same time had this crazy guy going around killing people. So I had this script about two sisters living in this apartment, and their neighbor in the next apartment was the guy who was killing people. It was quite a good script, but after a while Lars and I thought we should maybe try to divide them into two different scripts. So one part became my first short film after film school, *Talk,* which is about a lonely guy who lives in an apartment and a Hare Krishna girl knocks on his door and by accident he kills her and continues to talk to her when she's dead, because he's very lonely. And the other part became the story of these two teenage girls who are sisters. So it didn't start as a love story or anything. It was just about two sisters sitting in a room talking about things.

One of the things I loved about the film was the vividness of its depiction of the teenaged girls. A large part of this is the dialogue between them. Can you say something about how you work on your scripts? Do you work from beginning to end? Or do you grab a scene when it comes to you?

It's changed a lot. But when I was making *Show Me Love* I was trying to learn to tell a story. This is ironic because I'd never been interested in storytelling really. I'd never told a story in my life. I'd been interested in small details. I'd written poetry. I'm interested in the hat on the head of that girl down there [LM points to a girl in the hotel bar]. Anyway, I wanted to try to do something new, so I thought, "This time I'm going to try to tell this as a story from beginning to end." And then I didn't know how to do that.

Did you start with details?

Absolutely. It started with details. Small, small fragments of dialogue between the two sisters, which were cut out of the big splatter script. For example, their discussions about what to do tonight, could we

find something to drink, that lipstick isn't your style. And why do you throw your clothes on my bed? That kind of thing.

How did the script evolve from a story about two sisters to a gay love story?
I still think the skeleton of the film is the scenes between the two sisters. That's the story for me. But my intentions are not very important. Because I create something and it turns into something else. This is how it works for me. I go out looking for something and then I find something else. And I have to force myself to be open enough to look not just for the things I had decided to look for but to pick up the things I find instead. Writing is like traveling or something. It should take you to places you didn't intend to go.

Did the script go through many drafts?
A lot. But I was writing very small changes all the time. So maybe ten drafts.

And you were still involved in this dialogue with Lars?
Yes. And I think he finally felt this was a script that was good enough to show.

How long did you work on the script?
Six months.

What happened when you sent it out?
In the first place we didn't get any money from anyone. Swedish film financing is based on the Swedish Film Institute. They have this system of film consultants who decide whether to put money into a film. We went to one, then we went to the second, and then we went to the third, and they all said no. I remember just thinking that they were complete idiots.

Did they give any reasons?
They just said they didn't like it at all. And when everyone had said no, we thought of making the film in Norway. You know, maybe

they'd like it in Norway? And then there was one person who liked the script, but she was only allowed to give money to short movies. So we thought maybe we should pretend it was a short movie, take the money from her and just try to make it as a feature-length movie. But for some reason that didn't happen. But then what happened was—and we in Sweden don't like to say this—the Danes saved the movie. The Danish Film Institute saw some quality in the script, and someone from the Danish Film Institute said they were interested in the movie and they might be interested in financing part of it if they could collaborate with the Swedish Film Institute. I think there's something interesting about the fact that when something comes from Denmark, we like it. The film establishment in Sweden thinks that Denmark is a much better film country than Sweden. The film critics in Sweden always say that Danish films are better than Swedish films. So when the Danish Film Institute said, "This is a good script," the people at the Swedish Film Institute had to change their minds. So suddenly one of the film consultants was interested. Before this, I'd talked to her on the phone. I'd said, "So you mean you don't really like this script?" And she'd said, "No, I don't." But then I had one of the most terrible meetings I've had to have in my life—in the film world at least. Because when she suddenly got interested, she couldn't just say she'd changed her mind and was interested. She had to say, "Okay, I've been thinking, if you make this, this, and this change . . ." So I had to have this enormously frustrating meeting with her in her office in Stockholm. I had to sit down with her and listen to her telling me all her ideas about how to change the script. And I remember walking out of that office and thinking she was just someone I wanted to kill. I thought, "If this is the price of making films, no more, never again!" Then I went down to the restaurant in the Film Institute and I met with my old teacher, Michal [Leszczylowski]. And I said, "I don't think I will make any movies in my life. I think it's over." And Michal said something that I think saved the film and my career. He said, "Never, ever trust people who haven't proved what they can do by making a film." And I thought, "Okay, I have never, ever seen a film produced by or directed by or written by this woman, so I won't listen to a word that she says. I will just ignore her." So after that I just smiled and

said, "Okay." But I didn't make any of the changes she had recom-
mended. And the funny thing is—and this is starting to sound like I
still want to kill her—the funny thing is that after *Show Me Love*
became such a big success in Sweden, there was an interview with her in
some paper where she said that she was the person who made the film
what it was because of her suggestions about how to change the script!

So you didn't change it at all?
I changed it in many ways, but not in any of the ways she wanted. I
remember she said, "There are no adults in the movie that understand
the situation of these girls, so I think you should put in a kind and
understanding teacher. Maybe a female gymnastics teacher who can
talk to Agnes." I said, "Okay." And ignored her. I don't want to pick
on her especially. But I think it's typical of what directors have to go
through. And I just repeat what Michal said to me: Don't listen to
people who haven't proved what they can do. That's the reason why I
listen to him. Because he's proved himself. He's made films.

*I thought Alexandra Dahlström and Rebecka Liljeberg were brilliantly
cast as the two teenaged girls, Elin and Agnes. Did you search far and
wide?*
We actually did two separate types of casting session. The film is made
in a particular dialect, so we were looking for actors in this western
region of Sweden, but also in Stockholm. The two main characters,
Alexandra and Rebecka, they're from Stockholm but the rest of the
actors are from Trollhatten, where the film was shot. I took part more
in the Trollhatten casting sessions. I think I personally auditioned
around five hundred people. And that was great fun. We had a lot of
fun there. I think we auditioned almost every teenager in Trollhatten
and in the surroundings! I think it took much, much longer to find
actors than to shoot the film. I think a lot of the time I was doing
things I wouldn't do today, which is to audition the same actors over
and over again in different combinations, then go back and think,
"Maybe if we do it like this, or maybe if we do it like that . . . ?" So I
think it was frustrating for the actors, especially for the ones who
didn't end up in the film.

Did you know immediately when you met Rebecka and Alexandra that they were the ones?
No. If I had trusted my instincts more, maybe I would have known. But I took a long time to audition them over and over again. At the time I thought there were only two important things in a film: the script and the casting. Or the casting and the acting. I used to think if I just had a good script and a good actress, I could just relax and have a pizza or something.

Do you still feel that?
Absolutely. Actually, I think something changed with *Lilja.* I started to think I was really a director. Before that I thought of myself as a writer with an ability to find actors. [Laughs.] And the ability to give them some kind of confidence, support them, give them some kind of freedom to do what they wanted to do. So in my first two movies most of the visual or technical aspects of the film were just based on giving the actors freedom. In *Together,* for example, I'd just put the camera in the corner, as far away from the actors as possible. It was both a way of trying to make the film in a seventies kind of style with a zoom lens and everything, and also a way of just giving them a room to inhabit and not interfering too much. And the same thing happened with *Show Me Love,* even though it wasn't made in exactly the same way. It was a way of saying, "Okay, this is your room, do what you want to do here, say your lines, but you can also change your lines if you want to say something else, you can move from there to there and the camera will follow you in some way."

What made you choose Trollhatten as the location for Show Me Love?
It was for a socioeconomic reason. This was one of the first movies to be made there. But now it's the big film capital of Sweden, and everything's made there. And some foreign movies, too, Lars Von Trier, for example.

Did you have much time for rehearsals?
No. I've never really been a fan of rehearsing. Rehearsing is boring, I think. I think we rehearsed a little bit because I thought, "Okay, we

have to rehearse something." I remember one day we read the whole script through with all the actors, but that was horrific, that was terrible, because suddenly it just sounded like such a bad movie. That was a terrible day! It's what they do in theater.

A lot of directors think too many rehearsals can kill a performance.
Absolutely. In *Together* and in *A Hole in My Heart,* I've taken it to an extreme, just putting the camera on without saying anything, without the actors even knowing what scene they're about to do. It usually doesn't work but sometimes it does. I just say one word. And I had this thing with my DP, when I say "thank you" at the end of a scene, if something interesting happens, just let the camera roll, because often before and after a take there's something that happens because people relax and they continue to do what they were doing, but in a more relaxed way. So you must try to find some techniques to find those moments.

How did you prepare? Did you draw storyboards or shot lists?
We didn't really plan anything.

It looked very technically assured to me.
Ulf [Brantås, DP] was more experienced than I was. And we connected in a good way. Unlike a lot of cinematographers, he's very present when you're shooting the scene. Many cinematographers are working mostly before the scene, preparing the lights, et cetera. But Ulf is intuitively very present with the camera in the room, and he's very unusual because he knows when to pan from one person to another—better than anyone else. He's really there, feeling the energy in the room. So he knows exactly when to go to the reaction and so on. And I think that level of experience really clicked with my inexperience and with my laziness!

Did you rely on Ulf in terms of choosing lenses and so on?
It was collaborative. When I wanted something, we did it my way. But if I didn't say anything specific, we'd do it his way. We all had a lot of fun. Ulf was probably the oldest guy on the set. Apart from him, it

was everyone's first time, so I think we had the feeling of being amateurs in a nice way. I think Ulf also let other people into things. I remember Alexandra, who was a person with lots of opinions about lots of things, sometimes thought the lighting wasn't very nice and should be different. So we said, "Okay, Alexandra, you can decide how you want it."

Were you at all nervous?

I was very nervous. Making the film was fun, but there were some moments when it was terrible. I remember one time when we were shooting a scene and there was someone playing drums in the background. The sound man was saying, "We can't do the scene because of the drums." It was when Elin was talking to her boyfriend on a park bench. So I called my producer and said, "Is there any way we could stop the film now?" I think he said that he'd looked at the material and it looked nice. Something like that. So there were moments like that. It's terrible, making movies. You feel completely lost. But there's also something intoxicating about being lost. I think it's a way of making a disturbance in your senses, creating chaos in your head so that something will be born out of it. I think that's the feeling I had with *Show Me Love,* and that's the feeling I want to go back to. I wanted to challenge myself the whole time after that film because there was something I liked about it. But then once a month I decide I'll never make a film again. I say, "This is enough." The last time was two days ago! I said, "I will never go through this again because there's too much pain." It's like I had this dream where I'm standing in a theater directing some actors, and we're making a film about cancer. The foundation of the whole film is the idea that cancer is contagious like HIV, which it isn't. And after we've worked on it for a long time and the place wants to open the next day, one of the actors says, "Do you really know that cancer is contagious?" And I'm like, "Oh my God, the whole play is based on the fact that it's contagious." So everything just collapses. But then in a strange way there's something about the feeling when everything collapses that is addictive. There's something that makes you want to do it again. I think there were lots of

moments like that when I made *Show Me Love.* I thought, "I don't have a clue. I have no idea what I'm doing."

You hadn't had very much experience of working with actors at this point. Were you confident of how to stage action?
I was scared of professional actors, but not really of amateurs. I think amateurs need more courage.

But your two leads weren't amateurs.
They were, more or less. My level of experience and their level of experience were similar because I'd made a short and they'd made some things. But all the other actors were amateurs.

So how did you work with them? Did you have a sense of what they should do? Where they should go?
I think if you're really confident about what you're doing, it's like bungee jumping. You know you're falling, but there are these ropes to catch you. So, as a director, when I trust the ropes, then I allow everything to be very loose. But when I don't trust the ropes, I'm very strict. I say, "You stand here and the camera's going to be here," and so on. And, "Say exactly the words you're supposed to say."

Which do you think describes you best as a director?
It's like what I said earlier. I thought of myself as a writer with a talent for casting. But that has changed very much now. I try to be the one who trusts the ropes. But sometimes I don't, and then I'm very strict about things. I'm a much better director when I trust the situation.

Was there anything you didn't like about the experience of directing?
The thing I was scared about was that when I finished the movie it would be a complete failure. It wasn't that I was scared of the film being a failure, but I was scared the failure would color my experience of making the film in retrospect. Because, apart from the moments where it was pure fear, a pure death wish or something, I liked the experience very much. I made very good friends. And I'm still very

good friends personally with some of the people in the movie and who worked on the set. I was scared that if everyone hated the film, it would change my memories. It's like if you go to a really great party and then you take some pictures of it and you look at the pictures and it looks like shit, it looks like a boring party. That's one reason you shouldn't photograph people you like. I don't really want to put actors I know into my films.

Did you have any pieces of good or bad luck?
There are so many things that can go wrong with a movie, so that if it turns out to be something you can watch without breaking down in tears or committing suicide, you had a lot of luck.

Did the film change in postproduction?
I think it changed. But I think it was one of the films I've made that changed the least. It was rather a straight story, but there were some changes, yes. It took quite a long time to edit. I edited the film in Stockholm, but I lived in Malmö, so I had to go up and down the whole time. And when we said, "Now it's finished," I remember a really good feeling going back to Malmö. I was extremely proud. That was the best professional moment, because I thought I'd made a really wonderful movie. That changed because the next day you'll think your movie was really terrible, but you do have these moments when you can see what you've done. Those moments are rare, when you can really see what you've made.

Can you remember the first time it was shown in public?
In Sweden everything was very good around the film. I had two or three months when it felt like everyone was just smiling at me. The whole world was just smiling at me. And then by accident or design I destroyed everything again.* And after that everybody hated me. I don't really know what they felt. But I had those two or three

* *After accepting an award for* Show Me Love *at the Swedish Oscars in 1999, Moodysson told his audience that the film industry didn't belong in the glamorous setting of the Royal Opera House in Stockholm. When the audience started booing,*

moments when it felt like no one had anything negative to say about me or what I'd done.

That's rare.
Very rare, yes. But I actually don't think I liked it very much. It feels like if you don't destroy that feeling, if you don't destroy that atmosphere, it would be very easy for you to go on trying to find that feeling again by trying to live up to other people's expectations. It's like people are coming up to you and saying you're so great, and you want to hear that again and again. There are some things that are good to be addicted to, but that's not one of them. Being addicted to praise is a very bad thing.

On the subject of praise, Bergman praised your film in an interview. How did you feel about that?
Like I said, everyone was smiling at me. The film was a low-budget film, and I don't think people thought it could become the kind of big phenomenon it became in Sweden.

Looking back on it now, how do you explain its success in Sweden?
Afterwards, especially after I'd made that speech at the awards ceremony, people were saying, "I looked at *Show Me Love* again yesterday, and it's not really that good." And also people come up to you and say that you're great. And then you hear from someone else that they hated the film. I had some people who came up to me—and these are people I think are my friends—they came up to me after the premiere of one of my films, and they were saying it was wonderful, it was great. And then I heard from one of my friends that they hated the film! So I try to protect myself against opinions. I don't want to get addicted to the positive ones and I don't want to get kicked in the head by the negative ones. So I try to stay away from them. I try not to read reviews or interviews with myself.

Moodysson gave them the finger. "The TV viewers at home didn't hear the booing, so they thought I was showing the finger to all Swedish people," he says. "People hated me. They thought I was really ungrateful."

Terry Gilliam

JABBERWOCKY

Prior to making your solo debut on Jabberwocky, *you co-directed* Monty Python and the Holy Grail *with Terry Jones. Did you already have a strong sense of yourself as a director at this point?*

Yes, I think I did, but I wasn't necessarily right. Animating was like making films, except with pieces of paper. I couldn't use the camera in the way I wanted to on film. I couldn't move it in the same way. My cartoon work tended to be fairly flat, proscenium-like stuff, so film was a chance to really start letting the camera do things. At the same time, I think it's taken a long time to get the camera looser with me because, again, I was still looking at paintings. I look through the lens and there's a picture and I try to compose a painting and the people move around within that painting, as opposed to the camera being the extra character that's also doing a dance with these people. I think I got better at that as time went on. If you look at *Grail,* for example, it's actually very simply shot. Basically, you've got a wide shot of the scene with one person on one side, somebody on the other, and then you've got two close-ups, and that's really the way most of the film is shot. There are a couple of moments when the camera is moving, but it's a very simply shot film. I mean I mainly concentrated on the visuals on that thing. Because of *Python,* it was almost self-directed. I was just trying to make that world as believable as possible because I thought the comedy sprang out of that. You were so used to seeing *Carry On* films where everything was clearly phony. I was obsessed with Pasolini and Bergman who really created atmosphere, and I

220

thought the jokes would be funnier if we could really make the audience feel that people were eating shit—that it was uncomfortable and it was painful. And that's what we did. It comes and goes in the film because so much of it is really silly.

Did you see what you did with your first feature film as a progression from Monty Python *or as an escape from it?*
Escape is a better word. I was trying to get out of it. But having done *Python* for as long as I did, it was just there. So the problem was to try to escape from the sketch format. *Holy Grail* is really a series of sketches strung together, and I was trying to get away from that. In *Jabberwocky* I was trying to tell a story, a real story. I was trying to tell a fairy tale. In fact, what I like about it is that it's like two fairy tales in collision. The guy has a fairy-tale ending where he gets the princess, but that's not where he wants to be; he wants to be in the other story where he lived a nice simple life. He was a hero caught up in a fairy tale, a normal guy dredged out of it, a reluctant hero.

That sounds like a description of many of your films' central protagonists. Do you think this aspect of Jabberwocky *foreshadowed your later work?*
Yes, I think so. I found that I go around getting caught in stories that exist, sometimes they're to my benefit, sometimes they're to my discomfort. They're like traps out there. I don't know if those stories exist because I've read them before, or whether they exist in their own right. All I know is that they're out there waiting for me. Maybe it's from reading a lot, but I recognize when I'm in a story, a preexisting story.

Do you think that your animation work prepared you for directing in terms of giving you a visual or spatial awareness rather than simply an awareness of performance?
Yes. I think that comes from animation or cartooning. I just saw the world in that way. A sense of scale has always been important for me, and I think that's what my films have. I think I have always given them scale, and I play with changes of scale—playing optical tricks in

a sense. I love doing that. It comes from cartooning, from painting. With cartooning, particularly, you're distorting things, you're stretching things to the limit. A good cartoon is one that really pulls things apart as far as they can go before they lose their original identity. So I think like that all the time, I'm pushing the world around visually. In *Jabberwocky* I relied on a storyboard, so I'm drawing this stuff. I'm imagining it. I'm seeing the picture. The storyboard is a sketch for this final thing. And that picture seems to be stuck in my head, and even though by the time we get there it's changed a lot because of input from other people and also not finding the right thing, it guides me in getting to the shot.

Do you storyboard all of your films?
I do less and less of it because the storyboard has become a restriction. In *Jabberwocky,* because of the cartoonlike way I draw people, trying to squeeze real, properly proportioned people into my storyboard was a nightmare. I kept trying to do it in *Jabberwocky,* and I was constantly frustrated because I couldn't get the picture to be like I had drawn it, and I think I wasted a lot of time trying to do that. I also think it made me too obsessed with the image rather than the performance.

Do you think your animation work prepared you technically in terms of knowing the effects that different lenses have?
With animation you're working with individual frames, which is actually very useful when you're making a film. I sometimes think in frames not just in scenes like a regular director. When I'm cutting a film I'll sit there looking at the cuts and I'll take one frame off one side of the cut, then I'll say, "No, put it back! It's on the other side of the cut!" That's kind of crazy, but sometimes it actually does make a difference. I'm trying to escape from all of that. I was so much into the detail that I was sometimes losing the big picture.

Let's talk about Jabberwocky. *What were you doing prior to working on it?*
We'd made *The Holy Grail* and I was very frustrated because I felt

there was a lot of the medieval world we hadn't been able to deal with or hadn't had the money for or didn't fit into the film because the joke was more important than the detail. So that was one thing that I was trying to correct in *Jabberwocky*. I was trying to break away from the sketch format, trying to break out of just being comedic. I was trying to do a real narrative, a real story with romance and suspense and adventure, things I liked in films. So that was it, it just sprang completely out of *Holy Grail*—from the frustration of not being able to do these other things. And at the time I was languishing trying to decide what I was going to do next, and I was offered a film called *World War III and All That*. I was just getting nowhere and obviously didn't want to do it. I can't even remember what it was that had got me thinking about *Jabberwocky*, but I'd been thinking about Lewis Carroll at that time and I loved Alice and *Through the Looking Glass* and I always loved the poem. It's like *Brazil* comes from the song and that film comes from that poem and a poem can be almost anything that you want it to be. I also think there were monster films being done in Pinewood and so much was awful, terrible. I guess I was arrogant enough to think that I could do a better version.

Did it take long to write the script and raise the money?
No. I was working with Chuck Alverson and we did it pretty quickly. I've got a terrible memory for time, but it came out quite fast.

How did that work?
I would go out wherever Chuck was living. He was out in Wales a lot of the time, and we would go out and spend four days working on it and then split up and I'd be back here [in London] doing bits and pieces and he'd be there. I have to work with other writers because they're better at writing dialogue than I am. My weakness is the dialogue, but I can always see the film there; the ideas generally come from me. The dialogue comes from them.

What do you think your visual influences were when you made Jabberwocky?
Pretty much Brueghel and Bosch. I like the iconography of the

medieval ages. I like the images; the demons are not abstract ideas. It's touchable, it's real, it's there. Both painters have an incredible humanity in their work. They love the people that are in there, and their paintings to me are like movies because they're vast and there are stories from one end of the canvas to the other. I mean, if movies had been invented then, they would have been making them because they're storytellers who painted. I like the fact that on one level their world is very basic and simple and the hierarchy within those worlds is very straightforward—you've got a king, you've got a knight. Everybody knows the pieces, the chess pieces, and once you've got that slightly simplified world, you can play with it. I think that's when the fun starts because everybody knows that's the king and he should be there, that's a princess and she should be there. And then you start playing with those clichés. Brueghel's and Bosch's paintings are just full of life, and they're disturbing. They're not frightened of the darkness of life. There's a harshness there, a portrayal of survival and struggle, and then there's just this extraordinary beauty in them as well.

And the sense of scale you were talking about earlier?
Yes, again it's a bit epic.

Like your movies?
That's what I grew up on. The ones that I remember and loved the most were epics, because I loved the ability to disappear into another world, into another time and place. And there it was with all the extras, everything around you, I was in those worlds. It was modern time travel, that's what it was for me. So I wanted to do that, but never had the money to do it. I was always, and continue to be, far more ambitious than I have the money to be, and that sets up this constant problem of how I deal with achieving something with no money. And in a sense it's made me technically a pretty skilled filmmaker because I had to do that. I think most of the people with the kinds of budgets I was using were doing contemporary films where the people are sitting around in a regular, normal world, while I was trying to create these other worlds for the same kind of money.

I like the sense of scale that you achieve with tiny effects. For example, the moment when the king dislodges a brick in the princess's chamber and you see it fall and realize how high up the chamber is. A wonderful moment, and very cinematic.

Yes, that's right. It may have come from having lived in New York with these great big gigantic skyscrapers. I was at the bottom, sometimes I'd be at the top. It's the verticality of things, and I use it all the time in my films but certainly it applies to the Middle Ages a lot. You've got kings up high, you've got peasants down low, and the struggle in a sense is that character's struggle up this ladder, and that really excites me. One film that used verticality is *The Prince of Egypt*. It's turned Egypt into this totally vertical kingdom. Egypt is actually very flat, but they somehow architecturally made it vertical. Scale is also about putting people in environments where they are very small. In a forest you are quite a small creature in this great space. Like in the beginning of *Jabberwocky*, we established the monster as incredibly tall, certainly nothing like the one that you see at the end. We were down to no money at the end. I saw it the other week, they showed a clip and I just thought, "This is embarassing." At the time I was very proud of it, though.

What was the budget?
It was five hundred and fifty thousand pounds.

Talking slightly more generally, what do you think are the director's main tools in achieving a film's overall style, in terms of lenses and so on?
I've always tended toward wide-angle lenses, and I think that comes from being a cartoonist, again being able to distort. They also show me more than a normal lens. The wide-angle lens shows a lot more of the world, and it creates a different way of shooting, in a sense. With a wide lens you've got to lay the elements out more carefully. The lens isn't doing the work for you. You've got to deal with the light, positioning people, all that stuff. It's much easier working with a long lens, because you stand back from the action and you pick out the stuff you want to shoot. A long lens isolates the things you want to focus on.

So less composition, in a sense?
Yes, totally. You make a good shot really easy with a long lens because everything else is out of focus except the thing you're looking at. It's very simple. A wide-angle lens is a much more complex thing to work with but I like it. It's me looking through the camera saying, "I want to see more; I'm trying to get into the film." It's almost like pulling the edges of the frame out so I can see what's there, and it's also partly because of the spaces within the film; the places are all part of it as much as the characters. That's how I approach it: the rooms, the buildings are characters as well and they've got to be seen in the right way. It's like people aren't isolated from the rest of the world, they're a part of it all the time. Again, it goes back to Brueghel and Bosch's paintings which are incredibly complex things and it takes a long time to see them. I try and do that in every frame, and the camera's moving and the film's cutting and for an audience it's like, "Whoa, it's an awful lot of stuff," but that really excites me. I remember people coming out of *Jabberwocky* saying that they just felt that they had to take a bath afterwards, they felt the dirt of the time, and that's fantastic. I actually got them into that world. Now that's really important. Again, it's taken me a while to get away from this sort of proscenium-arch cartoon thing and get into the detail properly. Even in *Jabberwocky* I was still trying to do it all within a canvas frame.

A master shot?
Yes. I look at other films and they write in close-ups and the details of, say, a hand, and I'm sitting back there watching the play. Not always, but I do that more than a lot of other people.

You did the jousting scene in Jabberwocky *using long lenses, didn't you?*
Well, that was out of necessity. It was more of a ramshackle way of making a film, as opposed to, say, *Brazil*. In *Brazil* I was really using wide-angle lenses all the time, *Fear and Loathing* constantly. I mean, we don't even go beyond using the 25 mm lens. With *Jabberwocky* it was a bit more flexible than that, and I hadn't quite got the full wide-angle-lens thing, but again a wide-angle lens gave me scale. The spaces looked bigger than they really were.

How much did you rely on your DP, Terry Bedford? Were you sufficiently technically proficient to be able to say, "This is the lens I want"?
Pretty much, but I got better. We were fighting a lot. Terry is actually a brilliant cameraman, but we got caught up in a situation where he thought we were rich beyond his wildest dreams, which was not the case, and he couldn't understand why we had no money to make this film properly, because he knew how ambitious it was, and he was constantly railing about this. At one point he walked off. It was difficult because we were trying to do a lot with little. I mean, the sort of situation where we got into fights was the scene where Bernard Bresslaw, the innkeeper, is released from jail and some money drops into his hands. And I said, "Okay, a jail cell, all we need is a black velvet backcloth, and one of the little windows we had built for the throne room"—basically a box with light coming through—which gave a sense of depth to the wall. "And a grille for the door. I don't need anything else." And Terry was going crazy. We don't need to see any more, we got a window, light coming through, it's hitting the bars of the grille, we see a hand, we see Bresslaw's face. That's a prison cell, end of conversation. I was enjoying that kind of limitation, working with the constraints. Terry was having a terrible time because he thought we were making a great big movie. I mean, there's the scene where Deborah and Mike are being married, and all there is is a rose window made out of colored gels behind them. I think there were one or two columns we stuck in, but the rest is black. It does the job, it's perfectly adequate, but Terry said, "We've got to build a cathedral!"

Has that principle stood you in good stead for the rest of your career, in terms of what is going on in front of the camera?
It's a constant fight, particularly when I work with designers. I say, "I just need this one wall," and they say, "No, no, no, you need the others in case you want to use the others." I don't want to use the others and they start building the others, and I go crazy because they're used to directors who need everything in front of them and because I know what I want, that's all I need to build, and that saves money. In fact, that's why films cost a lot of money. The directors haven't made up their minds about what they want, so the designers build a whole

world for them, even though they only need to shoot one little corner, just in case. And the "just in case" bothers me because if I can give us the opportunity to do that extra shot and make it more complex, I know I'm going to lose time. I'm going to do it because I'm greedy. I will go for the extra bit, and will spend more time on the shot than I should, and so I'm not getting the next shot. I'm aware of it all the time.

So having a storyboard helped you in terms of bringing the film in on time and on budget?
Totally. Because then I know what shots I need and that's it. Now I'm more flexible.

And you have more money!
Yes, that helps!

The cast of Jabberwocky *is like a roll call of British comedy of the time. Was this a conscious attempt to bring the film to the attention of the television audience who already knew your work as a member of the* Python *team?*
I never think about an audience. I just chose people that I admired. We were at the height of British comedy, and I just thought these were the best guys. I saw Max Wall in some television thing, and just fell in love with him. Putting him and John Lemesurier together was fantastic. What's wonderful is when you get good actors and you give them time together and things happen. They started doing this "oh, my darling" thing like two old queens, and it was really funny so I left it in. I just thought, "this is great, let's leave it in." It was really the moment that I started to get excited about real actors as opposed to Pythons because they came up with more things, and also I learned from them that's what it was about. I watched them and learned from them all the time. On *Python,* we did what we did and it was fantastic. But I kind of knew what everybody was capable of or was going to do. So these were new people, they brought new ideas into the mix, which were not my ideas or *Python*-like ideas. That I liked.

It sounds to me that the Pythons were undirectable?
I actually thought directing *Python* was a dogsbody job.

Because they would do what they wanted to do anyway?
Yes. I was frustrated with them on *Grail* because they weren't doing what we needed to make a film. They were just interested in the performances. Terry concentrated more on dealing with them, and I sat back with the camera and dealt with that.

Did you have time for rehearsals on Jabberwocky?
Basically I put Max Wall, John Lemesurier, and Michael Palin together. Mainly John and Max, because they'd never met each other. They just hit it off immediately. It was wonderful, seeing these two old stalwarts of British comedy together. But there weren't many rehearsals; we just read through it, talked, and that was just about it. I mean I didn't really get time for rehearsals until I got to *The Fisher King.*

Did you feel nervous when you were about to start? Or was your feeling more one of pure, unalloyed confidence?
I sort of just leaped into it. If I think about it I freeze up, so I drive myself in order that I don't get caught up in that. I mean my attitude to every film is that you just start. Even now, as I'm approaching the first day of shooting, I suddenly realize that I know nothing about filmmaking! I don't know a single thing!! I don't know how any of it works. I don't know what makes actors tick. And then I just jump over the edge and discover, "Oh, it's all right. I'll put the camera there." The hardest thing is always the beginning of the day: "Where's the first shot?" That's how a day begins. You need the first shot, and you've got to get it in a certain amount of time or you're doomed.

Did you find with Jabberwocky *that you knew instinctively where you were going to put the camera, or did you have moments of panic or uncertainty?*
I don't panic, but there are always moments of uncertainty. That never

changes. There's always uncertainty, but the advantage of the storyboard is that there it is: that's the shot. So that at least kept it going and, knowing how little money and time we had, I was more insistent then than I am now on sticking to the storyboard, because I didn't know how to get through it if we didn't. And, again, working with some of the other crew who had much more experience than I did, they said, "What about this and what about that?" And I said, "No, no, no." They were good ideas, and had I had more time and money, I probably would have tried them, but I just focused on what we had to do to get through.

What did the crew make of you at that point? What did you make of them?
Luckily most of them were young, and so it was a good gang of people. We were just grabbing and cheating all the time. We were at Shepperton studios, there was the *Oliver* set that we revamped. There was a German production of *The Marriage of Figaro* and they had sets there and they were finished and we bought them for five thousand quid. The sets were not medieval, but we didn't care. I mean there were flats and there were bits that we revamped. Blake Edwards was there making a Pink Panther film and he had built a castle and I said, "Oh, we've got to use it." Of course they wouldn't let us near it. They also built a catapult, which we stole. They kept dumping everything they'd finished with on the heap at the back of Shepperton, and we would go and steal the stuff. It was a scavenger filmmaking crew with a great construction manager named Bill Harmon. He would send his boys out to grab anything lying about, and they found this incredible sewer set. So I wrote a scene to use it. Dennis was going to get into the castle down the sewer. When they found out we were nicking their stuff, they started destroying it, burning it all, breaking it up so we couldn't get at it. It was just so petty and pathetic, and they had all the money in the world and we had nothing. They were worried that this stuff was somehow going to be seen before the scene in their film. I said, "You don't understand. The whole point is that I wouldn't want to do anything that's going to look like anything in your film. I don't want to be accused of that." But they didn't understand. For the inte-

rior of our castle, all we could afford was to build eight-foot-high stone walls, and the rest was black velvets and the window boxes that I'd had made. We put those in different places so you got a sense of thick walls. For the floor we would put pools of light in different places, and we would put our fake flagstones in those pools of light, and when there weren't pools of light, there was just the studio floor. We were constantly working like that. If I found some columns, I'd stick them into the shot. We had to do corridors in the castle, and basically we just made plywood cutouts of arches, painted black, and layered them one behind the other and, bingo! you've got a long arched corridor. I remember painting a little door down at the end about a foot tall to get this sense of a long corridor, but the corridor's only forty feet long at most, and it looks twice, three times that length! We would just change the lighting pattern on the arches and walls and it would be a different corridor. And, again, people on the crew would fight against this approach because it was cheating. Of course it's cheating, that's how you make films.

In other words, you discovered that filmmaking is all about cheating?
Yes. I think too many people believe that films are real, even the people who make them! And they need a real atmosphere to work in. It's bullshit, it's all artifice. I'm happy to fake any of it. I think it makes me happiest when I pull off a bit of fakery and it works! That's when I think, "Oh shit, that's fantastic!" But I think for a lot of the crew it takes a while to be confident in the director, and they're not always confident, especially when you're starting out. They just think you're out of your mind!

They want to believe it when they're making it rather than when they see it?
Kind of. They like to be a part of something. You can see them walking on the set saying, "Whoa, look at this. What a great set!"

What was the hardest thing to execute on Jabberwocky?
I suppose it was the monster, because we ran out of time and money,

and the guy who was supposed to be building it had a nervous break-down. We discovered late in the day that he had been wasting months going around in circles, and we had to gather a couple of people together and myself to try to build that thing in a week. It wasn't half-assed, but it could have been so much better if things had gone right. It was terrible knowing that we were going off to Wales to shoot it with just a scratch crew. It was disappointing because we were tired and we had run out of money and the story had been building to the revelation of this extraordinary creature. It gets by, but it's not what it should be, and that's disappointing. In the end I only had a couple of days to shoot the whole monster fight.

When I watched it, I thought that the design was intentional. Because "Jabberwocky" comes from Lewis Carroll, the monster is like something out of a children's book or rhyme.
You see, that's what's interesting. I sit there and try and make these things like proper films, and they don't succeed and afterwards other people find ways of absolving me of my failure. I think that's really wonderful! As if there's an intention to it. My intention is to be just like every other big-budget, big-time filmmaker, but I keep failing at this and end up with something that's often more interesting. It doesn't become the big thing I intended. It becomes something else, but it has a certain style, nevertheless.

Were there any unforeseen blessings or disasters, or did everything basically go okay?
No, it never went okay! I hate making films because it always feels like a nightmare. Nothing is being achieved in the way I want it to be achieved. It's always terrible—compromises and failures. With the joust, for example, we'd run out of time and the light was awful. Another moment I don't think looks very good is when the bandit is attacking the Fishfinger family and he's crushed by the knight falling and he's just a rubber thing. I don't know what people think of it any-more. I look at it and say, "I wanted something here. I wanted it to be more believable that the guy was being crushed." On the other hand,

where I think one of my ideas worked really nicely is when Harry Corbett is crushed under the bed and just this trickle of blood comes out! It's awful, it's really disturbing, but you don't see anything. I think I was just playing with all these different ideas and they hadn't quite all come down to a consistent style. One minute I'd be really jokey, the next I'd be seriously trying to re-create something genuine, and there's sort of a mixture which I guess kids love. It's a kids' movie, really. I think it works at other levels, but if it works for kids, then I'm really happy, and when I made it they didn't understand I'd made it for kids as well. What the distributors have never appreciated about my stuff is that it works for kids as well as adults. It works on different levels; the two things don't necessarily correspond and they don't really conflict. I mean, the kids get it and the distributors don't get it. For the distributors, everything has to be generic, it has to be for this audience, for that audience. And I said, "No, no, there's some really intelligent stuff in there, and then there's some really silly work in there, too."

What do you think was the hardest thing about the experience for you as a first-time solo director?
I'm sort of way out here, swinging left, swinging right, but at the same time trying to hold on to my own initial idea, whereas everybody around me was making a different film. It's kind of like everybody's making their own film and you've got to try and remember what it was that you set out to make.

Did you learn a lot from it?
Yes. One thing I learned is not to be arrogant and to get as much coverage as I can. I get more coverage now than I used to. I mean, I did this scene where the prince climbs up to the princess's window and then falls. The timing isn't quite right. But I was determined that I would always stay in one shot, so I just shot it in one shot with not enough takes to get it absolutely perfect. Now I would make sure I had a cutaway of Mike or the princess so that if I needed to adjust the timing on that, I could just cut away for a moment. Nobody would

probably notice there is a cut, but it would have made the timing absolutely precise. I get less bold as I get older!

Isn't the function of the storyboard that you need less time because you specify your shots?

Yes. But what happened in this incident is that we didn't have enough time on the day. I should have done five more takes to get this thing right, but I couldn't so I was stuck. In the limited amount of time I had, I should have covered my ass: just got a cutaway, which would have taken only a short moment. It would have given me a chance to adjust the timing of that background action with the dialogue in the editing room. I didn't because I didn't want to have the shot that could be used against me later in the cut. When I'm making a movie I'm always thinking about the final hours when you have all this pressure, and I don't want to leave stuff out there that could be used against me. But I've gotten better about that. I don't care now.

What are the things that you didn't like about directing?

What I hate about directing is getting up early in the morning. I hate it! I mean, getting up at dawn is the most awful thing. It's just something that I've always hated. It's a killer. It's also that sense you have every day of not getting it as good as you thought it would be, and then you've got to carry on with this growing depression that just gets greater and greater.

Does that happen to you a lot?

Always. And they're all waiting for you to give them the answers. That's the other thing: all these people depending on you for an answer. What I try to do—and I've done it right from the beginning—is to make it as collaborative as I can. On *Jabberwocky* I was once saved by the prop master. I can't remember what I was doing. I can't remember what the shot was. I had basically painted myself into a corner. I'm sitting there and he says, "Why are you doing that, Terry? Why don't you do this?" And this is the prop guy! I said, "Jesus, that's right. Thank you!" Having people come up with suggestions

can be difficult because you just hear so much noise all the time. But on the other hand these are the guys that can save you, dig you out of a trap you got yourself into.

They're there to give you good advice?
Yes. Too many directors seem to me to be in this game for power, especially in America. When I did my first American film, *The Fisher King*, it was as if the crew had all been working for a bunch of Nazis. They were so unforthcoming, they didn't offer anything; they were just waiting.

They were like a machine for you to use, rather than bringing their own ideas?
Yes, that's exactly right. It took me three weeks to get them to understand that I wanted their ideas. A dialogue is what you need. But it took ages for them to do that. I don't know what the directors over there do. I suppose it's like, "I want this. I want that." There's no argument. At least the British crews are a bit more bolshy. I mean, they ask why and then give you some shit. Whereas the American crews are just, "Tell me who to shoot," rather than "Should I really have a gun in my hand?" It's real fascism the way American films work, and I don't like that.

Why do you think it's like this?
Well, it's like American football and British soccer. American football is all specialist: each player does a specific job. The guard does that, the center does that, the halfback does that. In soccer, everyone is pretty much an all-rounder and British crews are more like that. Most of them don't just stick to their task.

How fast did you have to work on Jabberwocky? *Do you give yourself a maximum number of takes per setup?*
Yes, I think in terms of doing five takes unless sometimes I get stuck, and then I may go to thirteen or whatever. But I always try not to do a lot of takes. I'm trying to remember how many days we took to

shoot *Jabberwocky*. It wasn't a lot. I usually try and find the First ADs who'll be ruthless timekeepers and push me along, but actually it's often me trying to push it forward, and so I'm never enjoying the moment. I've learned to chill out more, but in those days I wasn't enjoying the moment and letting it roll into what it could or could not be. I was "got to keep moving."

So you think you're more relaxed now when you make films?
Yes, much more. I'm more at ease with the whole thing, and I'm not as frightened of things going out of control.

Would you say you were good at delegating, or would you like to control every aspect?
I am in on every aspect, and so I do want to control it, and yet I don't want to control it. It's a very fine line between saying, "This is what I want," and not being intimidated by people coming up with their own ideas. It's a fine balancing act between, "Okay, I'm bringing in all these references, this is what I want," and still being flexible. I mean, Hazel Pethig, the costume designer, was great because she'd worked with us on the television shows and had done *Holy Grail*. So I would draw a cartoon, something like Max Wall, the king with all of his robes, and she would translate that cartoon into something that would work on a human being. That was really good. I loved that. I love being surprised by other people's ideas when they're really good ideas. I suppose what I keep trying to do is make sure that people don't build empires within the production, or go off just doing what they want to do. I've got to see it all, so I spent an incredible amount of time in the costume department. I spent forever in the art department. When we did *Munchausen*, I built my office in the art department because then I could keep an eye on things, and other department heads would have to see how the sets were developing every time they had to meet with me. And yet, although I'm guiding it, I'm not totally controlling it. If somebody comes up with a better idea, I don't have a problem, I don't have an ego in the sense that it has to be my idea. If it's a better idea, it's a better idea! And that's what I'm interested in because the

film will benefit. The film is what we're serving, not me, and I keep saying, even to the crew, "If the director gets in the way, if he's fucking up the film for you, just push him out of the way." Of course, nobody quite does that. People will just say, "What the fuck are you doing, Terry?" And that's the way they should do it.

Obviously, to begin with your great strength was visuals. Did you find it easy to deal with actors? Did you find the basic mechanics of moving people around in a space easy? Did it come from you, or did it come from the actors?

It's a bit of both. When you're working with good actors you say, "Let's just start. You come in through the door. You sit down there. Wait a minute, say the lines. Feel like getting up?" And then you start. And if you've got the time you let things grow: "That's great, that's a wonderful thing that's happened there. Let's do that." In *Jabberwocky* it tended to be a little bit more mechanical, because there were just people walking round a room. So I kept the movements of people in the film very simple. The actors walk into a room and talk to each other. It's not like people roaming around each other, taking positions. That doesn't happen. So the blocking was very simple, basic stuff. I think I've gotten better. I can do more things now. But that was the way I was doing it.

Some of the scenes looked very intricate. The scene in the armory, for example.

That was one of my finest moments! We had no money at that point, so everything was incorporated into one day. We set up the foundry, the armory. I just said, "Okay, that's going to happen there, that's going to happen there. You guys up there, you throw some shit down, now you push this over there." A scene like that you normally plan out, you normally do over a couple of days. But it was the only way we could do it because we had run out of time. Even the production said, "You can't do it." So I said, "If I do it in one day, could I do it?" "Okay," they said. "Here we go." And we just did it! There were no second takes on anything, and we were probably using only two cam-

eras on the whole sequence. But it works! Given enough time, those moments are ones where I can get myself tied up in terrible knots when planning it. But if I have to do it immediately, I can do it really fast. There's a moment when you're creating these sequences when you start thinking too much.

So too much preparation can be a bad thing?
I think so.

And that obviously applies to actors as well. Less spontaneity?
But there are no rules on this. Other times you just want the opposite. I mean, that's all I know about any of it. That's all I've learned: there are no rules. More rehearsal times can be good and it can be bad. What you do as you go on making films is you get more confident knowing that there are no rules.

So it doesn't matter?
It's like being on a tightrope. You've got to judge each situation as it comes along rather than saying, "This is the way it's done." Like working with actors. I didn't know how to work with actors, really. I was always in awe of people like Bergman who managed to get incredible performances. I just didn't have any technique. All I did was to provide a good audience for the actors. When they are funny, I laugh, when they are emotional, I cry. I try to make it as enjoyable as possible to work so we're having a good time. We're kids in a playground. My job is to build this perimeter fence so it's safe to play.

Let's talk about postproduction and editing. Was that another steep learning curve for you? How did you work with the editor?
It was a strange one because Mike Bradsell was a really fine editor, but on the films that he had worked on before, the director would come in and view Mike's cut, comments would be made, and the director would leave. I didn't know how to work that way. The idea of the director being in the editing room every day was something Mike just wasn't used to. I was frustrated because I wasn't used to not getting my hands physically on the film. It was an uncomfortable relationship.

Do you feel that you learned a lot from him?

I don't know. I don't think I did because I went back at a certain point and recut the film after the edit was over—and I think I improved it. His sense of comedy wasn't that good. His experience was doing more classical films. He played opera all the time! I mean, I play opera all the time, too, but that wasn't what we were doing. Maybe it was me reverting back to *Python* in a strange way rather than going forward. Maybe I could have learned more if I had let the film be less funny, let it be more beautiful, whatever. But I just felt that in many cases the comic timing was being destroyed. Either you have a sense of comedy or you don't, and his wasn't as good as mine!

So how did you feel when you saw his first cut? Or your first cut?

I don't know. I get so wrapped up in the editing that I never know anything after a while. I'm learning to step back more as I go on, because you have to try and keep a certain distance. If you're there every day, cutting it yourself, you lose that distance. It's harder to judge it because you know every cut. You know everything and it's hard to watch the film. And yet I was so obsessed with it. That was the only way I could work.

What was the reaction of the film's backers when they saw it? Do you remember showing it to the public for the first time?

When we were cutting our film, we were showing it every couple of weeks. You get friends in, friends of friends, and you go down to Wardour Street and go into a little screening room and show it. And then you go to the pub afterwards, get everybody pissed, and hopefully they're honest with you. You need to start asking, "Is that funny? Did that work? Did you understand what was going on there?" All those basic things as you try to get a sense of whether it's working.

You're doing your own audience research?

Yes. But it's on an informal basis rather than Hollywood's formalized market research screenings, which are pseudoscientific, statistical bullshit. By the end of the process we know the film's as good as we're going to get it. That's another thing people have to come to terms

with: the film is not going to get any better! It is what it is. It's a flawed thing. That's the best we can do with what we've got. But executives in Hollywood don't want to think like that. They think that films are perfectible or changeable. But things aren't changeable. A film is what it is very early on. I mean, we got caught in a curious situation because *Jabberwocky* looked like *Holy Grail* in the sense that it was medieval, it was comic, I'm in it briefly and directing it. Mike is the lead. Terry Jones is in there. Three Pythons are involved, and so people were looking at it as the next Python film. It wasn't. And so there was a lot of disappointment, certainly on a critical level. It wasn't as funny as *Holy Grail,* they thought. Well, it wasn't intended to be as funny as *Holy Grail.* As with almost every film I've done, it drove the reviewers crazy. Reviewers like nice, tidy films that are this or that, and I never give the reviewers that. I remember the screening that I liked the most. It was at what is now the Curzon Soho. We had families bring their kids, tons of kids. Again, people thought, "We can't show it to kids. It's too dark, it's too gruesome." It was a great screening. The kids were bubbling and laughing and shrieking. And everybody came out beaming. It was as if the parents could finally see what the film was, too. They weren't having to go and see a "sophisticated Python comedy," so everybody relaxed. For me, that was the best.

How did it fare commercially?
It broke even. Over the years it actually made money. Ultimately it was a commercial film.

Were the backers pleased?
I think everyone wanted it to be more successful, because *Holy Grail* had done really well and it didn't do what *Holy Grail* did. And particularly in New York the distributors were bemused by it. I said they couldn't sell it as a Python film, and they ended up doing just that because they'd tried everything else.

What do you think of it now? If you were making a similar film now, what would you do differently?

I once saw the film when we showed it to some distributors, and somebody had forgotten the soundtrack, so we just showed the film without the sound and I actually thought it was a better film; it wasn't jokey, it was just beautiful. You got the chance to appreciate the world—how well we had done it. And after that I thought, "Whoa, let's get away from the cheap jokes." So I think I would probably cut out some of the more silly aspects now. Actually, I don't think I could be that silly anymore. The guy who made that film isn't here today, that's all. I'm a different guy now.

Would you say it was Holy Grail *or* Jabberwocky *that unlocked your directing career?*
Grail was the first step outside of the isolated world of animation—a man and his pieces of paper. But I think *Jabberwocky* was the one, in a sense. I learned a lot. I tried all sorts of things and I failed on different fronts and got other things right. You make a film and afterwards you look at it and say, "I got that bit right. I didn't get that bit right. That one surprised me." And I think that's how you learn. You watch what you do and then you realize, "Yeah, that's good." And even nowadays a lot of stuff surprises me in the editing room. When you're shooting, you're convinced that it didn't work and you see it two months later in the cut and it works. It's like trying to develop your own sense of observation when you're shooting, and that's the hardest thing: to know what you've got. Did I get it? Did I *not* get it? I still don't know if I ever get it, but I feel better about it. I'm quicker, so I say, "Okay. That's good enough."

Do you think you could have come to be the kind of filmmaker you are without having gone through the Python *experience?*
No, no. *Python* was the most important thing that ever happened to me. Everything that subsequently followed was based on the success of *Python.* Doing the animation was something I never planned to do. But it loosened me up in a way nothing else ever has: it allowed me to become this sort of magpie-eclectic artist, grabbing whatever interests me and using it. Then *Holy Grail* was successful and the credits

claimed I was a director. That was the turning point. Any young, aspiring filmmakers out there, make sure you get your name up on the screen and then you're a director. That's what happened on *Holy Grail*. As the film finished, it said, "Directed by Terry Gilliam and Terry Jones." So everybody saw us as the directors. In reality, of course, we were still guys trying to learn how to make movies.

Sam Mendes

AMERICAN BEAUTY

Can you say a little about your background?
I was born in Reading and brought up in London and Oxford. My dad was an academic and my mum was a publisher and is now a children's book author. I had a very bookish upbringing. I went to the theater and to the movies. I was very sporty. My dad took me to football all the time. I became obsessed by cricket and still am. I'm an only child and my parents separated so it wasn't an untroubled childhood. But it wasn't an unhappy one, either, although there was a certain amount of upheaval. Moving backwards and forwards, that sort of stuff. Displacement. My grandfather on my dad's side had an extraordinary life. He fought in the First World War, was a door-to-door salesman on Long Island in the thirties, was the governor of port services in Port of Spain, Trinidad, and ran Singer Sewing Machines. And in the meantime he found time to be a novelist and published what was effectively the first Third World magazine, *The Beacon*, in Trinidad. So there was a literary streak running through my family. But there was also my dad's mother, who was part of a traveling circus in South America in the early part of the century. So there was also the vulgar showman presence in the family. I like to think that I've brought them both together! [Big laugh.]

Were there any signs of your future theatrical talents when you were a child? Bossing children about in the school playground and so on?
I was always very bossy! When you've been a young kid and you've lost

control of your environment, I think you either go under or you become someone who attempts to control it. And I think that's what I became. I was genuinely very bossy, but I wasn't at all focused. I certainly wasn't good at schoolwork. I struggled very much at school until I was about seventeen, when I sort of took control of my life. I worked out that if I wanted to do well I had better get my act together. And then I worked hard to get into Cambridge. And from then on it was easier because I had a sense of purpose. But I was only ever really good at English and Art. That was basically it. Everything else went for a Burton.

How old were you when you caught the theater bug?
I think it was around that time, seventeen, eighteen. We lived in Oxford, and my mum would take me to Stratford from time to time. I remember seeing early productions there and loving them. But I never thought, "I want to be an actor," or even "I want to be a director," until leaving school and going to university. Until I directed my first play, I thought it might just be one of those fanciful notions. You know, I might go and work in radio. I might go and work in television. It wasn't founded on any kind of evidence. And then, literally the first day I directed a play, I remember being very nervous because it was so exciting and so much fun. I felt myself to be so good at it that I thought, "What do I do now? Am I going to blow it?"

What was the play?
It was *Little Malcolm and His Struggle Against the Eunuchs*. It's a David Halliwell play written in 1965. I think the original version starred John Hurt. In fact, I think the original production was directed by Mike Leigh, which is one of the only times he's directed anything not written by him or devised by him. It was when they were all at RADA [Royal Academy of Dramatic Art] or wherever they were. So I think that cracked it. From then on, I hoped I would be able to become a director, but for the next three years at Cambridge I directed nothing but pretty ordinary productions. It was only when I left Cambridge that I thought I could do this for a living. I then went to the Chichester Festival Theatre. I was very fortunate because John Gale was

running the theater and he loved young people and loved giving them a bit of responsibility. So I got some shows there and then I got the studio theater to run. One thing led to another, and I ended up being able to call myself a professional theater director, which always seemed an incredible stroke of luck. You've got to remember that I'd spent three years at university begging people, pleading with people just to turn up at rehearsals and to ignore the essay they were supposed to be writing. I remember on many occasions going round to people's rooms and literally getting them out of bed, saying, "You've got to come and rehearse." So suddenly to be paid for it, and furthermore, for the actors to be paid for it, too, so they had to turn up, was amazing.

Did directing always come very naturally to you?
You may think I'm very easygoing, affable, all that stuff. But when I was at university, I was literally physically ill every time I did a production. I lost weight. I got ill. On one occasion I ended up in hospital. I was so nervous and so terrified about it that I didn't eat. I think it must be like childbirth: the woman's brain is conditioned to forget about the pain and remember only the pleasure. I think it's the same with the theater. You remember the good stuff. And every time you get to a first night or a preview, you think, "How can I be doing this to myself again?!"

Were films as important to you as the theater during this period?
Films were a big thing for me. If I'd been aware that it was even possible to become a film director from where I stood, I would have tried. But there was just no obvious way to do it in those days. There were no film courses. There was a postgraduate course at the National Film School, and that was it. And it was so oversubscribed. You could go to things after university, but there was only one undergraduate film course, film studies at Warwick, and I applied for it. And I didn't get in! I got into Cambridge afterwards. As it happened, I then stumbled into something I think suited me more, which was to be a theater director.

Had you been accepted by Warwick, though, you might have tried to go directly into film?

Absolutely. I mean, I think it was fanciful, but I just had a sense I might be able to do it. I do remember, during my careers application time at school, studying all the cameraman jobs in television and thinking, "I wonder if I could be a cameraman." Because there seemed to be no way of getting one's hands on film as a career, and that seemed to be the closest. So I looked at all the BBC courses and all that kind of stuff. But it seemed like there were tram lines laid down for you, and none of them led to film. It's a class thing, apart from anything else in England. If you go to public school and do well in your A-levels, well, you're going to try and get into Oxford or Cambridge. And if you don't get into Oxford or Cambridge, you try and get into one of the better redbrick universities. Or, occasionally, people are clever enough or sensible enough to decide not to go to Oxford or Cambridge but to go to Bristol or Exeter or wherever, of their own volition. But the point is, there was a sense that this was the way you're going to go if you're any good and there's really no other way. Why would you *not* go to university? And if you go to university, why would you not try to go to the best university? And if someone like me gets into the best university, all you can really do is study English literature, because everything else is too difficult!

Were you glad you didn't study film in the end?

I'm very glad I didn't study film. Thank God! For a start, Cambridge gave me three years to read books and direct plays. And the combination of the two gave me a bedrock of understanding of Western literature and drama. And I think that's really stayed with me. I think everything I've done in film is only standing on the shoulders of what I've done in theater. The fact is I've spent twenty-odd years telling stories that last two hours to a group of people sitting in a room. And cinema's no different. You look around at the moment, and there are very many wonderful filmmakers. But there are very few people who are used to telling stories so often. And there are some who are less good storytellers than they are filmmakers. And I've always felt it's the

other way round with me. I'm used to telling stories, whereas I'm not used to making films. So that's been the learning process. So that's how I've ended up where I am.

Did you see a lot of movies as a student at Cambridge?
I saw all my first important movies there. The repertory cinema there, the Arts Cinema, was fantastic. There were twenty movies shown there a week. I saw Truffaut, Godard, Kurosawa. And then there were two or three really seminal film moments there for me: *Paris, Texas; Repo Man;* and *True Stories,* the David Byrne film. They absolutely stayed with me, and you can see them all in different ways in *American Beauty. Paris, Texas* I saw three times on consecutive nights. And to me that was an absolutely awe-inspiring masterpiece. And it also very much influenced the plays that I did after that because, you know, Sam Shepard wrote that movie, and if you look at the Donmar [Warehouse], we did Shepard and Mamet and Williams and all sorts of American drama. [Mendes was artistic director of the theater, housed in a former brewery warehouse in London's Covent Garden, from 1992 to 2002.] I think a lot of it came from the taste that I developed during that time. Because of that I studied Shepard the playwright, and because of that I did the American literature paper in my third year. So that developed my taste for American drama.

So many of your future tastes as a director can be traced back to that one film?
A lot of it just comes from watching that one movie, yes. Because it unlocked the possibility of contemporary America as a mythic landscape. I'd only understood the mythic landscape to be something of the past, and suddenly it was completely available to me because here was a contemporary film that seemed to have the weight and scale of a Greek tragedy. It was a huge, massive film. The lead character didn't speak for the first hour. It somehow effortlessly reached a mythic grandeur without even seeming to try. And it affected me in all sorts of ways. For example, the sets were very influential in *American Beauty.* I mean, you see Harry Dean Stanton walk the streets of the

town where he arrives. Everyone is behind glass. They're all in interiors. And the only person you see walking the street is him until you see him walk the street with his kid, a wonderful scene where they're talking for the first time. But this all leads to that one moment where he confronts his ex-wife, Nastassja Kinski, behind glass. She can't see him but he can see her. The whole thing leads to that one moment, and in *American Beauty* you see it all the way through the first half of the movie, people trapped behind glass, people trapped within frames. It was my own naïveté, but Wim Wenders was telling a story in every frame literally without dialogue. I mean, I'd never seen anyone do anything quite like that anywhere before. *True Stories* by David Byrne was another big influence. He also managed to find a contemporary mythic landscape, but this time in suburbia. And *Repo Man* was an example of an English director taking on an American film, but this time working in a high style, in a highly stylized way.

Given your obvious love of movies, did you try to direct anything prior to American Beauty?
I flirted with a lot of things. *Wings of the Dove* I nearly did. I went as far as taking casting meetings and meeting DPs. But the only film I really wanted to do and would have done, had the circumstances been right, was *Little Voice,* which I'd directed on stage. That was the one I wanted to do. But I couldn't get it past Harvey Weinstein. He wanted it to be set in America at that time and star Harvey Keitel and Gwyneth Paltrow. I kept saying, "No, no, it's an English film. Let me cast Julie Walters and Jane Horrocks." I even wrote a screenplay for it myself. But he just didn't want to do it. I spent a lot of time trying to get that together. I mean, it went on for a couple of years, '96 and '97. Harvey Weinstein managed not to return my phone calls for about nine months. So I wasted a lot of time and energy on it. Other movies, for one reason or another, they felt wrong or I couldn't get them financed. But I never really pushed for anything apart from *Little Voice.* Then, having gone out to L.A. to try to finance *Little Voice,* I'd decided I was never going out there again. I mean, I was walking into rooms and there were people saying, "So what do you do? Tell me

about your productions." And I thought, "I can't describe what I do." None of them had seen anything. I thought, "This is ridiculous." It was bordering on the humiliating. People just saw me as a bloke from the London theater trying to get a film version of a play financed. Which is exactly what I was. But it was a miserable experience. So I thought, "There's really no point coming back unless things change."

Which is what happened with your revival of Cabaret *on Broadway in 1998?*
Cabaret was funny, really. Because I originally did it in London in 1993 and it was "good but no cigar," as they say. It was a very good idea that wasn't fully realized. And I've always avoided taking shows from England to New York. If I felt they were fully realized and with an English cast, I didn't quite see the point in doing them all over again unless I could take the whole lot over, which I never could. Anyway, it took me a long time to get *Cabaret* together over there, because I wanted to find a non-theatrical space to do it in. I did eventually get it together in 1997–98. So it opened in 1998, which was nearly five years after it opened at the Donmar. By now I was represented by the wonderful Beth Swofford at CAA [Creative Artists Agency]. And Beth said, "You need to come out to L.A. Now that the show's opened, people will want to meet you." And I said, "Look, if I go out there, you have to guarantee that everyone I meet will have seen the show. Or at least something I've done." And she said, "I absolutely guarantee it. No problem." So I went out. And I said, "I don't know where to stay." And she said, "Come and stay with me." So I was staying in her spare room and she said, "There's a pile of scripts on the stairs there. I haven't sent them to you because I knew you'd be staying. They're just waiting on the stairs on the way up to the spare room." There were about eight scripts in the pile, and the top one was *American Beauty.*

It sounds very karmic!
Absolutely. And not only that. An agent will write a cover letter to go out with a bunch of scripts. You know, "I'm enclosing three scripts, this one is set up at Fox with so-and-so producing and so-and-so is

interested to star." And I've got the cover letter for that pile of scripts, and there are eight scripts on it and the last one on the list is *American Beauty*. And there was a summary of the movie: "This is a quirky, midlife-crisis movie," et cetera, et cetera. Something awful like that. This was CAA's description of the project, not Beth's. And below that it said that Dan Jinks and Bruce Cohen were attached to produce, and it was set up at Dreamworks. And there were seven other movies listed on that page. They had all sorts of people attached to star, all sorts of people producing, they were all set up at studios. And you've never heard of any of the other seven. Why? Because none of them ever happened! They never got made and they never got released! That just shows you the sheer luck of getting that script. And at the time it was the first script I picked up and read. And I just thought, either I've graduated to this nirvana where now that I've done a hit show on Broadway, every script I read is going to be totally miles better than anything I've ever read before, or this is a really good script that somehow freakily has crossed my path. I mean, I now know that it was one in a million. The script I'm doing next is that rare thing, an amazing original screenplay, but I've not seen one since *American Beauty*. This is literally the first one, with the possible exception of *Adaptation,* which I thought was brilliant if a little eccentric at the end. They just don't exist, really. It's a sort of Holy Grail. So I said to Beth, "You're going to think I'm mad. I haven't read any of those other scripts you've given me. But I'm telling you now I want to do this movie. I think I know exactly how to do it. It's exactly what I've been looking for. And some part of me is telling me that I know exactly what to do with this material." It was very odd. Because all those things I just described about discovering how contemporary America could be mythic somehow met my own experiences, my own upbringing as an only child. There are two only children in the movie. There are two basically dysfunctional families. They live in suburbia. I lived on the outskirts of Oxford in the oddest house you can imagine. With very odd neighbors, exactly in the same way as the movie. So there were all these things in the movie that chimed with my own experiences. But somehow it also allowed me to express this other side of me which I'd been

dying to express since seeing *Paris, Texas* at university. So there were these two things. But I never imagined that I'd get the job. I mean, of course I loved it, but surely there were people out there better qualified than I was, all clamoring to do it? On the other hand, when I heard that it had been offered to Mike Nichols and Robert Zemeckis, I thought, "They're probably not going to do it because it's not a big enough film for them, and it's also not a star vehicle."

How did your meetings in L.A. go this time?
I actually read the script on the plane back from L.A. I'd picked it up and then gone for my meetings. And one of the meetings was with Steven Spielberg, who had seen *Cabaret* and wanted to meet me. I said to Beth, "You can't honestly mean he really wants to meet me? He's surely got better things to do." But she said, "No, no, he loves meeting young filmmakers." So I say, "Fine," thinking, "He's probably not going to turn up. There'll probably be some bloke there making apologies for him." So I go in. Sure enough, he's not there. I'm thinking, "He's not going to show up." Five minutes later he walks in. "Hi, how are you are? Nice to see you. Loved your show. You should make a movie. Let's make a movie!" Just like that. In his inimitable way. You know, energy, big smile, baseball cap. So I'm sitting there opposite Steven Spielberg and he says, "We've got these scripts. This, this and this. And we've got this really freaky, weird, brilliant, eccentric one called *American Beauty*. You'd love it! Have you got it? Take it away with you!" And I said, "Actually, my agent's already given it to me." "Read it, read it. You want to do that, we'll make that!"

It all sounds as easy as falling off a log!
Well, it always is at the first meeting. Because they want *you* to want it. But as soon as you want it, you're just one of the people who wants it. Along with ten others or however many there are. And then you've got to pitch for it. So what happened was, I said, "I do want to do it," and Beth said, "Okay, hang on. It's on offer to such and such, he won't do it. It's on offer to such and such. Then it'll go on offer to such and such, but they won't do it, either."

Why do you think it had been turned down by all those people?
You'll have to ask them. I mean, why Mike Nichols didn't do it, I don't know. But I know he went as far as having early conversations about it and then decided not to do it. But I don't know. I mean, these guys would have to cut their fees massively to do it. But I don't think the reason was necessarily financial. It's probably the same as some of the movies *I* didn't do. The stars weren't in alignment. Who knows?

What happened once you'd expressed your interest in the script?
It's like this weird courtship dance. You go into the studio and they say, "We're enthusiastic about you, of course we are. But now you have to prove to us why we should give it to you rather than someone else." And I thought there were two ways I could have gone. The first way was to be very withdrawn and English and say, "Come and see my plays and trust me. And if I believe I can do it, surely you must believe it, too." And all this kind of stuff. And the other way is to go all out and pitch for it. And that's what I did. I said, "I want to come and tell you that you should give it to me." And Beth said they really want you to come in and do your best. So I flew myself out on my own money.

Who was present at the meeting where you pitched yourself to the studio?
Dan and Bruce and the screenwriter, Alan Ball, who, of course, was the other key figure in all this, had already met me. And we'd already realized that we all got on incredibly well and we all thought about the movie in the same way. It was my first movie. It was Dan and Bruce's first movie, and it was Alan's first movie. So there was something about the whole team that felt like it was meant to be. So they were all behind me, going, "Go on, go get it! We want you to go in and impress the studio." So I felt their support. But then I had to go in— I think Dan and Bruce were there, but more as observers—and pitch to Bob Cooper, who was then the head of production at Dreamworks, and Walter Parkes and Laurie MacDonald. And I was terrible at the first meeting. Normally I've got the gift of the gab. I'm a motor-mouth. Basically, you just have to switch me on and I'll talk. And it usually makes some sense. And for some reason, maybe because I

really wanted it and because I'd flown myself out there, I was nervous. And also my brain wasn't working because I was jet-lagged. So I wasn't very good. I was okay but not great. The other thing was that I'd expected them to ask me, "Who do you want in it and how do you want to shoot it?" I had prepared answers to those questions. But they asked me stuff like "What do you think the movie is about?" These big questions! And what they're looking for is an answer that they already possess. They know that they think—because they've all sat in a meeting about it two weeks earlier—that it's about "imprisonment." So what they're looking for is the word *imprisonment*! But all I'm saying is "Well, it's about sexuality, it's about longing, it's about the suburbs . . ." [Big laugh.]

So they repeat the question in different ways until you give them the correct answer!

Yes. I'm afraid that's exactly what happens! There is a correct answer. Instead of being interested in what happens when a script like that touches a European sensibility, they were looking for a simple answer. But to their eternal credit, Bob rang Beth and said, "Look, we liked him very much. But we don't think he was quite on top form. We'd like to see him again." So I went in the next day. This time it was just Bob. And this time I was awake and this time I was much better. The next thing I know, they're saying, "We're interested. But you've got to do it for nothing. And I did do it for nothing. I did it for a hundred and fifty thousand dollars, which was the Director's Guild minimum. After taxes and agent's commission, I earned thirty-eight thousand. I can say that very precisely. But I didn't give a shit what I was being paid. I would have done it for nothing. In fact, I would have paid to do it, I wanted to do it so much. And I said to them, "This is who I want to cast." And they came back and said, "Right, but we're not sure about these people. We're not sure it's Kevin Spacey. We're not sure it's Annette Bening."

They had ideas of their own?

Hundreds! They say things like "Bruce Willis?" And you have to say, "Bruce Willis? That's interesting. Let me have a look at some of his

work. I liked him in *Pulp Fiction*. He can be very funny and warm. Let me think about it." Knowing all the time that you don't want Bruce Willis. I should say here, of course, that Bruce Willis can be fantastic. Then they say, "Kevin Costner?" And you've got to do the same thing. And they say, "John Travolta?" And you've got to do the same thing. So you've got to go down the list. Because Kevin Spacey isn't the biggest star in the world, and he's down there at number eight or nine on their list. So very early on, you learn you have to listen to their ideas, but you have to hold on very tight to the core of your beliefs. Where the movie sits. How it should be pitched. At that time, Kevin had just come off *The Usual Suspects* and *Seven* and *Glengarry Glen Ross*. So as far as I was concerned, he was a good actor and he was cool. I didn't want a big movie star weighing the film down. And Annette was absolutely always the person I thought was the one to play Kevin's wife. But again, the studio were suggesting people like Helen Hunt and Holly Hunter and so on. All totally fantastic actresses. I mean, I should be so lucky. In fact, I got into big trouble because I actually met with Annette Bening and offered her the part, but hadn't told them I was going to offer it. And the agent said, "We're thrilled with the offer, what's the money offer?" And when Bob Cooper found out, he screamed at me over the phone, "She hasn't been offered the part!" So I just had to do everything in my power to get the people that I wanted. And it was the same across the board, from cinematographer to composer. I wanted the best, and they're not cheap. Then I had to get them to cut their rates. And they didn't want me to use experienced people, they wanted me to work with new people. When Conrad Hall's name came up, the response was, "Why don't you work with a young cinematographer? You don't want to work with this crabby, old, slow, pedestrian, bad-tempered git." And I was like, "Yes I do!" [Big laugh.]

This was all happening on the phone between London and L.A.?
Yes, it was. I was running a theater at the time and loving it. And L.A. is so much easier when you're not there. There's something about being there that makes it much more difficult to deal with. The kind

of life-and-death stakes that exist there all the time. If you don't own the material, that is. If you've written it, fine. Because you've got it and it's like, "If you don't want to do my fucking movie, I'm taking it away and going somewhere else." At least you've got that. I had none of that. I was a director for hire—a *young* director for hire—and they could have walked away from me just like that if I'd been too difficult. So I had to hold on to the project and be passionate about it, but at the same time I couldn't get too heavy because they would have said, "You can't talk to us like that." The lucky thing was that Bruce and Dan and Alan were all behind me, and without them there's no way I could have done the movie. If they hadn't wanted me in the first place, I never would have got to make the film. So it was really up to them. But, yeah, I did it all on phone calls. Then I went over there a couple more times. At the time I was in rehearsal for *The Blue Room* with Nicole Kidman. So I was rehearsing that in the days and storyboarding the film in the evenings with a storyboard artist called Tony Chance. Tony was absolutely great. I loved him and I used him on *Road to Perdition.* I'm very nostalgic about that period when I was beginning to work out how I was going to shoot the film.

How did you storyboard the film, given that you weren't in the States and hadn't yet seen the locations?
It didn't matter because I had it all in my head. So I storyboarded it before I saw the locations, then looked for locations that matched the storyboards. I also did that with *Road to Perdition.* The only time I've not done that is with *Jarhead.*

It wasn't hard to find locations that matched a preexisting design for each scene?
Yes, it was. But I'm very very pleased that I did it. Because everything was dictated by the way I saw it. The relationship between the two houses, for example. So it meant I couldn't use any real locations for the house. We ended up finding them on the Warner Brothers ranch—it's a sort of separate backlot—and on location around L.A.

You later described the script for American Beauty *as "visually literate." What did you mean?*

I meant that Alan had written into the script much of the visual language of the film. You know, the red roses and the red front door were all in the script. So he'd written an intentional visual correlative to the main story. But he'd also written an unintentional one, which I pointed out to him, and which he wasn't even aware of, which meant that you saw the central character trapped in a series of enclosed spaces for the first twenty minutes of the film. In fact, Alan's script was more similar to a theater script than most because it had long, stagy scenes. For example, the dinner-table scenes. But it also had another dimension which couldn't possibly have been achieved in theater, which was these running images which happened very quickly, very fluidly, very fleetingly.

Did you cast the main parts at the same time as working on your story-boards?

Kevin and Annette were both cast. Kevin was in *The Iceman Cometh* in London. I met him in the pub round the back of the Old Vic, and he'd just got his puppy, Minnie, and was much more interested in playing with his puppy than talking to me. I mean, he couldn't have been less interested in what I was saying. He'd half read the script and he was much more interested in this dog he'd just picked up from Battersea Dogs' Home or somewhere. But the fact was that he was as hot as could be at that point. He was in a huge hit show. He had lots of offers, presumably. And I was just one of them. But then he met me and we got on despite the fact he was more interested in his dog. Then he finished the script and he really liked it. And he said, "I think I could do this." What I didn't realize until I started reading it aloud and working on it with Alan was that it needed a comedian. And Kevin on form is a very, very funny guy. His timing is amazing. But there's something so alive about him in the movie. I think one of the things I'm most proud of in the movie is that his performance is so spontaneous. I think the problem with Kevin sometimes is that he feels very preplanned, almost Machiavellian, as if his performances

have all been worked out beforehand. He's the cleverest guy in the room.

As in The Usual Suspects?
Basically. But also in his roles in *Seven* and *K-Pax*. They're all about him knowing more than you. Here that just wouldn't have worked.

Did Kevin have any worries about portraying forty-something Lester lusting after Angela, a girl the same age as his daughter?
Kevin wasn't worried, but, yes, there were a lot of worries on the part of the studio. A lot of nerves. It was, "Well, hang on a minute, we don't want to see Kevin semi-naked, buffed up." Frankly, there aren't many movie stars who one would want to see semi-naked, buffed up!

Did it take long to assemble the rest of the cast?
With the kids I was given carte blanche by the studio. I cast them and Alison Janney and Chris Cooper and Peter Gallagher as we approached production. I must have had around eleven or twelve weeks of pre-production.

Did you spend much time on rehearsals in this period?
Yeah, I insisted on that. I said, "Look, if you're going to hire a bloke from the theater, at least give him the chance to do what he's good at, because the rest of it might be shit! At least let me have a good rehearsal period so I can try and get some good performances out of these people." So I did two weeks' rehearsals, which was great, although it wasn't as formal as I would have liked. I like a proper formal rehearsal period, with everyone round the table all the time. In film, you can't do that. Someone's got a fitting. Someone's got to nip off for half an hour to have their wig changed or whatever. These things go on the whole time. In film, rehearsals are supposed to fit around everything else. In theater, everything else is supposed to fit around rehearsals. But once you've understood that, you can still get a huge amount of good work done. I did a lot of what I would call "lateral rehearsing." In other words, I gave Annette Bening a tape of the

music I thought her character would listen to. I gave Alison Janney a book of Edvard Munch paintings and said, "Your character is in there somewhere." I gave Wes Bentley some tapes of his kind of music, and also gave him a video camera and told him to go out and film things that his character would be interested in. Stuff like that. Exercises and research which are about the character they're playing. So they can marinate in it rather than me sitting at a table saying, "I want you to say a line like this." And there's another difference between rehearsals in film and theater. In the theater, rehearsals are supposed to end up with a finished product in the room which you then take on stage if you can. In film, you don't want anyone performing full on in rehearsals because it can be eight, nine, ten weeks before they're actually doing the scene. And the worst thing they can be doing at that stage is thinking, "Well, what was I doing eight weeks ago? I can't remember. But it was good then!" You want their gas tank filled with petrol, but you don't want to ignite the engine till much later. So you fill them with ideas, ways it may be possible to do the line, a sense of what I'm going to expect from the scene. Maybe, if I have the set design there, I'll show them the set. I'll say, "This is how I think we're probably going to stage it." Occasionally someone will come along with a specific request. I remember Annette Bening saying, "How are we going to do the sex scene, me and Peter Gallagher?" I drew a little diagram and said, "It's just one shot. I'm going to shoot it from here, and I'm not going to want to see anything except moving sheets and your legs in the air." She laughed and said, "Great." I think sometimes an actor just needs reassurance. You know, "What's the level of embarrassment I'm getting into here? Just tell me I'm not going to have to show my boobs." Also, they'll want to know if I'm planning to do something in one shot, or two or three or four or five, so they know how to pitch their performance during the course of the day. That's the job of the director working with actors. That's the easy bit. That's the fun bit.

How did Conrad Hall get involved? Were you aware of his work?
I knew about his work. I don't think I knew quite what a famous fig-

ure he was in the world of cinematography. But it was really entirely
to do with our meeting. I'd realized pretty quickly that my key rela-
tionship other than with my actors was going to be with the cine-
matographer. To be honest, he wasn't my number-one choice. I
thought, I can't meet Conrad Hall. He's too old and too experienced.
And I'd heard rumors that he was crabby and difficult. So I met other
people, offered it to other people, and they turned me down. I
remember meeting Fred Elmes, of whom I was a big fan, and who
shot *Blue Velvet* and *The Ice Storm*. I was desperate for him to do it,
but he said no because he didn't like the script. I don't think he under-
stood what it was meant to be. Then a year later I got a very sweet card
from him saying he regretted it.

What was it like meeting Conrad for the first time?
Fantastic. He loved the script. He loved how rude it was. How angry.
It just made him laugh. He just wanted to know everything about it.
"Who wrote this? How come you're doing it? How the fuck are you
going to shoot it? Why do you want a sad old fucker like me to do it
with you?" He's very direct. So I described how I wanted to shoot it. I
said, "This is how I think it's going to be. I think I want it to be very
composed, very still. I want the camera to move very little, and when
it does, I want it to be on a dolly." I'd thought about it very, very care-
fully and in great detail. You know, "Here are my storyboards." In an
early draft of the script there are flying sequences. Kevin flew through
the air. And I'd storyboarded all these very carefully. And he loved all
of this. We talked about using blue screen. I talked about how I
wanted it to feel. A sort of clean white light. Then softening as the
movie went on. And muted colors for the color palette. We talked
about everything, really. And I asked about the directors he'd worked
with. I was dying to know about John Huston, about George Roy
Hill, about Paul Newman, and so on. I wanted to know about his life
as a cinematographer, about the good experiences and the bad experi-
ences, why the bad had happened and why he stopped shooting
movies for ten years. So I had lots I wanted to ask him. And I loved
him and the producers, Dan and Bruce, who were in on a lot of this

meeting, loved him, too, even if they were worried about his age. He was already seventy-one, seventy-two, and I think when he walked in, they thought, "Jesus Christ, he's an old man." But to me there was no question about offering him the job. He just was an amazing guy. I fell in love with him. I think that anyone who met him fell in love with him. He was a human being first and a cinematographer second. So what you got was all of him.

What was he like on set?
He was not an easy presence because he could be short-tempered and cranky. He was very cantankerous, he was very opinionated, he was very easily bored. But you never took offense somehow because of the absolute love and adoration he had for what he did and the sheer focus he had on getting things right. One thing I remember is that he would always hum to himself as he worked. When he was lighting, he used to put his eye to the eyepiece of the camera and hum a tune to himself. I don't think he knew he was doing it. He was such a happy man. He was exactly where he wanted to be. Of course it often took him an age to light a scene, which meant we went over our schedule. But look what we got in the end. His work is astonishing.

How did the two of you work together? Did you have a sense of where to place the camera when you visited locations for the first time?
Even when I hadn't storyboarded a scene, as was the case for the whole of *Jarhead* and half of *American Beauty* and *Road to Perdition,* I always knew how I wanted to shoot a room. I could have my mind changed by Conrad or by Roger [Deakins] very quickly if they'd found what I thought was a better shot for the scene. But I've never walked onto a set and thought, "Where do I put the camera?" I've often actually pre-designed the sets in order to put the camera in a particular place. And whether that's rebuilding an existing interior or building the thing from scratch, I've always had a sense of where I'm going to be shooting from. I think that's very important for me. I think you can make a movie in other ways, but I just don't enjoy it. The days when I've gone on set but I really haven't known where we're starting with the camera,

I just can't think clearly. I don't have the bedrock of certainty about how I'm going to approach the day's work. To me, it's about finding the key shot in the scene, then expanding out from that shot. Generally speaking, you start with a master shot. You find a good master, then you start exploring the details. You go in on a close-up or a midshot. And then you get an extreme close-up of a hand or something. Then you've got the whole thing and you can put them together as you want. Sometimes it's the other way round. I started every scene on *Jarhead* close up to the central character, and then I turned the camera around to see what he saw in the scene, and then I took it from there. So that was my way in. But I always had a way in. I think if I had any advice for a young director, it would be to know how you're going to get in and get out of the scene. Even if you change it in the editing room, as you almost certainly will, you need to know where you're starting, where you're finishing. What's your first shot? What's your last shot? In the theater, on the other hand, I would never in a million years go into any scene knowing how I was going to start it or finish it. Theater is about group exploration. On a good day you can start with a totally blank page and say, "Right, where are we, what do we feel about this scene?" You've made certain decisions, such as where the door is. You've already made that decision, probably. But beyond that, nothing. And that's pleasurable. In film, forget it. If you haven't made those decisions, you might as well go home and start again. Because everyone's staring at you, going, "Well, what's the scene?" There are a hundred and twenty people looking at you. That's a certain amount of pressure. So I'm not an improviser on the set with the camera, although I am an improviser with dialogue occasionally.

How would you describe your technical knowledge at this point?
Minimal. I think I'd read *Film Directing Shot by Shot* or something. Because I thought as a director you need to have in your head what you want to achieve. And you need to be able to judge whether you've achieved it or not. But from my perspective, *how* to achieve it is someone else's job. My role is to ask, "How do I achieve this feeling?" To say, "I want the depth of field to be from here to here. I want to have

it all in focus. I want a sense of calm. I want to achieve this feeling out of this shot." Then the DP will choose a lens and say, "Have a look at this. Look at this through the eyepiece. Does this feel right?" In terms of the feeling of the light, of the emotional terrain occupied by light and shade in the movie, you're in the hands of the cinematographer. How they light it on the day is up to them. You can't really judge it until you see the dailies. And to a certain degree the color is down to how you print it, how much you choose to desaturate it.

Did you have a kind of Orson Welles moment when Conrad sat you down and said, "This is what you need to know about lenses"?
I did, absolutely. I knew a little about lenses. But what I asked him was, "What do I do when you've started rolling the camera? At what point do I say 'action'?" [Big laugh.] And he chuckled and said, "Well, I get ready, then the AD says 'rolling,' then I say 'set,' and when I've said that, you can say 'action.' " I said, "Great, thanks." That was literally the one big question I asked before we started. It was the day before we started. He came up for a drink or a cup of tea to the place I was staying in the hills in L.A. to toast good luck.

How about Steven Spielberg? Did he give you any advice before you started?
He gave me the advice he traditionally gives everyone, which is "Wear comfortable shoes." And he also gave me some advice as one director to another. And here you should remember that he's not only a very brilliant and famous director, but was also running the studio that was making the movie. So he had a choice: he could give me the head-of-the-studio advice. Or he could give me the filmmaker advice. And he gave me the filmmaker advice. He said, and it's most definitely not something you would hear from the head of the studio, "There will be days when you're about twenty minutes away from finishing and you suddenly think, 'Shit, I've missed a great shot, maybe even two shots, but if I take these shots, I'm not going to make my day. I'm going to have to come back here tomorrow. What do I do?' " He said, "If you feel in your gut that those are the key shots of the scene, don't make

the day, go back there tomorrow and get them." He said, "It's your first movie, you'll never be able to do it again." He said, "Dig your heels in and say, 'I haven't finished my day,' and be strong." That's basically saying, "If you want to go over, I'll trust you and you can go over a little bit. But don't tell anyone I said this!" That really meant a lot to me. Because what he was saying was, "Between you and me, the most important thing is the movie and not the fact that you've come in on schedule." And so, you know, I didn't come in on schedule, but I made a better movie for it. Two or three weeks in, Steven came down to visit. I was shooting the dinner-table scene. And I was shooting it all on one long push-in. I wasn't shooting any coverage at all until the very end of the scene. And he said, "You're not taking any coverage?" And I said, "No, I'm going to do it all on this one shot." And he said, "Oh, to be a first time director!" Because the confidence you have with your first movie will never be repeated. And he's absolutely right. Because now, while I might play it like that in the movie, I would never have the confidence to take a whole scene absolutely without coverage. Actually, in *Jarhead* I did that a couple of times. Because what happened to me on *Road to Perdition* was that because I didn't have that confidence anymore, I was covering my arse the whole time and eventually I just thought, "This isn't right." So that's what I did. But going back to *American Beauty*, in spite of Steven's kind advice, I completely blew the first day.

What happened?

My first day of principal photography was the day after *The Blue Room* had opened on Broadway. I hadn't slept at all, really. And the first thing that greeted me was a copy of the *New York Times* with a bad review of the play in it. And the second thing that greeted me was an incredibly depressing location, a tiny burger joint on the outskirts of L.A., which didn't feel like a movie set. There were a lot of people there, but there was a lack of specialness to the occasion. It felt like a day in the office. You think it's the first day of your movie, so it's going to be great! But you get there and people click into a rather mundane rhythm. Everyone except you has done it a hundred times before so

for them there's something incredibly routine about the whole thing. If you want it to be special, *you* have to make it special. You have to gather everyone together. Make a speech. Get everyone pumped up. But on your first movie, it's easy to forget that this is your job. You're more likely to be waiting for everyone else to take the initiative. To create the atmosphere. And having had the long conversation with Conrad the day before about saying "action," I remembered to say "action," but forgot to say "cut"! It was a shot of Kevin looking out of a car window at the burger joint that wasn't ever in the movie because it was reshot entirely. And then the whole day passed very fast, the light went very quickly. I thought it was all going brilliantly. I was very happy with it. Then, lo and behold, I saw the dailies the following evening. And it wasn't at all what I wanted. Conrad was also pretty depressed. I said, "I thought that was pretty bad, didn't you?" He said, "I thought it was terrible." I said, "Give me some time to think about it." Then the next day we were shooting the real-estate convention, and Bob Cooper came down to the set and said, "What did you think of the first day's dailies?" And I said, "If you want my honest opinion, I thought they were terrible and I'd love to reshoot them." And he went, "Thank God! Because we want you to reshoot them as well!" So I said, "Fantastic." And that was literally it. I think, weirdly, the fact that I'd admitted they were bad made the studio feel safer. I guess they felt, "Well, if he knows when it's bad, then we're okay." Also it was me just being straight with them and saying, "I want to reshoot the scenes, and, in addition to that, I want to rewrite them slightly, too." And then after that, things got progressively better. The first couple of weeks were still a little hesitant, but then, when we hit our stride, which was after Christmas '98, we were really rolling. And then we never looked back. I think those were eight of the most gratifying, enjoyable, fulfilling weeks I've ever spent—and am ever likely to spend—doing anything. It was just one of those magical groups of people with the right script at the right time. It was just a really enjoyable experience. And it's very rare, as most directors will tell you, for an enjoyable experience during the shoot or the rehearsal of a play to translate into a good result. Normally speaking, the good results come out of blood, sweat, and tears.

What did the experience teach you about the difference between theater and film directing?

The main difference for me is that in the cinema the burden of telling the story falls on the director. You cannot, as a group, experience the story constantly. At the end of the day, in theater, if you want to you can stop and read the play again. Feel what the story is. Feel the shape of the story. And then try and tell the story as best you can. You can never feel the shape of the story in movies. The moment you break it apart, it turns into tiny fragments. So the only person who holds the film in his head is the director. And to that end, you have to really make it in your head. And hold what you have in there, hold its shape, for as long as you can. And when you lose it—I felt I lost it, for example, in *Jarhead* for a while, I lost the sense of the shape of the film—it's very dangerous because it becomes this formless mass. The other major difference is that theater you make once. Movies you make several times over. First of all, you design it and cast it. Well, that's the same for theater. But then you shoot it. Then you make it again in the editing room. Then you make it again with the composer. Because the music can make or break the film. And within those parts of making a film there are infinite ways in which you can fuck things up. So you can have got through the first three stages and still fuck it up by putting the wrong music on it. Or, more traditionally, you can get through the first two stages and fuck it up in the editing room. So there are these successive waves of creativity that take place over a long period and over which you have to maintain your energy.

What was hardest for you about making the transition to film?

How slow it is. I think that's what I found. Because the moment you pick up momentum in the rehearsal room in the theater, you can get eight hours of one thing building on another and another—ideas piling on top of each other. A sense of energy in the room. And this sense of exhilaration is very difficult to repeat on a movie set because just when you've broken through on a scene, you have to stop! You start lighting again. People have a cup of tea. Or something goes wrong. You have to reload. And that's just the way it is. So the only people who can impose momentum are the director and the AD. You have to

push and push the whole time. So what I found difficult was how slow it was and how much you keep pushing in order to motivate and how much you have to keep explaining in order to enthuse. In other words, "I want it to feel like this and this and this! Now, let's go!!" You have to be the one to help them get it up. You know, it's five thirty in the morning and they're pissed off that they've got to be there. But you've got to get that love scene right or whatever it is that you're try-ing to do. That's the difficult thing: the sheer self-motivated energy or willpower that you have to generate on a daily basis. To some people that comes naturally. You watch Spielberg on a set, and he's like a force of nature. He doesn't have to invent enthusiasm. The guy is like pure ambrosia. He's like, "Come on! We're making a movie!!" He's young again. I mean, despite being nearly in his sixties or whatever he is, he's like a twenty-three-year-old. You've never seen anything like it. But for those mortals amongst us, who at six in the morning are wip-ing the sleep out of our eyes and are on our third cup of coffee and trying to remember, in the dim and distant past, "What was the idea I had to begin this scene?" it's very, very difficult. That's the real diffi-culty. You know, theater is very civilized. You get up and have break-fast. Then take the kids to school and at ten o'clock you're in the rehearsal room for six hours. You can do a nice day's work, pick the kids up again, take them home, and put them to bed. That doesn't happen in movies! Everything gets dominated by them. That's one of the big differences.

Was there anything about the shoot that particularly tested you as a director?
There was nothing that was really difficult. Nothing that really con-founded me. And I've been confounded by things many times before and since. I think that the most difficult thing with *American Beauty* was the start. I think that once I'd got the relationship between me and Conrad right, everything followed, to a degree. Actually, one thing that was difficult was to keep Kevin and Annette from laughing all the time. Because they really got the giggles on a number of occa-sions. For example, the scene where she catches him masturbating in

bed and he says, "So what?" In order to keep it alive, I got him to change what he was saying in every take. And Kevin came up with just the most unbelievable list of phrases for what he was doing. You know, "I was choking the hamster, I was jerking my gherkin. I was flogging the gerbil, I was spanking my twinkie," and so on. And Annette just couldn't keep a straight face. And it was like that a lot of time. The two of them were on the verge of collapsing with laughter. I know that might sound facetious, but the truth is that a lot of the energy in many of their scenes comes from that. They're right on the brink. There's something abandoned about it. The same is true of the scene where Kevin's jogging and he comes up to Colonel Fitts. He was on the verge of laughing. He was also on the verge of laughing when he's buying dope off Ricky and when he gets stoned with Ricky. And when he was working out with the weights in the garage and Annette comes in, they were both almost hysterical on a couple of occasions. It's all for real. The thing about it is that there's a sense of enjoyment there. And that's a very rare thing. And it's all there on film, just under the surface.

What was the biggest challenge technically? The scene with the rose petals?
Technically the rose petals weren't actually that difficult, other than the occasional computer-generated rose petals which had to come out of Angela's chest when we were doing the cheerleader sequence. We'd tested them all before we'd started, and we realized that a rose petal looked incredibly beautiful falling if we shot at a hundred and twenty frames per second, when in actual fact, to the naked eye, it drops like a lead weight. So we built an upside-down ceiling for Angela to lie on, and dropped rose petals from a gantry on top of her, then reversed the film. It looked beautiful in tests, so we knew what we were doing and it wasn't that complicated. The only complicated thing was to have her wave in reverse.

One of the scenes that everyone remembers is the plastic bag fluttering in the wind. Was that as simple as it looked?
To be honest, shooting that scene has to be one of the most eccentric

moments in the whole of my career in theater and film. I had to shoot
it four times. First of all, I had the second unit do it on a minicam.
And both times it wasn't long enough and it just looked wrong
because it was set against the wrong backdrop. So then I did it again
myself. But somehow there was something wrong with it. It didn't
have any grace to it. And the last time I got it right. I think the reason
it worked that time was because I'd put leaves all around it and
because I shot it against a red brick wall so you could see the outline
of the bag very clearly, which I couldn't the first time we shot it. So it
ended up with me at five o'clock in the morning before the day's
shooting with a digicam in a school playground with two enormous
riggers holding these massive wind machines, firing them at this tiny
little plastic bag. And people were walking to work and looking at me,
thinking, "Poor young student filmmaker shooting a plastic bag!"
And also, the riggers holding the wind machines couldn't have been
less interested in what I was doing. And because I couldn't get it right,
I had to keep delaying the day that we shot the actual scene with
Ricky and Jane because I couldn't shoot it without the video. I wanted
to shoot the video on the TV live, rather than drop it in afterwards.
But also I thought it was very important that he could see what he was
describing, and of course he couldn't see it until I'd shot it. So we
waited and I got it. I then showed it to Wes and he said, "I've seen it
now, let's just go." So the take he does in the movie is the second take.
There are a lot of early takes in the movie. Maybe take two or three.

*Did you ever feel intimidated by the filmmaking machine that had been
assembled on your behalf?*
I was overawed the first couple of days. But after that it was okay. The
thing to remember is that the machine is personal. And the moment
you personalize it, it doesn't feel so much like a machine. I think when
you're an outsider visiting a set, you think, "Jesus Christ, this is a mas-
sive great army of people." But everything makes sense when you
know that's the props department and they're called such-and-such.
And those are the set dressers and here's the camera crew. And there's
costume and makeup. It feels like a kind of family. No different from

a theater cast. Just bigger. And also, it's not the done thing in the movie world to talk to the director very much. They call you "sir" in America, which causes my wife no end of amusement when she comes to see me on set.

How about the fact that you were making your first film for a Hollywood studio? Was that ever intimidating?
Yeah. But if you get scared, you don't go and pitch a movie to Steven Spielberg in the first place! I wouldn't describe myself as excessively pushy. But I'm not a shrinking violet, either. I'm certainly capable of pushing something when I think I know how to do it. And on *American Beauty* I was confident about what I wanted. I felt that I knew better than anyone what it was necessary to capture on that particular day for that particular movie. And I think unless you have that feeling, you shouldn't be doing it. The other thing you learn very quickly is that this notion of "Hollywood" doesn't really exist. What's Hollywood doing this year? What has Hollywood produced recently? In reality, it's not really a place. And just as it isn't a place, but a fragmented community occupying a giant suburb built in the desert, so the film industry isn't really one thing—it's six or seven studios. With the big Hollywood movies, you're talking about the decisions made by seven or eight quite different people. In addition to that, "Hollywood" now also embraces all the specialty divisions, all the independents that live and work in L.A. and distribute international films, and on top of that there are thousands of craftsmen in L.A. who are there to make movies. There are the best cinematographers, the best standby painters, the best greensmen, the best swordmakers, the best stuntmen, the best background supervisors. They're all there. It's a place where people come to work on movies. And you'll find many fine and wonderful people there. But they are all different. They are not one organism.

I suppose the other thing in your favor as a first-time director was that American Beauty *wasn't considered a high-profile movie when you were making it.*

Quite the reverse. When I made it, it was seen as a small-budget film. As small as, if not smaller than, many of the movies that get made in the UK. But there was a certain point in the afterlife of the film where it ceased to be a film and started to be a message. So many people had been to see it that it must have hit a nerve. People started to say, "Surely you must have been making this as a larger point about America?" The truth is, sure, there were points about America in there. But we made what we wanted to see, what we liked, what made us laugh. And that remained the case to the end. It was a very personal journey for all the people involved, Alan, Dan, Bruce, and me. And we really didn't look at the end result very much at all when we were doing it. It was a small movie, so it went under the radar. There wasn't the pressure of, "Well, this has to take a hundred million dollars at the box office." So we just did what we wanted.

How did postproduction go?
It was fantastic. I worked with two editors, Chris Greenbury and then Tariq Anwar. Chris went off to work with the Farrelly brothers about halfway through, and then Tariq came on. And in the middle there were about ten days when I cut it myself with the assistant. It was just fantastic fun. Editing is fantastic. It's like spending years being the conductor of the orchestra and suddenly discovering you can play the piano. Because your hands are right on it. After being at so many removes, you really are right there. And rhythmically it's amazing what you can achieve and sometimes make out of nothing. It's actually very dangerous, because a lot of the time you can make a silk purse out of a sow's ear. You can rescue things that shouldn't work. And we did that on a lot of occasions on *American Beauty.*

Did it change much during the edit?
It changed a lot. We dropped the beginning and we dropped the end.

Wasn't there originally a courtroom scene at the end in which Ricky and Jane were found guilty of Lester's murder?
There was. But that was dropped. A lot of it was still there, intact,

when Alan and Bruce and Dan saw it. And they said they thought I should put the rest of the beginning and the end back in. And I said, "My feeling is that there's too much there, and it's better without *any* of it. Will you let me do it tonight and we'll watch it tomorrow?" And what we cut that night was literally how the movie ended up. I don't think we changed anything after that. Maybe the cheerleader sequence was shortened by thirty seconds, but that was it. And the way we ended it is the absolute definition of smoke and mirrors. I think if we'd known how successful it was going to be, we would have fought for more money and reshot some stuff. Annette doesn't have a final scene, for example. Neither does Ricky. So at the end it's all music and voice-over. If you go back and look at it in detail, one of the criticisms I would have of the movie is that it doesn't quite add up at the end. I think that's where you hear the wheels of the plot creaking a bit, as the movie tries to generate a third-act climax.

Films often seem to run out of steam when they try to tie up all the strands of the plot at the end.
Absolutely. But of course they were all tied up brilliantly by Alan in the script. The problem was that as you watched what happened after Lester's death in the original version of the movie, everything else seemed diminished by it. The characters seemed diminished and the story seemed diminished. And somehow we lost the sense of Lester as the central character, and the whole thing seemed to curl up and die. So the purpose of cutting the original ending wasn't that we didn't like it, but just that the movie seemed to be diminished by it. I wouldn't argue that the film is any way flawless, particularly in the third act. But there's a section in the center of the film which starts with the plastic bag sequence and travels all the way through to the scene where Ricky is beaten up by his father, there's a ten-minute patch there that I'm really, really proud of. But of course what happens with movies, particularly ones that are as successful as *American Beauty,* is that there is the inevitable backlash—you know, "Well, I didn't like it that much to begin with." Once a movie wins a certain amount of awards, it's very rare that it remains popular. You get the occasional

Godfather or *Lord of the Rings* or something where everyone just says, "I love it." But most of the time, movies like that, particularly contemporary zeitgeist movies, tend to be shot down afterwards. I thought some of it was entirely justified—it was a little overpraised at the time—but some of it obscures the fact that there are sections in the film that actually have real power.

I thought the scene at the end when Ricky's dad appears in Lester's garage, drenched by the rain, was extraordinary.

That's where I come back to the beginning again, talking about this mythic scale. Even though it was basically one bloke walking round to this other bloke's garage, it felt like this huge, epic journey through the rain. And if you ask yourself what's really happening, all it is is two blokes on a back lot under a rain tower. But somehow Conrad's cinematography and Thomas Newman's score and Chris Cooper's performance—particularly Chris in that scene, because Lester basically doesn't know what's going on—combine to create something greater than the sum of its parts. It's very weird. And I think that there are some sections of the film that just do that. It's so difficult now to divorce yourself from what we know about a movie before it opens with its trailers and its posters and its commentary on who's doing what and what stage they've reached in their career and what choices they've made. To remember the feeling you had when you saw something that was strange and odd and didn't quite fit into any of your received notions of what you should be watching. And I think that's still there in *American Beauty*, although the movie's been subsumed into mainstream culture. I see it regurgitated in the same way that I was regurgitating David Lynch and Wim Wenders. I see it in things like *Desperate Housewives,* but also in commercials. It's interesting how it's been assimilated, centralized. But when we made it, it was marginal. I remember that when I met all the long lead press, they'd say it was very European. I'd say, "What do you mean?" And they'd say, well, long takes, wide lenses, nakedness, full frontal nudity which is uninflected—in other words, it isn't "look at how the camera is making these breasts look beautiful," but "here are some young breasts, make of them what you will." And now, five or six years later,

it feels like it's deeply conventional. Because it's been a success, it's been lauded, it's been given prizes. But at the time some small part of it was shocking.

How did the Dreamworks executives respond when they saw the film for the first time?
They were absolutely delighted. I know this sounds like a cliché, but Steven stood up afterwards and said, "You've made a masterpiece. Don't touch anything. You don't have to preview this if you don't want to, because I don't know what a preview audience will make of this." I said, "Actually, I would like to preview this because one of the things I've learned from the theater is that I need to feel an audience's reaction to a piece." And indeed, I was very pleased that I did because there were sections of it that were too long, and I adjusted it a bit. But basically Dreamworks were totally behind it from the moment they saw it. I remember I ran out to go to the loo at the end, and when I came back, Walter said that the reason they hadn't applauded immediately was that they were so stunned. He said, "We had no idea what you were making." And I think that was the main thing. They didn't expect the tone of the film to be what it was. I think what they expected was the first thirty minutes stretched over two hours. A buoyant, light movie, rather like a soufflé. The whole thing in quotation marks. I think when it started to descend into darkness, they had no idea that's what was going to happen. So they were incredibly positive. And from then on they were incredibly behind it.

Were you surprised by the film's success at the box office and at the Oscars?
Yeah. To me the whole thing was and still is a bizarre turn of events. I imagined right up until long after it was released that what I'd done was make a small, fifteen-million-dollar, almost art-house movie. I'd imagined it in the same territory as a movie like *Fargo*. I don't mean stylistically. I mean commercially and all that kind of stuff. I didn't feel like I was making a mainstream film. So what happened to it was totally bizarre to me. And still remains one of the biggest surprises of my career.

You weren't anticipating anything?

Not at all. I remember that on about the fifth or sixth week of princi-
pal photography, Conrad was nominated for an Oscar for *A Civil
Action,* a John Travolta movie he'd done the year before, and we were
like, "Oh my God! Amazing! Fantastic!" And somebody said to me
[low whisper], "Do you think you might get an Oscar nomination for
American Beauty?" And I was like, "Fucking hell, probably not. But
wouldn't it be great?!" So that's what we were thinking: if one person
on this movie got an Oscar nomination, we'd be pumping our fists.
Because it was a tiny movie. And a first-time movie. So we had liter-
ally no idea what was going to happen. And then when it opened and
started to get this response and I started to see other movies and real-
ized that the audiences weren't as transported as they had been with
our film, I started thinking, "Maybe we'll get nominated." But then it
just got picked up by the culture. It never took more than ten million
dollars in a week. It was constantly there or thereabouts. But I think it
still holds the record for the longest time a film has been playing in a
single cinema. Century City in Los Angeles, I think. It opened there
in early September and played constantly until the following August.
The Oscars were in late March, early April. So it just kept going.
Everyone saw it, bit by bit. It was never number one. It wasn't even
number two. It just kept going. There was never the moment of "It's
arrived! It's a huge hit!" It just stuck around. And before I knew it, I
was sitting in L'Hermitage Hotel in L.A. the day before the Oscars,
talking to a BBC reporter who said, "You are aware, aren't you, that if
it doesn't win now, it's going to be a big disappointment to everyone
back home?" And I thought, "How is it possible for me *not* winning
the Oscar for best director for my first movie to be a disappoint-
ment?" But it had got to the point where it would have been. And I
hadn't done anything for the previous six months except sit around
and talk to people about the movie. Nothing else had changed.

But it must have changed your life.

Yeah. You become more visible. There's more pressure. All that kind
of stuff. It meant that I got offered more things. I tried very hard for it

not to change my life in the short term. I stayed at the Donmar. I didn't emigrate to Los Angeles. Although what people say in England is, "I suppose you're going to fuck off to Hollywood now, are you?" And when you say, "No, actually, I'm staying here," they say [look of disbelief], "Why?" And that's the problem with the British. On the one hand, people say, "Okay, you're succesful, fuck off!" But if you say you're not going, they say, "You're mad! *I* would." And there you have the central paradox of the British relationship with fame and Holly-wood. It's a kind of cognitive dissonance between "Why wouldn't you want to leave this country? It's a shithole," and on the other hand, "Well, fuck off, then. We never liked you anyway." But, yeah, it changes your life in ways you can't imagine. But it also puts fear into you. It's a terrible thing in many ways. Before that, I was thrilled if anyone wanted to know me or do things with me or whatever. After-wards, I mistrusted why people wanted to meet me or get to know me. So I went through a year and a half of deep suspicion and para-noia. But after that, it went. And it's gone now. My Oscar's in a safe deposit box where it's been for four years. All it means is that it'll be a little while longer before they stop me from making movies.

DIRECTOR BIOGRAPHIES

Richard Linklater – SLACKER

Richard Linklater was born in Houston, Texas, in 1960. After dropping out of university in his early twenties, he spent two years working on the oil rigs in the Gulf of Mexico. He subsequently moved to Austin and spent the next few years immersing himself in every aspect of film culture while living on his savings. In this period he began to make no-budget Super 8 films and founded the Austin Film Society. *Slacker,* which he wrote, directed, self-financed, and co-produced in 1989, was a rare example of a film that, despite its no-budget origins, managed to express the personality of a generation of Americans at odds with the ethic of hard work and self-improvement that had characterized their parents. Picked up and released by Orion Classics, the film has come to be regarded as the indie movie *par excellence,* not only inspiring many other young directors to try their hand at low or no-budget filmmaking, but also bequeathing the term *slacker* to mainstream American culture. Propelled by the success of his first film, Linklater went on to make a studio film aimed at the same generation, *Dazed and Confused,* before revealing his art-house sensibilities in *Before Sunrise* in 1995. Since then he has managed to navigate a line between smaller, art-house films such as *Waking Dream* and *A Scanner Darkly,* and mainstream studio fare such as *School of Rock* and *Bad News Bears.*

Richard Kelly – DONNIE DARKO

Richard Kelly was born in Richmond, Virginia, in 1975, the youngest son of a NASA engineer and a remedial schoolteacher. After enrolling in the fine-arts course at the University of Southern California, Kelly moved to the film department, where he made several short films before his graduate project, *Visceral Matter,* a medium-length science-fiction film, which he completed with a loan from his father. Fearing that his graduation film was meaningless as a calling card without a script to accompany it, Kelly wrote *Donnie Darko* in a matter of months after graduating from USC. Although the script quickly gained Kelly an offer of representation from one of the largest talent agencies in Hollywood, the project's development remained far from straightforward. While studio executives were drawn to the script for *Donnie Darko,* many thought Kelly—still in his early twenties—was too young to direct his own material. Even when Drew Barrymore's offer to appear in the film finally secured financing for the project, it was still beset by difficulties. First, Kelly fell out with the film's backers during postproduction. After premiering at Sundance, the film was finally picked up by Newmarket Releasing, but it was quickly pulled by its distributors owing to lackluster performance at the box office. It was only with the word of mouth that greeted the film's subsequent DVD release that a buzz started to develop around the film, which eventually led to its rerelease in theaters. The rollercoaster ride Kelly experienced on *Donnie Darko* seems to be repeating itself on his second film, *Southland Tales,* which elicited less-than-favorable responses from critics when it premiered at the Cannes Film Festival in 2006. In spite of mixed responses to his work, however, Kelly continues to work as a writer-for-hire and director. He is currently preparing his third movie, *The Box.*

Alejandro González Iñárritu – AMORES PERROS

Alejandro González Iñárritu was born in Mexico City in 1963. In his early twenties he began working as a DJ on one of Mexico's most popular radio stations, WFM. Although his garrulous, off-the-wall per-

sona meant his daily radio show quickly attracted an audience of several million listeners, González Iñárritu soon tired of his role as a radio personality. When a friend offered him a job writing and directing clips for a fledgling television channel in Mexico City, he seized the opportunity with both hands. Buoyed by his success as a director of promos, he yearned to elbow his way past the old guard of Mexican cinema into the world of feature films. After he founded a production company to make television commercials and directing a pilot for a television series, his chance came when his producer, Pelayo Gutiérrez, introduced him to the screenwriter Guillermo Arriaga Jordán. The pair initially decided to make an eleven-minute film about Mexico City comprising ten intersecting stories. Two years and some thirty-six drafts later, the script for González Iñárritu's first feature film was ready. Released in 2000, *Amores Perros* was perhaps one of the most incendiary film debuts in the past twenty years. Seeming to come from nowhere, the film won countless awards around the world and established González Iñárritu as a heavyweight talent with whom Hollywood's A-list were queuing up to work. Since 2000, he has made two further films, *21 Grams* and *Babel,* both characterized by the same fractured narrative that marked *Amores Perros.* In 2006 he won the prize for Best Director at Cannes for his third film, *Babel.*

Takeshi Kitano — VIOLENT COP

Takeshi Kitano is arguably the most famous celebrity in Japan. In his comic persona, "Beat" Takeshi, he appears almost nightly on Japanese television and consistently tops polls among the Japanese public for the most popular Japanese entertainer. At the same time, he is known internationally as a masterful filmmaker who has authored a series of highly individual movies, often characterized by moments of deadpan, highly stylized violence. Born in Tokyo in 1947, he studied engineering at the prestigious Meiji University in the 1960s before dropping out in 1970. Over the next two years he worked as a waiter, a baggage handler, a salesman, a supermarket clerk, and a taxi driver. He then moved to Tokyo's entertainment district and took a job as a

lift operator in a comedy club, where he began performing comedy routines onstage. An encounter with fellow comedian Kineko Kiyoshi led to the formation of the comedy duo called the Two Beats. Riding the wave of the comedy boom that engulfed Tokyo in the seventies, the pair quickly established themselves as celebrities throughout Japan. On the strength of this success, Kitano began to be offered small parts in films. Yet it wasn't until 1989, when he stepped into the director's shoes on *Violent Cop,* that Kitano's prodigious talents as a filmmaker were revealed. So dark was his portrait of an out-of-control policeman confronting the venal heart of Tokyo, it looked as if he wanted to annihilate all traces of his comic persona. Instead, he simply divided himself into two personas: Takeshi Kitano, the internationally acclaimed film director, and Beat Takeshi, the popular comedian. Since his debut, he has continued to flip-flop between these two public identities, appearing regularly in the guise of talk-show host and entertainer while continuing to fashion a series of films bearing the hallmark of extreme violence—*Boiling Point, Sonatine, Hani-Bi, Brother,* and *Zatôichi*—as well as experimenting with different genres in films like *Dolls.* His most recent film, *Takeshis,* makes use of his own comic persona in its narrative, and as such shows the clarity with which Kitano sees the schism that runs through his career.

Shekhar Kapur – MASOOM (INNOCENCE)

Shekhar Kapur was born in Lahore in 1945, and moved to Delhi two years later. A nephew of one of India's most celebrated movie stars, Dev Anand, Kapur felt the tug of show business from an early age. Yet his parents were keen that he gain a professional qualification. After being educated at St. Stephen's College in Delhi, therefore, he moved to London in the early 1960s to train as an accountant. After qualifying, he worked as a planner at Burmah Oil, where he reported to Denis Thatcher, the husband of the future British prime minister. Although Kapur found much to enjoy in London in the sixties, he eventually tired of accountancy and—much to his parents' horror—decided to return to India to try his hand as an actor. Several years

then passed as Kapur tried unsuccessfully to establish himself in Bollywood. In 1974 he was given a small part in his uncle Dev's film *Ishq Ishq Ishq (Love, Love, Love)*. Several more parts in film and television followed, but his career in front of the camera was never more than piecemeal. His break came in 1983 when the producer Devi Dutt agreed to let him direct a feature for the first time. The resulting film, *Masoom*, was a major success at the box office in India and confirmed Kapur as an instinctive filmmaker with a keen eye for the mores of India's growing middle classes. It was another ten years, however, before the success of *Bandit Queen* in 1994 brought Kapur to the attention of audiences outside India and launched his career as a director on the international stage. Since then he has directed two big-budget Hollywood movies, *The Four Feathers* and *Elizabeth*. Kapur's latest film is *The Golden Age*, his second set during the reign of Elizabeth I.

Emir Kusturica — DO YOU REMEMBER DOLLY BELL?

Sometimes described as "the Fellini of the Balkans," Emir Kusturica is the only director to win the Cannes Film Festival's Palme d'Or twice, first in 1985 for *Father Is Away on Business*, then in 1995 for *Underground*. Born into a Bosnian Muslim family in Sarajevo in 1954, he studied film at Prague's celebrated Academy of Performing Arts (FAMU), which also nurtured the talents of such filmmakers as Milos Forman and Jiri Menzel. After graduating in 1978, he returned to Sarajevo, where he taught at the film institute and made two television films, *Buffet Titanic* and *The Brides Are Coming*, before directing his debut feature film, *Do You Remember Dolly Bell?*, which was awarded the Golden Lion at the Venice Film Festival in 1983. Since his debut, Kusturica has shown himself to be a true visionary of the cinema, creating a series of films such as *Time of the Gypsies, Black Cat White Cat*, and *Arizona Dream* which lend an ecstatic, magical dimension to the lives of the marginal characters they portray. Despite his success with art-house audiences and critics throughout Europe, Kusturica has frequently courted controversy in his home country. The

fact that *Underground* was partly financed by the state-owned television network at a time when the regime of Slobodan Milosevic was in power led to accusations—vehemently denied by Kusturica—that he was friendly with the regime and sympathetic to the dream of a greater Serbia. In spite of such controversies, Kusturica's cinematic output seems undiminished. Since the end of the Balkan conflict, he has continued to produce and direct, as well as appearing in cameo roles in films by Neil Jordan and Patrice Leconte, and touring with his band, the No Smoking Orchestra. His most recent films include *Life Is a Miracle* and *Promise Me This.* He has also recently directed a documentary on the life and times of the Argentinian footballer Diego Maradona.

Agnès Jaoui – LE GOÛT DES AUTRES

Born of Tunisian Jewish parents in 1964, Agnès Jaoui grew up in Paris before training as an actress with the celebrated French theater director Patrice Chéreau. After a period in her twenties when she found work hard to come by, she began to write plays with her partner and collaborator, fellow actor Jean-Pierre Bacri. When their first produced play, *Cuisine et Dépendances,* became an overnight theatrical hit, the pair were invited to adapt it for the big screen. The critical and commercial success of the resulting film quickly established Jaoui and Bacri as one of the most respected screenwriting partnerships in France—collectively known by their admirers as "Jabac." The pair went on to script a series of films distinguished by their wit, sly intelligence, and gentle humor. These include *Smoking/No Smoking* and *On Connaît la Chanson,* directed by Alain Resnais, and *Un Air de Famille,* directed by Cédric Klapisch. In 2000, Jaoui's first film as writer/actress/director, *Le Goût des Autres,* became a massive hit in France and was subsequently nominated for the best foreign-language film at the Academy Awards of 2001. Jaoui has since written, acted in, and directed the scabrous portrait of Parisian literary society, *Comme un Image,* and taken the title role in *La Maison de Nina.* She is currently working on her third feature as writer/actress/director, *Parlez-moi de la Pluie.*

Lukas Moodysson – SHOW ME LOVE

Lukas Moodysson was born in Malmö, in southern Sweden, in 1969. As a teenager he wrote several collections of poetry before switching to film. After graduating from the Swedish Film Institute, he spent several years trying unsuccessfully to establish himself as a writer-director, before debuting in 1998 with *Fucking Åmål.* (The film was retitled as *Show Me Love* for foreign release.) A gay love story between two teenaged girls, the film proved to be one of the most commercially successful Swedish films of all time, outperforming *Titanic* at the domestic box office. It also enjoyed huge critical acclaim in Sweden, winning four Guldbagge awards and being described by Ingmar Bergman as "the first masterpiece of a young master." In spite of *Show Me Love*'s enormous commercial and critical success, Moodysson has been unwilling to rest on his laurels. While his second film, *Together,* a gentle satire about a hippie commune in the seventies, showed much of the same lightness of touch as his debut, the two films that followed, *Lilya 4-Ever* and *A Hole in My Heart,* were so bleak and brutal that they drew mixed responses from the very audiences and critics so enchanted by his earlier films. Moodysson himself is unrepentant, believing it is the duty of the artist to reinvent himself at every turn. Accordingly, his latest work, *Container,* is his most experimental full-length film yet. Lacking both the plot and characters of a conventional film, it is perhaps best regarded as a return to his poetic roots.

Terry Gilliam – JABBERWOCKY

Terry Gilliam was born in Minnesota in 1940. After graduating with a degree in political science from Occidental College, Los Angeles, he worked as a cartoonist on Harvey Kurtzman's magazine *Help!* before moving to London in the late 1960s, where he began to create cartoons for the surreal comedy series *Do Not Adjust Your Set* and *Monty Python's Flying Circus;* the first program of the latter was broadcast by the BBC in 1969. Such was the success of the *Monty Python* series that it was only a matter of time before its stars were offered the chance to make a feature film. *Monty Python and the Holy Grail,* co-directed by Gilliam and Terry Jones, was released in 1975. Two years later,

Gilliam's solo directorial debut, *Jabberwocky,* revealed a visual style—the extensive use of extreme wide-angle lenses, coupled with an extraordinary richness of detail in his compositions—and a predilection for larger-than-life fantasy that would become the hallmarks of his later work. Since then he has forged a career as a visionary filmmaker who, while using the tools of the mainstream—stars and studio financing—has managed to create a series of highly idiosyncratic films that are both visually stunning and nightmarish in their intensity. Gilliam's films include *Time Bandits, Brazil, The Adventures of Baron Munchausen, The Fisher King, Twelve Monkeys, Fear and Loathing in Las Vegas, The Brothers Grimm,* and *Tideland.* His unsuccessful efforts to film *The Man Who Killed Don Quixote* were recently chronicled in the documentary *Lost in La Mancha.*

Sam Mendes – AMERICAN BEAUTY

Sam Mendes was born in 1965 and educated at Cambridge University. After graduating in 1987, he joined the Chichester Festival Theatre, where he directed Judi Dench in an award-winning production of *The Cherry Orchard.* He subsequently moved to the Royal Shakespeare Company, where he directed productions of *Troilus and Cressida, Richard III,* and *The Tempest.* In 1992 he became the artistic director of the Donmar Warehouse in London, where he directed numerous award-winning productions, including *Assassins, Glengarry Glen Ross, The Glass Menagerie, Habeas Corpus,* and *The Front Page.* In 1998 his Broadway production of *Cabaret* was seen by Steven Spielberg, who offered him the chance to direct Alan Ball's script of *American Beauty.* After a shaky start, Mendes found his feet and made one of the most polished debuts of recent years. *American Beauty* went on to win five Oscars—including Best Director—and three Golden Globe Awards. Since 2000, Mendes has directed two further films financed by American studios, *The Road to Perdition* and *Jarhead.* He continues to work in theater and film, and divides his time between the UK and the United States.

A NOTE ON THE TYPE

This book was set in Adobe Garamond. Designed for the Adobe Corporation by Robert Slimbach, the fonts are based on types first cut by Claude Garamond (c. 1480–1561). He gave to his letters a certain elegance and feeling of movement that won their creator an immediate reputation and the patronage of Francis I of France.

Composed by North Market Street Graphics,
Lancaster, Pennsylvania
Printed and bound by Berryville Graphics,
Berryville, Virginia
Designed by Wesley Gott